Hispanic and Lusophone women filmmakers

MANCHESTER
1824

Manchester University Press

Hispanic and Lusophone women filmmakers

Theory, practice and difference

Edited by Parvati Nair and Julián Daniel Gutiérrez-Albilla

Manchester University Press

Manchester and New York

distributed in the United States exclusively by Palgrave Macmillan

Published by Manchester University Press
Oxford Road, Manchester M13 9NR, UK
and Room 400, 175 Fifth Avenue, New York, NY 10010, USA
www.manchesteruniversitypress.co.uk

Distributed in the United States exclusively by
Palgrave Macmillan, 175 Fifth Avenue, New York,
NY 10010, USA

Distributed in Canada exclusively by
UBC Press, University of British Columbia, 2029 West Mall,
Vancouver, BC, Canada V6T 1Z2

British Library Cataloguing-in-Publication Data
A catalogue record for this book is available from the British Library

Library of Congress Cataloging-in-Publication Data applied for

ISBN 978 07190 8357 0 hardback

First published 2013

Typeset in 10/12 Sabon
by Servis Filmsetting Ltd, Stockport, Cheshire
Printed in Great Britain
by TJ International Ltd, Padstow

Contents

Part III Migration, transnationalism and borders

Part IV Subjectivity

Notes on contributors

Isolina Ballesteros is Associate Professor in the Department of Modern Languages and Comparative Literature at Baruch College, CUNY. Her teaching focuses on Modern Peninsular Studies (nineteenth- and twentieth-century literature and film), Comparative Literature and Spanish and European film. Her field of specialty is contemporary Spanish cultural studies and her current research reflects a dual interest in gender, ethnicity and migration to Europe, and the cultural memory of the Spanish Civil War. She is the author of two books: *Escritura femenina y discurso autobiográfico en la nueva novela española/Feminine Writing and Autobiographical Discourse in the New Spanish Novel*, (1994), and *Cine (Ins)urgente: textos fílmicos y contextos culturales de la España postfranquista/(Ins)urgent Cinema: Filmic Texts and Cultural Contexts of Post-Franco Spain* (2001). She is currently working on a book called, *'Undesirable' Otherness and 'Immigration Cinema' in the European Union*.

Catherine L. Benamou is Associate Professor of Film and Media Studies and Visual Studies at the University of California-Irvine. Recent publications include a book chapter, 'Televisual Melodrama in an Era of Transnational Migration', in Darlene Sadlier (ed.), *Latin American Melodrama* (University of Illinois Press). She is the author *of It's All True: Orson Welles's Panamerican Odyssey* (University of California Press, 2007), and is currently researching televisual flows, migrant audiences and the mediated public sphere at selected urban sites in Spain and the United States.

María Caridad Cumána González is a film critic and programmer. She is an adjunct professor at the University of Havana's Department of Art History, ISA (Instituto Superior del Arte) and the Fundación del Nuevo Cine Latinoamericano (FNCL), where she teaches courses in Latin American and Cuban film. The author of two books and over fifty essays and reviews about Cuban cinema, her recent book, *Latitudes del Margen: El Cine Latinoamericano Ante el Tercer Milenio*, co-authored with Joel del Rio, was awarded a special jury prize from the FNCL and the Alcalá de Henares University (Spain). With Susan Lord, she is co-editing a collection of essays on Sara Gómez, *The Dimensions of Sara Gómez: Images of Utopia,*

Documents of Belonging. She coordinates the popular website www. cinelatinoamericano.org.

Ann Davies is a senior lecturer in Spanish at Newcastle University. Her books include *Daniel Calparsoro* (Manchester University Press), *Pedro Almodóvar* (Grant and Cutler) and *Carmen on Film: A Cultural History* (Indiana University Press, with Phil Powrie, Chris Perriam and Bruce Babington). She is the editor of *Spain on Screen: Contemporary Developments in Spanish Cinema* (Palgrave Macmillan) and is also the co-editor of *The Trouble with Men: Masculinities in European and Hollywood Cinema* (Wallflower Press, with Phil Powrie and Bruce Babington) and *Carmen: from Silent Film to MTV* (Rodopi, with Chris Perriam). She has written various articles on Hispanic cinema.

Jo Evans is a senior lecturer in the School of Modern European Languages, University College London. She is the author of books on the Franco regime poet Ángela Figuera Aymerich and the Spanish director Julio Medem, and her essays on Spanish film and narrative have appeared in *Screen*, *New Cinemas*, *Studies in Hispanic Cinemas*, *Hispanic Research Journal*, and the *Bulletin of Hispanic Studies*.

Rosa Linda Fregoso is Professor and former Chair of Latin American and Latino Studies at the University of California, Santa Cruz. Her writing, research and teaching focus on gender violence and human rights, social media, artivism and culture. She has published numerous articles on the issue of feminicide on the US–Mexico border, in journals and books, including *Terrorizing Women: Feminicide in the Américas* (co-edited with Cynthia Bejarano, Duke University Press, 2010); the award-winning, *meXicana Encounters: The Making of Social Identities on the Borderlands* (University of California Press, 2003). Her other books are: *The Devil Never Sleeps and Other Films by Lourdes Portillo* (University of Texas Press, 2001); *Miradas de Mujer* (co-edited with Norma Iglesias, CLRC & COLEF, 1998); and *The Bronze Screen: Chicana and Chicano Film Culture* (University of Minnesota Press, 1993).

Charlotte Gleghorn is a postdoctoral researcher at Royal Holloway, University of London. To date, her research has principally focused on Latin American cinema, particularly on contemporary Argentine and Brazilian women's filmic production, the role of the body in light of the repressive dictatorial regimes suffered by both countries, issues of memory and cultural transmission, and how the audio-visual industries intersect with these debates. She is currently involved in the Indigeneity in the Contemporary World project, hosted at Royal Holloway. This research project explores authorship and cultural memory in indigenous filmmaking from Latin America. In particular, she aims to build a critical dialogue with scholarly

work on indigenous cinema and video from other anglophone parts of the world, namely Australia, Canada, the USA and New Zealand.

Julián Daniel Gutiérrez-Albilla is an assistant professor in the Departments of Spanish and Portuguese and Comparative Literature at the University of Southern California. His research interests are in Spanish and Latin American cinema, gender studies and critical theory. His publications on Spanish and Latin American Cinema have appeared in journals and edited collections, including *Revista de Crítica Literaria Latinoamericana*, *Bulletin of Hispanic Studies*, *Bulletin of Latin American Research*, *Studies in Hispanic Cinemas*, *Spain on Screen*, *Gender and Spanish Cinema* and *Almodóvar: el cine como pasión*. He is the author of *Queering Buñuel: Sexual Dissidence and Psychoanalysis in His Mexican and Spanish Cinema* (Tauris, 2008). He is currently co-editing a *Blackwell Companion to Buñuel* and writing a book on ethics, memory and subjectivity in contemporary Spanish cinema. He collaborates frequently with Spanish and Latin American film festivals in Los Angeles.

Helena López has a Ph.D. in Spanish literature. She has been a Fulbright Fellow at the Hispanic Studies Department (University of Brown) and a postdoctoral scholar at the School of Advanced Studies (University of London). Her main research fields are literary and cultural studies in Spain and Mexico. More specifically, she is interested in three areas: feminist theory, cultural analysis and pedagogy; the culture of Spanish Republican exile (especially in relation to personal narratives by women); new visions of literature and cinema from the perspective of memory and affect studies. She has taught and researched in different institutions in France (École Normale Supérieure and Université de Paris XII) and the UK (University of Bath). She is currently working at the Programa Universitario de Estudios de Género at the Universidad Nacional Autónoma de México, where, in August 2011, she was also appointed convenor of the research area 'Literatura, cine, afectividad'. Her last research project, *El clamor de las ruinas. Una interpretación cultural de narrativas personales de exiliadas españolas*, has been awarded at the V Premio Internacional de Ensayo Mariano Picón Salas and will be soon published.

Susan Lord is Associate Professor in the Department of Film and Media and the Graduate Programme in Cultural Studies at Queen's University. Her research interests in globalisation, technology and culture are anchored in studies of urban screens and gendered projections, Cuban film and art since 1959, and urban ethnography and decolonising cosmopolitanism. She is co-editor of *Fluid Screens, Expanded Cinema* and *Killing Women: The Visual Culture of Gender and Violence* and *New World Coming: The 1960s and the Shaping of Global Consciousness*. She is completing a monograph, *Cinemas of Belonging: Imaging the Non-aligned World*, and co-editing a

volume with María Caridad Cumána on the Cuban filmmaker Sara Gómez. She curates programmes of media arts and is a member of the Public Access collective publicjournal.ca.

Leslie L. Marsh is an assistant professor of Spanish at Georgia State University in Atlanta, where she teaches courses on Hispanic and Lusophone cinemas. Her research focuses on women's filmmaking in Brazil, citizenship and representations of gender and sexuality in Latin American film. She has also written on representations of violence in recent Brazilian cinema.

Steven Marsh teaches Spanish film and cultural studies at the University of Illinois at Chicago. He is the author of *Popular Film Under Franco: Comedy and the Weakening of the State* (Palgrave, 2006), joint editor (with Parvati Nair) of *Gender and Spanish Cinema* (Berg, 2004). He is a co-author of the international collaborative book *Cinema and the Mediation of Everyday Life: An Oral History of Film-Going in 1940s and 1950s Spain* (forthcoming, 2012). Currently he is finalising a book-length study provisionally entitled *Spanish Cinema: A Counter History*.

Deborah Martin is a lecturer in Latin American cultural studies in the Department of Spanish and Latin American Studies at University College London. She has published on women's literature and film in Colombia, and on Cuban 'mockumentary'. Her book *Of Border Guards, Nomads and Women: Painting, Literature, and Film in Colombian Feminine Culture 1940–2005* will be published by Tamesis in 2011. Her current research focuses on representations of the child in Latin American cinema, and on the work of Lucrecia Martel.

Alejandro Melero Salvador is a lecturer in film studies in the Department of Audiovisual Communication at the Universidad Carlos III, Madrid. He is the author of *Placeres ocultos: Gays y lesbianas en el cine español de la Transición* (2010) and *Guía ilustrada del cine europeo* (2010). He has contributed to several academic books and journals. His research interests include cinema studies, gender, queer studies and film narratives. He has also published fiction.

Rui Gonçalves Miranda holds a Ph.D. in Lusophone studies, awarded by the University of Nottingham, and has taught Portuguese literature and cinema in Nottingham and in Queen Mary College, University of London. He is currently a postdoctoral research fellow (Fundação de Ciência e Tecnologia) in the Centro de Estudos Humanísticos (Universidade do Minho) and the University of Nottingham, working on post-conflict literary and cultural disseminations and dialogues within the Lusophone countries and communities.

Parvati Nair is Director of the United Nations University Institute in Barcelona and professor of Hispanic, cultural and Migration Studies at Queen Mary University of London. Her research focuses on representations of migration, ethnicity and gender in film, music and photography. She is the author of *Configuring Community: Theories, Narratives and Practices of Community Identities in Contemporary Spain* (MHRA, 2004), of *Rumbo al norte: inmigración y movimientos culturales entre el Magreb y España* (Edicions Bellaterra, 2006) and of *A Different Light: The Photography of Sebastião Salgado* (Duke University Press, 2012). She is also the co-editor of *Gender and Spanish Cinema* (Berg, 2004) and the principal editor of the refereed journal, *Crossings: A Journal of Migration and Culture*. She is currently writing a book on flamenco in local and global contexts, *Flamenco Rhythms: People, Place, Performance*, to be published by Liverpool University Press.

Sofía Ruiz-Alfaro is an assistant professor of Spanish at Franklin & Marshall College, where she teaches courses in contemporary Latin American literature and cinema. She has published book chapters and articles on questions of gender and genre in the cinema of Lourdes Portillo and on the queer world of Chavela Vargas.

Paul Julian Smith is Distinguished Professor in the Hispanic and Luso-Brazilian Programme in the Graduate Centre, City University of New York. He was previously the Professor of Spanish in the Faculty of Modern and Medieval Languages of the University of Cambridge and Visiting Professor in ten universities (including Stanford, UC Berkeley, NYU's King Juan Carlos Chair, Johns Hopkins, Universidad del País Vasco, Lund, Sweden, and the Carlos III, Madrid). He has given over 100 invited lectures and conference papers around the world and is the author of fifteen books (with translations into Spanish and Chinese) and sixty academic articles. He is a regular contributor to *Sight & Sound*, the magazine of the British Film Institute, and a columnist for *Film Quarterly*, published by University of California Press. He is one of four founding editors of the *Journal of Spanish Cultural Studies* and was the editor of the book series Oxford Hispanic Studies, published by Oxford University Press. His books include *Writing in the Margin: Spanish Literature of the Golden Age*, *The Body Hispanic: Gender and Sexuality in Spanish and Spanish American Literature*, *Laws of Desire: Questions of Homosexuality in Spanish Writing and Film 1960–90* (all Oxford University Press), *Desire Unlimited: The Cinema of Pedro Almodóvar* (Verso), and *Amores Perros: Modern Classic* (British Film Institute). His most recent book is *Spanish Screen Fiction: Between Cinema and Television* (Liverpool University Press, 2009).

Patricia Torres San Martín is a social anthropologist and a research professor in the Department of History, Universidad de Guadalajara, Mexico.

Her research interests are in Mexican and Latin American cinema. Her recent publications include: *Del sujeto a la pantalla: La recepción del cine mexicano y su audiencia en Guadalajara* (2004). She is also the editor of *Uso y construcción de fuentes orales, escritas e iconográficas* (Universidad de Guadalajara, 2007) and has contributed to the following volumes: *Los nuevos objetos culturales*, ed. Celia Del Palacio (Universidad Veracruzana, 2009) and *La revolución Mexicana en la literatura y el cine*, ed. Olivia Díaz Pérez (Iberoamericana, 2010). She has recently published on Latin American women working in the silent film industry for the *Women Film Pioneers Project* directed by Jane Gaines, Radha Vatsal, and Monica Dall'Asta at the Centre for Digital Research and Scholarship, Columbia University Libraries, New York. An edited volume is forthcoming in 2012.

Tom Whittaker is a lecturer in film studies at Kingston University. He is the author of *The Films of Elías Querejeta: A Producer of Landscapes* (University of Wales Press, 2011). His research has mainly focused on the relationship between film and geography in Spanish cinema, and his publications have appeared in journals such as *Jump Cut, International Journal of Cultural Studies, Bulletin of Hispanic Studies* and *Studies in Hispanic Cinemas*. His current research centres on the history of sound in Spanish cinema.

Sarah Wright is a senior lecturer in Hispanic Studies at Royal Holloway, University of London. She is the author of *The Trickster Function in the Theatre of Garcia Lorca* (Támesis, 2000), *Tales of Seduction: The Figure of Don Juan in Spanish Culture* (I.B. Tauris, 2007) and of articles on Spanish film, theatre and cultural studies.

Acknowledgements

We are very grateful to the contributors, without whose work this volume would not have been possible. Similarly, we thank Matthew Frost and the rest of the staff at Manchester University Press for their support and guidance. We also wish to thank our colleagues and students at the School of Languages, Linguistics and Film, Queen Mary, University of London, and in the Departments of Spanish and Portuguese and Comparative Literature, University of Southern California, for their interest in this project.

Introduction: through feminine eyes

Parvati Nair and Julián Daniel Gutiérrez-Albilla

The purpose of this volume is to critically examine the work of Hispanic and Lusophone female filmmakers. In paying homage to the creative work of these women directors, we want to start by alluding to another creative practice which functions as a metaphor that is associated with the realm of the feminine: weaving. If weaving has historically been seen as a marginal craft practised by women, our critical project self-affirmatively rescues this creative practice from its marginal status and uses it as a metaphor that describes the process of bringing this project into existence. In other words, this volume 'weaves' several 'threads' by working at the intersections between feminist film theory, gender studies and film practices by women in Latin America, the US, Portugal and Spain. As is well known, feminist film studies in the Anglo-American academy, highly influenced by the pioneering psychoanalytically inflected work of Laura Mulvey (1975), have primarily concentrated on the way in which women are represented in dominant cinema, namely that of classical Hollywood, as objects of a cinematic gaze that is ideologically shaped by the hegemony of patriarchy and heteronormativity. Although, since the 1980s, there has been significant research in feminist film studies celebrating non-mainstream and avant-garde cinematic practices by women, as well as directors working in more marginal areas such as exploitation cinema, using a wide range of theoretical and methodological frameworks, there is as yet very limited scholarship on this vital aspect of the study of Hispanic and Lusophone cinemas. The limited research in the field of Hispanic and Lusophone female filmmakers has concentrated on empirical approaches that are primarily based on compilations of interviews with these female filmmakers, without establishing conceptual and theoretical frameworks for interpreting such filmic practices. The focus of this volume is less on an empirical and/or exhaustive documentation of Portuguese, Spanish, Latin American and US Latino films made by women than on the critical and theoretical implications of pertinent films with regard to the study of each contributor. This volume does not attempt to trace a history of cinematic practices directed by women in Latin America, Portugal, Spain or the US, or a history of feminist film criticism in the Anglo-American academy or in Latin America, Portugal and Spain. Instead, using films directed by women during the twentieth and

twenty-first centuries as case studies, this volume concentrates on issues of critical discourse and debates and filmic or cultural representation, thereby seeking new ways of approaching the complicated status of Hispanic and Lusophone female identities and subjectivities through filmic and theoretical analyses and offering critical interventions and theoretical interrogations in existing scholarship. The pioneering works of Susan Martin-Márquez, *Sight Unseen: Feminist Discourses and Spanish Cinema* (1999), or Ofelia Ferrán's and Kathleen Glenn's edited volume on women's narrative and film in twentieth-century Spain (2002) applied a feminist film theoretical perspective to films directed by women in Spain. Although this book pays tribute to the invaluable research carried out by these authors and editors, it intends to establish a strong transnational and comparative emphasis on films made by women in Portugal, Spain, Latin America and film practices made by US Latina filmmakers. We include a chapter on Chicana cinema, namely the cinema of Lourdes Portillo, as this is an area that has yet to be given its due place within the Hispanic cinematic canon. The book also points to the current necessity to work at a transnational level by establishing resonances and disjunctions between films made by female filmmakers on both sides of the Atlantic. As Helena López argues in Chapter 11, 'the digital revolution, together with the transformation of industrial capitalism, has resulted in an intensification of transnational economic, political and social structures, in turn resulting in both the erosion of the old notion of the modern nation-state and the global circulation of flows, of financial capital, commodities, information, people and images'. Hence, to return to the metaphor that opened this volume, it is the 'weaving' of all these 'threads' that allows us to create our own 'tapestry': a critical study that both fills a gap in and extends the field of Hispanic and Lusophone film studies.

Rethinking the terms 'Hispanic' and 'Lusophone'

It is important to question, then, the starting points that necessarily frame the cultural parameters of this project: the terms 'Hispanic' and 'Lusophone' that bring with them the haunting of Empire and of long histories of violence and exploitation, with an attendant subsuming of the local and the indigenous. Our aim is most definitely not to corroborate these echoes from the past, nor, indeed, to perpetuate them. Yet, we are also aware that these very terms cover vast geopolitical tracts and also that, in their persistence through and beyond the collapse of Empire, they further carry within them the seeds of resistance and renewal. The Hispanic and the Lusophone have come to denote not merely the extension of imperial Iberia, but also the claims to recognition of that which is hybrid and evolving, dissonant perhaps, but also dynamic. For different political reasons and evolving over different time-spans, this is so both in the Iberian Peninsula and in the Americas. They denote the transformation of elitist culture imposed by the ideology and practice of Empire and the pervasive legacy

of colonialism to an engagement and creativity that flows back and forth across cultural, historical and economic circuits that continue to connect Spain and Portugal with the Americas. In their evolution from the imperial agenda, these terms have turned fluid and transatlantic, mediating between the Iberian Peninsula and its languages and cultures, on the one hand, and the diverse and enormously vibrant cultural milieux of its former colonies, on the other. Cinema plays a crucial role here and, when seen in terms of the filmmaking of women, marks out the assertion of the doubly marginalised in innovative ways. The result, as we see in the chapters to come, has been a vast and rapidly expanding mosaic of cultural innovation. In addition, as Paul Julian Smith emphasises in Chapter 1 of this volume, Spanish and Latin American cinema is currently relying on the system of co-productions between these two geographical regions in the face of the economic and cultural globalisation that is associated with our neoliberal societies. This system of co-productions has enhanced the cross-fertilisation of ideas across the Atlantic, as well as contributing to problematising the idea of what constitutes a national cinema. While the work of these filmmakers will be considered within the Portuguese, Spanish, Latin American and Latino contexts from which they arise, defined as these are by Hispanic, Luso-Brazilian and Latino cultures, the volume establishes productive connections between film practices across these geographical areas by identifying common areas of concern on the part of these female filmmakers. The volume also pays attention to the heterogeneity of the different socio-cultural contexts in which these film practices by women emerge. This book thus explores the transcultural connections, as well as the cultural specificities, that can be established between these Spanish, Portuguese, Latin American and Latino contexts within and beyond the framework of the nation state. Our volume thus attempts to trace the historical connections that can be mapped vis-à-vis the production of films made by women and the process of social emancipation of women in societies that have been historically associated with a patriarchal and even heteronormative ideology. To focus, therefore, on Hispanic or Lusophone women filmmakers is not to predetermine the contours either of such cinema or of the perspectives of such a grouping of filmmakers. Instead, it is to query and to explore this shifting arena, starting first of all by turning to the historical. For it is precisely the haunting of Empire that, as previously mentioned, resonates in the Hispanic and the Lusophone, as well as with regard to the position of women in such ideological contexts, and so it is to this haunting that we must first turn.

The haunting of empire and patriarchy

The spread of the Iberian empire, concomitant as it was with the Catholic Reconquest of 1492, was predicated on religious grounds. Catholicism accompanied, and indeed supported, the harnessing of the Americas to

the political and economic benefit of Spain and Portugal. The conquest of America meant that the languages and cultures of Iberia became common currency across the Atlantic and, more importantly, that the values and social norms of the colonisers were transported and imposed upon the locals, often in ways that were stultifying to women in particular. No doubt one of the better known of these cultural phenomena is that of *marianismo*, or the socio-religious cult of Mary that imposes idealised gender stereotypes on women, which has played a determining role in the evolution of gender long after decolonisation. In turn, this has led to a complex web of politics that must be noted. As Hanna Herzog and Anne Braude note (2009), it is particularly in postmodern contexts, where the unfinished and splintered projects of modernity overlap confusingly with tradition, that gender, religion and politics are most enmeshed. If, on a global scale, this is most apparent in the margins of hegemonic cultures, then, within these spaces, it is once again the crevice or the margin (i.e. the margin of the margin) – gendered, this time, and very commonly peopled by women – that displays the complex entanglements and turmoil of gender, religion and politics. Equally, these are also the loci of resurgence, whereby *marianismo*, particularly in today's 'post-feminist' context, ceases to be the passive acceptance or imbibing of the stereotype and turns instead into the fertile ground from which a resurgence of gender propositions can be formulated (Montoya *et al.*, 2002). In this context, feminism and feminist theory play a pivotal role in the triggering of new ways of imagining and performing gender. Cinema, as a medium of the masses, offers ample scope for delineating and envisioning new possibilities for gender. As Steve Marsh and Parvati Nair state, 'films open up a panorama of experience that temporarily transports the cinema-goer away from private, domestic routine to public, global horizons and in that movement lies the disturbing power of film' (2005: 3). Filmmaking by women becomes, as we shall see in this volume, an important route to exploring what lies outside of and beyond the stereotype through reflexivity on violence and conflict, and through visual and narrative explorations of migration, exile, subjectivity, history or individual and collective memory.

In opening a space for filmmaking by women, it is perhaps also worth noting that the politics of gender, whereby women have traditionally been disempowered, apply in similar measure across Hispanic and Lusophone contexts. There is little doubt that, on both sides of the Atlantic, the hold of religion on society translated into an entrenched patriarchy and a displacement of women as political and social agents. This, in turn, has had serious economic repercussions for women. In Spain, for example, the belated emergence of even the most basic legal rights for women in the wake of almost four decades of dictatorship (from 1939 to 1975), such as those of divorce or ownership of finances, to name just a few, coincided with the sustained, if limited, emergence of women filmmakers. As María Camí-Vela states, the first generation of women filmmakers to emerge in

Spain following the end of the dictatorship did not do so from film schools (2001: 16). Their efforts and their determination were crucial in renewing and refreshing Spanish cinema. In the Iberian Peninsula, as also across the Atlantic, cinema offers a space for constructing identity and exploring the possibilities of gender over and beyond the bondage of history and patriarchy.

Indeed, Spain, Portugal and many Latin American countries have all experienced the trauma and the drama of totalitarian regimes and repressive military dictatorships. Although it is important to emphasise that these repressive military regimes, such as the Franco regime, changed dramatically over their years of rule, under totalitarian regimes or military dictatorships almost no single physical or symbolic space can escape their omnipotence. For instance, right until the death of Franco in 1975, one could neither criticise the Catholic Church nor talk about politics in public spaces in Spain. The civil population in these areas has had no other choice than to come to terms with the lasting toxic effects of such a pervasive presence or omnipresence of state terror. The re-establishment of political democracies in these parts have given rise to new social and political situations in these societies that have, in turn, led to the development of social movements in favour of the emancipation of women in everyday life. Despite the increasing number of women filmmakers or women working in the film industry, Portuguese, Spanish and Latin American women filmmakers are still culturally undervalued on the basis of their gender identity. As is well known, the exhibition of the majority of films directed by women remains circumscribed to film festivals that exclusively showcase the work of women, thereby contributing to the ghettoisation or compartmentalisation of films directed by women and ultimately of women themselves. As Alison Butler notes, the work of female filmmakers 'continues to be pulled into spaces of exhibition, criticism and debate defined in terms of gender, such as women's festivals, conferences, courses, and publications like this one' (2002: 2). The present volume does not intend to contribute to the academic ghettoisation or compartmentalisation of the cinema produced by women in Latin America, Portugal, Spain and the US, precisely by producing a volume that is exclusively consecrated to their work. By fulfilling the pedagogical function of generating and facilitating both filmic and interpretive material that relates to cinematic practices directed by women in Latin America, Portugal, Spain and the US, this book acknowledges the way in which gender configuration is changing in Latin American, Portuguese, Spanish and US Latino cinema. Our focus is on aesthetic, theoretical and socio-historical studies, which question the manifest or latent gender and sexual politics that inform and structure the emerging number of cinematic productions by women filmmakers in Portugal, Spain, Latin America and the US, as well as the work of important women filmmakers who have contributed to their cinematographic industries since the silent period.

Female filmmakers, feminist theory and Hispanic and Lusophone contexts

The contribution of women filmmakers is part and parcel of this evolving cultural panorama on both sides of the Atlantic. In choosing to focus on women filmmakers, numerous questions arise around the idea of women filmmakers. In what ways, we wonder, could filmmaking by women be seen as a category in itself? Could it be said that such a category exists prior to the intervention of scholars, or is it, in fact, a product of the academy, of feminist film studies and gender theorists? Is it an imposition on our part to attempt to analyse the fluidity of celluloid through the preconceived lens of gender? And to what extent would any academic attempt at labelling define, and so perhaps contain, the creative efforts of filmmakers, regardless of sex or gender? As Levitin *et al.* have asked, 'does it still make any difference when it is a woman wielding the camera? How does the feminist critique of the male gaze hold up when examined by a practicing camerawoman?' (2003: 10). The crucial questions formulated by the editors of *Women Filmmakers: Refocusing* prompt us to formulate further questions that point to the tensions that are generated when thinking about the intertwined matters of film production, gender and feminism. The idea of gendering cinema is therefore fraught with uncertainties. Such nomination, as is so often the case with nomination in general, brings with it the threat of violence and of fixing; it comes with a call for responsibility on the part of those who wield language in order to clarify and bring into focus what would otherwise be lost in the indistinct blur of namelessness. The challenge is to do so, while also leaving open the possibility of imagining the inevitable transformations across time and space of that which is being defined. Moving beyond the gender politics of Hispanic and Lusophone contexts into a more global one, it is clear that there is indeed a curious weighting the world over whereby women directors remain a relatively rare breed, even as female actors abound. Cinema, as hitherto mentioned, has played a pivotal role in placing women at the centre of the gaze. As objects of desire that flit across the celluloid screen, women have played a primary role in and through cinema as triggers of fantasy, charged with sexual promise and yet entrapped and fixed by having to enact such spectacles. Nevertheless, on more than one occasion, women actors have slipped behind the screen and re-emerged as filmmakers. The rise of women directors has done much to counter the fetishised approach to women in cinema and to broaden gender perspectives. It has also foregrounded the fact that women are not merely objects of the gaze, but also those who hold the gaze – this time, though, quite clearly, no longer in any singular or fetishising sense, but as an affirmation of plurality and alterity on- and off-screen. Indeed, the very foregrounding of the female gaze explodes any assumption that the gaze was ever the prerogative of the masculine, understood in terms of heteronormativity, nor indeed that it can be – or has ever been – fixed, despite the

preponderance of such singular articulation. Through the filmmaking of women, the gaze devolves into a point of view shaped by ideology and so becomes contestable, open to challenge, debate and rethinking. It is in this context that Claire Johnston writes of women's cinema as 'counter-cinema' (1999). Women's cinema is not predetermined or predetermining, in any sense, but it is the kind of filmmaking that arises both from and in spite of the obliterating hegemony of patriarchal modes. However, is it counter-productive to relegate these heterogeneous film practices to the space of 'women's cinema', or, to what extent does the creation of a counter-canon of female auteurs reinforce a metaphysics of presence, thereby perpetuating traditional patriarchal epistemology? As Peggy Kamuf forcefully signalled back in the 1990s, the very concept of a woman author reinforces a traditional, liberal and humanist perspective that has been dismantled by poststructuralist thinkers (1990: 105–11). Thus, if, as Teresa de Lauretis warned us, women can only speak 'as subjects of discourses which negate or objectify women through their representation' (1987: 127), the chapters in this volume point to rearticulations of language and subjectivity that might question and subvert dominant ideological constructions of gender and sexual identity. The chapters that follow look at these cinematic practices in order to raise questions of alterity in subjective and intersubjective processes, thinking, thus, of the question of femininity beyond a patriarchal system of thought based on lack and castration. For instance, as Julián Daniel Gutiérrez-Albilla's theoretical analysis of Lucrecia Martel's *La ciénaga* asks in Chapter 15, does the pre-existing status of the filmmaker confer her 'femininity' on the film, or is it more productive to think of the working of the film that produces the filmmaker in the feminine?

Celebrating heterogeneous practices and methods

One of the major concerns that emerged while putting together an edited volume was how to place a heterogeneous body of interpretive work into a coherent methodological and conceptual framework. In order to discipline the approach adopted in this edited collection to the heterogeneous and diverse body of films directed by women in these specific geopolitical areas, this book consciously and purposefully reflects the diverse methodological and theoretical approaches and positions adopted by the individual contributors in their chapters. With a combination of emerging and internationally renowned scholars from the UK, the US, Spain and Latin America, some chapters examine primary documents through archival research, or provide the reader with a historical overview of the contribution of women to their national or transnational industries; other chapters tend to opt for an examination of previously neglected critical literature, or re-examine more established critical literature, as well as offering original textual, theoretical or historical analysis of the selected films. Other chapters tend to become more self-reflexive by engaging with the filmic text, as well as with

the meta-language that is produced within and by the critical and theoretical methodology adopted by the particular contributor. Instead of looking for consistency or congenial approaches, we have intentionally put together a combination of heterogeneous and almost mutually exclusive critical, conceptual and methodological frameworks and perspectives that will contribute to the volume's formulation of a shift in critical perspectives in existing film criticism on Portuguese, Spanish, Latino and Latin American cinema and cultural studies and gender studies in Anglo-American and Spanish and Latin American scholarship. Nonetheless, the present volume also explores key conceptual routes that can be traced to link the plethora of issues and concerns in women's filmmaking. These conceptual routes will serve to lend coherence to the book as a whole, while also allowing for an exploration of diversities within Hispanic and Lusophone socio-historical contexts. The book clusters the chapters under four central themes: (1) Memory and History, (2) Culture and Conflict, (3) Migration, Transnationalism and Borders and (4) Subjectivity. These themes have been chosen as being common areas of focus in women's filmmaking. The volume explores these themes in order to set up resonances among the chapters grouped under each one, so that affinities of concern will emerge within these clusters. These divisions are by no means prescriptive and one will find issues that resonate throughout the volume.

The politics and poetics of alterity

By documenting and interpreting a fascinating corpus of films made by women coming from Latin America, the US, Portugal and Spain, the present volume proposes research strategies and methodologies that can expand our understanding of socio-cultural and psychic constructions of gender and sexual politics. These strategies may help us to rethink notions of gender identity and subjectivity within national cultures and transnational frameworks that are neglected in current modes of feminist film theory within Anglo-American scholarship. Thus, the chapters that follow establish productive connections and tensions between theory and practice. In other words, as Griselda Pollock wonderfully puts it, the cinematic work produces 'seeds of theory'. It is, paradoxically, at the very moment of 'applying' those seeds of theory to the cinematic work that the cinematic work itself disappears (Pollock, 1996: 82). While women directors continue to be a minority in most, if not all, national and transnational film contexts, nevertheless, there are those among them who rank among the most innovative and inventive of filmmakers. In this sense, there is a certain parallel between the situations of women filmmakers and independent filmmakers, even if, as Butler points out, women's cinema should be freed 'from the binarisms (popular/elitist, avant-garde/mainstream, positive/negative) which result from imagining it as a parallel or oppositional cinema' (2002: 22). With regard to Hispanic and Lusophone cinema, the work of many of

these notable women filmmakers features in this volume. The contribution of women filmmakers becomes all the more noteworthy when one considers it in terms of economics. Above all, it has been hard for women to make films because their access to finance has been limited and curtailed. Further complications arise when questions of gender and economics are viewed through the prisms of race and social class (Levitin *et al.*, 2003). Add to this global and historical inequalities, such as those that afflict many parts of Latin America and the Lusophone world, for example, and the difficulties for women to access filmmaking abound. Filmmaking continues to be the prerogative of the privileged, so that many women find themselves barred from a rightful place at the helm. Despite opportunities that arise through transnational funding, as Smith explains in this volume (Chapter 1), the sad fact remains that there is a correlation in general between the economy of a nation and the number of female directors it produces. Refreshingly, though, there is also a correlation between the degree to which women as a global minority seek empowerment through political awareness and action, on the one hand, and their involvement in the mass media, on the other.

There can be no definitive parameters for cinema crafted by women. Nor, for that matter, can we come to any final definitions of what constitutes such filmmaking or make any attempts to write gender into cinema. For cinema inevitably both reproduces and challenges the normalising discourses of society. The chapters that follow are an invitation to explore and to rethink cinema in terms of the feminine; in other words, to do so in terms of alterity and open-endedness. It is thus also to rethink the casting of gender and its related stereotypes through cinema. In this sense, this book argues for what lies outside the margins of the hegemonic and the normative. In turn, it is hoped that such cinema will also throw light on and so foreground the paradoxical centrality for cultural renewal of that which is marginal or other. In addition, given that women filmmakers have made an impact on documentary as well as on fictional cinema, it is the purpose of this volume to hold onto an act of thinking and a process of analysing the work of women filmmakers in terms of a deliberate borderline approach, both in form or genre and content, that serves to highlight and explore the borderline position of women as filmmakers. Equally, this exploration will also foreground the ways in which women's filmmaking, from the 'margins' as it were, impacts upon hegemonic cinematic trends, altering the course of cinematic developments in Hispanic and Lusophone contexts.

From this perspective, this book, while revisiting and rewriting the past and examining and thinking the present, also reflects upon the future of feminist film theory and practice, or the futurity of feminism and femininity. If women's filmmaking affects and transforms dominant modes of representation from the margins, there is always the risk that the margin will be incorporated into the hegemonic at the very moment of enunciation. We hope that, if this is an inevitable fate, the cinematic signifiers and ideological languages that are produced by and within the film practices directed by

women will contribute to expanding the social and symbolic order in order for the social and symbolic order to be able not to repudiate or to incorporate gender and sexual difference, but to encounter and be affected by the specificities of gender and sexual differences in all their irreducible alterity. As Emma Wilson notes in relation to French women filmmakers, 'before their work is inserted too quickly into the broader context of contemporary French cinema, criticism might seek to find means to track such films in their moment of metamorphosis and rupture, their new transitory and transitional modes' (2005: 223). Hence, our critical and hermeneutic practices offer, in the same way that the formal and thematic possibilities of cinematic practices by women do, a transitory and transitional space between the self and others.

We open this volume with an introductory chapter before the four parts that comprise this volume, in which Paul Julian Smith focuses on the transnational nature of the film industry in Spain and Latin America and how such a transnational structure affects the regions' productions, including the films directed by Lucrecia Martel and Isabel Coixet. As Smith argues in this opening chapter, these two female auteurs, some of whose films have been funded by Almodóvar's independent production company, El Deseo, have not only established a body of work but can also lay claim to a transnational reach. Moving between a concern with empirical questions related to the production, the distribution and the reception of the films by these female auteurs and a close textual analysis of Martel's *La ciénaga* (2001) and Coixet's *My Life Without Me* (2002), Smith demonstrates that industrial constraints need not condition artistic individuality, as exemplified in the work of Martel and Coixet. The transnational remains a key referent for much of the cinema studied here and, as such, Smith's chapter stands by itself so as to frame the conceptual and practical ground upon which the entire volume rests.

We should emphasise that, while we have organised this volume under the four main headings of 'Memory and History', 'Culture and Conflict', 'Subjectivity', and 'Migration, Transnationalism and Borders', we hasten to point out that each of these categories is linked both conceptually and cinematically to the others in intrinsic ways. Our aim in forging these divisions within this volume is to clarify and facilitate the mapping of these conceptual tropes. They are of relevance beyond the chapters included in each section, if only because they form important intersections in women's filmmaking, and this is rendered evident through conceptual gestures found in individual chapters that are of relevance across the volume. As such, and as Smith's chapter emphasises in terms of the transnational, each of the conceptual frames that structure this collection should be read as transcending the individual sections and crossing paths with one another so as to better highlight the vibrant and dynamic nature of women's filmmaking in and against the historical circumstances in Hispanic and Lusophone contexts.

References

Butler, A. *Women's Cinema: The Contested Screen* (London: Wallflower, 2002).

Camí-Vela, M. *Mujeres detrás de la cámara: Entrevistas con cineastas españolas de la década de los 90* (Madrid: Ocho y medio, 2001).

de Lauretis, T. *Technologies of Gender: Essays on Theory, Film, and Fiction* (Bloomington: Indiana University Press, 1987).

Ferrán, O. and K. Glenn *Women's Narrative and Film in Twentieth-Century Spain* (London and New York: Routledge, 2002).

Herzog, H. and A. D. Braude *Gendering Religion and Politics: Untangling Modernities* (Basingstoke and New York: Palgrave Macmillan, 2009).

Johnston, C. 'Women's cinema as counter-cinema', in S. Thornham (ed.), *Feminist Film Theory: A Reader*, (Edinburgh: Edinburgh University Press, 1999), pp. 31–40.

Kamuf, P. 'Replacing feminist criticism', in M. Hirsch and E. Fox Keller (eds), *Conflicts in Feminism* (London and New York: Routledge, 1990), pp. 105–11.

Levitin, J., J. Plessis and V. Raoul *Women Filmmakers: Refocusing* (London: Routledge, 2003).

Marsh, S. and P. Nair *Gender and Spanish Cinema* (Oxford: Berg, 2005).

Martin-Márquez, S. *Sight Unseen: Feminist Discourses and Spanish Cinema* (Oxford: Oxford University Press, 1999).

Montoya, R., L. J. Frazier and J. Hurtiq *Gender's Place: Feminist Anthropologies of Latin America* (Basingstoke and New York: Palgrave Macmillan, 2002).

Mulvey, L. 'Visual pleasure and narrative cinema', *Screen*, 16(3) (1975), 6–18.

Pollock, G. 'Inscriptions in the feminine', in C. de Zeguer (ed.), *Inside the Visible: An Elliptical Traverse of Twentieth-Century Art in, of, and from the Feminine* (Cambridge, MA: MIT Press, 1996), pp. 67–87.

Wilson, E. 'État présent: contemporary French women filmmakers', *French Studies*, 59(2) (2005), 217–23.

Transnational co-productions and female filmmakers: the cases of Lucrecia Martel and Isabel Coixet

Paul Julian Smith

Auteurism and 'new' cinemas

Undercapitalised and subject to recurrent crises, the film production sectors in Spain and Latin America remain fragile and dependent on national government subsidies. Yet they are clearly tending to converge. A special feature in the trade journal *Screen International* claimed in February 2010 that 'Spanish producers are working with their international counterparts on an unprecedented scale in an attempt to increase budgets and widen the appeal of their films around the world' (32). Co-productions within the Spanish-speaking world have long benefited from Ibermedia, a transnational scheme that encourages collaborative projects between different countries. Based on a point system, which allots a set rating according to the national origin of directors, actors, technical staff and shooting locations, Ibermedia provides a transparent way of allocating national labels to features, deciding for example whether a film is to be officially branded as 'Argentine-Spanish' or 'Hispano-Argentine' (Smith, 2006: 163).

Although Ibermedia is credited as the 'film financier' for one of the features I discuss later (Lucrecia Martel's *La ciénaga*), in practical terms such collaborative arrangements have proved asymmetrical: while a great deal of Latin American production relies on Spanish funding (often funnelled through state television network TVE), little or no production in Spain is dependent on Latin American funding. And although there may be cultural affinities between nations, it is not clear that at the level of consumption a single Spanish-speaking market has been (or indeed should be) created. Even in the sphere of television, where telenovela functions as a hugely successful transnational genre, nationally distinctive elements are muted in order to facilitate the flow across national boundaries, with actors actively schooled on how to disguise their local accents and scripts stripped of specific references to regional geographies or cultures (Smith, 2009b: 124). As we shall see, this process of 'neutralisation' may also be at work in the more rarefied sphere of art-movie production.

The position of women filmmakers is anomalous in this process. It is perhaps unsurprising that the most powerful auteurs on both continents,

whose films are globally distributed (Pedro Almodóvar; the Mexican triad of Alejandro González Iñárritu, Alfonso Cuarón and Guillermo del Toro) are all male. Although Spain has, under its current Socialist administration, one of the highest rates of female participation in government in the world, according to the Spanish society for women in film and media (Asociación de Mujeres Cineastas y de los Medios Audiovisuales), the proportion of female film directors has actually fallen from 17 per cent to 10 per cent in the first decade of the millennium (Smith, 2009a: 68). This chapter focuses on two cases that are thus exceptionally rare: female auteurs who have not only established a substantial body of work but who also lay claim to transnational reach.

Isabel Coixet, Catalan in origin, has made six mainly English-language features in the US, Galicia, Canada and most recently Japan: *Demasiado viejo para morir joven* (1989), *Things I Never Told You* (1996), *My Life Without Me* (2003), *The Secret Life of Words* (2005), *Elegy* (2008) and *Map of the Sounds of Tokyo* (2009). While her work clearly began within the paradigm of low-budget US independent cinema, it has now expanded to embrace wider and sometimes more audience-friendly modes. Lucrecia Martel, on the other hand, has remained faithful to her native north-western region of Argentina, far from the film capital of Buenos Aires. Martel's more severe art movie aesthetics identify her with other transnational auteurs favoured on the festival circuit, even as her work gestures somewhat obscurely to specifically Argentine issues, such as the traumatic heritage of dictatorship. Coincidentally, both female auteurs have been sponsored by the same Spanish independent production company, Almodóvar's El Deseo. Such support for young filmmakers is an explicit part of El Deseo's business mission, which stresses 'project diversification' (Smith, 2009b: 18–20). The considerable differences between the films of Coixet and Martel suggest, however, that in this case at least industrial constraints and transnational flow need not compromise artistic individuality.

Coixet's feature films have received a varied reception from critics and audiences alike. In something of a hostage to fortune, her website (Coixet, 2010) gives evidence of her professional activity in such commercial fields as publicity spots and pop promos. Thus although the trade journal *Variety* predicted that *My Life Without Me* would be 'an art house sleeper' (Stratton, 2003), it dismissed *Map of the Sounds of Tokyo* as 'a perfume ad without a product' that was 'greeted by boos' at the Cannes press showing (Felperin, 2009). Interestingly, however, this (female) critic also suggested that the exquisite costumes and props of Coixet's later film ('accessory porn') and its sensitive but sexy male protagonist (Catalan Sergi López) might prove seductive to select women viewers.

Martel, on the other hand, is arguably the auteur in Spanish-language art cinema who is most critically acclaimed, outside Latin America at least. In 2009, all three of her features (*La ciénaga* (2001), *La niña santa* (2004), *La mujer sin cabeza* (2008)) figured among the top-ten Latin American films of

the decade in a poll of New York-based critics organised by specialist distributor Cinema Tropical (2009). Her first film took top place, beating the better-known (and more accessible) works of the Mexican male triad. Yet as *Variety* noted in its review of *The Headless Woman*, even the 'small head of B[ox] O[ffice] receipts' it predicted for Martel's film on the basis of her track record '(would) depend on critical support' (Felperin, 2008). If mainstream cinema is dependent on acceptance from fickle general audiences, the distinct economy of art house film (which is of course opposed to that of commerce) is no less reliant on the unpredictable responses of elite critics.

Attempting (like the directors themselves) to combine industry and art, in the first half of this chapter I focus on the divergent figures of my two filmmakers, seeking to locate them within the cultural fields in which their work is produced, distributed and exhibited. In the second I offer close readings of one feature from the early 2000s by each director: Martel's *La ciénaga* and Coixet's *My Life Without Me*.

We begin, then, with the industrial context and auteurism. It would seem safe to say that the turn of the millennium was not the most auspicious time to begin a cinematic career in either Argentina or Spain. Yet both countries proved surprisingly tenacious in their commitment to film production. In her monograph *The Cinematic Tango*, Tamara L. Falicov (2007) gives a detailed account of the emergence of 'young filmmakers and the new independent Argentine cinema' in the mid-1990s (115). For Falicov, this 'movement' (which always denied it was such a thing) was contingent on a number of factors. While the national cinema institute INCAA favoured the funding of local blockbusters such as crime thrillers, it also set aside 'a small pool of funds' for first-time directors by instigating competitions. But this public stimulus was supplemented by the 'host' of film schools (mainly, but not exclusively, private) that opened in and around Buenos Aires and whose graduates tended to reject both current Hollywood norms and previous Argentine auteurist modes. The press also contributed to the phenomenon by claiming to identify a trend they baptised 'new Argentine film'.

Although these young directors were initially rejected for public funding, 'alternative cinema' spaces emerged for exhibition both at theatres in the Argentine capital and at foreign festivals (116). New directors tended to specialise in new subjects and milieux: Generation-X-style youth or 'invisible' populations such as immigrants (119). While this low-budget and often artistically minimalist 'dirty realism' was held to be autochthonous (responding to local conditions in Argentina), it coincided, as Falicov notes, with at least one influential international trend: the back-to-basics Danish Dogme movement, which was launched with much media fanfare in 1995 (122).

Martel at once coincides with and diverges from the improvised but rapidly consolidated criteria for the 'new Argentine cinema'. She studied filmmaking in Buenos Aires and won a public competition with an early short that was distributed as part of the portmanteau *Historias breves* (1995). In

common with other local features, her films were exhibited (briefly) on the dedicated screens of the national public circuit run by INCAA, such as the theatre in the very centre of the capital named after veteran actress and tango star Tita Merello. But they also found vital support abroad, with *La ciénaga* winning the Best First Feature prize at Berlin (Falicov, 2007: 126).

Martel's subject matter and style were, however, very different from others in her so-called 'generation'. Rejecting Buenos Aires, she shot only in neglected, provincial Salta; and, with the partial exception of *La niña santa* (which treats an adolescent girl, her mother and a mature male), she tended to focus on middle-aged protagonists, often women of the middle classes, whose milieu is far from the urban grunge of other directors. Moreover her oblique style (off-centre framing and elliptical editing) calls attention to its quirky artistry in ways that the low-budget realism typical of the New Argentine cinema does not.

Beyond these industrial constraints, Martel's rise to precarious art house fame was obliged to negotiate a new understanding of auteurism. In an article published in 2000 called 'www.auteur.com?' Catherine Grant investigates these new conditions, paying particular attention to Latin American film. The main question asked by Grant is the following:

> How might auteurism continue to adapt itself to the processes of 'globalisation', namely the apparent 'deterritorialisation' of some forms of cultural production and the elaboration of new transnational systems of distribution with the accompanying fragmentation of mass markets and the targeting of particular audiences segments? (101)

Borrowing a term from Timothy Corrigan, Grant discusses the 'commerce of auteurism' (102), whereby the latter had become by the 1990s 'a commercial strategy for organising audience reception [and] a critical concept bound to distribution and marketing'. Now linked to consumption rather than production, the new auteurism was based not so much on films themselves as on promotional interviews identifying and addressing the potential cult status of filmmakers (103).

As Grant notes, however, this 'cinema without walls' (no longer limited to the film text) was problematic in a Latin American context. Old-style cultural nationalism became impossible when revenues within a single territory could no longer cover film budgets. New multinational funding arrangements were reliant on distributors' ability to 'ceaselessly capitalise' on the [few] names of individual directors known abroad, with those directors collaborating in auteurist commerce and 'adopting the tactical "auras" of novelty, topicality, personality, and ... distinctiveness' (105). More complex commercial arrangements thus affect the very nature of such art movies, as well as their promotion: while the auteurs' selves are 'dramatised', their projects, must also necessarily be 'translatable' to foreign audiences (106).

Conversely Grant identifies one locally successful film of the incipient

New Argentine cinema (the grungy youth movie *Pizza, birra, faso* (1998)) as, initially at least, 'non-auteurist' and 'culturally nationalist'. Yet by taking their film on the international festival circuit, even its directors were likely to be 'co-opted' by auteurist commerce (105). Interestingly, Grant fails to refer to women as a distinct constituency in this context, either as producers or consumers, but she does address how gay and lesbian spectators have emerged as a niche market (106–7).

Once more Martel's position in relation to the new commerce of auteurism would seem to be problematic. On the one hand she has indeed cooperated with the new commercial strategies to some extent, giving promotional interviews and glossing her enigmatic films orally in terms that are relatively accessible to audiences at events such as that held on 4 December 2008 in London's Tate Modern gallery. As a media figure she is readily recognisable by the same props employed by Coixet: very visible spectacles. But if Martel appeals, necessarily, to transnational systems of distribution, she clearly rejects the parallel trend of the deterritorialisation of cultural production through her continued commitment to everyday life in regional Salta, however filtered and defamiliarised that life may be through art-movie aesthetics.

On the other hand, once more, her projects, although resolutely oblique, have generally proved 'translatable' to world art house audiences. Foreign critics either refer to global precedents (she is 'the mini-Chekhov of the tropics' (cited by Falicov, 2007: 126)), or read Martel's narratives allegorically in ways that invoke broad Argentine themes (the gulf between the middle classes and the poor, willed amnesia to the dictatorship (Holden, 2009)) but demand no specialist knowledge of that country's history or society. Both are strategies, of course, that promote a key quality or 'aura' (the 'distinctiveness' of Martel's auteurist vision), while tending to neutralise the particularity of her national context.

Mutatis mutandis, there are clear parallels between Martel's Argentine situation and the Spanish context in which Coixet emerged. In her *Spanish National Cinema* (2003), Núria Triana-Toribio argues that in the 1990s and beyond discourses on 'Spanishness' in film 'continue(d) to be dominated by the question of transnational projection or the reactions against this projection' (143). However, the now traditional goals of the 'Europeanisation of Spain' and the creation of a 'cinema oriented towards Europe' became increasingly problematic. In an atmosphere of financial 'crisis', generous film subsidies from the public purse were cut, with 1994 marking the historical lowest point ever in production (144). As in Argentina, in reaction to this perceived decline, critics (especially the influential Carlos Heredero) began to promote a generation of 'new directors' in the mid-1990s (144).

It remained the case, however, that veteran consecrated auteurs with a faith in social realism and financial support from ICAA remained active, even as younger filmmakers (especially women), who were less socially committed, sought 'different routes into the industry' including training abroad

(145). Meanwhile, the autonomous communities (especially the Basque country and Catalonia) were actively promoting and financing films with 'distinct traits' and often languages. This 'plurality of production', which could be read negatively as a 'splintering and fragmentation', was repackaged by ICAA as 'diversity', a 'banner under which any market trend ... [could] be accommodated' (145).

Coixet marks an extreme case of this accommodating of diversity. One of just three female filmmakers in the canon of fifteen 'new directors' established by Heredero in a hefty collection of interviews (1997), she was refused entry to the Rome film school and entered the industry only after an apprenticeship in advertising. Her career is clearly based on transnational projection, though targeting not Europe, but the US. After her first feature failed in 1988, she relaunched herself as one of the new generation of the mid-1990s, albeit with no financial support from Madrid, by shooting in America, a move that she claims as 'natural' (301). It is an adjective she also uses when asked about the higher profile of women directors in Spain in the same period. However, it is telling that when asked by Heredero for her favourite Spanish films (her debt to North America is transparent), Coixet cites cinema of the 1950s and 1960s and makes no reference to more recent filmmaking (297). Distant in her cinematic tastes from contemporary Spain in both time and space, she can nonetheless be identified with that cinema's dominant mode of 'diversity', identified as she is, in spite of herself, as a Catalan and a female filmmaker within a national cinema that is defined precisely by its lack of definition.

Elsewhere Triana (2008) studies Coixet herself with Álex de la Iglesia as examples of a new brand of auteurism directly parallel to that analysed by Grant for Latin America (Triana's article was also published in the same journal as Grant's: *Screen*). As Triana writes:

> Those directors who can claim the status of auteur do so as part of their commercial strategies ... [My] focus is on two case studies of media-friendly and established auteurs ... who have and manage homepages with information about their work, their careers and other aspects of their authorial personas. Both auteurs can be considered to be at opposite ends of the spectrum genre cinema/art cinema within the Spanish cinema traditions. (259)

It could be argued, however, that Coixet's sources in US indie cinema are as 'generic' as de la Iglesia's in horror. Certainly the director's blog, while intended as a strategy to organise respectful audience reception for the auteur, may well prove a double-edged sword. At the time of writing, one disappointed fan has posted a message complaining bitterly that 'Miss Wasabi' (Coixet's studiously transnational heteronym) has failed to update her site and thus neglected her on-line community.

It seems likely that Coixet's overt transnationalism, even nomadism, benefits from consideration within a Catalan context: her well-wrought but unchallenging art movies, although spoken in English, are not dissimilar

to those made by a consecrated Catalan-language director such as Ventura Pons. Conversely Martel's regionalism, highly visible (and audible) to local audiences at least, is by no means incompatible with transnational trends at the most prestigious festivals (Cannes, Berlin), where her demanding features are regularly premiered.

We turn now to reviews first published in *Sight & Sound* (and reproduced here with permission) of co-productions by Martel and Coixet that exemplify the complex but productive tensions I have sketched above: between art and commerce, location and flow. While I trust these reviews remain of interest as close readings of their respective texts, they are now also historical documents that testify to the reception of two female auteurs as they emerged onto the transnational art house stage. It is a reception that the reviews at once reflect (with their reliance on press notes and interviews of the time) and helped in turn to create.

Elusive atmospheres

La ciénaga *(Argentina/USA/Japan/France/Switzerland/Spain/ Brazil, 2001)*

North-western Argentina, the present. Alcoholic Mecha lives with her faithless husband and three of their children on a decaying country estate, La Mandrágora. After cutting herself on broken glass, Mecha is taken to hospital in the nearby town of La Cićnaga. Also at the hospital is her cousin Tali, who has taken her young son Luciano to have a leg wound stitched. Tali, her husband and four children drive up to stay with Mecha's family. Mecha's husband Gregorio is also an alcoholic, while her daughter Momi is in love with indigenous servant Isabel, who has a boyfriend, Perro. Mecha's son José comes up from Buenos Aires where he lives with Mercedes, his father's former girlfriend. The children hunt in the forest, fish or swim in the pool, while the adults watch television, drink and sleep. At the town carnival, José gets into a fight with Perro over Isabel. Tali's small daughters frighten little Luciano with stories of a 'rat-dog'. Mecha and Tali make fruitless plans for a shopping trip to Bolivia. Isabel leaves Mecha's employ, claiming her sister needs her. Back in town, Luciano climbs a ladder to see the rat-dog next door and, when the ladder collapses, he falls to the floor.

In the opening scene of *La ciénaga*, first-time director Lucrecia Martel's understated family drama, tropical thunder reverberates over the hills, ice cubes tinkle in glasses, and deck chairs clatter over the patio. It is a disorienting sequence, but one typical of a film that favours diffuse resonance over well-defined clarity. Rejecting the certainties of classical narrative, Martel (whose screenplay won the Sundance/NHK Filmmakers Award) trusts to accidents, quite literally in the opening moments. While drink-sodden Mecha stumbles into broken glass by the pool at her country estate, child Luciano cuts his leg in the cramped urban home of his mother Tali, Mecha's

cousin. These accidents initiate the interaction between the two families as they coincide at the hospital. And since the audience is plunged without preparation into a tangled web of relationships, we feel as disoriented as Mecha, floundering on the patio floor.

Slowly patterns emerge. Mecha's is the bad family: a drunken mother, feckless father and worthless son José shacked up in distant Buenos Aires with his father's ex-mistress. Only teenage daughter Momi, mooning over indigenous servant Isabel, seems untainted. Tali's is the good family: a conscientious mother, supported by a faithful father, and surrounded by a gaggle of boisterous kids. The contrast is, however, unforced. And the viewer searches in vain for allegory. Mecha's estate is called La Mandrágora (meaning mandrake, a plant traditionally used as a sedative), suggesting the comforting anaesthesia of sloth and alcohol into which her family has sunk. But 'la ciénaga', the swamp of the title, is both an actual bog in which the children find a trapped cow and the name of Tali's vibrant home town. Mecha's filthy pool, whose filter has long since ceased to work, might be read as a symbol of the Argentine bourgeoisie, luxuriating in torpid decadence. More likely it serves as the ultimate black hole in a narrative full of lacunae: when children jump in we never see them re-emerge. Nature is no consolation here. Rather it heightens the characters' unease in their environment.

La ciénaga thus adroitly avoids the two kinds of filmmaking associated by foreign audiences with Argentina. It is neither social realism of the kind favoured by 1960s radicals such as Leopoldo Torre Nilsson, nor poetic allegory of the kind explored by post-dictatorship fabulists such as Eliseo Subiela. Rather it focuses on the poetics of everyday life, mini-miracles analogous to the appearance of the Virgin by a water tank that is repeatedly glimpsed on television. This is just one of the running gags in a film that is by no means lacking in humour: the children's tall tale of 'rat-dogs' that devour cats, or their fear of the father who dyes his hair are others. Martel coaxes wonderfully unselfconscious performances from children and adults alike, revealing family life of a kind that is rarely seen on-screen, neither sentimental nor falsely dramatic. Aimless conversations (which Martel associates with a provincial reluctance to face facts directly) are subtly coloured by the ravages of alcohol or an unspoken eroticism that shades into incest. When José talks on the phone to his mistress while in bed with his convalescent mother, he addresses the former by the latter's name. Typically, we cannot tell if this is an actor's error or a subtle sign from the filmmaker.

This, then, is a cinema of languor, a condition too rarely explored on-screen. The camera pans repeatedly over promiscuously mixed bodies sleeping fitfully through the siesta. If resonance replaces structure, then atmosphere takes the place of action. The reticence of lovers who cannot speak the truth of their desire (most movingly, teenage Momi obsessed with her indigenous servant) is paralleled by the daring of a director who leaves bleeding holes in her narrative. It is symptomatic of this uncertainty that

the English and Spanish versions of the synopsis in the press notes disagree on such basic plot points as the number of accidents which bring together the two families. Likewise the great questions of birth, love and death go unanswered. Does servant Isabel leave her employment, as we suspect, because she has been made pregnant by her boyfriend? Do siblings José and Verónica desire each other, as suggested by a shared shower sequence? And, finally, does accident-prone Luciano die when he tumbles from a ladder in search of the fabled rat-dog? Bravely leaving her film open, Martel has created a truly distinctive cinematic atmosphere, as allusive as it is elusive (Smith, 2001).

Emotional geographies

My Life Without Me/Mi vida sin mí *(Spain/Canada, 2002)*

Vancouver, the present. Ann is a 23-year-old mother who cleans the university at night and lives in a trailer in her mother's yard with her loving husband Don and two young daughters. Her only friend at work is diet-obsessed Laurie. Ann's relationship with her mother is difficult and her father is in prison. Ann is unexpectedly diagnosed with terminal cancer, but does not tell her family. She makes a list of things she wants to do before she dies. One of them is to have an affair with another man. This she does with Lee, a depressed surveyor whom she has met in the launderette. Ann records a series of audiotapes for the people she will leave behind, including one for each of her daughters' birthdays until they are 18 years old. Ann also visits her father in prison, where he makes sports shoes. A new neighbour moves in next door: a single woman also called Ann. The first Ann invites the second to look after the kids and to have dinner with the family, hoping she will become Don's next wife. During a romantic lunch with Lee, Ann is taken ill and phones to have her husband pick her up. Lee confesses his love for her, but she does not reveal her diagnosis to him. As Ann lies at home in bed, she imagines what will happen after her death.

The UK distributors of Isabel Coixet's fourth feature (the first film in English from Pedro Almodóvar's El Deseo production company) handed out tissues in the cinemas where it previewed. The director herself disowned this promotional gimmick, saying that her film, in which a young mother diagnosed with terminal cancer seeks to live the rest of her life to the full, is 'uplifting'. Certainly *My Life Without Me* is less of a weepie than might be expected, given its emotive premise and knowing references to Hollywood melodrama (a scene from *Mildred Pierce* (dir. Michael Curtiz, 1945) is glimpsed on the TV). Sarah Polley as Ann, placid and almost impassive in the face of death, must take much of the credit for this, her unexceptional looks and soft Canadian accent drawing us gently into her predicament. And, as in most cinematic accounts of fatal illness, her lot doesn't seem too bad. Many in the audience might envy the fact that she is provided with

both a hunky blond husband (sunny Scott Speedman) and a hunky dark boyfriend (brooding Mark Ruffalo). Movie diseases don't come with much sexier consolation than this.

The mood is also lightened by expert supporting actors cast as comic eccentrics. The braided hairdresser stuck on Milli Vanilli (Maria de Madeiros), the skinny friend obsessed with diets (Amanda Plummer), and the cadaverous doctor who feeds Ann ginger sweets (Julian Richings) are all good value. The script generously allows each supporting character their moment. Deborah Harry is excellent as the mother (a Joan Crawford fan) who smokes furiously as she hangs out the washing, but gives a touching account of a solitary birthday (a barman put a candle in her bowl of peanuts). The luminous Leonor Watling (dir. Pedro Almodóvar *Talk to Her*, 2000), as the too-good-to-be-true new neighbour, has a lengthy soliloquy on the death of a child, which makes one wonder what she could have done with the central role. And if the dialogue sometimes hits a bum note ('Dying isn't as easy as it looks') the unstressed, quirky detail is a delight: Ann meets future lover Lee in the Ticky Poo Laundrymat.

Coixet has said that each film has its geography and this one could only have been set and shot in Canada, with its particular sense of emotional and spatial distance (no one could accept in Spain that a daughter would live in a mobile home outside her mother's house). The locations, shot at night, are strangely seductive. The harbour is romantic or unsettling in turn (black water, frosty breath, distant lights), while a deserted coffee shop, with only pineapple cheesecake on the menu, is straight out of Edward Hopper. From the opening shot, where Ann stands barefoot in the pouring rain, Vancouver proves to be even wetter than its prodigiously damp southern neighbour Seattle. On the other hand, undercutting sentiment once more, the trailer Ann shares with her doting husband and daughters is a riot of colour: bright bead curtains, gaudy furnishings and motley children's clothes. In the last sequence, as Ann silently bids farewell to the family she has not told about her illness, we see them from her point of view, distanced and haloed by the shimmering screen of ruby-red beads.

The documentary-style camera work, by Coixet herself, is surprisingly jittery and the editing features frequent jumpcuts. This also helps to distance the film from the women's pictures of classic Hollywood, with their smoothly seductive style. *My Life Without Me* is perhaps closer to *Dark Victory* (dir. Edmond Goulding, 1939) than it is to *Mildred Pierce*: the negative prognosis leads to a romantic encounter with a handsome stranger. But, unlike the tragic heroines of old, Ann is not punished for her love life. Shunning melodrama, Coixet does not allow Ann's husband to find out about her affair, even though the two suitors coincide in one scene. And it's a rare date movie that encourages its audience to find an adulterous fling romantic when there is a doting husband looking after the kids back home. Ann could so easily have proved unsympathetic.

The ending, then, is more ambivalent than might at first appear. Ann

imagines what will happen after her death: her husband will marry the new neighbour, her long-suffering mother will go out on a hot date, etc. The voice-over states in its disconcerting second-person style: 'This will be your life without you.' But, just as Ann has not prepared her family for her fate, so she cannot know what the future will bring for others. This expert reworking of the tear jerker thus ends on a suitably melancholic and elegiac note (Smith, 2004).

Art, industry and gender

Coixet's *Tokyo* seems positively calculated to disorient the spectator. Beginning with a night sequence shot from a boat navigating the waterways of the megalopolis, as if in some high-tech Venice, the film goes on to feature some disconcertingly incongruous locations. For example, the two lovers (played by Japanese Rinko Kikuchi, familiar to Western audiences from *Babel* (dir. González Iñárritu, 2002), and Catalan Sergi López) have sex in a love hotel, where their room is a recreation of a Paris Métro carriage. Conversely Kikuchi's character, an unlikely hit woman, works by night in the central fish market which was until recently one of the principal tourist attractions of Tokyo. López's character, meanwhile, is a vintner specialising in the wines of Spain, a unique repository of the nation's *terroir*, here showcased on the other side of the world. This tension between location and dislocation is yet more acute in the version of the film released in Spain, where all of the actors, whether Asian or European, are dubbed into an incongruous Castilian by overfamiliar voice artists whose tones are instantly recognisable to Spanish audiences.

Such extremities of spatial dislocation are not found in Martel, where arguably it is a temporal sleight of hand that is more disturbing. Thus *La mujer sin cabeza* appears to be set in the present, with the cast of provincial bourgeois wearing modern clothes and driving contemporary cars. Yet the music chosen by Martel, especially in the crucial opening scene, where the protagonist Verónica (María Onetto) believes she may have run over a child, derives from the 1970s, thus suggesting a continuity between dictatorship and democracy which is nowhere voiced in the laconic and enigmatic script. Local television viewers would also have been aware of a disconcerting intertext. Onetto had previously played in *Mujeres asesinas* (2005), a series of quality one-off dramas (later remade in Mexico) based on real-life cases of female murderers.

As ever, industrial questions mirror these artistic considerations. Coixet has moved freely in search of funding between Spanish independent producers (such as El Deseo, as mentioned above), the larger US indies (Lakeshore Entertainment, which is responsible for some broadly commercial romantic comedies and action movies), and commercial Catalan-based companies (Mediapro was also behind Woody Allen's *Vicky, Cristina, Barcelona*, 2008). Martel has had to rely rather on a cocktail of small, mainly

European, companies: *La mujer* was put together with Argentine, Spanish, French and Italian backing.

It seems possible that it is Martel who is best placed to confront current conditions. As the *New York Times* reported on 26 April 2010, the environment for independent films had changed rapidly since the global financial crisis (Cieply, 2010). With the collapse of Hollywood specialist divisions such as Miramax, which had long won Oscar prestige for their studio owners, and the decline of art house distribution, the sector had been 'decimated' by a 'new austerity'. Swollen budgets for both production and marketing were also held responsible for this collapse.

According to the *NYT* commentator, 'rebuilding' independent film will rely, on 'fleet-footed, penny-pinching guerrilla operations that are trying to resuscitate the business by spending less on production, much less on marketing and embracing all forms of distribution, including the local art house and the laptop'. While both my female transnational auteurs have earned hard-won reputations for their *œuvres*, it is clear that Coixet has, over the course of her career, moved closer towards the mainstream and has thus been rewarded with higher budgets. Martel's uncompromising avant-gardism, apparently more fragile, may prove more fleet-footed and assured in connecting with newly fragmented art house audiences.

References

Cieply, M. 'A rebuilding phase for independent film', *New York Times* (25 April 2010). Accessed 30 April 2010. www.nytimes.com/2010/04/26/business/media/26indie.html?ref=movies

Cinema Tropical. 'The ten best Latin American films of the decade' (December 2009). Accessed 8 February 2010. www.cinematropical.com/programming.php?pid=3

Coixet, I. 'Miss Wasabi' (blog). Accessed 8 February 2010. www.misswasabi.com

Falicov, T. L. *The Cinematic Tango* (London and New York: Wallflower, 2007).

Felperin, L. Review of *The Headless Woman*. *Variety* (21 May 2008). Accessed 8 February 2010. www.variety.com/review/VE1117937236.html

—— Review of *Map of the Sounds of Tokyo*. *Variety* (22 May 2009). Accessed 8 February 2010. www.variety.com/review/VE1117940352.html

Grant, C. 'www.auteur.com?' *Screen*, 41 (2000), 101–8.

Heredero, C. F. *Espejo de miradas: entrevistas con nuevos directores del cine español de los años noventa* (Alcalá: Festival de Cine, 1997).

Holden, S. Review of *The Headless Woman*. *New York Times* (19 August 2009). www.nytimes.com/2009/08/19/movies/19headless.html

Screen International. 'Spain Special Focus'. (5–11 February 2010), 29–42.

Smith, P. J. Review of *La ciénaga*. *Sight & Sound* (December 2001), 45.

—— Review of *My Life Without Me*. *Sight & Sound* (January 2004), 56.

—— *Spanish Visual Culture: Cinema, Television, Internet* (Manchester: Manchester University Press, 2006).

—— 'Film culture in Madrid', *Film Quarterly* (summer 2009a), 63–8.

—— *Spanish Screen Fiction: Between Cinema and Television* (Liverpool: Liverpool University Press, 2009b).

Stratton, D. Review of *My Life Without Me*. *Variety* (11 February 2003). Accessed 8 February 2010. www.variety.com/review/VE1117919945.html

Triana-Toribio, Núria. *Spanish National Cinema*. (London: Routledge, 2003).

—— 'Auteurism and commerce in contemporary Spanish cinema: *directores mediáticos*'. *Screen*, 49 (2008), 259–76.

Part I

Memory and history

According to the philosopher Paul Ricœur, 'narrative attains its full significance when it becomes a condition of temporal existence' (1984: 52). In stating this, Ricœur foregrounds the importance of history and memory, the two narrative routes that assist and orient our navigation through time. Unlike certain other philosophers, such as Hegel, Ricœur did not, in fact, see these two routes as necessarily separate. Nor did he ever consider history to be written in stone, authoritative or in any way unchangeable. Indeed, history and memory in his view are interwoven, both being selective in their choice of what is remembered, reliant upon traces of the past in order to do so and fraught with forgetting. Both are also reliant upon the forging of narrative, the play of imagination and – dare we acknowledge it? – the making of fiction in order to be coherent and cohesive. Both can therefore be rewritten.

Yet, most will agree that the narratives of history have been repeatedly used to commemorate and consolidate a fixed and authoritative vision of the past in order to perpetuate set ideological schemes. Memory, on the other hand, has too often been relegated to the realm of the private or the subjective, whereby it becomes politically irrelevant. This binary opposition has permeated much cultural production, resulting in a particular politics of the 'right', umbilically tied to notions of patriarchy, capital, control and authority. In the wake of this come silencing, forced amnesia and repression. Cinema has traditionally been as subject to this scheme as any other cultural medium. Its industrial nature and its mass outreach further strengthen its role in the propagation of history as authoritative knowledge of the past. In turn, this has led on occasion to the use of cinema as a tool in the forging of nationalism. Furthermore, and by establishing a set frame, this also confirms hierarchies. In the context of Hispanic and Lusophone cinema, we can add to this fixed ideological landscape the overriding influence of Hollywood, with its attendant focus on questions of capital, hegemony and domination. Meanwhile, memory, both collective and individual, has often remained overshadowed, unvoiced and apparently irrelevant.

It is therefore curious to note that it is precisely from the relatively marginal position of women's filmmaking that cinematic enquiry into the often-blurred border zones of history and memory in Hispanic and Lusophone

contexts departs. Borderline by force of gender, the filmmaking of women plays, as we shall see in the chapters that follow, a vital role in revisiting and revising questions and perceptions of history and memory. While this is not a gender-specific concern, it is nevertheless the case that the contribution of women filmmakers is crucial. Demarcations between history and memory have become destabilised by the many scatterings and ruptures of postmodern culture, whereby the constructed, and hence alterable, nature of historical narrative has become acknowledged. At work here is the effort by filmmakers to challenge traditional demarcations of memory and history, and thereby both to destabilise hierarchical divisions and to unlock and so release fixed categories. Nevertheless, this must be measured against the wide and unmistakable backdrop of colonial legacies, right-wing dictatorships and totalitarian regimes in Hispanic and Lusophone countries, combined with the social and religious pressures of patriarchy. The chapters in Part I all share a common politics of revision with regard to hegemonic perceptions of history and memory at a collective level.

In her chapter entitled 'Lost and invisible: a history of Latin American women filmmakers', Patricia Torres San Martín offers a historiography of the work of women filmmakers from a range of Latin American contexts. Her focus is on the ways in which these women have used the medium of film to overcome the forces of tradition and politics in order to forge new genres and styles of cinema. Thus, cinematic history is both revised and revived. This vital historical endeavour further opens up spaces on-screen for new discourses of and by the feminine.

The politics of such revisions and recuperations becomes all the more explicit in Isolina Ballesteros's chapter, 'Feminine spaces of memory: mourning and melodrama in *Para que no me olvides* (2005) by Patricia Ferreira'. Here, Ballesteros takes Pierre Nora's notion of *lieux de mémoire* and explores the ways in which cinema offers spaces of memory to those silenced and relegated to forced amnesia in the wake of the Spanish Civil War and the ensuing period of dictatorship. Ballesteros further analyses the ways in which this film probes the uncertain borders between official history and the effort to make sense of memory that is necessarily piecemeal.

The complexities of experiencing dictatorship and then emerging into democracy also inform Catherine Benamou and Leslie Marsh's chapter 'Women filmmakers and citizenship in Brazil, from *Bossa Nova* to the *retomada*'. The chapter considers the work of several women filmmakers who share a common concern with overcoming entrenched gender and social patterns, as well as with exploring the potential of cinema to invoke new gendered imaginations of citizenship within the framework of democracy. The chapter also traces the shifts in the status of women filmmakers in tandem with larger socio-political changes, thereby offering a panoramic overview of gender performances and politics over the course of two decades and two generations. Once again, memory and history become entangled and deeply influence the play of gender.

The following two chapters uncover the work of two little-known women filmmakers from Spain. The focus on this pioneering work is in itself an important act of the recovery of memory and so constitutes a contribution to the history of Spanish cinema. In 'Ana Mariscal: signature, event, context', Steven Marsh analyses the work of Ana Mariscal, a woman filmmaker of the early Francoist period, in terms of genre, gender and ideology. Generally considered allied to Francoist nationalism, Marsh considers both the possible political interpretations of her work and also her contribution to new directions in Spanish cinema.

In his 'Rosario Pi and the challenge of social and cinematic conventions during the Second Republic', Alejandro Melero Salvador focuses on an even lesser-known woman filmmaker, Rosario Pi. Notable for its archival worth, this chapter situates its focus on the work of this filmmaker of the Second Republic in the context of the Socialist government's *Ley de Memoria Histórica* and efforts to recover lost memories. In particular, Melero Salvador traces Pi's career, thus also highlighting the ways in which she struggled to overcome patriarchal modes and to forge an early form of feminism in Spain.

In their 'Deterritorialised intimacies: the documentary legacies of Sara Gómez', María Caridad Cumana González (Cuba) and Susan Lord (Canada) analyse the work of three contemporary Cuban women documentary filmmakers in the light of the trailblazing cinema of Sara Gómez. Chiefly a documentarist herself, Gómez set the agenda for Cuban feminist filmmaking. Cumana González and Lord consider in Chapter 7 how the memory of her work continues to orient the course of documentary cinema by women filmmakers in Cuba today. Her legacy shapes representations of gender, race and sexuality. In this sense, and while being forward-looking, documentary by women filmmakers in Cuba today becomes a gesture of memory.

References

Ricœur, P. *Time and Narrative*, vol. 1, trans. K. McLaughlin and D. Pellauer (Chicago: University of Chicago Press, 1984).

2

Lost and invisible: A history of Latin American women filmmakers

Patricia Torres San Martín

The aim of this chapter is to revise the trajectories and cinematic prac-
tices of Latin American women in two countries with a longstanding film
industry, namely Brazil and Mexico, with a particular emphasis on para-
digmatic feature films produced by these female directors from the 1930s
to the 1980s.[1] In addressing the historical and cultural dimension of these
trajectories and practices, and by means of brief comments on prominent
directors, I will examine how their cinematic agendas were connected to or
detached from the feminist ideology that dominated the 1960s and 1970s,
and how their filmmaking and aesthetics propositions reactivated genres
and challenged traditional canons of female representation. This approach
is concerned with incorporating film practice into a new critical framework
based on a distinction between feminist consciousness (a political position
aimed at improving the social status of women) and a female identity (a
gendered construction of identity and subjectivity).

The participation of Latin American women in cinema is an invisible,
hidden and incomplete history, which needs to be written, disseminated and
linked to current film practices. In other words, we need to highlight the
kind of rupture that women undertook since the early part of the twentieth
century: taking a camera and becoming subjects of their own dreams and
discourses, thereby pushing their imagination beyond the established limits
of patriarchal culture. New critical agendas compel us to reflect upon and
explain this history by means of two analytical categories: the formation of
gender identity and female authorship. As Janet Staiger explains:

> The implications of this theorizing for authorship theory and feminist histo-
> riography include thinking about what and where to look for, and how to
> analyze, these textual traces of identity and agency, especially in cases in which
> for multiple reasons these traces are submerged, suppressed, and, consequently,
> missing. (2006)

Hence, gender identity is considered to be framed within a system of rela-
tionships, contradictions, changes and continuities across different historical
periods and social contexts. Female authorship is understood as evidence of
women's participation in film since the early silent period, and their struggle
to achieve labour equality against structures aimed at granting them only

a subordinate status. Consequently, this historical recapitulation highlights the social role of women filmmakers and acknowledges their position in the public sphere. Rather than viewing women through the prism of exclusion, or at best their marginal status, we must recognise women filmmakers as social and cultural transgressive subjects who created a social agency for their discourse, and were committed to women's emancipation and gender-aware agents of cinematic transformation.

Until three decades ago, the study of women's contribution to the fields of history and culture, including cinema, seemed an implausible task. Accounts about women in film highlighted their participation in front of rather than behind the camera. The advent of feminist and gender theories in the 1970s expanded the scope of this study, introducing new perspectives. Within the field of film studies, the reflection has been framed either by means of the insufficiently theorised category of 'women' or a feminist film studies approach privileging feminist tendencies. It is also necessary to argue for the renovation of film discourses on women and to justify the lack of a strong tradition of authorial theory in feminist film studies. These approaches also express different applications of the same theoretical frameworks, as well as divergent conceptions of women as an object and as a subject of academic study.[2]

What I propose is to conceptualise women as social subjects anchored in history and culture in order to tease out a more objective account of their incursion into mainstream, industrial filmmaking and their search for equality. This approach reveals a rich, diverse, dynamic and political process whereby the study of women filmmakers serves to dignify their struggles for equal social status and grant them agency as gendered subjects.

A vigorous and visionary enterprise by women

From the turn of the twentieth century to the 1970s, generational fractures and discontinuities characterise the participation of Latin American women in cinema. The transition from silent to sound film proved productive for the work of women. It represented a fertile territory for experimentation and opened creative opportunities. National cinema industries flourished in the 1940s and beyond. During this time the national context defended a new national project, where 'order and progress' were supplied by 'modernity' with the purpose of getting a new national audience identification, such as the Mexican.

The combined effect of technology, industrialisation and economics substantially transformed cinematic practices. In spite of the discriminatory and gender-differentiated labour rules, a group of women filmmakers emerged not unlike the directors who have appeared since the 1970s and 1980s. The approach to women's cinema, as suggested by Catherine Benamou:

> Will involve a consideration of how the structural positioning of the filmmakers with respect to two patriarchal institutions, the state and the film industry, has exerted a profound impact on the direction taken by their work. (1995: 257)

At the turn of the twentieth century, long before national film industries were constituted, women contributed alongside men to the development of cinema. Fascinated by the new technology, its creative potential and global reach, these pioneers embraced the transformative power of the new medium. Cinema reconfigured the public sphere, recorded social and cultural change, disseminated ideas, values, lifestyles, fashions and constructed audiences through the development of new cultural and social practices. In the process, it shifted from being simply an entertainment to become a venue of artistic expression and an industry, despite the difficulties faced by theatrical entrepreneurs.

Despite the dominance of Hollywood, two Latin American film industries achieved some measure of success, at least in their own domestic market. In Brazil, 1,685 films were made during the silent period (Buarque de Hollanda, 1989). In Mexico, filmmakers left a legacy of over a hundred short and feature-length fiction films and documentary shorts and features, all made between 1898 and 1928 (García Riera: 1985).

Thanks to individual and collective projects aimed at locating and restoring some of the lost films,[3] it has been possible to rediscover the work of some of the pioneers of women's cinema. Notable among them are the Brazilian Carmen Santos; the Argentines Emilia Saleny (*La niña del bosque*, 1917 and *Clarita*, 1919) and Maria V. de Celestine (*Mi derecho*, 1920);[4] the Chileans Gaby von Bussenius Vega, a writer and art director of *La agonía de Arauco*, 1917, Alicia Armstrong de Vicuña (*El lecho nupcial*, 1926) and Rosario Rodríguez de la Serna (*Malditas sean las mujeres*, 1925, *La Envenenadora*, 1929); the Mexicans Maria Herminia Peréz de León (*La tigresa*, 1917),[5] Cándida Beltrán Rendón (*El secreto de la abuela*, 1928) and Dolores and Adriana Ehlers.[6] In all of these cases, the women who assumed the tasks of producers, writers, cinematographers, technicians and directors managed to make progress without a feminist ideological platform to strengthen them. During this time, a view within patriarchal systems of signification and representation did not exist of women as cultural agents capable of female authorship. Only their tenacity and drive for creative expression confirmed how vigorous and visionary their enterprise was.

María Herminia Pérez de León (1893–1953), better known in artistic circles as Mimi Derba, founded Azteca Films with Enrique Rosas. She produced six films during what has been defined as the second period of the Mexican silent cinema (1917–31), characterised by the development of fictional genres modelled on Italian and North American films. Derba's primary objective was to produce a national cinema that would provide European and North American audiences with a new image of Mexico, and counter the Hollywood stereotypes of the *greaser* (a brutal outlaw) and *la china poblana* (a colourfully dressed village girl) found in films such as *Across the Mexican Line*, 1911, *The Mexican Defeat*, 1913, *Captured by Mexicans*, 1914 and *The Mexican Chickens*, 1915.

The sisters Adriana (1894–1972) and Dolores Ehlers (1896–1983) also

contributed to the refashioning of Mexican silent film. Their newsreel-style documentaries challenged conventional images of Mexico: *Real España vs. Real Madrid*, 1921, *Servicio postal en la ciudad de México*, 1921, *Museo de arqueología*, 1921, *Las pirámides de Teotihuacán*, 1921, *La industria del petróleo*, 1920, *El agua potable en la ciudad de México*, 1920, *Un paseo en tranvía en la ciudad de México*, 1920.

Instead of the common post-revolutionary depictions of Mexico as a socially and economically backward nation inhabited by picturesque Indians, the Ehlers' newsreels presented a vibrant and cosmopolitan urban society. The sisters also contributed to the technological development of the entire Mexican film industry by distributing cameras and projectors produced by a US firm, Nicholas Power Company.

Unfortunately, very little is known about the contribution of women to silent film in Colombia, Ecuador, Peru, Paraguay, Uruguay or Venezuela.[7] In addition, it is impossible to have a clear appreciation of these films, since most are lost or only excerpts of the original footage are preserved. The history of the period must, therefore, be reconstructed from photographs, newspaper clippings, film scripts and film reviews. This 'ruined map' echoes the resources used by Giulana Bruno (1993) to rewrite the history of Elvira Notari's work. It means rewriting women's film history through a cultural map as a metonymy of fragmentations.

Genre and gender transgression

With the arrival of sound in the early 1930s, industries were established and nationally produced films grew in popularity. Yet, the rapid development of cinema also brought about a gender-based division of labour that had not existed in the silent period. As newly formed unions introduced restrictive measures, women were denied access to directorial positions and cinema became a male-dominated practice. At the same time, industrially produced films in countries like Brazil and Mexico promoted distinctive models of femininity and masculinity based on the gender categories and patriarchal notions of sexual difference circulated by Hollywood cinema. For example, the women's roles were linked to topics and problems defined in the feminine, meaning plots and contexts related to private spaces and domestic living, the family, children, motherhood and sacrifice. The public space, which was seen as the privileged domain of men, was inaccessible to them. Nevertheless, women maintained their presence in the public sphere through their creative work.

The most important women filmmakers in Brazil were Cleo de Verberena, Gilda de Abreu (1904–76) and Carmen Santos (1904–52). Verberena started as a producer and actress in the film *O mysterioso do domino preto*, 1931. The well-known Brazilian actress Carmen Santos founded a production company, Brazil Vita Films, and made her directorial debut with *Incôfidencia Mineira*, 1948. With an exorbitant budget for that time, which

was required for building monumental sets and hiring hundreds of extras, the film dealt with the failed uprising against colonial rule in 1789. In light of the film's cold popular reception, Santos decided to give up directing. The almost complete destruction of the negative of *Incôfidencia Mineira* in a fire has precluded the reassessment of both this unique work of Brazilian cinema and its no less unusual creator. Santos' career places her within a context in which sexual difference mattered. After starring in *Urutau*, 1919, she categorically rejected being consigned to the role of a seductive muse of the silver screen, placing her talent and energy at the service of constructing a Brazilian cinema. Gilda de Abreu, a singer, composer, writer, radio and film actress,[8] directed *O Ebirio*, 1946, *Pinguinho de gente*, 1949 and *Coração materno*, 1951. The most popular of these three films was *O Ebrio*, a typical family melodrama containing musical elements adapted by Vincente Celestino, Gilda's husband. Exhibiting the same features as the dramatised novels broadcast on the radio, this melodrama attracted more than four million spectators and became a box-office success. In fact, the film draws on the canonic structures of Hollywood melodramas and radio dramas in the 1930s. According to Jose Carlos Avellar:

> The story is the drama of a doctor abandoned by the wife and who then drowns in alcohol, and leaves everything to live in the street with the 'friends, only in the taverns' – to discover the open door of a church. As the dialogues, the image is a naïve and schematic reaffirmation of acute platitudes in solemn tone. So, the story doesn't matter. (1986)

During the 1930s, Mexican cinema discovered a generic formula (the rural melodrama set in the *hacienda*, a big farm), and transformed the national cinema project into a successful film industry. Fernando de Fuentes's *Allá en el Rancho Grande*, 1936 became the prototype of the 'melodrama ranchero' and increased the revenues of the industry. Due to its popular appeal and box-office success, this film inspired more than twenty-eight imitations. Like the films that followed, Fuentes transformed the feudal farm into an idyllic universe where the newly implemented agrarian reform did not exist and the sole focus was on only a man's fight to conquer the love of woman.

In spite of the patriarchal ideology, conservative values and prevailing complacency of this context, Adela Sequeyro Haro (1901–94) excelled as a film journalist, producer, director, screenwriter, actress and editor. She embraced these tasks with professionalism, tenacity and creativity. Like many other women filmmakers, Sequeyro started her career as an actress in the silent period.[9] Being on the set, and drawing on her experience as a journalist, she learned the secrets of film direction. Perhaps she even developed a taste for melodrama by being exposed to the canonical genre.[10] Sequeyro resumed her acting career in the 1930s, starring in Fernando de Fuentes's classic *El prisionero trece*, 1933, as an extra in José Bohr's *La sangre manda*, 1933, and playing a small part in Ramón Peón and Juan Orol's *Mujeres sin alma*, 1934.

Encouraged by the artist-driven cooperatives set up by avant-garde groups and with the support of a group of film technicians and the Banco de Crédito Popular, Sequeyro founded Éxito ('Success'), a filmmaking cooperative, in 1935. She produced and co-directed with Ramón Peón *Más allá de la muerte* (1935). While the film's failure at the box office bankrupted the company, it proved her talent as a filmmaker, thereby defying normative practices and conveying a feminine vision through the film's aesthetic concern with organic forms and natural elements, such as flowers. Two years later, she created her own cooperative Carola, and completed the feature *La mujer de nadie*, 1937, as the sole author. *La mujer de nadie* garnered qualified praise from some critics who recognised its innovations and cultural validity as an art film. Writing after the premiere on 29 October 1937 in the *Revista de Revistas*, Carlos del Paso suggested: 'this film may not be out of this world, but some of its achievements are without precedent in local film culture'. Another film critic, María Celia del Villar, writing on 30 October 1937 in the newspaper *El Universal Gráfico*, argued that:

> Due to her unflagging effort and artistic enthusiasm, Adela Sequeyro has achieved great success in all aspects of her chosen forms of expression – as a screen writer, as an artistic director, and as a national screen star. In the judgement of Sequeyro herself, *La mujer de nadie* was daring for its time because it involved 'a woman doing something that only men could do'. (n. p.)

Sequeyro's statement about 'a woman doing something that only men could do' was audacious, because it challenged the prevailing discourse on sexual difference: that is, that the female character could only function as a muse or as a mother figure. Her creative skills and ability to determine her fate gave her agency, thus setting her apart from the normative representations of gender found in Latin American cinema. The director turned gender representation upside down. In her films, male characters were bohemian artists, and exhibit traits that were associated at that time with the realm of the 'feminine'. They enjoyed light-hearted camaraderie and were very naïve; they handled their feelings by crying and assumed the victim's position commonly reserved for women.

La mujer de nadie also celebrates the female's capacity for loving. The protagonist, played with great passion by a beautiful Sequeyro, projects feelings of equal intensity towards the three gallant artists who court her. Although the film ends with her character leaving, rather than destroying, the bonds of friendship that unite the men by choosing to be with one of them, Sequeyro developed and expressed a specifically female erotic universe through a strikingly modern film language. As a director, she showed an impressive control over cinematic resources, namely a rare economy in the narrative and, with the groundbreaking cinematography of Alex Philips, she was able to convey a symbolic use of fire, candles and flowers that became a metaphor of love.

However, Sequeyro's innovative cinematic style was neither appreciated

nor seen as evidence of her intelligence. Instead, she was disqualified by the male-dominated cultural milieu of Mexico. Her third and last feature film *Diablillos de arrabal* (1938) bears no resemblance to its predecessor. Probably inspired by the famous *La pandilla* (1922) serial, it narrates the adventures of two rival youth gangs who end up joining forces to defend their neighbourhood from the ravages of a group of adult bandits. The rediscovery of Sequeyro and her films in the 1990s brought about a revalorisation of her cinematic work. Rescued from anonymity, she is now a fully-fledged protagonist of Mexico's film history.

Throughout the 1940s and into the 1950s, during what is known as the golden age of Mexican cinema, film became a fundamental vehicle for disseminating national discourses stressing modernity and unity. It meant combined progress, industrialisation and urbanism, opposite notions facing the values of tradition, rural life and Catholicism. New themes, settings and characters replaced the heroic post-revolutionary rhetoric, *mestizo* melancholy and the memories of a utopian past that never existed. The prototypical nationalist scenarios encouraged filmmakers like Matilde Landeta (1913–98) to 'rewrite' the nation from a feminine perspective (Benamou, 1995: 260), creating strong female characters and subverting established models of gender identity.

After a long education on seventy projects as a script girl and assistant director, 'Doña Mati', as she was known, was able to become a director with the film *Lola Casanova*, 1948, and went on to make three more features: *La negra Angustias*, 1949, *Trotacalles*, 1951 and *Nocturno a Rosario*, 1992. Notorious throughout her career for defying labour bosses and discriminatory union rules, Landeta's practice challenged three popular modalities within the national cinema; namely the revolutionary, the 'prostitute' and the indigenous genres. Her adaptation of *La negra Angustias*, a film based on the novel of the same name published in 1944 by Francisco Rojas González, included a new ending, conveying an affirmative and strong message of female liberation.[11]

Landeta's heroines are powerful characters, as they are independent women who are recognised for their moral strength and gender awareness, rather than for their physical attributes. Paying attention to issues of racial and gender identity, Landeta opened a new different position vis-à-vis the patriarchal revolutionary discourse and vision, by placing women as the protagonist characters, revolutionary leaders and heroine's *gesta*. In addition, instead of unlettered women, her rural and indigenous female characters assumed the identity of modern, educated women. In her film, women, such as for instance, the Coronela, can be a leader of men, an officer in the Zapatista Army, rejecting the roles assigned to women in a society governed by patriarchal ideology, such as refusing marriage, maternity and obedience to men. If they are resigned to marrying by force, they choose a man and court him. Gender transgression also applies to male characters. Rather than conforming to established models of heroism

and moral integrity, Landeta portrays the revolutionary soldier as an illiterate coward and the white, educated teacher as a patronising 'mamma's boy'. Hence, women inhabit the male public sphere. For instance, dressed in the revolutionary uniform (wide-brimmed hat, pants and boots), the character of the Coronela feels more at home in the battlefields and canteens than in the feminine space of the home. She is powerful and behaves aggressively or unconventionally. As in the concept proposed by Mary Ann Doanne (1987), there is a double intention in this 'masquerade'. The masquerade that the Coronela embodies can be seen as a privilege, as it protects her from assuming the imposed female gender attributes, so when she decides to 'feminise' with a new garment (a colourful dress) and a new behaviour, it imposes a feeling never known to her, that of being in love. Matilde Landeta was a self-conscious feminist filmmaker and auteur. She placed gender identity at the centre of her work and challenged the male-dominated film establishment. Like Adela Sequeyro, she exemplifies how female discourse and practice was used to reconfigure national identity from a feminine perspective.

A transitional period

With the exception of documentary film production, the presence of women in fiction filmmaking is practically non-existent in the 1950s and 1960s.[12] It is during this period, characterised by widespread social and political conflict, that a revolutionary project emerges. Better known as the New Latin American Cinema, it links filmmakers from Argentina, Bolivia, Brazil, Chile, Colombia, Cuba and Uruguay, sharing a common agenda: to denounce repressive dictatorships, promote social change and break the hegemony of Hollywood. The resonance of the films and manifestos associated with the Cinema Novo in Brazil (Glauber Rocha and Ruy Guerra), 'Imperfect Cinema' in Cuba (Julio Garcia Espinoza and Tomás Gutierrez Alea), 'popular cinema' in Bolivia (Jorge Sanjinés) and 'Third Cinema' in Argentina (Fernando Solanas and Octavio Getino) reinvigorated and endowed Latin American cinema with a collective identity.

The 1970s brought about a new documentary approach, and the feminist-inspired voices of women renovated the New Latin America Cinema movement. Documentary revitalised women's cinema, creating new expressive venues and spaces for social and political participation. Indeed, the time had come for women's emancipation. The English and French feminist waves came to Latin America, now fully inserted into the global economic system, shifting paradigms and proposing new ways of thinking. Either from the concept of *écriture féminine*, drawn from French philosophy and psychoanalysis, or the North American essentialist notions of the feminine, women's agency in cultural production and discourse increased. As a result, women played an ever more important role in political and cultural life and developed feminist political films and cultural practices. For the first time, a

new generation of filmmakers appeared who ventured into independent and industrial cinema by working on either documentary or fiction film.

One of the most prolific directors in Mexico, Marcela Fernández Violante (two shorts, one documentary and six features) was the first woman with an academic training in cinema. She also assumed a left political and ideological position, creating critically engaged films that denounced the patriarchal ideology of military and clerical institutions. In addition, she had an important career by serving in film organisations. From 1978 to 1982, she was the technical secretary at the first public cinema school, and in 1988 she became the school's first female director. In her current position as the General Secretary of the Union of Writers of the Cinema Industry, she has forcefully defended the legal rights of the Mexican cinema community against the neo-liberal policies of the state. These neo-liberal policies were accentuated with the entry of Mexico into the NAFTA in 1994, which changed the relationship of the state to Mexican cinema. Due to the fact that state companies were privatised, the film industry suffered from the loss of state financial support. For instance, one of the very direct consequences was that public bodies working in production (CONACINE), distribution (Azteca Films) and exhibition (COTSA) were privatised and unions were closed.

In Brazil, Ana Carolina Texeira Soares, started in the field of short and medium-length documentary. In 1974, she shifted to feature film with *Getulio Vargas*, a documentary about two periods in the president's political career (1930–45 and 1951–54). Her contributions to feature-length fiction are: *Mar de Rosas* (1977), *Das tripas coração* (1982) *Sonho de Valsa* (1987) *Amelia* (2000) and *Gregorio de Matos* (2002). The focus on rebellious characters whose lives have been adversely affected by religion and sex is most apparent in the first three films. The influences of Buñuel and Federico Fellini permeate her work; in *Das tripas coração* there is an outstanding shot recalling the piano scene in *Un chien andalou* (1929); in *Mar de Rosas* the encounter of the protagonist with a group of clowns recalls the world represented in Fellini's *La strada* (1954); the plot of *Sonho de Valsa* is analogous to *Juliet of the Spirits* (1965). It revolves around an insecure woman questioning the meaning of life and her marriage. According to Laura Podalsky:

> Ana Carolina's focus on state and religious collapse with her presentation on stage, and her characters create a polyphony out of small bodies that are placed in the family and school environments, and are imposed to ravage them and to celebrate the institutional imperatives wishes. (1999: 87)

The protagonists of her films, perhaps her alter egos, choose to rebel, challenging the fetishisation of the female body and thus subverting the normative characterisations and narratives of female identity.

In the 1980s and 1990s, a large number of Latin American filmmakers were given international awards and much-deserved critical recognition. From Argentina, Maria Luisa Bemberg received two Oscar nominations

for *Camila* (1984); from Brazil, Susana Amaral won the Silver Bear Award for Best Actress for Marcelia Cartaxo's interpretation in *A hora da estrela* (1985), at the Berlin Film Festival in 1986; and from Mexico, Maria Novaro's second feature film, *Danzón* (1990) participated in the Cannes Festival, confirming her standing as one of the leading directors of the New Mexican Cinema.

With *A hora da estrela*, Suzana Amaral reconfigured the allegorical impulse found in the work of Glauber Rocha and the Cinema Novo movement. The heroine of the novel by Clarice Lispector, Macabea becomes in Amaral's version an anti-heroine and a metaphor for Brazil. An orphan who describes herself thus: 'I am a virgin, I am a typist and I like Coca-Cola', she is a naïve, semi-illiterate migrant from the rural north-east who is ill-equipped to survive the indifference and cruelty of urban life. Yet, Amaral's compassionate representation challenges preconceived notions about class, sexuality and gender. This groundbreaking work signalled a new trajectory for Brazilian cinema and became a paradigmatic model for a new generation of prolific and professional female directors. Notable among them are Lucia Murat, Tete Moraes, Helena Solberg, Tata Amaral, Susana Queiroz, Susana Moraes and Sandra Werneck, to mention just a few (Avellar, 2004).

To return to Mexico, Maria Novaro is the most prominent Mexican director, recognised at home and abroad for her innovative work and the 1990 box-office hit *Danzón*. Its popularity was an indicator of a shift in audiences' preference for national films and a renewal of Mexican cinema. Novaro's film practice has been characterised by its inspirational representation of issues confronting women at the end of the twentieth century. She belongs to the generation of women filmmakers in the 1970s, who believed in feminism as a political discourse for approaching cinema practice.[13]

In her five features, *Lola* (1989), *Danzón* (1990), *El jardín del edén* (1993), *Sin dejar huella* (2000) and *Buenas Hierbas* (2010), and ten short films, she has avoided portraying women as victims. The majority of her protagonists are ordinary women exploring their personal and cultural identities. There is a serene and gentle quality to her work as well. The cinematography replicates the characters' emotional journey, surveying the urban and social landscapes and redefining female sensibility in visual terms. While Novaro belongs to the 1970s generation of filmmakers that assumed a radical feminist position, her practice exemplifies the women's cinema of the transitional 1990s. Shaped by a feminist ideology, her work seeks to reconnect feminist consciousness and female identity by reactivating aesthetic and narrative genre conventions. By using melodrama as a popular cinema genre and by focusing on the contradictions of motherhood and other female concerns, she displaces the masculine narrative associated with Mexican national cinema. There is also a particular privileging of a haptic cinematic experience, as she places the emphasis on colours and soft textures as a way of addressing the mood of her female characters.

To sum up, in this chapter, I have attempted to retrace the cinematic practices and trajectories of Latin American women filmmakers. Taken together, their cinematic agendas and representational proposals have contributed to the reconfiguration of gender identity and female authorship. In spite of generational fractures and discontinuities, women's practices have granted women labour equality and cultural validation as producers and creative agents. Following in the steps of the vigorous and visionary enterprise of the pioneers, women filmmakers rose above social restrictions, challenged normative gender and genre representations, maintaining an active presence within the industry, thanks to their engagement and powerful work. Enticed by the revolutionary promise of the 1970s feminist movement, women translated their fantasies and subjectivities into a new political vision and redefined women's social and cultural position. The energetic women of the 1980s generation placed feminine vision at the centre of their practice and addressed contemporary struggles. With a less radical feminist position than their predecessors, they developed new production and aesthetic strategies, guaranteeing women's visibility in the fields of cinema and film studies.

Notes

1 This chapter pays tribute to Adela Sequeyro. I would like to express my deepest thanks to Zuzana Pick for her advice and invaluable feedback on earlier versions of this chapter.

2 See Mayne (1990).

3 The National Autonomous University of México Film Archive has been restoring footage and old films copies of directors such as Mimi Derba and Cándida Beltrán Rendón. In 1993, the Chilean film journalist Eliana Jara Donoso published one of the most important histories of the silent period in Chile, *Cine Mudo Chileno* which included information on women who participated in the production of silent cinema.

4 See Pessoa (2002).

5 See Miquel (2000).

6 See Torres San Martin (1997).

7 New research on the Peruvian industry has been uncovered by Angela Ramos de Rotalde, Stefania Socha, Teresita Arce and Maria Isabel Sanchez Concha Aramburu.

8 She made her debut as an actress in the Cinedia Production *Benerquina de la seda* (1935) directed by Oduvaldo Viana.

9 She starred in *El hijo de la loca* by José S. Ortiz, *Atavismo*, 1923, and *Un drama en la aristocracia*, 1924, both directed by Gustavo Sáenz de Sicilia; Ortiz's *No matarás*, 1924; *Los compañeros del silencio*, 1925, by Basiliao Zubiaur; and *El sendero gris*, 1927, by Jesús Cárdenas.

10 In the late 1920s and early 1930s, through her journalistic collaboration with *El Demócrata, El Universal Ilustrado, El Universal Taurino* and *Revista de Revistas*, 'Perlita' had surrounded herself with a group of friends who were very prominent on the national cultural scene: the cartoonist Ernesto 'El Chango' García Cabral and the Stridents movement.

11 See Torres (2011).
12 Margot Benacerraf from Venezuela and Marta Rodriguez from Colombia became the anthropology documentary pioneers whose award-winning and paradigmatic films *Araya*, 1958 and *Chircales*, 1967–71 now belong to the classical repertory of the Latin American cinema.
13 María Novaro participated in the Cine Colectivo Mujer (1976–79), a group of women from different disciplines who worked with lower-class women making films about taboo topics, such as abortion.

References

Avellar, J. C. 'Lengua provisional', in P. Torres (ed.), *Mujeres y Cine en América Latina* (Guadalajara, México: Ed. Universidad de Guadalajara, 2004).

——, *O cinema do tempo de radio. O´ ebrio de Gilda de Abreu* (1986) in www.escrevercinema.com/cinemabrasileiro, accessed 12 January, 2010.

Barnard, T. (ed.), *Argentine Cinema* (Toronto: Nightwood Editions, 1986).

Benamou, C. 'Notes toward a memography of Latin American women´s cinema', *Symposium* (1995), 256–69.

Bruno, G. *Streetwalking on a Ruined Map: Cultural Theory and the City Films of Elvira Notari* (Princeton, NJ: Princeton University Press, 1993).

Buarque de Hollanda, H. (ed.) *Quase Catologo 1: Realizadoras de Cinema no Brasil (1930–1988)* (Rio de Janeiro: Universidade Federal do Rio de Janeiro; Museu da Imagen e do Som do Rio de Janeiro, 1989).

De la Vega, E. and P. Torres, *Adela Sequeyro* (México: Ed. Universidad de Guadalajara and Universidad de Veracruz, 1997).

Doane, M. A. *The Desire to Desire, The Woman's Film of the 1940s* (Indianapolis: Indiana University Press, 1987).

García Riera, E. (ed.) *Filmografía mexicana de medio y largo metrajes 1906–1940)* (México, Ed. Cineteca Nacional, 1985).

Mayne, J. *The Woman at the KeyHole* (Bloomington and Indianapolis: Indiana University Press, 1990).

Miquel, A. *Mimi Derba* (Mexico: Archivo Fílmico Agrasánchez, 2000).

Pessoa, A. *Carmen Santos*, O cinema dos anos 20 (Río de Janeiro, Brasil: Ed. Aeroplano, 2002).

Podalsky, L. 'Fantaias e prazeres', *Cinemaias*, 16 (1999), 75–94.

Raskin, E., *Mexican Women Filmmakers* (Austin, TX: Texas Press University, 2000).

Staiger, J. 'Because I am a woman: thinking and "identity" and "agency" for feminist historiography', paper presented at IV International Congress Woman and the Silent Cinema , June 2006, University of Guadalajara.

Torres, P. 'Las mujeres del celuloide en México', *Nuevo Texto Crítico*, 19(20) (1997), 93–106.

—— 'Adela Sequeyro and Matilde Landeta: two pioneer women directors' in J. Hershfield, and D. MacIel (eds.), *Mexico's Cinema. A Century of Film and Filmmakers* (Wilmington: Scholarly Resources, 1999).

—— *Cine y género. La representación social de lo femenino y lo masculino en el cine mexicano y venezolano* (Guadalajara, México: Ed. Universidad de Guadalajara, 2000).

——, *Mujeres y Cine en América Latina* (Guadalajara: Ed. Universidad de Guadalajara, 2004).

—— 'Imaginarios fílmicos de la revolución y su discurso en femenino: *La Negra Angustias*', *Archivos*, 68 (2011).

3

Feminine spaces of memory: mourning and melodrama in *Para que no me olvides* (2005) by Patricia Ferreira

Isolina Ballesteros

Coinciding with the excavations of the Spanish Civil War's mass graves (that began in 2000) film and the mass media are playing a crucial role in the construction and dissemination of 'spaces of memory' of the war that intend to compensate for the willed amnesia that characterised both the Franco dictatorship and the post-Franco years.[1] Spanish women filmmakers are documenting this public process through the use of different cinematographic genres, mainly social and anthropological documentary and melodrama. Within this trend, it is important to acknowledge the pioneering documentaries *Les fosses del silenci* (*The Graves of Silence*) and *Els nens perduts del franquisme* (*Franco's Lost Children*) (2003) by Montse Armengou and *El cielo gira* (*The Sky Spins*, 2004) by Mercedes Álvarez, as well as the fictional dramas: *Para que no me olvides* (*Something to Remember Me by*, 2005) by Patricia Ferreira and *La buena nueva* (*The Good News*, 2008) by Helena Taberna.

Patricia Ferreira's film, *Para que no me olvides*, differs from the aforementioned films by women and from other memorialist filmic productions made in Spain in so far as it does not document or fictionalise specific historical events or individual actions taking place during the Civil War and the post-war years. Instead, this film relocates in the present the collective response to loss and pain caused by the political conflict, as well as the subsequent oblivion and remembrance, all from an individual perspective that attempts to connect personal trauma to socio-political awareness, while bridging the differences of three generations of Spaniards.

In order to merge individual and collective memory, the film examines the concepts of memory, oblivion and trauma through the lens of a present-day death, that of a young architectural student called David, and the diverse reactions that such loss provokes among his loved ones: his mother Irene, his grandfather Mateo and his girlfriend Clara. As we will see, the family's reactions to David's death mirrors response to memories of the Spanish Civil War as experienced in the collective consciousness of present-day Spain. David's unexpected death leads to the family's painful confrontation with its past, following the conventions of the family melodrama and linked to the rediscovery and restoration of the architectural space that constitutes

a 'space of memory' for Mateo, a war survivor, as well as for his descendants. Mateo lost his entire family during the Civil War and the immediate post-war years: his sister died in a Madrid bombing, his father was executed after the war, and his mother died in a Franco prison. The young member of the family (emblematic of the nation) undertakes the task of mapping the past's scattered fragments and constructing an individual and collective memory that will prevail against oblivion.

Indeed, I argue that in Ferreira's film, micro-affects (typically the realm of the feminine and the private) effectively refer to macro-social relations (typically the realm of the masculine and the public), and that micro-ethics (the ethics of individuals) are connected to macro-ethics (the ethics of collectives) (Margalit, 2002: 14). With this film, Ferreira moves away from the thriller format that characterised her previous films, *Sé quien eres* (*I Know Who You Are*, 2000) and *El alquimista impaciente* (*The Impatient Alchemist*, 2002), and opts for looking at one of the most controversial and still-painful periods of Spanish history via the melodramatic mode, with its characteristic female protagonist, narrative development of conflicts, secrets and chance encounters that enhance pathos, and a sphere of action that is displayed mainly in the domestic space. As it prompts spectatorial projection through its reliance on the viewer's ability to fill in emotional content – a modern application of the notion of catharsis in tragedy – melodrama may be therapeutic: '[It] fundamentally engages the desire for reversibility and change, enabling alternative endings where tragedy presents causal inevitability' (Kakoudaki, 2009: 208). In this sense, Ferreira's melodramatic mode provides a means through which individual memory can become official history, as well as a potential therapeutic model for dealing with the trauma that generates collective empathy and affective identification.

Spain's process of creating public spheres of memory to counteract the past's politics of forgetting must be situated within a larger global tendency. As Andreas Huyssen affirms, 'the culture of memory' is a phenomenon that mainly occurs in the context of Europe's memory of the Holocaust and Latin America's memory of the disappeared during its military dictatorships (Huyssen, 2003: 15). In proposing that the memory of the Holocaust, in its various artistic and political manifestations, functions as a 'universal trope', as a metaphor for other memories and traumatic histories, Huyssen curiously ignores the Spanish case (2003: 14). Perhaps Huyssen's own forgetfulness, in a book published in 2003, should be understood in light of the vertiginous changes that the politics of memory have undergone in Spain during the past decade, and especially since the return to power of the PSOE in 2004.

The transition's political 'pact of forgetting', that neglected the Republican victims of the war during the last quarter of the twentieth century, was reconsidered for the first time during the government of José Luis Rodríguez Zapatero, giving way to the project of the *Ley de la Memoria Histórica* (Law of Historical Memory), which was approved in the General Courts

in December 2007. In accordance with the Law, the government increased the monthly pension benefits given to the orphans of the victims (€132,86) (Art. 6); it compensated those who were imprisoned for three or more years (€6.010,2 for three years and €1.202,02 for every additional period of three full years) as well as the spouses of those who were imprisoned for fewer than three years and were given the death penalty and who never received compensation from the state (€9.616,18) (Art. 7), and the beneficiaries of those who died between 1968 and 1977, defending democratic rights and freedoms (€135.000) (Art. 10); it regulated the discovery and identification of victims, as in the exhumation of the Republican graves (Arts. 11–14); it promoted the withdrawal of all shields, insignia, plaques and other commemorative mentions of the exaltation, personal or collective, of the military uprising of the Civil War and of the dictatorship's repression (Art. 15); it redefined the symbolic function of the Valle de los Caídos (Valley of the Fallen), prohibiting all celebrations of the war and establishing as one of its objectives the honouring of 'the memory of all of the fallen as a result of the Civil War and the political repression that followed it' (Art. 16); it conceded Spanish citizenship to the members of the International Brigades (Art. 18); it set up the Centro Documental de la Memoria Histórica (Documentary Centre for Historical Memory) and administered and made publicly accessible the Archivo General de la Guerra Civil Española (General Archive of the Spanish Civil War).

One of the most contentious aspects of the debate that arose before the passing of the Law project was the decision not to revoke the Consejos de Guerra (Court-Marshal Laws) and the Francoist trials. Although the Law states that 'we recognise and declare the radically unjust nature of all of the sentences, sanctions and all manner of forms of personal violence perpetuated on the basis of political, ideological or religious beliefs during the Civil War as well as those perpetuated for the same reasons during the Dictatorship' (Art. 1.1), and although the Law declares 'the illegitimacy of the Tribunal of the Repression of Masonry and Communism, the Tribunal of Public Order, as well as the Tribunals of Political Responsibility and War Councils' (Art. 3.2) and recognises the right to obtain a 'Declaration of reparation and personal recognition' (Art. 4.1), the Law also explicitly states that although this Declaration will be compatible with the reparations already contemplated, it 'does not represent grounds for the recognition of the capital liability of the State nor of any Public Administration, nor will it produce any redress or compensatory effect of a professional or economic nature' (Art. 4.5).

This last statement has most intensified the division between the two opposing sides: the one side that feels that the Law disappoints, as it winds up offering a mere moral renovation that maintains the pact made during the transition in order not to offend the more conservative forces in society and does not go far enough in establishing the necessary judicial reforms, and the opposing view that considers it damaging to 'reopen old wounds'

and maintains that recognition is not necessary since it was already made in different ways during the transition. Although the Law is the first official measure that has been made to counteract the politics of forgetting, it shies away from the work of defining the exact content of a politics of memory. In its 'Statement of Purpose', the Law declares, 'it is not the duty of the Legislator to set up a certain collective memory.' This assertion leaves open the question of where historical and collective memory are articulated and recorded. The founding of the Centro Documental and the Archivo General are specific initiatives that move towards the creation of official spaces for public access to history and memory. As Avishai Margalit notes, these types of initiatives constitute the essence of a 'shared memory' in a modern society, which 'travels from person to person through institutions, such as archives, and through communal mnemonic devices such as monuments and the names of streets. These communal institutions are responsible, to a large extent, for our shared memories' (2002: 54). Nevertheless, the legislators prefer that other spaces of memory share the task of 'closing the wounds still open among the Spanish' ('Statement of Purpose').

We live in an era in which it is almost impossible to conceive of any kind of historical trauma outside of its spectacularisation and marketing in various manifestations of high and popular culture: museums, cinema, television, the internet, comics, music, etc. (Huyssen, 2003: 18–19). These can be considered real spaces of memory without assuming that they render banal the historical facts that are represented. Establishing a simplistic opposition between history and memory, the latter understood as the subjective and inconsequential from which historians derive 'the real thing', merely reproduces the old modernist dichotomy that held that there was both an appropriate way of historicising reality and an inappropriate way that trivialised reality and turned it into entertainment (Huyssen, 1995: 6). Nowadays, 'traumatic memory and entertainment memory occupy the same public space' and cannot be perceived 'as mutually exclusive phenomena' (Huyssen, 2003: 19). This implies the need to consider with equal rigour both the political debate over the legislation of memory as well as those cultural and mass media productions that represent memory. Above all, we must take into account the effects that both legislative and cultural processes have on the collective consciousness. If it is indeed true, as Huyssen suggests, that 'memory can be no substitute for justice, and justice itself will inevitably be entangled in the unreliability of memory', it is also true that memory 'is active, alive, embodied in the social – that is, in individuals, families, groups, nations and regions' (2003: 28). It is precisely these individual memories, always unstable and threatened by oblivion, that will be preserved by the Centro Documental and the Archivo General and that, in fictionalised form, integrate the diversity of memorial representations that seek to 'transform [individual] affects into effective political action' (Butler, 2009: 99).

In her comprehensive study *Políticas de la memoria y memorias de la*

política (*Politics of Memory and Memories of Politics*) (2008), Paloma Aguilar reminds us that collective memory manifests itself through individual actions and declarations. While individuals possess memories that are influenced and transformed by the memories of other individuals, social groups determine what is 'memorable' and how it should be remembered (47). The interpretation of the past is sustained by groups that share a feeling of common identity, and the memory of a determined group may end up becoming an institutional memory (58). This concept of interpretation (rather than remembrance) of the past is what Avishai Margalit has called 'shared memory' (different from 'common memory'): 'it requires communication. It integrates and calibrates the different perspectives of those who remember an episode … into one version' (2002, 51–2). In the same vein, Marianne Hirsh established the distinction between memory and postmemory. The latter 'is distinguished from memory by generational distance and from history by deep personal connection;' it is 'the experience of those who grow up dominated by narratives that preceded their birth' and whose connection to past objects or sources 'is mediated not through its recollection but through imaginative investment and creation' (1997: 22).

Along these lines, I have proposed in a previous essay that recent cultural productions – including exhibitions, novels, documentaries, films and television series – generated in response to the obsession with the recuperation of the memory of the Civil War should be considered 'postmemorial' collective spaces of memory defined by 'the mixture of mourning and re-creation' (Hirsch, 1997: 251). Furthermore, I argued that these spaces were affecting public opinion more effectively than the proposed legal processes, and I reiterate now that they have contributed to the creation of institutional memory. I also stressed that the intergenerational bridge is a central feature in many narratives of this postmemorialist tendency, in which the active investment of children and grandchildren in the memories and history of their parents and grandparents provides a nostalgic yet creative means of avoiding oblivion, interpreting the past and transforming memory into utopian action (Ballesteros, 2005).

I want to expand these arguments here – specifically the idea that collective memory is the result of communication, interpretation and the imaginative re-creation of individual shared experiences – and consider them in the context of the memorialist dialectics that constitute the plot of *Para que no me olvides*. The film locates the collective trauma of a historically shared experience, the Civil War, within the fictional microcosm of an individual family's past and current traumas, a network of micro-affects that metonymically refer to social relations. Within this microcosm, memory, before being shared, is both halted and triggered by amnesia, family dissolution and death. The traumatic family history is presented through a sequence of scattered clues and hidden documents to be solved and investigated by its members, who exhibit different attitudes towards the family's traumatic past, in keeping with the generation to which they belong.[2] Mateo, the

grandfather speaks with the ghosts of loved ones in order to keep them alive, and he has related his memories of the dark years to his grandson, David, who in turn has documented them in his diary, a sort of biography of his grandfather, that he has kept secret from everyone. Meanwhile, Irene, a representative of the generation that witnessed the transition to democracy, focuses on the present, largely oblivious to the memory of the events that so much affected her father. The grandfather's fragile memory, threatened by illness and age, is rescued by his grandson's writing, which enables the discovery of an urban reliquary: the childhood home of the grandfather.

At the same time, the melodramatic mode, beyond seeking to engage the audience in an emotional response to grief by transforming it into a communal experience, facilitates the conversion of emotion into reason and ultimately fosters the pursuit of social action. Annabel Martín makes the case for the therapeutic potential of melodrama, during both the dictatorship and the post-Franco transition, for channelling 'the emotional stress caused by lost meanings and relationships ... and the despair over the enormity of the loss' and for 'grounding an ethical politics in the face of the vicissitudes of reality' (2005: 76, 77). Martín proposes that for the filmmakers (and audiences) of the post-war period, melodrama became an 'operational model [in life and politics] of confrontation and response' that generated 'collective empathy and affective identification' (59, 61). I am most interested in her interpretation of how the melodramatic mode operated in post-Franco Spain as an 'epistemology of a moral quest' and 'a place in which to insert individual memory in official histories' (87, 201). Memory, immersed in sentiment, arises as a form of 'restitution, a settling of accounts with a violent past' (247).

In Ferreira's film, such melodramatic 'restitution' is linked to the rediscovery and restoration of an ancestral architectonic and urban space. In so doing, Ferreira conflates space and time to reveal memory's material presence (Hirsch, 1997: 246). The grandfather's former house, now on the brink of being condemned but once associated with a happy childhood – all traces of which disappeared during the war – is a family heirloom: the 'architectural space of memory' from which the recovery of familiar and collective trauma can be initiated. The architecture of the past and its relocation and relevance within the urban space provide the civil (socio-political) text in which the inequality between society's political and cultural hegemonies and individual members who lack access to those spaces can dissolve, establishing a mediation between the public and the individual (Martín, 2005: 224). The narrative of grief and the process of mourning experienced by the family members after David's death in a bicycling accident are also contained in the current family home, a modern apartment in Madrid, where the members of the three generations coexisted happily before the accident.

The remodelling of the democratic city is another determining factor, along with the fragility of memory, in the spatial location and consequent resolution of the trauma. Because of urban sprawl, the house – which in the

1930s was on the outskirts of Madrid, in the middle of the countryside and surrounded by vineyards – has been absorbed by the city and has therefore been displaced, literally in terms of geography and metaphorically in the family memory. David, a talented student of architecture, has located the family house and, without telling anybody, has been helping its current tenants prepare the necessary documents to qualify it as a place of historical significance, thereby avoiding its destruction. Locating and rescuing the family home is David's first step towards restoring individual memory and paying homage to its former inhabitants, the great-grandfather who was executed by the Nationalists and the great-grandmother who died in jail, but converting the home into a monument also implies turning individual moral reparation into public commemoration, granting it a historical dimension. While transcribing and documenting the oral testimony of the grandfather belongs to the register of individual memory, the project of classifying the house as a place of historical significance is an official action subject to a process of administrative regulation. Ferreira's film transcends the individual homage paid to the victims of the conflict that is inherent in the majority of revisionist filmic texts. In doing so, she suggests that merely localising and identifying the remains of the past, whether human or architectural, is insufficient. Instead, restoration should also consist in making public recognition of individual architecture and in contemplating the qualification, disqualification or requalification of the symbols, buildings and places of historical commemoration – just as the Law proposes the qualification of the mass graves, the disqualification of commemorative mentions of the Civil War, and the requalification of the monument of Valle de los Caídos.

In this way, the protagonists' individual trauma that results from David's death provokes conflicting responses in his grandfather Mateo, his mother Irene and his girlfriend Clara, and metaphorically alludes to the polemic that has divided the country since it undertook the task of confronting the trauma of the war and defining the concept of 'historical memory' for the future. The hospital where David, still alive, is taken after the accident is the site where the melodrama unfolds as the two women, who do not know each other yet but who have been presented as rivals for the love of David, are confronted for the first time with the loss of their beloved. In order to survive the loss, Irene chooses to 'forget in order to stay alive', eliminating the traces of the past and erasing the memory of her son. On the other hand, Clara desperately collects David's objects in order to revive his memory. In order to complete the Freudian 'work of mourning' and overcome the loss of her son, Irene declares that he no longer exists and severs her attachment to him (Freud, 1957: 255); that is, she forgets in order to survive. Conversely, Clara cannot overcome melancholia, and displays 'an extraordinary diminution in her self-regard, an impoverishment of her ego on a grand scale' (Freud, 1957: 246). The loss of David is experienced as the annihilation of her self, and only her obsessive recollection of shared memories can compensate for the loss.

The pathos is concentrated on Irene's guilt over not having resolved her disagreements with her son 'in time', and on Clara's melancholy over not having got to know him better before it was 'too late'. Irene is obsessed with the fact that it is 'too late' for her to show any understanding of David's decision to leave home and move in with Clara – 'If only I had made peace with him'; 'I failed him in the end –' and yet she is unable to shed tears, which would offer relief and would prove that she is 'reconciled with the irreversibility of time' (Moretti, 1983: 180). Clara, on the other hand, is a melancholic who displays sadness before the actual physical loss of David due to her status as a rejected daughter after her mother's death and her father's remarriage. She acknowledges, 'I was lost before I met David', and she weeps in most scenes, starting in the hospital, where Irene scolds her for her lack of restraint, referring to her as: 'that weeping child'.[3] In both cases, the articulation of sentiment is directed towards the recognition of the victim's virtue and towards a continuation of the ethical action that was cut short by his death (Williams, 1998: 66). The film reveals the progressive recognition of David's virtuous and heroic life. He is a combination of melodramatic victim and tragic hero: disaster was imposed on him, his death came from outside, not as a consequence of his actions or decisions; his ethical commitment, kept secret and discovered posthumously after his death, elevates his character to the status of martyrdom.

This dialectic of the negation–affirmation of the memory of David is expressed through the objects in the domestic spaces, the spaces of the feminine. In melodrama, spaces and objects take on metaphorical significance, visually enhancing or carrying the full weight of the emotional dynamics of the drama. In Thomas Elsaesser's words: 'the more the setting fills with objects to which the plot gives symbolic significance, the more the characters are enclosed in seemingly ineluctable situations. Pressure is generated by things crowding in on them, life becomes increasingly complicated because cluttered with obstacles and objects that invade their personalities, take them over, stand for them, become more real than the human relations or emotions they were intended to symbolise'; characters' emotional reactions are reinforced stylistically by a 'complex handling of space in interiors … to the point where the world seems totally predetermined and pervaded by "meaning" and interpretable signs' (1985: 183).

David's rooms, filled with his personal objects, in the houses of both Irene and Clara, are the territories of mourning and melancholy, where the women confront the trauma by removing or venerating the traces of the deceased and competing between themselves for the right to forgetting and the right to memory. The film's positive outcome provides a resolution to their opposed views: a spirit of reconciliation is effectively expressed by the two female protagonists who forget their disagreements and unite forces in the task of rescuing and continuing David's restoration project. An aural trace of David – a message recorded on Clara's answering machine and kept by her as a *memento* – functions as a ghostlike reminder of his

existence and, later, as the catalyst that breaks down Irene's resistance to confronting her son's loss and coping with the trauma. In the last sequences of the film, Clara offers the tape with Daniel's voice to Irene, who accepts it and listens to it, demonstrating her willingness to finally open the door to remembrance. The recorded voice brings the dead back to life every time the tape is played back but, most importantly, it builds a bridge between the women that enables the construction of a communal and shared memory, and which is encapsulated in the objects that symbolise his existence.

Conversely, Mateo has survived the loss of his sister, parents and wife by 'speaking with them as if they were alive', thereby establishing a phantasmatical dialogue with the past. What his family understands as the beginning of dementia is an alternative means of surviving trauma and honouring the memory of the dead. The melodramatic code, says Annabel Martín, 'sets up a bridge between writing and life ... pacifies pain by transforming it into writing' (2005: 267). In the film, the bridge is a literal one. Upon discovering his grandson's diary, Mateo transcends both Irene's negation and Clara's melancholia by writing a biography of David, in an initiative of reciprocal commemoration. Grandson and grandfather share similar strategies of creativity and action to avoid forgetting and complete the task of mourning: the oral transmission and written documentation of memories. Their two diaries have to be considered sites of memory, acts of mourning, 'spaces of connection between memory and postmemory' (Hirsh, 1997: 247).

If the two diaries are the repositories of the memories of both Mateo and David, some pictures taken by David before he died and retrieved from the photography studio by Clara some time after his death provide the missing clue that enables the discovery of the existence and exact location of the family house. The pictures record the happy times shared by the couple during a trip to Alicante, but also present an unexpected mystery related to David's architectural activities. Photographs of a house and a family unknown to both Clara and Irene trigger Clara's curiosity, and her determination to unveil the mystery will drive her to discover the significance of the house and David's personal involvement in it. As she works to locate the house, whose address is visible in some of the pictures, Irene retrieves David's architecture dossier from his professor. In melodrama, objects make coincidences possible: the photographs of the house unveil David's secret restoration project. In search of clues while filling in the gaps in David's story and project, the two women coincide at the house on the same day and at the same time. In this way, Ferreira follows the traditional melodramatic use of secrets and their slow or partial disclosure through discovery and detective work. As the characters, and the audience with them, put together the pieces, the sentimentality gives way to suspense, and the melodrama turns into a thriller.[4]

The photographs, like the recording, bring David back in the form of another ghostly revenant, 'emphasizing, at the same time, its immutable and irreversible pastness and irretrievability' (Hirsh, 1997: 20). At the same

time, the photographs demonstrate David's commitment to both the present and the future: the preservation of the architectural space, initiated by him, offers the family members the opportunity to rediscover their past, to look past the myths that enshroud lost people and spaces, and to commemorate their absence. The house – like the crypt, the tomb and the monument – provides material evidence as well as the possibility of turning lament into praxis: the past is translated by the written word and materialised in architectural space. The three positions represented by the protagonists – the negative forgetting, the victimising obsession and the positively coded active resolution that transforms mourning into ethical action – reproduce the perspectives common in Spanish society and present an opportunity for reflection that runs parallel to the collective and official discourse that attempt to define and repair historical memory. As embodied by Irene and Clara after David's death, the film's dialectics of mourning and melancholia, of oblivion and remembrance, implicitly refer to the controversy that the revisionist initiatives and the approval of the Law have provoked in Spain since 2000. Ferreira first establishes this connection through the characters of David and Mateo. In spite of the propensities of his own generation, which is typically oblivious to the past, David was before his death the repository and transmitter of Mateo's memories of the war and an active promoter of the recovery and preservation of the space of memory. His actions have to be considered an individual homage to his family's memory. At the end of the film, in a conversation with Irene, Mateo addresses his own work of mourning and the dialectics of oblivion–remembrance, connecting them to the moral obligation that Spanish society has to remember and pay collective and official homage to the victims of the conflict:

Irene: How am I going to do it, dad? How can I live the rest of my life like this? How did you do it? How did you survive?

Mateo: I started to talk to them. It was like they were still alive and could go on telling me things. Sometimes I even used to laugh picturing my father's face when my mother disagreed with him. What you don't know is how much it has cost me; and the times that I have wanted to free myself from that burden that just got heavier with time, but I couldn't. I knew that I had to remember everything. Until they give back to the dead the honour that that ruthless regime carried away.

Irene: I'm sorry, dad. I'm really sorry.

Mateo: But with every day that goes by I realise that they are going to let us die without apologising, that they're not going to put the names of the victims in a place visible to all, as they did for more than sixty years with the names of the fallen, for God and for Spain; so that the younger generation would know it.

Irene: David knew it, dad.[5]

The Law offers 'general recognition' of the unfair nature of all forms of persecution and violence perpetrated during the Civil War and the

dictatorship and declares all governmental institutions that enforced them illegitimate. The Law also grants the victims a symbolic 'Declaration of personal reparation and recognition' but, as Paloma Aguilar reminds us, unlike the post-dictatorial governments in Argentina and Chile, the Spanish state has not offered a public apology to the victims, nor has there been official or public repentance for the crimes perpetrated during and after the conflict (2008: 439–40). Ferreira's film articulates the unfulfilled needs of individual Republican victims and exposes the still incomplete collective and institutional work of mourning implicit in the Law's shortcomings. Using film as a cultural space of memory and recognition, Ferreira addresses the premise, made explicit in the Law's 'Statement of purpose', that the healing of personal wounds and the right to personal and familial memory cannot be legislated for. Instead, such wounds have to be worked on at an individual level and in the private sphere at first, although their moral significance derives from the subsequent public acknowledgement that they must be 'vigorously protected and consecrated as an expression of democratic citizenship' in order 'to promote knowledge and reflection about the historical past and thus avoid its reproduction in the future' ('Statement of purpose').

Notes

1 I am referring to the term 'lieux de mémoire' coined in the collaborative project led by Pierre Nora about sites of memory in post-war France and published between 1984 and 1992. 'A *lieu de mémoire* is any significant entity, whether material or non-material in nature, which by dint of human will or the work of time has become a symbolic element of the memorial heritage of any community' (1996: xvii). These include: places such as archives, museums, cathedrals, palaces, cemeteries and memorials; concepts and practices such as commemorations, generations, mottos and all rituals; objects such as inherited property, commemorative monuments, manuals, emblems, basic texts and symbols. I choose the term 'space' as a translation of 'lieu', instead of 'site' or 'realm', because it denotes both temporality and spatiality and evokes in a broader sense the multiplicity of sites and objects, both real and imagined, on which memory relies. See Ballesteros (2005).

2 Antonio Hernández *En la ciudad sin límites* (2002) presents striking coincidences with Ferreira's film: they both cast the actor Fernando Fernán Gómez as the character of the father/grandfather, a survivor of the war, and connect Spanish society's collective oblivion with this character's amnesia/early dementia.

 I want to stress the relevance of casting Fernán Gómez in these Spanish memorialistic films and the effect this is intended to have on Spanish audiences, due to the prominent role he played in the intellectual and political movements of Francoist and post-Franco Spain as an actor, writer, political activist and filmmaker.

3 For melodrama's mechanisms to generate pathos and move audiences, see Franco Moretti's study of moving literature (1983) and the revision of Moretti's theories in Neale (1986) and Williams (1998).

4 For melodrama's use of coincidence and suspense structures, see Kakoudaki (2009).
5 Author's translation.

References

Aguilar, P. *Políticas de la memoria y memorias de la política* (Madrid: Alianza Editorial, 2008).
Ballesteros, I. 'La exhumación de la memoria histórica: nostalgia y utopía en *Soldados de Salamina* (Javier Cercas 2001, David Trueba 2002)', *Film-Historia*, 15(1) (2005) (*Online Journal of the Centre for Cinematic Research*, Universidad Central de Barcelona) (www.publicacions.ub.es/bibliotecadigital/cinema/film historia/2005/Ensayo_Soldados%20de%20Salamina%20_1.htm).
Butler, J. *Frames of War: When Is Life Grievable?* (London: Verso, 2009).
Elsaesser, T. 'Tales of Sound and Fury: Observations of the Family Melodrama', in B. Nichols (ed.), *Movies and Methods*, vol. 2 (Berkeley: University of California Press, 1985), pp. 165–89.
Freud, S. 'Mourning and melancholia', in *The Standard Edition of the Complete Psychological Works*, vol. 14, trans. James Strachey (London: Hogarth Press, 1957), pp. 239–58.
Hirsh, M. *Family Frames. Photography, Narrative and Postmemory* (Cambridge, MA and London: Harvard University Press, 1997).
Huyssen, A. *Twilight Memories: Marking Time in a Culture of Amnesia* (New York: Routledge, 1995).
——— *Present Pasts: Urban Palimpsests and the Politics of Memory* (Stanford: Stanford University Press, 2003).
Kakoudaki, D. 'Intimate strangers: melodrama and coincidence', in B. Epps and D. Kakoudakis (eds), *All About Almodóvar: A Passion for Cinema* (Minneapolis, MN: University of Minnesota Press, 2009), pp. 193–238.
Ley de la Memoria Histórica (2007) Boletín Oficial del Estado núm. 310. www. mpr.es/NR/rdonlyres/D03898BE-21B8-4CB8-BBD1D1450E6FD7AD/85567/boe memoria.pdf
Margalit, A. *The Ethics of Memory* (Cambridge, MA: Harvard University Press, 2002).
Martín, A. *La gramática de la felicidad* (Madrid: Ediciones Libertarias, 2005).
Moretti, F. *Signs Taken for Wonders* (London and New York: Verso, 1983).
Neale, S. 'Melodrama and tears' *Screen* (1986) 27.6: 6–23.
Nora, P. (ed.) *Les lieux de mémoire*, 7 vols. (Paris: Édition Gallimard, 1984–92).
——— 'From *Lieux de mémoire* to Realms of Memory', in P. Nora and L. Kvitzman (eds), *Realms of Memory: Conflicts and Divisions* (New York: Columbia University Press, 1996), xv–xxiv.
Williams, L. 'Melodrama revised', in N. Browne (ed.), *Refiguring American Film Genres: History and Theory* (Berkeley: University of California Press, 1998), pp. 42–88.

4

Women filmmakers and citizenship in Brazil, from *Bossa Nova* to the *retomada*

Catherine L. Benamou and Leslie L. Marsh

Contrary to what might be expected, Brazilian women's filmmaking – like women's filmmaking in Argentina, Chile, Colombia and Mexico – began long before the emergence of what could be called 'explicitly feminist' cinema. Yet there is little doubt that the first attempts at Brazilian women's production, owing to their singularity and their relative independence from male-dominated studio structures, contributed in meaningful ways to the ideological foundations and propagation of various strands of feminist activism from the 1930s through to the 1990s. As Elice Munerato and Maria Helena Darcy de Oliveira have observed in their breakthrough essay on the subject (1995: 340–50),[1] film directing in the early industrial era was possible mainly for women who had access to family or conjugal capital, or whose accomplishments as screen actors provided them with the leverage needed to take the helm as producers and directors.

The trajectory of women's filmmaking throughout and beyond this initial industrial period follows a pattern of syncopation in relation to the general flow of national cinema. Although the silent era harvested the first feature film by a woman director, *O mistério do dominó preto* (*The Mystery of the Black Domino*, directed by Cleo de Verberena in 1930, a year before women's suffrage was granted), no films were directed by women during the first wave of *chanchadas* (musical comedies) in the 1930s, nor throughout President Getúlio Vargas's *Estado Nôvo* (1938–45). Then, following a brief revival populated by three feature films by radio, theatre and film actress Gilda de Abreu and the studio owner Carmen Santos's *A inconfidência mineira* (*Rebellion in Minas*, 1948), there is another hiatus during the intensification of studio production and the second peaking of the *chanchada* in the early to mid-1950s. When women's cinema finally re-emerges in the early 1960s with the release of *carioca* artist Lygia Pape's *O guarda-chuva vermelho* (*The Red Umbrella*, 1963) and Helena Solberg's experimental short documentary *A entrevista* (*The Interview*, 1964), it coincides with the advent of a military–civilian *coup d'état* and, partly as a result, stands in sharp thematic contrast to the first films of the Cinema Nôvo, which adopted the French New Wave's preference for open-ended plots and hand-held location shooting with a 16 mm camera to forge archetypical portraits

of north-east Brazilian subaltern and marginalised subjects – the landless or destitute and illiterate, or wilfully itinerant (whether artists, bandits or spiritual leaders) – in an overt critique of perennial regional suffering and neglect. While Solberg, a close associate of this group, does incorporate the mobile, 'open air' camera and everyday rhythm of life espoused by the first wave of Cinema Nôvo, and embraces the ritualistic rather than prosaic narrative structure that one finds in films like *Barravento* (dir. Glauber Rocha, 1962), *Deus e o diabo na terra do sol* (*Black God, White Devil*, dir. Glauber Rocha, 1964) and *Pagador de promessas* (*The Given Word*, dir. Anselmo Duarte, 1962),[2] she purposefully trains her camera and sound recorder on members of her own class and educational background. Hers is a threshold film that reveals the doubts and aspirations of young women of marriageable age (seventy women between the ages of 19 and 27 were interviewed for the project), while ending on a somewhat apprehensive note as footage of a mass of self-righteously conservative, mostly middle-aged well-dressed people marching for 'Familia com Deus pela Liberdade' (Family with God for Liberty) is intercut with Solberg's on camera interview with a newly wed woman, Gloria, who confesses to making peace with the internal 'ambiguities' provoked by her marriage, resigning herself to the role that has been carved out for her by her social class. The beginnings of a movement to resist the perpetuation of those roles are thus literally cut short. Beyond this disrupted turning point, we will be exploring to what extent women's filmmaking was *exceptional* in the dramatically changing Brazilian Cultural context of the late twentieth century; in the process, we will attempt to situate the periodic interventions of this cinema with respect to *both* the ruling patriarchal ideology and the socio-economic challenges facing the nation as a whole.

The time-span we will be addressing in this chapter – the mid-1960s to the turn of the millennium – is characterised by the gradual structural (if not exactly discursive) convergence of women's cinema with trends in national cinema at large, paralleled by a self-conscious effort from the earliest stages to use cinema and video as transformative tools in response to the social, economic and psychobiological conditions experienced by various demographic strata of Brazilian women. The paradox resulting from this synchronisation and simultaneous movement towards relative independence suggests that women's production has been capable of underscoring with a certain stridency how masculine production, even of the vanguardist variety, has been unable to speak for all nationally defined subjectivities and contemporary concerns. What, concretely, women's cinema has had to say regarding the silences and lacunae in masculine or mainstream Brazilian cinema needs to be considered in active tension with shifts in gender norms and expectations, along with more encompassing changes in the sociopolitical context.[3] For example, although women's work outside the home might have been frowned upon inside middle-class circles in the 1960s, it certainly wasn't – at least in the Central South – in the inflationary late 1970s, while

the awareness of race as an influential factor in women's oppression did not appear firmly on the national radar until a spate of scholarly works and women's video films started to circulate in the early to mid-1980s.[4] Filtered through different layers of censorship and access to state filmmaking support, these themes received different degrees of exposure to audiences outside Brazil.

Conversely, at times, state discourse and public policy appear to stand in contradiction to both dominant gender ideologies and popular practice. This has been especially true for the screen portrayal of female and alter sexualities, but also for access to reproductive choice, HIV prevention and alternative conjugal relations (legitimate vs. informal, hetero- vs. homo-sexual). Also noticeable along this trajectory is the transition from a cinema of 'apprenticeship', whereby fledgling filmmakers take hold of available filmmaking apparatus through their associations and collaborations with male cinéastes (as was the case for Solberg and her immediate successors) to formally schooled, yet stylistically and generically diverse, cohorts of direc-tors who have openly advocated gender equality and sexual liberation both on the screen and within the cultural institutions and organisations in which they have worked. To evaluate the progress made by women directors, it is important to consider the degree of infrastructural support provided by the state and other agencies (from regional television networks to grass-roots media collectives) to women filmmakers as well as international recognition for the work of individual directors, which has helped to legitimise their efforts vis-à-vis a series of state film agencies (especially Embrafilme and ANCINE). Indeed, international recognition – taking the form of festival awards and a transnational, collegial 'call and response' beginning in the 1970s – carries weight in a national context where the lion's share of the film market has been occupied by foreign cinema, especially studio products from the United States.[5] Beginning in the 1980s, Canada's National Film Board (Studio D) and the '*Un certain regard*' women's showcase at the Festival de Créteil (France) were especially influential in this regard.

What women's – and more specifically feminist – filmmaking 'means' in Brazil has varied not only according to the history and contemporary status of women's rights and gender-related expectations, but also the chosen medium of expression (35 mm film or small-format video) and targeted audience (grass-roots or city centre venue), as well as the geosocial locus of production. Whereas nearly all of the women filmmakers producing work into the mid-1980s hailed from the Central South (particularly the Rio de Janeiro–São Paulo axis), where state and private film-funding sources, labs and studio facilities and distributors have traditionally been clustered,[6] it became more common during and after the ensuing constitutional reform, a process initiated through the *Assembléia Constituinte*, to find audiovisual works that were purposefully shot and exhibited at ex-centric locations prior to national and transnational circulation. This was facilitated greatly by the expansion of university- and community-level media instruction,

along with the proliferation and spread of non-governmental organisations outward to regional and provincial capitals (such as Recife, Salvador, Porto Alegre, Brasilia, Belém and Belo Horizonte). Since the eruption onto the cultural scene of women's films made both with and without state support during the early years of military rule, the most dramatic shifts in women's filmmaking have been tied to the return to electoral democracy (*abertura*) in the mid-1980s, followed by the presidentially mandated closure of the largest and most durable state film agency, Embrafilme, in 1990.

In reviewing the contributions of distinctive filmmakers in each of the three corresponding 'periods' – dictatorship, *abertura* and *retomada* – we will analyse the productive intersection of three transhistorical strands of activity – women's film education and their respective moments of creative emergence, the on-screen and off-screen relationship to the Brazilian state as an arbiter of cultural expression, and the textual definition and address of specific constraints and aspirations in relation to gendered subjectivity. In the process, we will direct our focus to the productive interaction of gender politics and aesthetics in the work of major women directors, nearly all of whom are still actively producing films today.

Feminist eruptions and allegorical implosions under military rule (1963–79)

My first impulse to create cinema was in '67. It was a desire like this: I was sixteen years old, I wanted to intervene in concrete life, concretely through the most abstract means, through ideas. (Tereza Trautman, in Sereno, 1985)[7]

The re-emergence of women's cinema in the 1960s occurred as a series of bold interventions by a new generation intent upon breaking the mould of traditional gender norms and screen imagery in a climate of entrenched conservativism under military rule, which began on 1 April 1964 when a 'bloodless' coup brought an end to the João Goulart (PTB) presidency. One sees a push in this fledgling feminist wave to foreground contemporary gender relations and preconceptions (mostly in an urban, upper middle-class context), and also to develop a new poetics of socio-spatial representation that could call attention to the disturbances created by the deepened superstructural imposition of patriarchally based, physically enforced rule on civil society. Within the textual fabric, this often led to a stylistic rupturing of the diegesis, manifested in either disjunctive relations between sound and image (as in Solberg's *A entrevista*), or discontinuities in performative and audiovisual tone and even genre (as in the work of Ana Carolina). Proceeding from fairly straightforward documentary commentaries, directed by Solberg (1964), Ana Carolina (Teixeira Soares, 1968–74), Leilany Fernandes (1972–77), Suzana Moraes (1973–76), and Suzana Amaral (1970–77), along with more explicitly experimental works (Lygia Pape, 1963–78) (see Paranaguá, 1990: 13, and Buarque de Hollanda, 1989), films by the mid-1970s exhibited a gravitation towards a more

multivocal, allegorical mode of representation, mainly in reaction to the arbitrary suspension by the state of civil liberties through Institutional Act No. 5 (AI-5), which doubtless impeded juridical and cultural progress towards gender equity. Included in this latter category are the early fictional works of Teresa Trautman, such as *Curtição* (*Enjoyment*, 1971, an episode in *Fantastikon – os deuses do sexo*, co-directed with José Marreco, in which drug use leads to an imaginary engagement with contemporary reality), and Ana Carolina's *Getúlio Vargas* (1974), a revisitation, by way of a compilation of newsreel footage, of the reign of the populist dictator who preceded the democratic surge in the 1950s.

One notes in films of this period a palpable preoccupation with power at the intersection of institutional culture, on the one hand, and gendered subjectivity, on the other, reflecting a blend of Freudian and Foucaultian sensibilities: adolescent rebellion is framed allegorically not only as the expression of unresolved 'Oedipal' or 'Electral' crises,[8] but also as a bodily struggle against the arbitrary and inaccessible power dynamics of the patriarchal state, which, more often than not, can be discerned seeping, in introjected form, into characters' dialogue and behaviours. This is illustrated in films beginning with Solberg's fictional short *Meio dia* (*High Noon*, 1968), in which a young man skips school only to organise a revolt with other students, then destroys the classroom and kills the teacher, and continuing through Ana Carolina's landmark *Mar de rosas* (*Sea of Roses*, 1977), the first of a cinematic trilogy exploring the misadventures and experiments with civil disobedience of a young middle-class woman coming of age in the Brazilian Central South. In contrast to the relatively linear plot lines and feminine characterisations in women-directed films in the commercial industrial period, in which female desire was usually portrayed as trapped in the vicissitudes of hetero-romantic triangles (Munerato and Darcy de Oliveira, 1995: 345–8), or channelled through acts of maternal sacrifice, 1970s films not only endow feminine protagonists with dramatic – and by allegorical extension, sociopolitical – agency, but also dare to explore the boundaries of unsanctioned or rarely represented forms of affect and socially repressed vectors of desire especially. This is evident in *Mar de rosas*, Trautman's *Os homens que eu tive/The Men in My Life*, 1973, and Pape's visually metaphoric *Eat Me*, 1976, as if to expose the manner in which, according to Laura Mulvey, the process of the subjectification of women in capitalist patriarchy is never fully achieved, while female viewership remains subject to patriarchal encroachment, as dictated in this case by a censorious state apparatus, rather than by commercially motivated and male-dominated filmmaking enterprises (1989: 162, 174–5).

It is truly remarkable, given the extent and the forms taken by state repression (some of which was later detailed in survivor Lucia Murat's *Que bom te ver viva* (*So Nice to See You Alive*, 1989), that at least seven women directors were able to launch their careers during this period, nearly all of them working in 35 mm gauge, and most going on to direct other films

once the dictatorship ended. Representing women's experience during the dictatorship came at a certain 'cost' not only to mainstream narrative form and seamless editing style (albeit to the advantage of formal experimentation and the articulation of new audiovisual vocabularies for the voicing of women's concerns), but also to the kind of continuity and growth afforded by the infrastructural support needed by women's media that would not be in place until a decade later. Even though at least three film schools existed in the Central South (in Brasilia, Rio de Janeiro and São Paulo) by the early 1970s, only three filmmakers (Luna Alkaray, Suzana Amaral and Ana Carolina) were able to receive a formal film education inside Brazil; the others (Pape, Solberg, Trautman) developed their personal visions in initial collaborations with male directors and editors, and yet others (Eunice Gutman and Tete Moraes) learned the craft while in exile abroad (see Sereno, 1985, and Marsh, 2012). The support emanating from public cultural institutions and semi-autonomous state agencies was uneven. During this period, these agencies evolved from a legislative-lobbying and distributing organisation, GEICINE, 1961, followed by the Instituto Nacional de Cinema (INC, 1966), and Embrafilme, formed in 1969 under the military government and converted into a major producing and promotional force after 1974.[9] Official support for women's filmmaking was virtually non-existent until the formation of Embrafilme. Yet although, as Marsh notes, only one woman director, Lenita Perroy, was able to secure a loan from Embrafilme for a feature film (*A noiva da noite/The Night Bride*, 1974) (Marsh, 2012: 18), the emerging cohort benefited in general from the policy of exhibiting nationally produced shorts before feature films and from the possibility of occasionally producing and distributing their shorts through Embrafilme. Both Ana Carolina and Suzana Amaral availed themselves of production opportunities offered by TV Cultura and the State Secretariat for Culture in São Paulo, while Rio-based filmmakers, such as Solberg and Pape, built on their relationships with local news media, such as the *Metropolitano* newspaper (Solberg), and the Cinemateca of the Museum of Modern Art (Pape) (Plazaola Trelles, 1991: 72–4; Sereno, 1985; Buarque de Hollanda, 1989: 20–1, 83–4).

Always lurking in the background, however, was the severe threat of state censorship, a major factor in the privileging of the body over dialogue as a vehicle for creative expression within the *mise-en-scène*. Trautman's *Os homens que eu tive*, in which a young woman experiments with and retains multiple sexual relationships, was released with cuts in 1973, only to be immediately pulled from distribution by the federal censors, then was liberated for limited distribution during the *distensão*, or 'relaxation' of military rule in 1979; Solberg, along with several cinema novistas opted for exile, and even Ana Carolina, who maintained a steady output into the *abertura*, has complained of the effects of both state censorship and economic discrimination during this period (see Esquenazi, 1980: 6; *Filme Cultura*, 1980: 5–6; Plazaola Trelles, 1991: 95; Marsh, 2012: 19–36). The

explanation for the total censorship of Trautman's film could be complex: given the proliferation of low-budget, commercially driven *pornochan-chadas*, or 'light sex comedies' during the 1970s, it appears to be more connected to the implications regarding gender roles within the institution of marriage (divorce was not legalised in Brazil until 1977), than the representation of sexual relations per se.[10] In spite of these barriers, news of Brazilian women's cinema began to circulate abroad, thanks in part to the continued work of Amaral and Solberg, respectively, in the United States, and in 1976, five women directors, including Trautman and Teixera Soares, were invited to the New Orleans Film Festival to show their work, as was reported in the Brazilian press (Pereira, 1976).

Into the *abertura*: women's media in the 1980s

Although General Ernesto Geisel had mandated in 1974 a 'slow, gradual and safe' transition to democracy, the period of *abertura* that was launched with the declaration of amnesty in 1979 was characterised by an intense economic crisis that placed strains on government agencies and pushed civil society to demand more immediate political change.[11] As the authoritarian regime slowly faded from dominance, social movements grew and dispersed, and political parties (and subsequent activism) were reauthorised. The female body, which had been taken up in early feminist discourse, became ever more politicised. Women's groups fought for the decriminalisation of abortion[12] and protested against the 'legitimate defence of honour' (*a legítima defesa da honra*) used in Brazilian courts to exonerate men who had killed their wives or female companions for presumed infidelities.[13] Social demands were particularly successful in the area of public health. As early as 1983 and prior to the official end of the dictatorship, the passage of women's integrated health care reform fundamentally altered the relationship between the state and women's bodies and redefined the position of women in the social context (Osis, 1998: 25–32). The restructuring of society grew increasingly more tangible. In early 1987, the National Constitutional Assembly opened session and afforded an unprecedented opportunity for civilian intervention in the drafting of a new Constitution that would, in turn, establish the political and social parameters of the new state.

Women's film and video took on a new, significant presence in these political openings. Already in 1980, Tizuka Yamasaki, a *sansei* director who had recently apprenticed with Nelson Pereira dos Santos after studying film in Brasilia and Niterói, Rio de Janeiro, began exploring the permutations of gender roles along the edges of cultural difference with her first feature *Gaijín-os caminhos da liberdade* (*Gaijín: A Brazilian Odyssey*). The film reconstructs the migratory experience of thousands of Japanese immigrants who suddenly found themselves labouring in the fields of coffee plantations through the eyes of a young, single woman, Titoe (Kyoko Tsukamoto),

who is loosely modelled on the filmmaker's own grandmother. Whereas Yamasaki situated the narratives of her first two films, *Gaijin* and *Parahyba, mulher macho* (*Parahyba, Macho Woman*, 1983) at the beginning of the twentieth century, her third film, *Patriamada* (*Sing, the Beloved Country*, 1984), plunges into the public fight for direct free elections in the early 1980s (i.e. the *Diretas Já* movement), which helped to bring an end to the military regime. To better capture the Zeitgeist of an exceptional moment in which popular will, no longer restrained from open expression, begins to trump the exclusionary political strategies and uses of arbitrary force by the regime, Yamasaki incorporated handheld documentary travelling shots with carefully composed melodramatic scenes, to craft what Julianne Burton has called a 'transitional mode' of representation (1988: 139–55). The masses of people who actually took to the streets in protest have as much a role in the diegesis as Yamasaki's fictional characters. Given that the mainstream media had refrained from broadcasting images of people protesting in the streets for some time, Yamasaki's documentary footage should be seen as taking an important step in registering the renewed vigour of civil society. The melodramatic scenes of the film revolve around Lina, a twenty-something journalist who dons masculine clothing (i.e. trousers and neckties), and balances her affection for two men – a wealthy industrialist and a filmmaker – with whom she collaborates in documenting the transition. A number of previously taboo subjects, such as male impotence, single parenthood, divorce, female sexual desire and pleasure, are discussed or shown in a complex, open manner.

In contrast to women's cinema during the dictatorship, women's audio-visual production in the 1980s exhibits a departure from allegorical representation towards a more explicit discussion of women's positioning in society and politics. Nevertheless, the critique of power relations and women's institutionalised disenfranchisement is carried over from the 1970s and receives more direct scrutiny upon the return of a civilian government in 1985. As a point of comparison, in her first feature film *Mar de rosas* (1977), Ana Carolina uses the 'not-so-accidental' detours of a family road trip between Rio de Janeiro and São Paulo to make ironic references to the acting, settings and characterisations found in Globo telenovelas as well as the pervasive presence of US pop culture, thereby making an allegorical dent in the 1970s economic 'miracle'. The progressive, yet partial, undressing of the adult female body (that of Felicidade, the unhappy wife and mother (Norma Bengell)) converts that body into a privileged site not for the projection of male desire (in this case, the husband's employee and surrogate, Orlando Barde, played by Otávio Augusto), but instead for the somatisation of sexual repression in middle-class society, torture, and resistance experienced under a patriarchal military regime that was being supported by that same class. Thus, Ana Carolina appropriates and makes clever, deviant use of the carnavalesque aesthetic that had been introduced in the *chanchada* to air, rather than intensify, socio-economic tensions and anxieties.[14] Suzana

Amaral's first feature, *A hora da estrela* (*The Hour of the Star*), based on the eponymous novella by Clarice Lispector and shot in São Paulo in 1984 after her departure from film school at New York University, similarly presents a dystopian portrait of a trip to and around São Paulo, this time by a penniless, orphaned and mistreated migrant from Paraíba who has the dubitable, trans-gendered biblical name of Macabea. However, the young female body, also shown, like *Mar de rosas*'s Betinha in an 'indecent' pose while urinating, is this time deployed as a symptomatic, rather than an allegorical sign for the chronic abjection of marginalised subjectivities, while the film's style is, as Susan Ryan correctly assesses, 'neorealist' (1996: 209), rather than self-consciously parodic and dissonant. Nevertheless, as in *Mar de rosas*, there is an explicit, painful interrogation of the Brazilian female beauty ideals propagated by the mass media (Betinha's clothes-pinned nose to the sound of 'Isn't she lovely', is refracted in Macabea's purchase of a frilly blue and white party dress in the hope that it will extract her from her unbearable misery and help her to land a wealthy *paulista*, who turns out to be a reckless Mercedes driver who strikes her down at a busy crosswalk).

The growth of women's feature-length fiction filmmaking in the 1980s was supported largely by funds from Embrafilme. Rare, however, are the cases in which women received full or continual support from the state agency. Most women directors established their own production companies through which they independently produced their works. In the meantime, starting in 1985, women filmmakers were petitioning collectively for increased state support (*Jornal da tela*, 1986: 2). Indirectly, Embrafilme contributed to the growth in women's filmmaking by assisting with distribution, exhibition and, crucially, by supporting the inclusion of women's filmmaking in general discussions of Brazilian cinema. Women filmmakers formed associations such as the Rio-based Coletivo de Mulheres de Cinema e Vídeo to draw attention to mobilise activity around women's filmmaking. In 1986, with the support of Embrafilme and the Gramado Film Festival, the Coletivo organised a seminar where the intersection of cultural policy and women's presence in front of and behind the cameras was debated (*Jornal da tela*, 1986: 2).

In the wake of the confluence of technological innovation and the inevitable systemic transformations brought about by a gradual return to an open electoral system, one notes a remarkable diversification of women's audiovisual production during the 1980s. Parallel to the growth in women's feature-length film production, the decade witnessed the flourishing of alternative film and video production, which received the attention and financial backing of numerous non-governmental organisations.[15] Women's alternative audiovisual production actively sought the political incorporation of previously disenfranchised peoples. Whether independently or as members of organisations, women explored the possibilities provided by both film and video for feminist consciousness-raising and to further debates about women's roles and general positioning in society. Since the

first Sony Portapak cameras, video has been utilised in Latin America as an artistic platform and for historical documentation. For example, video was used to document the proceedings of the Primer Encuentro Feminista Latinoamericana y del Caribe (First Latin American Feminist Meeting) in Bogotá, Colombia in 1979 and, at the Centro Cultural Cândido Mendes in Rio de Janeiro, the Primeiro Video Rio exhibition took place in 1983. In Brazil, in the early 1980s, video technology served as a powerful medium for social movements to spread information about their activities to mobilise others to join or collaborate in their efforts. Owing to the possibility of its circulation outside mainstream venues, small-format video was seen as especially effective in its ability to reach lower-income and regionally isolated (sometimes illiterate) audiences. Hence, video quickly played a vital role in expanding the discourses of citizenship during the 1980s.

Spotlight on alternative media-makers: Eunice Gutman and SOS-Corpo

Having trained in Belgium during the dictatorship, Eunice Gutman worked in 16 and 35 mm formats until rising production costs combined with advances in video technology prompted her to begin working in Betacam video in the early 1990s. While bridging two modes of production, Gutman's work has consistently focused on the fight for increased civil, social and political rights for women and the underprivileged. Through Cine Qua Non, the production company she established in Rio de Janeiro in the 1970s, Gutman has produced works that blend critiques of material living conditions with the provision of new meanings to life experiences. A self-labelled feminist, Gutman's work destabilises heteronormative gender expectations (*Só no carnaval/Only during Carnival*, 35 mm, 1982; *Segredos de amor/Love's Secrets*, Betacam, 1998), challenges patriarchal, discriminatory policies (*O outro lado do amor/The Other Side of Romance*, Betacam, 2000), and celebrates women's participation in cultural and political life (*Benedita da Silva*, Betacam, 1990; *Femenino sagrado/Sacred Femininity*, Betacam, 1995). Her film *Vida de mãe é assim mesmo? (Is a Mother's Life Really Like That?*, 35 mm, 1983) made a significant contribution to the national abortion debate (Barsted, 1992: 117). Although Gutman benefited from programmes in place at Embrafilme in the early 1980s, the vast majority of her production funding has come from international non-governmental institutions. She continues to train her camera on women's life experiences, having recently directed the award-winning documentary *Nos caminhos do lixo (On the Path of Garbage*, Betacam, 2009) that narrates the formation of a women's recycling collective and their efforts to generate income.[16]

The advent of video and non-governmental support also helped to extend audiovisual production outside the south and south-east regions of Brazil. Perhaps the strongest voice of feminism in the north-east of Brazil, the Recife-based organisation SOS-Corpo, developed a collective approach to

audiovisual production in the early 1980s and formed an alliance with the non-profit media organisation TV VIVA. Backed with funds from the Ford and MacArthur Foundations, among others, the corpus of SOS-Corpo's work (ranging from short segments included in TV VIVA's community TV programmes to longer 30-minute fictionalised dramas) made women's health an issue of public interest and shifted the relationships of power by providing health information and raising debates about female sexuality across a broad social spectrum, including young people, middle-class urban women and women residing in impoverished areas of the urban periphery. In the early to mid-1990s, funds were redirected to democratising the nations in Eastern Europe after the fall of the Soviet Union, and SOS-Corpo has since reduced its audiovisual production, and transitioned to becoming a resource centre for other women's organisations in north-eastern Brazil.

The *retomada*: the return of authorial cinema in the 1990s

How have women directors negotiated the current context of film production that lacks adequate support for distribution and exhibition? To what degree do works by women directors continue to pose challenges for viewers and for the field, in terms of aesthetics, ideology and production methods?

The cancellation of the Sarney Law (No. 7,505) and the closure of Embrafilme and CONCINE in 1990 during the Fernando Collor de Mello presidency dealt a significant blow to Brazilian cinema. A series of alternative measures were set in place to resuscitate film production, including the passage of fiscal incentive laws – the 1991 Rouanet Law (No. 8,313) and the 1993 Audio-Visual Law (No. 8,586) and the creation of a Brazilian Cinema Rescue Award (1993–94). Government involvement eventually led to the creation of ANCINE in 2001, charged with expanding and enforcing legislation for the film industry.[17] It was on the heels of the box-office success of Carla Camurati's film *Carlota Joaquina: princesa do Brasil* (*Carlota Joaquina: Brazilian Princess*, 1995) that the state became more inclined to support filmmaking, yielding a marked increase in film production. While only nine films were released in 1992, the total number of Brazilian films reached an average of twenty-five by the end of the decade.[18] Hence, the period starting in the mid-1990s has been termed the *retomada* or 'rebirth' of filmmaking. However, not everyone has celebrated this increased film output, and some have commented that filmmakers are now more tied to the state than ever before. A number of critics have noted that there has been no (import) protection for an *industry* to flourish.[19] Indeed, the vast majority of feature-length films released from 1995 to the mid-2000s relied on monies collected from fiscal incentive laws, creating what some have referred to as a system of 'incentivised patronage' (Melo and Oliveira Jr., 2005: 12).

Lacking readily identifiable aesthetic trends or ideological cohesiveness, the films of the *Retomada* have been noted for their great diversity and

the number of newcomers brought to the art form. Some critics, however, have critiqued the rhetoric of diversity as a specious, misleading observation (Melo and Oliveira Jr., 2005: 38). Perhaps owing to the entrée in the mid-1990s of several new women directors, including Carla Camurati, Tata Amaral, Monique Gardenberg, Daniela Thomas, Sandra Kogut and Jussara Queiroz, along with a general increase in the number of films directed by women, film critic and journalist Susana Schild asserted that women were at the forefront of the *retomada* (Schild, 1998: 123). During the first half of the 1990s, women's film production hovered around 5 per cent, but by the second half of the decade Brazilian films with women at the helm represented approximately 17 per cent of all productions.[20] From 1990 to 2010, no fewer than forty-five women have directed feature-length films for which they have received numerous awards. Yet, while women's participation in the film industry has greatly improved over time, female directors have hardly dominated the field. And, although women have successfully positioned themselves as feature-length film directors, they face a general film production context in which it is increasingly difficult to realise aesthetically and ideologically challenging works, let alone count on continued access to production funds. Thus, despite initial successes, some women filmmakers have faced difficulties in establishing solid career trajectories. The razing of state support for filmmaking in the early 1990s created a paradoxical situation. Although new talents could direct their first films, the resultant level field on which all were forced to play prompted complaints that veteran directors had to compete unfairly for funding alongside novice filmmakers (Moisés, 2003: 15). A number of women directors who debuted with feature-length films in the 1990s did not direct again in the 2000s. Similarly, some have experienced very long delays between films. Critic Fernando Veríssimo attributes the general phenomenon of the 'one film syndrome' to an 'autistic' (rather than artistic) style that lacks auteurist proposals that would allow filmmakers to engage in larger debates (2001: 42). However, women's careers as directors are more likely to be tripped up by an incentive system that focuses on production to the detriment of adequate distribution and exhibition. Such has been the case of Betse de Paula and her film *O casamento de Louise* (*Louise's Wedding*, 2001), which had limited exhibition in art house circuits, where its popular aims and origins received a poor reception and the film earned low box-office receipts (Melo and Oliveira Jr., 2005: 28). Government measures taken in the early 1990s have resulted in a cinema where influence, known names, mega-budgets and glamour have earned primacy. While Sandra Werneck has successfully managed, directing the smaller-budget documentary *Meninas* (*Teen Mothers*, 2005) and played the 'big budget game' in her feature-length films such as *Cazuza – o tempo não pára* (*Cazuza – Time Doesn't Stop*, 2004), she encountered numerous difficulties securing distribution for her film *Sonhos Roubados* (*Stolen Dreams*, 2009), and has had to persevere to get her film showcased in Brazil and abroad (Merten, 2010). Meanwhile, filmmaker Lúcia Murat has

ventured outside the national funding scenario and sought out transnational co-production funds for her more recent projects. Responding to the difficulties of securing financial backing for their works at home, some women filmmakers of the new generation have followed Murat's lead and have actively sought out possibilities for transnational co-productions. Such is the case of Sandra Kogut, who has lived between France and Brazil and co-produced the documentary *Un passeport Hungrois* (*A Hungarian Passport*, 2001) with funds from Brazil, Belgium and France.

From one angle, the era of big budgets during the *retomada* has muted opposition to expensive, large-scale productions, while alternative visions of the nation and of Brazilian culture rub up against increasing globalisation and the absence of a broad viewing public – now composed mostly of middle-class patrons in shopping centres. Nevertheless, although it may seem that the auteurist ideals of the 1960s have been quashed, filmmakers such as Tata Amaral have maintained an auteurist approach to their work while engaging directly with popular cultural trends. Choosing a low-budget strategy for her first feature *Um céu de estrelas* (*A Starry Sky*, 1997), Amaral, who is related to Suzana Amaral, confronts rather than elides the effects of globalisation on Brazilian contemporary culture in her gritty urban drama of a young *paulista* beautician (Leona Cavalli) who is packing her suitcase for the United States, when she is cornered by her possessive boyfriend (Paulo Vespúcio) in the cement-block house she inhabits with her mother (Néa Simões who, significantly, remains off-screen until she becomes a corpse at the hands of the boyfriend). It is not long before the standoff in the house-prison becomes a live performance for local television, an eerie, fictional rehearsal for the actual reality-TV treatment of the homeless man Sandro in José Padilha's 2000 documentary *Ônibus 174* (*Bus 174*). Like the latter film, *Um céu de estrelas* incorporates televisual discourse for the purpose of metacritique, although it is more successful in this endeavour, since, intercutting between the filmic *mise-en-scène* and the grainy, floodlit handheld video shots, it strips the unfolding television reportage of any narrative and aesthetic coherence. Amaral took up the theme of young working-class female subjectivity once again in her equally hybrid musical drama, *Antônia* (2006), this time produced with all of the casting and accoutrements allowed by a Globo Filmes production. Set in the *periferia*, or outskirts of São Paulo, the film project began as a successful television mini-series, and it follows the struggles of four young Afro-Brazilian performers (at least one of whom – Preta – had actually already achieved notoriety among youthful hip-hop fans) to remain active as a band while coping with the gender-specific challenges of urban slum life.

Notwithstanding accusations of a lack of ideological cohesiveness among the films of the *retomada*, several women directors have shown great consistency in their dedication and discursive approach to a series of pressing issues. For instance, Lúcia Murat, who calls attention to the silencing of political voices in *Doces poderes* (*Sweet Power*, 1996), has continued to

develop in her more recent films a multivocal representation of Brazil and its history that subverts hegemonic notions of the nation. And, although Sandra Werneck has successfully developed the romantic comedy genre (*Amores possíveis/Possible Loves*, 2001) and the biopic (*Cazuza*), she has reflected on the institutional marginalisation of young women in her documentaries and narrative films (*Meninas, Sonhos Roubados*). Indeed, the documentary mode, which once served as a starting point for Brazilian women's audiovisual production, continues to be an important outlet for feminist activism.

Concluding observations

Casting a retrospective glance over nearly forty years of consistent production by women filmmakers, and given the number of women mediamakers growing exponentially and expanding their geographical and social focus in the 1980s, there is little doubt that it is thanks to these women's creative initiative – and in spite of uncertain funding, institutional obstacles to gender equity and the threat of sudden censorship during two decades – that important cultural, juridical and public health issues tied to gender identity have been placed at the centre of the national agenda. The persistent work on these issues, in fact, has allowed Brazil to remain visible on the global radar as a nation aware of (if not fully past) its own areas of gender inequity. Through both direct representations and creative approaches to allegory in their work (especially in the 1970s, but evident as well at later junctures) women directors have helped in concrete ways to fuel debates and, when possible, legislation concerning divorce (*Mar de rosas*), abortion rights (*Vida de mãe é assim mesmo?*), the sexual double standard (*Os homens que eu tive*), women's professional opportunities (*Parahyba mulher macho, Patriamada*), media-fabricated stereotypes (*Mulheres negras, A hora da estrela*) and reproductive control (SOS-Corpo's *Camisinha*). As a reflection of the intensity of engagement by women directors in the fate of the nation, one leitmotif of women's filmmaking in Brazil, regardless of period, region or medium of expression, has been the indispensability of documentary as a training ground, a multilayered textual form (Solberg), a recognisable style (T. Amaral), or production strategy (Yamasaki), which, even though it may not always command the attention of commercial film audiences as a secondary mode in the global film hierarchy, has made its mark through community screening practices and, in recent years, the diversification in television genres and producing organisations.

Just as the steps taken by the first cohort of the 1960s to ensure that gender relations did not recede from the public eye assisted with the visible participation of women filmmakers in the democratic transition, subaltern voices were able to make it into the fray as veteran and novice women directors in the Central South stretched the social limits of their lenses and focused on the experiences of women at the urban and rural margins. The new

protagonists of women's films included indigenous women, as documented by Tânia Quaresma, Paula Gaitan, Virginia Valadão and, more recently, Mari Corrêa. The geographical decentring of women's production was made possible, as we have seen, by increased versatility in women's modes of production, owing to global technological shifts (such as the introduction of handheld video cameras and digital editing), along with the diversification in funding sources, both national and foreign. Concomitantly, the single auteur model that had informed the efforts of women directors in the 1970s and early 1980s was momentarily displaced by collective authorship or, at the very least, community-oriented practice. Although the need for multivocal media has certainly not receded, new, competitive structures of financing and exhibition favoured a return to the auteur model in the 1990s. Both of these paths can be seen as contributing, in parallel fashion, to the movement of women's filmmaking from the interstices of national trends (the Cinema Nôvo, with the urban avant-garde as a counterforce in the 1960s) to the centre of public discourse in an ever-changing Brazil.

Notes

1 For a useful Lusophone digital source on Brazilian women filmmakers, see 'Sala Ana Carolina' and 'Sala Dina Sfat' links at 'Mulheres do cinema brasileiro' website, www.mulheresdocinemabrasileiro.com. For the cultural background of de Verberena and Santos, see Abreu (2004).
2 For a discussion of narrative structure in key films of the early Cinema Nôvo period, see Xavier (1997: 1–23).
3 This has been one of the core tenets of Latin American feminism – that women's concerns are inseparable from those of the nation as a whole, and that therefore it is impossible to make an intervention – aesthetically or ideologically – from a strictly autobiographical or gender-specific position.
4 A. M. Rodrigues's *Samba Negro, Espoliação Branca* (1984) and L. Gonzalez and C. Hasenbalg's *Lugar de Negro* (1982) were pioneering in this regard, along with Lilith Video's *Mulheres negras* (*Black Women of Brazil*) directed by Silvana Afram, 1985.
5 In 1978, Gustavo Dahl estimated that two-thirds of the Brazilian market was taken up by US cinema; see Dahl (1995: 107); in the late 1980s, foreign cinema occupied over three-quarters of the film market; see Johnson (1995: 265).
6 A recent study conducted by the Brazilian Ministry of Culture, 'Cultura em números,' revealed that the south-eastern region still boasts the largest number of movie theatres (1,244) with the highest number concentrated in São Paulo, while Rio de Janeiro currently harbours the highest number of film festivals, cineclubs and film schools (CENA website, 21 June 2010).
7 Translated from the Portuguese by Catherine Benamou.
8 Building on Freud's theory of the formation of the masculine ego during the phase of phallic identification and castration anxiety, feminist theorists, especially Laura Mulvey (1989: 14–26, 29–34) have speculated on the formation of feminine subjectivity as it relates to the perception of visible gendered difference, both on- and off-screen. For Mulvey, and for Ana Carolina, who, following Carl Jung,

referred to the female version of the Oedipal complex as the 'Electra complex' (at a 30 January 1987 screening of *Mar de rosas* in New York City), the emphasis on phallic identification poses problems for the independent development of the feminine ego. French philosopher Michel Foucault provided insight into how institutional structures and power relations have been concretely expressed in social practice as well as manifested in the channels and conceits guiding cultural and academic discourse; see Rabinow (1984: 188–225, 206–56); Foucault (1994).

 9 For more information on the history of Embrafilme, see Dahl (1995: 105–8), Johnson (1995: 362–86); Johnson (1987: 137–70).

10 A useful discussion of the *pornochanchada* appears in Dennison and Shaw (2004: ch. 7).

11 For a detailed historical account of these political transitions, see Skidmore (1988).

12 For a history of the debates surrounding the legalisation of abortion, see de Andrade Linhares Barsted (1992: 104–30).

13 For a detailed discussion of 'crimes of passion' in Brazil, see Corrêa (1981). The 'legitimate defence of *honra*' as justification for these violent crimes against women is discussed in Ardaillon and Grin Derbert (1987).

14 For further discussion of these aspects of the film, see Benamou (1996: 183–4); Marsh (2012: 56–8).

15 Among numerous entities, notable contributors to women's alternative media production in Brazil include UNESCO, the MacArthur Foundation, the Ford Foundation, the Catholic Church and Croce Via of Italy. For more information on the popular video movement in Brazil, see Aufderheide (2000: 219–38) and Santoro (1989).

16 For this documentary, Gutman was awarded the prestigious *Prêmio margarida da prata para o cinema* from the National Council of Bishops in late 2009.

17 For analyses of ANCINE and the recent history of Brazilian cinema, see Rêgo (2005: 85–100) and Moisés (2003: 3–22).

18 Information compiled from Centro Cultural Banco do Brasil (2001: 109–16).

19 In addition to the essays by Rêgo and Moisés cited above, see Melo and Oliveira Jr. (2005: 11–50) and Melo (2005: 67–78).

20 Compiled from Centro Cultural Banco do Brasil (2001: 109–16).

References

Abreu, J. 'Portuguesa nasce no Brasil (para o cinema)', *Brasil: Almanaque de cultura popular*. April 2004, www.almanaquebrasil.com.br/o-brasil-em/portuguesa-nasce-no-brasil-para-o-cinema. Accessed 1 July 2010.

Ardaillon, D., and G. Grin Derbert. *Quando a Vítima É Mulher. Análise de julgamentos de crimes de estupro, espancamento e homicídios* (Brasília: Centro Nacional dos Direitos da Mulher, 1987).

Aufderheide, P. 'Grassroots video in Latin America', in C. Noriega (ed.), *Visible Nations: Latin American Film and Video* (Minneapolis: University of Minnesota Press, 2000), pp. 219–38.

Barnard, T. and P. Rist (eds), *South American Cinema: A Critical Filmography, 1915–1994* (Austin, TX: University of Texas Press, 1996).

Barsted, L. de Andrade Linhares. 'Legalização e descriminalização de aborto no Brasil: dez anos de luta feminista', *Estudos feministas* 0(0) (1992), 104–30.

Benamou, C. '*Mar de rosas*', in Barnard and Rist, *South American Cinema*, pp. 183–4.

Buarque de Holanda, H. *Quase Catálogo 1: Realizadores de cinema no Brasil (1930/1988)* (Rio de Janeiro: CIEC Escola de Comunicação/MIS Museu da Imagem e do Som do Rio de Janeiro, 1989).

Burton, J. 'Transitional states: creative complicities with the real in *Cabra marcado para morrer: Vinte anos depois* [*Man Marked to Die: Twenty Years Later*] and *Patriamada* [*Sing, the Beloved Country*]', *Studies in Latin American Popular Culture*, 7 (1988), 139–55.

Caetano, D. (ed.). *Cinema brasileiro 1995–2005. Revisão de uma década* (Rio de Janeiro: Azougue Editorial, 2005).

Centro Cultural Banco do Brasil. *Cinema Brasileiro Anos 90: 9 questões* (Rio de Janeiro: Centro Cultural Banco do Brasil, 2001).

Corrêa, M. *Os crimes da paixão* (São Paulo: Brasiliense, 1981).

Dahl, G. 'Embrafilme: present problems and future possibilities', in Johnson and Stam, *Brazilian Cinema*, pp. 105–8.

Dennison, S. and L. Shaw. *Popular Cinema in Brazil, 1930–2001* (Manchester: Manchester University Press, 2004).

Esquenazi, R. 'Tereza tira os homens da estante', *Jornal do Brasil*, Revista do domingo, (22 June 1980), 6.

Filme Cultura. 'Pra começo de conversa, batepapo com Andrea Tonacci, David Neves, Luiz Rozemberg, Tereza Trautman e Ismail Xavier, Jean-Claude Bernardet, José Carlos Avellar, Sergio Santeiro e Zulmira Ribeiro Tavares', *Filme Cultura*, 13(34) (1980), 5–6.

Foucault, M. *The Order of Things: An Archaeology of the Human Sciences*, trans. of *Les Mots et les Choses* (New York: Vintage, 1994).

Gonzalez, L. and C. Hasenbalg. *Lugar de Negro* (Rio de Janeiro: Editora Marco Zero, 1982).

Johnson, R. *The Film Industry in Brazil: Culture and the State* (Pittsburgh, PA: University of Pittsburgh Press, 1987).

—— 'The rise and fall of Brazilian cinema, 1960–1990', in Johnson and Stam, *Brazilian Cinema*, pp. 362–86.

Johnson, R. and R. Stam (eds). *Brazilian Cinema* (New York: Columbia University Press, 1995).

Jornal da tela. 'Cineastas mulheres ampliam organização', *Jornal da tela*, 22 April 1986, 2.

Marsh, L. L. *Brazilian Women's Filmmaking: From Dictatorship to Democracy* (Urbana: University of Illinois Press, 2012).

Melo, L. A. Rocha. 'Gêneros, produtores e autores – linhas de produção no cinema brasileiro recente', in Caetano, *Cinema brasileiro 1995–2005*, pp. 67–78.

Melo, L. A. Rocha and L. C. Oliveira Jr. '1995–2005: Histórico de uma década', in Caetano, *Cinema brasileiro 1995–2005*, pp. 11–50.

Moisés, J. A. 'A new policy for Brazilian cinema', in L. Nagib (ed.), *The New Brazilian Cinema* (New York: I.B. Tauris/Oxford: Centre for Brazilian Studies/ University of Oxford Press, 2003), pp. 3–22.

Mulvey, L. *Visual and Other Pleasures* (Bloomington: Indiana University Press, 1989).

Munerato, E. and M. H. Darcy de Oliveira. 'When women film', in Johnson and Stam, *Brazilian Cinema*, pp. 340–50.

Osis, M. J. Martins Duarte. 'PAISM: Um marco na abordagem da saúde reprodutiva no Brasil', *Cadernos de saúde pública*, 14(1) (1998), 25–32.

Paranagua, Paulo Antônio. 'Cineastas pioneras de América Latina, segunda parte', *Dicine*, 1990 (Mexico City), 12–18.

Pereira, M. 'Diretoras brasileiras debatem o papel da mulher no cinema', *O Globo*, 2 February 1976.

Plazaola Trelles, L. *Cine y Mujer en América Latina: Directoras de largo-metrajes y ficción* (San Juan, Puerto Rico: Editorial de la Universidad de Puerto Rico, 1991).

Rabinow, P. (ed.), *The Foucault Reader* (New York: Pantheon, 1984).

Rêgo, C. 'Brazilian cinema: its fall, rise and renewal (1990–2003)', *New Cinemas: Journal of Contemporary Film*, 3(2) (2005), 85–100.

Rodrigues, A. M. *Samba Negro, Espoliação Branca* (São Paulo, Brazil: Editora Hucitec, 1984).

Ryan, S. '*A hora da estrela*', in Barnard and Rist, *South American Cinema*, p. 209.

Santoro, L. F. *A imagem nas mãos: o vídeo popular no Brasil* (São Paulo: Summus Editorial Ltda., 1989).

Schild, S. 'Um gênero em transição', *Cinemais*, 9 (1998), 123–8.

Sereno, S. 'Primeira entrevista com Tereza Trautman', in S. Sereno 'Depoimentos de mulheres cineastas coletados entre 1985 e 1987'. Unpublished interview transcripts. Brasilia: Ministerio da Cultura/Coordenadoria da Mulher, July 1985. Cinemateca Brasileira, São Paulo, Brazil.

Skidmore, T. *The Politics of Military Rule in Brazil, 1964–85* (New York: Oxford University Press, 1988).

Veríssimo, F. 'Novos diretores: uma geração em trânsito?', in Centro Cultural Banco do Brasil, *Cinema Brasileiro Anos 90: 9 questões*, pp. 41–2.

Xavier, I. *Allegories of Underdevelopment: Aesthetics and Politics in Modern Brazilian Cinema* (Minneapolis, MN: University of Minnesota Press, 1997).

Internet sources

'Cultura brasileira em números', Centro de Análise do Cinema e do Audiovisual (CENA) website, 21 June 2010. www.cenacine.com.br/?p=5040. Accessed 2 July 2010.

'Mulheres do cinema brasileiro', website, www.mulheresdocinemabrasileiro.com. Accessed 1 July 2010.

5

Ana Mariscal: signature, event, context

Steven Marsh

The work of Ana Mariscal marks an event in the history of Spanish cinema. It is an event in the sense of a singular irruption into a particular field at a unique point in time that has left a legacy in its wake, a yield in 'reproducible' form, a tradition of 'women's cinema' in Spain, of which this cinéaste was undoubtedly a pioneer. Consideration of Ana Mariscal, the filmmaker, generates, I will argue in this chapter, a philosophical tension between repetition – both in the sense of what is inherited and what is mechanically reproduced, the very basis of film itself – and her singularity as a female director.

Nearly fifty years ago, Andrew Sarris, the critic who has most fervently defended auteurism in the United States, insisted upon what he termed the directorial signature as a defining characteristic of auteur theory and, aside from her status as a rare female director, Mariscal's work is indeed distinguished by a particular and highly recognisable style (as well as by her physical presence as an actress in, among others, many of her own films). Signature, for Sarris, is that distinctive feature of a filmmaker's work (such as Hitchcock's cameo appearances in his own films), the identifying stylistic flourish of the cineaste. In contrast with the North American critics' concept, Jacques Derrida's notion of the signature, while sharing the former's view of it as distinctive excess, focuses upon its function within what he terms 'spacing', i.e. the gap – the temporal deferral of the present, the spatial displacement of presence, *différance* and dissemination – that emerges between the past and the future, and with it a concomitant diffusion or disturbance of the conditions that girder identity construction. Sarris's notion of the auteur is rooted precisely in legitimating the figure of authority that Derrida, throughout his life, subjected to interrogation.

Space – such as the screen onto which film is projected – is, like mechanical reproduction, key to cinema; both depend on a play of presences and absences. The doyen of modern film theory, Christian Metz, maintains in his celebrated essay 'The Imaginary Signifier' (2000) that the identificatory impulse in cinema lies in and is defined by the specificity of film's alignment of absence and presence. To paraphrase Metz, the physical absence of the 'real' actors, in the spectatorial experience, is one element that distinguishes film from theatre, together with the absence of the 'original' recording

apparatus, the camera, its replacement by the projector. Meanwhile, Metz notes, the spectator, absent at the moment of the film's recording, is present at its screening and is manipulated in such a way that his or her identificatory gaze is guided by the projector as he or she sits in the womb-like auditorium. Derrida, albeit in a context somewhat removed from film theory, nonetheless echoes this terminology and argues that a signature, rather than an insistent mark of authorial presence as Sarris would have it, is, in fact, an elusive mark of absence. 'By definition, a written signature implies the actual or empirical nonpresence of the signer' he writes. He continues, however, in the same passage as follows:

> it also marks and retains his having-been present in a past now, which will remain a future now, and therefore in a now in general, in the transcendental form of nowness (*maintenance*). This general *maintenance* is somehow inscribed, stapled to present punctuality, always evident and always singular, in the form of the signature. This is the enigmatic originality of every paraph. For the attachment to the source to occur, the absolute singularity of the event of the signature must be retained: the pure reproducibility of a pure event. (1982: 328)

Questions of presence and absence are particularly important with regard to Ana Mariscal because of the persisting controversy in the critical reception of her work owing to her lead role as the heroine of the propaganda film *Raza* (dir. José Luis Saénz de Heredia, 1941), allegedly scripted by Francisco Franco himself, though significantly unsigned by him, or rather pseudonymously signed under the name of Jaime de Andrade; a film thus very much associated with an invisible signature.[1] As an actress, Mariscal's early performances earned her notoriety as a flag bearer for the regime and her personal testimony and reflections in interviews and autobiographical writing leave little room for doubt as to the depth and sincerity of her right-wing opinions. Those opinions though are not my concern here. In the films I will discuss her appearance, either in person as an actor or as a disembodied narrator, makes her presence insistently palpable but equally, and paradoxically, elusive. The contrasting critical erasure that her work has suffered is due in part to her gender (Mariscal was one of only two female Spanish filmmakers of the 1950s)[2] but also precisely because of her status as an auteur with a distinctive voice, whose singularity fits awkwardly within the packaging of a tendency or a school. Carmen Arocena writing on the commercial failure of Mariscal's 1963 film *El camino* (*The Way*) tellingly observes that the film 'supuso una experiencia estimulantemente excéntrica y fronteriza cuya frescura e inventiva fílmica no podía tener espacio ni en el ámbito generacional y cultural en donde nacía ni en el elusivo y quejumbroso Nuevo Cine Español que ya asomaba la cabeza' ['supposed a stimulatingly eccentric and borderline experience for whose freshness and filmic inventiveness there was no room in either the generational or cultural framework into which it emerged nor in the elusive and querulous

New Spanish Cinema that was beginning to show signs of life'] (1997: 584). Such effacement suggests a symptomatic in-betweenness. Mariscal's work sits ill with critical writing and with different political conjunctures. Arocena's observation suggests that her work falls between two stools (in its critical reception and its politics), rather than adapting to circumstances in hybrid form. Significantly, Arocena notes the 'borderline' element of Mariscal's film. Her *œuvre* is marked by displacement, precisely the product of 'spacing' (gaps between signifiers: filmic, generic, historical and those of gender – the theories of auteurism have traditionally excluded female directors). Such displacement in Mariscal turns on questions of absences and presences, pivots – as we will see – on the space between embodiment and disembodiment. A filmmaker of space, Mariscal was also, both in her professional autobiography and within the diegesis of her films, out of place in her epoch, ill-fitting and untimely. Indeed, all the films to be discussed here are marked by a sense of temporal displacement and spatial disjunction.

Susan Martin-Márquez, discussing Mariscal's first feature, *Segundo López, aventurero urbano* (1952), cites several instances of cinematic self-reference in the film and claims that its 'mise-en-abyme structure shows that all acting ... relies upon the creation of an illusion of truth' (1999: 117). *Misa en Compostela* (*Mass in Santiago*, 1954), made two years later, and commissioned by the right-wing production company Cifesa as a short promotional film to celebrate Santiago de Compostela in its Jubilee year (the *Xacobeo* – the holy year designated by the Vatican whenever 25 July, commemorating Saint James, falls on a Sunday) is, in many ways, even more exemplary of this filmic self-consciousness. *Misa en Compostela* employs a series of fictional and dramatic strategies in what purports to be a documentary. Technically, Mariscal has an expert eye for composing the frame; that is, for bringing into focus the subject of the shot. Ostensibly a religious film, Mariscal's formal dexterity – the mark of her professional vocation – together with her use of the 'false documentary' mode combine to suggest that this film is more interesting than would at first appear. The city – and this is reflected in the film – is after all keen to promote the apocryphal story of the relics, the bodily traces of the apostle Saint James who, contrary to the insistence of Christian dogma, is *not* buried in Santiago; a fiction, based on spurious physical 'evidence' that has taken hold of the popular imagination to present itself (by virtue of repetition) as fact.[3] In this sense, attentiveness to form and fictionalisation in documentary reflects the very subject matter of the text.

Misa en Compostela's play on similitude and reality, its representational persuasiveness, is, furthermore, reinforced by the use of non-professional actors (Alfonso Blanco 'O Padriño', the altar boy; the student, José Luis Desiré; the pilgrim, Manuel Seone; and the priest, Manuel Troitiño Marino, who plays himself, were all locals). The combination of naturalism and artifice – indeed the documentary style itself – recalls Italian neo-realism, the key reiterated observation found in almost all critical writing on *Segundo*

López, aventurero urbano. But, beyond the formal contradictions there lies a metaphysical paradox: in an unashamedly religious film, what Bataille calls 'the unreality of the divine world' (1997: 211) is grounded in a realist mode. This consistent feature of Ana Mariscal's work (and I will return later to this point) is linked to sacrifice and to the sacred; her cinema is singularly preoccupied with death, and although this is not my primary concern here, untimely death occurs in each of the films discussed in this chapter.

The body of *Misa en Compostela* (following a prologue discussed below) commences with subjective shots of a pilgrim on his way to Santiago. Dressed in traditional garb (complete with sandals, gown and stick), as he crosses the beach his footprints trace a pattern in the sand at dawn. The close-up of the footprints in the sand again suggests spacing. Spacing is important in this film in other ways, both diegetic and extra-diegetic. It is a film about the space of a city; the holy sites, the sacred space of Santiago and its secular counterparts. In terms of screen space, it is an exercise in shot style. The rhythm of the film is maintained by the interchange between public and private space. The first is represented in panning shots of the squares, drawing out their monumentality, the wide angular shots from above and below of the rooftops, the cathedral entrance. The latter alternates with the former; the intimate spaces of the altar boy's bedroom or the street corner, where he sneaks an early cigarette in the drizzle, the student's quarters, the shop window displays. Likewise, the exchange of interior and exterior shots captures the sacred spaces inside the cathedral, in contrast with the 'travelogue'-style cinematography that predominates in its representation of the city's architecture. This is a film that caters to the tastes of tourism as much as it does to devotional interests.

By means of a voice-over narrator (significantly delivered by Mariscal herself), the sites and the characters of the film are introduced to us. Indeed, the first words of the film after its prologue are those of a personal offering (in terms that suggest religious sacrifice): 'Año Santo de 1954, he aquí mi ofrenda' ('Holy year, 1954, here is my offering'). If the film itself is an offering, a kind of sacrifice, it is then a form of representation. A sacrifice is, after all, something that stands in for, on behalf of, or substitutes for something else. Here then the idea of authorship is once again complicated by the presence of the physical body of the film's author and its absence.

Martin-Márquez, again discussing *Segundo López*, draws attention to the unreliability of the voice-over narrator of the opening and final moments of that film, which she says, 'would seem to be narrated by a masculine "voice of God" typical of documentary filmmaking as well as of the Spanish historical genre of the post-war period' (1999: 116).[4] While this is true, voice-over is also something that is *grafted* onto the text, it is something that is added later in the editing room, it is supplementary to the filmic apparatus, like, in a sense, a signature. It is also – generally speaking, though not always – disembodied; that is to say that voice-over is marked by an absence, whether in the form of flashback or as the 'voice of God' narrator.

In all the films discussed here, Mariscal is present either by means of her voice (as narrator) or her body (as an actor) but almost never both at the same time. It is as if the autobiographical – the writing of the self – that constitutes the signature of this filmmaker is only ever partial (as, indeed, are all signatures). To use the same filmic term as that employed by Kaja Silverman below, there is rarely, if ever, synchronisation. The one exception to this is Mariscal's aural and bodily filmic presence in the opening sequences of *Misa en Compostela*. In this film the director both appears – she films herself – and narrates in the film's prologue in what is quite literally a signature (we see her writing the film's dedication that simultaneously we also hear delivered in speech). However her physical appearance and her narration are, once more, *not* synchronised. The on-screen Mariscal is present as an image. She does not address the spectator other than as a disembodied voice. There is an interesting bifurcation between the visual image and the soundtracks, an autobiographical authorial doubling. Further, the prologue is itself a paraph that acts as a supplement to the film that follows it. Here the performative offering or sacrifice (self-consciously announced by Mariscal herself) is supplementary to the sacred. From then onwards, Mariscal provides the voice-over but does not appear in the film. Silverman has theorised the disembodied voice-over extensively and, while I am not interested here in attempting the same kind of psychoanalytical reading of Mariscal's work, Silverman's insights lend weight to my argument concerning presence and absence.

> There is a general theoretical consensus that the theological status of the disembodied voice-over is the effect of maintaining its source in a place apart from the camera, inaccessible to the gaze of either the cinematic apparatus or the viewing subject – of violating the rule of synchronization so absolutely that the voice is left without an identifiable locus. In other words, the voice-over is privileged to the degree that *it transcends the body*. (1988: 49)

Mariscal's 'untimeliness' in combination with the sense that she is out of place ('without an identifiable locus') is pointed up by what Silverman designates as a lack of synchronisation and Derrida calls 'anachrony' (2004: 7). The voice-over narration that Martin-Márquez refers to in *Segundo López* is of a different category to that in *Misa en Compostela*. Again, voice-over in the earlier film is supplementary and, as convention demands, it is used in the prologue and epilogue of the film. The narrator of this film, however, is Leocadio Mejías who, in another autobiographical–authorial twist, is the *real* author of the novel upon which the film is based. Authorship in this film is diffused and complex: who then is the author, Mejías or Mariscal? Where is the point of origin, where is the film's authenticity to be located? The complexity of such questions is, moreover, exacerbated by gender considerations.

It is precisely anachrony – time disturbed by the traumatic event, the unresolved aftermath of the Spanish Civil War – that marks the diegesis

of Mariscal's second full-length feature, *Con la vida hicieron fuego* (*They Fired with Their Lives*, 1957). This film is also dominated by a voice-over narration, that of Quico (Jorge Rigaud), the film's protagonist, but it is one that is explicitly framed in terms of subjectivity by means of this character's flashbacks. *Con la vida hicieron fuego* is structured around three flashbacks narrated by Quico upon his return to his home town in Asturias after a fifteen-year absence in Latin America. Although not the narrator, Mariscal is present in *Con la vida hicieron fuego* as the lead actress. In both *Segundo López* and *Con la vida hicieron fuego* Mariscal plays infirm characters – she spends much of the time in both films bedridden – who suffer the physical effects of what have been emotional traumas. In *Segundo López* Mariscal's character, Marta, languishes in a state of melancholia due to having been abandoned by her former womanising lover and she eventually dies. In *Con la vida hicieron fuego* she plays Armandina, who suffers a miscarriage on learning of the death of her husband, Rafael (a Republican official), in the earlier stages of the war, and twenty years later has still not fully recovered. The element of suffering (and there are others), of giving bodily expression to affective injury is, as in *Misa de Compostela*, suggestive of the Christian figure of martyrdom, of sacrifice. Indeed, the very word 'figure' (as Silverman has pointed out, (1988: 199)) conjures up an image of physicality, of corporeal presence. Sacrifice, as suggested earlier, is substitutive, it stands for something else; the importance in Christianity of effigies that represent the human figure concerns Christ's 'sacrifice' on behalf of humanity. In the second of his flashbacks, Quico relives the death of his friend Marinín (Raúl Cancio) – the ultimate sacrifice – while endeavouring to rescue the Christ of the White Chapel, the protector of sailors and fishermen, a figure given reverential filmic treatment in the film's cinematography. The symbolism of Marinín's death sequence is potent. Martin-Márquez relates it to the 'religious sacrifice so central to Nationalist representations of the Civil War' (1999: 127) and, while this is undeniable, I would suggest that Marinín's sacrifice provides just one link in a chain of bodily representation in the film that goes beyond cinematic or ideological reference alone.

This chain of substitutions, of connections between bodily presences and shadowy absences, human physicality and effigies, reflects the signature and its invisibility at work in this filmmaker's corpus. The Christ figure in these sequences is quite literally substituted by Marinín in the film's diegesis. In the aftermath of the dramatic gun battle between the small, 'heroic' group of nationalists, led by Marinín and Quico, and the Republican soldiers patrolling the roads – filmed as grandiose melodrama, as operatic spectacle – a moment of calm prevails. As Quico's men row away, a panoramic shot captures the tranquil waters, the moonlight and the silhouette of the cliffs behind them as they pray together as a collective. Marinín's corpse is spread out Christlike in the boat. Meanwhile the figure of Christ on the cross floats horizontally in the calm waters behind the boat, paralleling Marinín's form. There is a kind of exchange between these sacrificial victims.

Just as Mariscal's directorial career is ill-fitting for its time, so too is Quico's narration skewed by hindsight. Two decades have passed since the battle and this flashback is Quico's way of explaining to Marinín's daughter Isabelita (Malila Sandoval) what happened to her father. The epilogue to this flashback concerns – aptly enough – a signature. The prosperous Quico seals his surrogate paternal presence in Isabelita's family by signing a cheque. This, in turn, leads Manolón (José María Lado) – Isabelita's grandfather and Marinín's father – to name, that is, to as*sign* a name, to de*sign*ate, by means of a signature each of his future boats *Morenita del Río* in honour of Quico's generosity. Quico's signing functions to cauterise the disrupted genealogical chain. He undertakes to stand in for Marinín, to act as a substitute in the wake of his friend's sacrifice (a role that is momentarily threatened – incestuously perhaps? – by Quico's brief and thwarted courtship of Isabelita). To sign is also, like cauterisation, to seal a breach or a rupture. Quico's political allies are nationalists, but his sealing or reconciling presence is also felt on the political left. In the absence of the Republican official Rafael, Armandina's deceased husband, Quico plays godfather to their son Falín, while seeking to replace Rafael in other ways, by proposing to his widow, Armandina, the character played by Mariscal. The film's central theme of national reconciliation swirls around a pattern marked by such absences and presences, by sacrifice and substitution. Discordant with the 'official' position of Francoism and indirectly echoing the policy adopted the year previous to its production by the Spanish Communist Party, *Con la vida hicieron fuego* is tensely bound up with biographical, historical and ideological data that links similitude with the real, the on-screen action with the world beyond the film and the ambiguous, flickering signature of its director.

If *Con la vida hicieron fuego* (1957) is a film about returns and reconciliations and about fusions, confusions and diffusions, it is, in the same vein, also an interrogation of generation and genealogy. The hiccups in national historiography reflect the disturbances in the familial lineage, and this is framed through its discourse on nostalgia. Quico's *return* is significant; he comes home after a prolonged absence to the place where he made his mark, where he left traces, signed cheques, where boats are named cryptically to commemorate him. His return, beyond being a vehicle for reconciliation, is a re-encounter, something I will discuss in the conclusion to this chapter. He is also the signatory of the film as its principal narrator, the person who introduces it and establishes its terms in voice-over, like Mariscal in *Misa en Compostela*. The first words of the film are Quico's, uttered prior to us seeing him in the flesh: 'Me faltan ya pocas horas para llegar. En Ferreira, mi pueblo, estará amaneciendo. El reloj de la plaza dando las horas' ('I will arrive in a few hours. In Ferreira, my home town, dawn will be breaking. The clock in the square will be chiming'). While a number of authorial and thematic factors emerge in these introductory sequences, two stand out for my purposes. First, Mariscal's directorial signature is made invisible or rather it is complicated by her presence (as an actor) shortly after Quico's

arrival, as his foil, his reluctant counterpart as the film's co-protagonist. Second, the prompting presence of Quico's friend and sidekick Fernando functions as a thematic paraph to the diffused signature of Quico/Mariscal, most significantly when he utters the phrase that sets the tone for the entire film: 'fuimos una generación trágica' ('We were a tragic generation').

It is noteworthy that almost all the conversations in the film take place in significant settings. The *mise-en-scène* establishes metonymic chains of association that cohere with the previous discussion of sacrifice. To this end, the dialogue is notably stilted, its artificiality is marked by the hand of an auteur at work, in contrast to the apparent naturalism of the cinematography: the long takes of the spectacular Asturian landscape (the 'source' of Quico's nostalgia), the picturesque town, the turbulent seas, the craggy rockface. Indeed, the film points up the contradictions between the eternal and the evolving. Exemplary of the former is the spring that pumps water from the ground, a symbol of unchanging origins that the film's *mise-en-scène*, perhaps ironically, associates with Armandina and the archetypical folk culture promoted by the regime: 'Siempre igual, siempre en el mismo sitio' ('Always the same, always in the same place') she says. The alternative lies within the transformations that are under way thanks to Isabelita and Falín's generation. As we will see, this contrast between an originary, immutable source and an inheritance undergoing renewal and renovation is paralleled in Mariscal's own filmic legacy.

While the previous discussion has focused upon the displacement of Mariscal's authorship through her voice and physical presence, by means of conclusion I want now to address the question of how the very materiality of film itself further complicates the question of the auteur. *El camino* (1963), Mariscal's film adaptation of Miguel Delibes's novel, shares almost all the religious themes of the other films discussed in this chapter, but in what follows I want, very briefly, to focus on one aspect. The film offers, as Martin-Márquez has suggested, an explicit critique of film censorship, as exercised by the Catholic Church. Likewise, in its filmic references and in Mariscal's own 'voice of God' narration, although without her physical presence on this occasion, the film provides an interesting and complex example of self-referentiality. Just as Mariscal and Quico dispute and diffuse the authorship of *Con la vida hicieron fuego*, in *El camino* filmic representation and reality engage in a debate concerning the film apparatus itself. Set in a rural village pivotally charged with a sense of impending modernisation, a group of Catholic women create a censorship board to monitor the films shown each week in the church hall. Though responsible for the selection of films, within the diegesis the censors are unable to control either the on-screen risqué activities or the off-screen activities between courting couples in the audience. One solution is for the priest to order his screening assistant to place his hand over the projector at the first sign of danger (the appearance of a scantily clad dancing girl, for example). In this the screen – the very site of virtual reproduction – meets

the physical body in the censoring shadow of the hand placed before the projector to block out the on-screen representation. What is interesting here are the different layers of virtuality in the intervention of what is quite literally a second hand and second-hand or surrogate (ghostly, absent and yet present) on the screen space, which is itself second-hand, mechanically generated, reproduction. This intervention also introduces or produces an additional layer of authorship, the substitute that manipulates the filmic material. The superimposed image upon superimposed image – the shadow play, associated with film itself – constitutes in a doubled sense, a form of *grafting*; that is, both a superimposition and a form of writing (and the auto*graph* is, of course, a signature) upon another form of writing, the cinemato*graph*.[5] Further, in one of the village hall screenings there is a very real instance of authorial signature in *El camino* (in Hitchcockian self-referential vein) that both conforms to Sarris's definition and, simultaneously, undermines it. While in the diegesis of *El camino* we generally see either credit sequences of the films themselves or posters advertising future films to be screened, with their titles prominently displayed, there is a moment when we are privy to a very brief sequence from an otherwise unidentified film that any follower of Mariscal's work would recognise as being from her first feature *Segundo López*. This fleeting self-quotation that, as Martin-Márquez has tellingly observed 'avoids a direct, graphic inscription of the director's name' (1999: 138), plays on the presence and absence of Mariscal herself (shc is, we might recall, the anonymous presence behind *El camino*'s voice-over). Such a complication of Sarris's defining terms of film authorship is located precisely in that play between the autograph and the cinematograph.

Paradoxically, the site of this play of virtualities – shadow play upon shadow play – is the screen itself, a material and ineludibly *real* presence, the space upon which, as Metz has reminded us, physically absent elements are projected by apparently immaterial means (light and shadow). As a momentary aside, we might consider that the shadow is opaque, that in its blackness and its blankness it has a paradoxically material substantiality. My point though is, nonetheless, that we see here, more clearly perhaps than in the previous films discussed in this chapter, the chain of virtualities marked by 'spacing', by movements in space and by the differentiation that is produced *between* spaces. By coincidence, it is interesting to note that Sarris – acutely and critically commented on by Silverman to argue a somewhat different case to mine – prefaces his 1962 essay on the auteur with a quote from Kierkegaard precisely concerning 'shadowgraphs' to suggest – in terms of platonic idealism – an organic link between external appearance and internal essence. Discussing this epigraph, Silverman observes that in this reference Sarris makes specific his claim that 'The intelligence behind the cinematic text, like that behind the Biblical creation, can be deduced only from the "traces" or "signature" it leaves behind, i.e., from the author "inside" the text' (1988: 195).

Sarris's position, as glossed by Silverman, clearly differs from Derrida's trace as the chains that establish multiple diffuse connections that loosen the bindings of authorial authority. Derrida's diffused signature – its graphism – is concerned with the marks left by the kind of marginalised legacy that is excluded from the Sarris's 'heroic pantheon' (1988: 196). For Derrida, the 'graph' is spatial, and we have already observed (in Arocena) the borderline element in Mariscal; borders are nothing other than marks on geographical terrains, spatial marks, a *grafting* on topology. Moreover, if – as we have seen above – Derrida's concept of the signature 'implies the actual or empirical nonpresence of the signer' it is dependent upon a counter-signature for its authentication and authorisation; that is, for its confirmation by something very different from itself, something that runs counter to its interests or intentions. With respect to making the case for Ana Mariscal as a pioneer, this *différance* helps to establish the 'spatial' grounds for a tradition of women's film as an en*counter* that might help to locate Mariscal as a female cinéaste that acknowledges her gender but goes beyond tokenism.[6] It helps, that is, to posit a legacy of female filmmaking – which gave rise in time to a feminist tradition – that eludes biological essentialism or specific political positions while suggesting a productive source that, unlike the originary spring in *Con la vida hicieron fuego*, which symbolises the inevitable and the eternal, *yields*. It does so in the double meaning of the word 'yield' as giving way and bringing forth, as ceding and reproducing, whose conceptual properties contain elements of both the past and the future. The word 'yield' points to a disruptive surplus production that once again suggests a certain subversive Derridian supplementarity that helps to locate a Spanish tradition of 'women's cinema' in terms that avoid the commonplaces and clichés of identity politics. This particular yield – a counter-tradition from within, an *en*counter – is perhaps to be found at the site of Spain's National Film School where Mariscal taught between 1956 and 1961 and from which the first generation of Spanish women filmmakers emerged shortly thereafter – namely Josefina Molina, Pilar Miró and Cecilia Bartolomé.[7] These figures, many of whom, unlike Mariscal, identified themselves as feminists, would in turn prove to be emblematic female representatives of Spanish film and television of the 1970s and 1980s.[8]

Notes

1 In this context it should perhaps be noted that the denomination Ana Mariscal itself is a pseudonym, a stage or 'artistic' name. Mariscal's real name was Ana María Rodríguez Arroyo.

2 The other was Margarita Alexandre who co-directed three films in the 1950s, before moving to Cuba where she pursued a career as a film producer.

3 This story is lampooned and forms a key structuring element in Luis Buñuel's film about the pilgrimage to Santiago, *La vie lactée*, made some sixteen years after *Misa en Compostela* in 1969.

4 The same could be said of the wry 'voice of God' narration (delivered by

actor Fernando Rey) in Luis García Berlanga's ¡*Bienvenido Mister Marshall!* (1952).

5 Brunette and Wills point out that the words '"graft" … and "graph" … have a common etymology in the Greek *graphion*, a stylus' (1989: 87). There is an echo here of one of the earliest theorists of the auteur, Alexandre Astruc, and his concept of the *caméra-stylo*.

6 I think here of Derrida's idea of an originary encounter: 'Spacing itself, the spatiality of spacing, distancing, does not drift or derive and what is *a priori* original, absolutely prior, is the "encounter" … the encounter … with space as region' (2004: 55–6).

7 The Escuela Oficial de Cine (the National Film School) formally the Instituto de Investigaciones y Experiencias Cinematográficos (Institute of Cinema Research and Experimentation) was established by the Francoist regime in 1947. It was finally closed down in 1972 owing to its reputation as a hotbed of political opposition.

8 Relevant to this – and perhaps to the notion of the remake as Derridian 'iteration' – is the fact that Josefina Molina would go on to direct a televised version of *El camino* in 1977.

References

Arocena, C. '*El camino*' in J. P. Perucha (ed.), *Flor en la sombra. Antología crítica del cine español, 1906–1995* (Madrid: Cátedra/Filmoteca Española, 1997), pp. 582–84.

Bataille, G. 'Sacrifice, the festival and the principles of the sacred world', in F. Botting and S. Wilson (eds), *The Bataille Reader* (Malden: Blackwell, 1997), pp. 210–19.

Brunette, P. and D. Wills. *Screen/Play: Derrida and Film Theory* (Princeton, NJ: Princeton University Press, 1989).

Derrida, J. *Margins of Philosophy*, trans. A. Bass (Brighton: Harvester Press. 1982).

—— *Spectres of Marx*, trans. P. Kamuf, intro. B. Magnus and S. Cullenberg (New York and London: Routledge, 2004).

—— with C. Malabou, *Counterpath*, trans. D. Wills (Palo Alto, CA: Stanford University Press: 2004).

Martin-Márquez, S. *Feminist Discourse in Spanish Cinema: Sight Unseen* (Oxford: Oxford University Press, 1999).

Metz, C. 'The Imaginary Signifier', in R. Stam and T. Miller (eds), *Film and Theory: An Anthology* (Malden and Oxford: Blackwell, 2000), pp. 408–36.

Sarris, A. 'Notes on the auteur theory in 1962', in G. Mast and M. Cohen (eds), *Film Theory and Criticism Introductory Readings*, 3rd edn (New York: Oxford University Press, 1985). 537–8.

Silverman, K. *The Acoustic Mirror: The Female Voice in Psychoanalysis and Cinema.* (Bloomington and Indianapolis: Indiana University Press, 1988).

Rosario Pi and the challenge of social and cinematic conventions during the Second Republic

Alejandro Melero Salvador

Since the Socialist government approved the so-called *Ley de la Memoria Histórica* (Law of Historical Memory) in 2007 and opened a public debate in Spain, historians and scholars have developed new approaches to examining the Second Republic, a key period that has too often been studied from a strong political bias. More than thirty years after Franco's death, a new, passionate debate aims to question the Second Republic and to deepen its enquiry into the innovations and modernity of that period, while leaving aside earlier optimistic and nostalgic views. Questions of gender and women's rights (from divorce to work status) are mentioned occasionally to distinguish this era as a unique time in Spain's history of feminism. Less has been said, however, about the cinema of the time and how it portrayed these advances in social rights and people's ways of thinking.

This chapter studies the legacy of Rosario Pi, Spain's first woman director, in the light of these new approaches to the Second Republic as the frustrated mother of today's Spanish democracy. I look at Pi's difficult and short career and study her *œuvre* as an exceptional case of challenging narratives in popular cinema. In order to do so, I analyse her film *El gato montés* (*The Bobcat*, 1935) as an example of subversive cinema in which the filmmaker used the popular folklore genre so as to present innovative perspectives of feminist thinking that were to emerge decades afterwards. While the Second Republic was trying to fight the threat of fascism, Pi was able to introduce independent female characters who confronted social conventions by refusing to live under their boyfriends' orders, remaining unmarried and defending their own sexuality. I will study how Pi was able to defy traditional ideas about women at the same time as she challenged long-established film narratives with a very atypical adaptation of a *zarzuela*, one of the most popular genres of the theatre and cinema of her time.

Caparrós Lera (1981) is one of the first film historians to have studied Spanish cinema of the pre-Civil War years. He has documented the filmmakers' efforts to fight the American industry of the early post-silent cinema, which used to produce Spanish-spoken versions of its blockbusters. Caparrós Lera considers this to be one of the reasons that contributed to the development of a Spanish cinema that tried to find its own patterns of

identity, different from that of other national industries. In many cases, this search for a national cinema resorted to successful novellas, theatre plays and *zarzuelas*, the Spanish operetta. These films would soon be categorised as *españoladas*, a cinematic genre that would survive the beginning of spoken cinema and be very popular until the late 1960s.

El gato montés, like most *españoladas*,[1] was based on a musical theatre piece which had been fashionable since its opening in 1916. It was written and composed by Maestro Penella, who is quite forgotten today but who was very popular in the first half of the twentieth century. Nearly a century afterwards, a look at his *œuvre* might shock the inexperienced listener/spectator, especially due to its highly reactionary and ultra-Catholic ideology. Some of his most popular titles include *El padre cura* (*The Father Priest*), *El milagro de San Cornelio* (*The Miracle of San Cornelio*), *La España de pandereta* (*Traditional Spain*), all of them very much in keeping with Penella's religious and traditional universe. His *Huelga de señoras* (*Ladies Strike*), for instance, tells the story of a group of women who demand their rights to work but who, as the play develops, learn that there is no place like home. *El gato montés* (stage version) is no exception to this world populated by wife-beaters, brave bullfighters, lazy but loveable gypsies and pious mothers-in-law who remind their daughters how to be good wives. However, its film adaptation subverted its original ideological content, as the rest of this chapter will show.

Despite being the first Spanish female director, Rosario Pi (b. Barcelona, 1899, d. Madrid, 1967) has received very little critical attention, and researching her legacy is not an easy task (her second and last film, *Molinos de viento* (*Windmills*) (1939), is supposedly lost for ever and all that we know about it is obtained from reviews of the time). The very few scholars who have studied her work complain that the copies of *El gato montés* that they have used are mutilated and in very bad condition, with missing scenes and inaudible dialogues. Three of the most important contributions to the study of this film, written by Caparrós Lera and Valero (1996), differ in their analysis of particular sequences; my study is based on two different copies of the film, one taped from television in the mid-1990s and a second one (presumably, the one used by Lera and Valero) edited on video in 1995, which is three minutes shorter.

El gato montés tells the story of Soleá, a gypsy woman who is in love with Juanillo. They have known each other since their childhood and their relationship is one of true love, which exceeds the demarcations of any institution (they say that they do not need to marry). They have grown up close to nature and live a happy life, until one night a drunken man in a bar tries to abuse Soleá, and Juanillo, trying to protect her, kills him with a knife. Juanillo goes to prison and Soleá is faithful to him but, as time passes, a bullfighter named Rafaé falls in love with her. He is a very wealthy and famous man, and Soleá, for reasons that are not really clarified (and this might be the film's main flaw) accepts his marriage proposal and goes to

live with him in his rich *cortijo* (an Andalusian villa). Meanwhile, Juanillo escapes from prison and becomes El Gato Montés, a notorious *bandolero*. He goes to Rafaé's *cortijo* and threatens him, but Soleá stops the fight. Juanillo advises Rafaé that he should let himself be killed by a bull in the next *corrida*, and die a hero, or else he himself will come back and kill him. Rafaé promises to defend Soleá (who has never really been threatened) and says that he will not let any bull kill him, but he dies in the arena anyway. Soleá, full of sorrow, dies as well when she hears the news. El Gato Montés interrupts Soleá's funeral and takes her corpse with him, to the mountains. He knows that the result of that action will be his death, but wants to die with his beloved. In the film's most famous sequence, the police arrive at the cave where El Gato Montés mourns Soleá, and he lets himself be killed by his friends before the police get him.

We do not know a lot about Pi's biography[2] but Caparrós Lera has studied some of the events that surrounded the shooting of *El gato montés*. Caparrós Lera has noted how a witness remembered that Pi had arguments of 'epic proportions' (1981: 124) with Penella, who was not happy with her direction of his original idea. Eventually, Penella would contribute to the movie as a musical and dialogue supervisor, and the rest of the script would be left entirely to Pi. She remained faithful in several respects and, in fact, the famous and prestigious last sequence of necrophilia was already in the original text. Her interests were more in the re-elaboration of the female characters (introducing a very independent woman who was not in the original version) and their relationships with the male leads.

A careful reading of Pi's rewriting of the original *El gato montés* can be very helpful for studying the director's intentions. The differences between Penella's script and that of Pi also reflect the differences between the Spain of the 1910s and that of the democratic Second Republic. From the point of view of contemporary gender studies, this comparison proves extremely useful, as the director aims to rework, mainly, those aspects of the original book that made the female characters weaker than the men. The clearest example of this rewriting is the total elimination of a leitmotif based on the idea of loneliness which, in the original story, was crucial both in terms of the creation of the characters and the development of the plot, and contained one of the play's most popular songs and lyrics. Thus, Penella's Soleá complains very often about how sad it is for a woman to be without a man: 'sola, sin pare ni mare, pa que de pena no me muriera, er me dio su cariño' ['alone, with no father or mother, so that I would not die of grief, he gave me his love'] (53). She explains how she, like other women, needs to be protected and helped by 'un hombre de verdá' ['a 'real' man'], the only possible solution to a woman's sadness ('si é qu'estoy triste ... sin un hombre que me ronde' ['I am so sad ... with no man courting me'] 52). Several other lines, sung by Soleá or other female characters, reinforce the representation of women as desperate to find a man to rescue them from loneliness. In Penella's universe, female characters are moved by a frantic

necessity to escape from loneliness, and it is this need to avoid loneliness that directs their actions and moves the story forward. Pi's interpretation of these events is meaningfully and drastically different, and she aims to make her characters act with an individual will. Her Soleá is a strong woman who, when confronted with Rafaé's abusive proposal (or, rather, order) of marriage, explains to him that she does not need to be protected by a man. Rafaé finds it difficult to believe that a woman can be independent and live on her own: '¿ande vas así, sola por la vida? ... eso no pué ser, tú necesitas quien te ampare, quien te defienda' ('where would you go like that, on your own ... that cannot be, you need someone to take care of you, to defend you'), but Soleá is very assertive in her answers and replies: 'ya me defiendo yo' ('I can defend myself'). Later on, to persuade her, Rafaé attacks her where he knows it will hurt, by bringing up the issue of money: 'necesitas dinero' ('you need money'), but Soleá does not turn back and affirms: 'no me hace falta' ('I don't need it'). Rafaé insists until Soleá makes it clear that, if she wants to find him, she will know how to do so: 'si quiero, le encontraré' ('If I want you, I shall find you'). This last sentence exemplifies Pi's reappropriation of the woman's voice: it is she who decides when, how and if she wants to be with a man. It is precisely in this decolonisation of the woman that Pi succeeds as a pioneer feminist filmmaker, anticipating the idea of 'ventriloquism' that has been very present in feminist historians and critics of the last decades. This concept stresses the dangers of speaking for others and the risks of speaking across differences of sex, gender, race, culture or sexuality, and can be very useful when problematising the presence and usage of different levels of voices within the same narrative.[3] Pi destabilises Penella's use of ventriloquist techniques, giving to her Soleá a voice she originally did not have.

Penella's text also reveals in several instances the role that women supposedly have. There are many scenes that insist on this, and some of the most interesting are those provided by Picador, a character of no relevance in Pi's adaptation. Picador insistently makes the place of women very clear: '¡a rezar!' ('go and pray!'), he says, 'eso es lo que tenéis que hacer las mujeres' ('that's what you women have to do'). Previously, a similar distribution of roles in this strongly patriarchal system had been clearly explained when Rafaé, proudly, sings: 'que mi pare q'esté en la gloria/ me enseñó a torear/ y la maresita mía/ me enseñó a resá' ('my father, may he rest in peace/ showed me how to bullfight/ and my little mother/ showed me how to pray'). The tradition of bullfighting is seen as being transmitted from one generation to the other, always from father to son, while the mother sees to the continuation of religious, Catholic values.

In Pi's reading of the story, however, this perspective changes radically. Her Soleá is an independent woman who not only does not need to be protected by a man, but also works hard to protect the men who surround her. Pi's Soleá ends the conflict between the two primitive men who fight to get her without considering her feelings and interests. As with the lines in which

Soleá clarifies that she will decide when and if she wants to see her boy-friends, in the sequence of the fight, she is the only one who does something to stop it. In Penella, Soleá was just a passive witness lacking the strength to intervene in the savage ritual of two men who fight to get her. In Pi, she is the interest of the action, the one who suffers it but also the one who directs it and orders the men to stop it, which they do.

By succeeding in her rewriting of a storyline that originally presented women as subjected to men, Rosario Pi anticipated one of the most relevant contributions of feminist film criticism and writing, that is, the problemati-sation of the dichotomy female-passive/male-active, developed by landmark feminist thinkers such as Laura Mulvey (1975: 40). According to Mulvey, as a result of voyeurism, cinema provides a split between active/male and passive/female roles. It is their passivity, stressed by endless cinematic and cultural resources, that makes female characters on-screen participate in what the early feminist film scholars called 'to-be-looked-at-ness'. Soleá, in the fight sequence, transgresses her original role as a mere witness to be observed by spectators while enduring unavoidable suffering. Instead, she takes on the active part that had previously corresponded to the two men. The new scene does not centre on the fight, nor even on the consequences of it (no matter who wins, none of the men get Soleá, whereas in Penella's original story, Soleá rewards Juanillo for saving her): what interests Pi's camera is Soleá's resolution and strength to stop the fight. The man who starts the fight starts leading the action too, when he orders Soleá to drink with him ('te la has de beber [la copa] porque lo mando yo', 'you shall drink from it [the cup] because I say so'), but she refuses: 'en mi cuerpo no manda naide' (lit. 'no one rules over my body'). Then, the man threatens to disrespect her: 'tú te bebes esta copa conmigo o por mi nombre te juro a la cara' ('you drink this cup with me or I will swear in your face'), and beats her. Soleá knows how to defend herself (unlike in Penella's version), and confronts the abuser: 'canalla, cobarde, malnacío ... malhombre' ('coward, bastard ... '). By adapting this sequence and introducing the idea of physical abuse towards women, Pi was able to foresee a topic that would dominate Spanish cinema of the twenty-first century in important films such as *Te doy mis ojos* (*I Give You My Eyes*, dir. Icíar Bollaín, 2003), *Sólo mía* (*Mine Only*, dir. Javier Balaguer, 2001), among many others.

Pi may have lacked the terms and notions that feminist thinking would develop decades after her work, but her screenwriting illustrates interest-ing positions in the prehistory of contemporary feminist cinema. Pi's script works hard to erase any representation of women as objects irrevocably subjected to men. I want to argue that, although she does not always manage to succeed, it is this very struggle and effort that make this film so relevant to the construction of a history of feminism in Spanish cinema. If women are objects, Pi seems to argue, it is not because this is necessarily so, but because there is something wrong with the way things are. Juanillo, in the original *Gato montés*, had been educated to play the active part in

any relationship with a woman. Anything, from beating to kidnapping, is permitted to gain access to the woman that a man is in love with. One of the most famous arias, sung by Soleá herself, explains how 'er torero querencioso/ que camela esa gitana/ der cortijo va a yevarse/ la rosita más temprana' ('that handsome bullfighter/ who flirts with this gipsy woman/ will pick up in the *cortijo*/ the earliest flower') (68). In a stereotypically funny verbalisation of Spanish machismo, the woman has no opinion and can just wait to be bewitched and taken away by the bullfighter. Her only comments to that action, in which she only participates as an object, are to praise it. 'Suya, suya, sí, suya quiero yo sé' ('his, his, yes, I want to be his') (81). The original Gato Montés uses Soleá's indecision as a consequence of her reduced space to operate and make her own resolutions. The man plays the active part ('di que me quieres', 'say that you love me', he commands) (80), while the woman is even unable to know whom she loves, and she confesses this to the priest: '¡ya no sé qué é lo que quiero, y sufro y lloro por mi queré' ('I don´t know what I want any more, and I suffer and weep because of my love') (81). And the reason why the man can afford this power is, simply, because he is the only one who is able to provide the protection that she, like all women, desperately needs: 'no t'asuste tú y no yore' ('don´t be afraid and don´t cry'), he says when she is weeping, 'q'a mi lao está segura, q'ha de ser pa siempre mío [tu cariño], mío na má' ('for, beside me, you are safe, and your love must always be mine, only mine'). The colonisation of the woman's decision reaches its peak when el Gato confronts Rafaé and says: 'esa mujé sólo é mía/ esa mujé me quié a mí/ porque ella no pué quererte/ aunque te diga que sí' ('that woman is only mine/ that woman loves me/ for she cannot love you/ even if she says she does'), that is, even if she happens to say that she loves a man (and she does not, as we have seen, because she is not able to express her feelings), that cannot be true, as love is not a woman's choice, but a man's. It is always the man's last decision that determines Soleá's will. On the other hand, Pi works obsessively to redirect this pattern of behaviour, to the extent that, by the end of the film, it is reversed and it is now the men of the film who are subjected to Solea's determination. The new Soleá decides first that she does not need to be married to share her life with the man she loves, thus defying the Catholic Church and social tradition; later, that she can be alone and happy and, only when she is in love with Rafaé (and not when Rafaé wants to, as was in the original), she decides to marry him. Moreover, when a man she is not interested in wants to be with her, Soleá utters what is possibly the film's most activist line: 'en mi cuerpo naide manda' (lit. 'no one rules over my body'). The result of this reworking of the female character's body becomes fascinating in the light of feminist and gender studies, but it does present serious problems in terms of the consistency of narratives that had been constructed upon pillars that are taken away and replaced with others that do not quite fit in the structure. Nonetheless, rather than seeing it as a flaw, I prefer to understand this as one of the film's greatest contributions. It is true that Soleá becomes a

blurred character: according to what she says, she is a strong, active woman but, nevertheless, she ends up with Rafaé, an inconsistency not only with her personality but also with the direction that the new storyline promised. This has bewildered critics in much the same way that that it also must have done to many spectators. For instance, Lera understands that Soleá is trapped (*'atrapada'*) by Rafaé, and criticises Gubern for understanding that she is *'emparejada'* ('coupled with'), as this is not of her free will (1981: 127); the reality is that none of them is totally right or wrong, as the Soleá of the last part of the film is not the Soleá that Pi rewrote, but the one that can be found in the original text, attached now to finish a story with very little consistency at this point. The final sequence, which is the most praised and the one remembered when the film is cited nowadays, becomes in the light of this an uninteresting ending, an imposition of a story that is less Pi's and more traditional than the line of work that Pi, as an auteur, had been struggling with.

These difficulties do not apply to an original sub-plot that was not taken from Penella's *Gato montés*. Pi's version introduces two characters who stress the filmmaker's ideological approach to the battle of sexes. The most interesting sequence shows a woman washing dishes, a labour she hates: 'no pueo con esta vida perra, yo no he nacío pa fregar platos, yo no he de casarme nunca' ('I cannot bear this dog's life, I was not born to wash dishes, I will never get married'). The man understands that, since she refuses to marry, she would become a nun, apparently the only other option, but she shows her determination to be an independent, working woman: 'me voy a meter a peliculera, y antes de un mes me has de ver en el cine trabajando' ('I will become a movie star, and within a month you will see me working in the movies'). A musical number follows, in which she orders the man to comply with her orders: 'así quiero yo a los hombres' ('that's the way I like men'). He understands that, with such an active lady, there is nothing that he can do: 'fíjate si te quiero, que me haces trabajar' ('see how much I love you, you make me work'), he says. Knowing so very little about Pi's biography, it is very difficult to venture into finding resonances with her personal life, but this sequence does invite us to consider the difficulties encountered by a pioneering woman, who singlehandedly decided to work in the male-dominated film industry of male-dominated 1930s Spain. Pi, who would live single until her death, must have experienced many of the thoughts expressed by her characters. Of regret here is the frustration implicit in a necessarily limited study of a director who offers insights into the prehistory of Spanish queer filmmaking.

Intriguingly, this sub-plot of the *peliculera*, or female filmmaker introduces an aspect that ceases to be further explored in the film, which explicitly refers to the free and untraumatic sexuality of the female character. After saying that what she wants is to have a French lover who can teach her to speak French ('que me enseñe la lengua', referring to the language and also the tongue), the man is disturbed when he notices

that the lady wears clothes that, by the standards of the time, are rather too revealing: '¿vas a salir en paños menores? ... apártate, impúdica, ¿pa eso te he ofresío yo mi blanca mano?' ('Are you going to show your underwear? ... get away, you indecent woman, is it for this that I have offered you my white hand?'). Once more, Pi's female character rejects such a display of machismo ('tu blanca mano no me sirve a mí pa ná', 'your white hand is useless to me'), and leaves him alone. Before doing so, however, she takes what she says are her swimming clothes, folded up in a little bag as small as her hand. This sequence, in which a woman punishes a man's chauvinism with her own unproblematic sexuality, would be impossible, not only and certainly in Penella, but also in the cinema that would follow the Civil War.

In this sense, it can be argued that the cinema of the Second Republic shares many similarities with that of the pre-Code Hollywood era. Mick LaSalle (2001) has analysed how between 1929 and 1934 women on-screen enjoyed their sexuality and led unapologetic careers and acted in the way many women only acted after 1968, but the enforcement of the Hays Code and its norms of censorship stopped this. This interruption, and others that would affect most national industries (Germany and von Stenberg's films are certainly another clear example), limited the exploration of sex and gender issues in Spanish cinema, and thus turns films such as *El gato montés* into valuable jewels in a fragmented and frustrated history of Spanish cinema. It is revealing that Penella's only reference to sex is quickly overshadowed by the religious fervour of his Rafaé: when Soleá complains that he has tried to kiss her ('¡Niño! Que t'has aprovechao', 'Boy! You are overstepping the mark!'), he defends his urge as follows: 'ties rasón/ pero te juro/ que la mano te he besao/ como se besan los pies/ de Cristo crucificao' ('you are right/ but I swear/ that I kissed your hand/ the way one kisses/ Jesus Christ's feet on the cross') (93–4). Far from Pi's, Penella's characters, written in the 1910s, position themselves in the narrative tradition that sublimated sex with religious passion, a trend that would often be repeated in Francoist cinema.

The dichotomy active/male–passive/female and the vindication of women's sexual decisions are not the only contemporary ideas that Pi explored. Since the 1990s, thinkers such as Judith Butler (1990) have urged feminists to challenge the notion of identity as static and unchanging and examine how individuals are gendered critically and analytically from different standpoints. This debate became very relevant in the field of cultural studies and popular culture. Joanne Hollows's *Feminism, Femininity and Popular Culture* developed aspects of these feminist theories in order to present the relevance of the study of popular culture as a means to understand how 'culturally produced masculine and feminine gender roles [have been] mapped on to biological differences between males and females making them appear to be part of men's and women's "biological" nature rather than cultural constructions' (2000: 10). Fifty years before this debate

came onto the political agenda of feminism, Pi's film explored this very same issue in very explicit terms, anticipating the idea that both men and women are socially gendered and that it is in this process of 'gendering' that binary identifications such as male–intellect and reason–female/body and emotion emerge as cultural constructions. The first third of *El gato montés* illustrates Soleá's transformation from child to woman and the ways she has to fight a number of limitations in a society that we would today call 'patriarchal'. In this sense, Pi, like Butler, questions the distinction between sex and gender that permeates feminist discourse, as they both seem to present the same questions: 'Does being female constitute a "natural fact"', Butler wonders, 'or a cultural performance, or is "naturalness" constituted through discursively constrained performative acts that produce the body through and within the categories of sex?' (1990: xxix). Soleá, as a child, grows up with Juanillo, and they learn to love each other and their bodies far from the civilised world. Pi illustrates this by showing the two children sleeping together in the horse-drawn carriage they have, and later, when they are kissing as they walk holding hands, barefoot. The shot of their little feet merges with a dissolve to that of their feet as adults, still holding hands and kissing. In the meantime, Soleá and Juanillo have had to learn the differences that divide their genders. The following sequences insist on these divergences that are new to them in their adulthood, far from the equality that they enjoyed as children. 'El vino está hecho pa los hombres' ('Wine is made for the men'), says someone at one point, after the priest has suggested that they have to marry when he sees them kissing. Again, it is important to note that Penella's original text included the scene of Soleá's childhood, but it is only in Pi's rewriting that spectators can see this interest in the exploration of the social constructions of womanhood.

There is a final aspect of *El gato montés* that reveals Pi's subversive approach to the traditionally more conservative *zarzuela*. The relationship between *zarzuelas* and class issues is a complex one and this explains the limitations of the genre as a popular but socially unconcerned art. Fernando Fernán-Gómez, as a member of a family of actors, was born and raised within this world of *zarzuelas*. In his novel *El tiempo de los trenes* (*The Time of Trains*) (2004), based upon recollections of his childhood, he remembers the popularity of these plays and notices the links between class difference and theatre genres: 'para las clases "menos favorecidas" había espectáculos de otra índole y de no menos valor artístico. Los individuos de dichas clases no eran muy adictos a las 'altas comedias' de Jacinto Benavente y sus epígonos, pero ahorraban unos cuantos reales para ver repetidas veces *La verbena de la Paloma*, *La Revoltosa*, y algunas piezas más del género chico, o melodramas como *Los dos pilletes* o *El soldado de San Marcial*' (22).[4] This must be taken into account when analysing *zarzuelas* from the perspective of their social interest, as two different levels operate. First, the majority of the audience belonged to the lower classes; second, the fact that the narratives moved more often than not between

different social classes (in the case of *El gato montés*, Soleá marries into money). Thus, it is possible to understand *El gato montés* as a case of subversive cinema, not only for its unprecedented concern with gender issues, but also when analysing its strong social criticism which, once again, does not come from the original text and must therefore be solely attributed to Pi. Some studies have attempted to find this type of social interest in the *españoladas* of the 1940s and 1950s, and it is true that, albeit rarely, it is possible to read some of these films as mild Spanish versions of neorealism. This is not the case with *El gato montés*; Pi's film is not a folklore musical in which some socially related issues are inserted. On the contrary, *El gato montés* aspires to be a social film in itself, to the extent that it neglects its escapist origins as a musical and just two songs are introduced while the rest of the original score is kept as background music. The very first sequence shows the main characters in their childhood. The costumes, hairstyles and *attrezzo* aim to show the dramatic conditions of the lower classes. Little Juanillo is rewarded with a sardine, 'por ser domingo' ('because it is Sunday'); sadly, he is obliged to share it with Soleá. When this prologue of their childhood ends and the movie forwards to their present time, the adult Juanillo says: 'no hay pesetas, nosotros también somos probes' ('there is no money, we are poor too'), as if to say that very little has changed for the lower classes. Many more explicit references of this kind can be found, and it is true that more than seventy years after its release, some of the social and political messages of the film look dated. There are even some references to the then powerful Marxist ideology, personified in Juanillo when he becomes the Gato Montés and explains that, like Robin Hood, he steals from the rich to give to the poor: 'rob[o] a los ricos... lo que hay en España, pa los españoles' ('I steal from the rich people... what there is in Spain, for the Spaniards shall be'). Thus, it is not solely gender differences that attract Pi, but a more open conception of injustice that includes class, race and ethnicity. Pi uses on several occasions her characters' ethnic background to condemn their marginalisation; Soleá is worried because she has been taught that gypsies do not go to heaven, until she learns that 'los gitanos también [son] criaturas de Dios' ('gypsies are God's creatures too').[5]

By mixing race, ethnicity, class and gender, Pi is able to place the focus, not on one of these perspectives, but on their intersection. In this sense, it can be understood that Pi follows what Johnnella Butler (2001) named a 'matrix model', which, interestingly, has also been present (and continues to be so) in contemporary Spanish film production, *Flores de otro mundo* (*Flowers from Another World*) (dir. Icíar Bollaín, 1999) being a landmark. The so-called matrix model looks at the 'matrix of race, class, ethnicity and gender ... within the context of cultural, political, social and economic expression' (108) in order to 'understand the result of it as a flexible diverse construct with multiple connections and interactions' (46). Pi, using Soleá as her mouthpiece, fights to examine the idea that race, class and gender are

not independent variables that can be tacked onto each other or separated at will, but that, instead, they are constructed upon social relations. The child Soleá, who has not yet positioned herself as an underprivileged gypsy woman, will have to learn as she grows the complications of an unfair world.

It seems that there is now an increasing interest in the years of the Second Republic, and certainly in its cultural production. *El gato montés* is a fine example of a film that could only have been made at a very special time of unawareness of the impending Civil War that would abruptly end any kind of liberation. Other periods in Spanish recent history, such as the much praised transition to democracy, have been revised as examples of exceptional freedoms in terms of cultural production, but it was during the Second Republic that Spain first attempted an approach to cinema as a means of portraying the reality of a country that was still highly under-developed. Other better-known examples of this tendency in filmmaking include Buñuel's *Las Hurdes* (*Land without Bread*, 1933), which has received considerably more attention from critics worldwide. This line of filmmaking, which, in many aspects, anticipated the neo-realism that the Italians were to invent a few years later, would be lost after 1936. The endless on-screen adaptations of popular theatre that prospered under Franco's dictatorship, and especially during the post-war years, would ignore the many possibilities of this genre, and would descend to a much more simplistic approach. Pi's characters, and this is one of her greatest achievements, refused to limit themselves to the restrictions of tradition; on the contrary, Soleá struggles to find the means to problematise her place as a member of a different ethnicity and of the lowest social class, as well as a woman in love. Her life has taught her that our experience of having desires, aspirations and erotic orientations, our needs for love and feelings of difference are constructed through relations of power and social regulations, which we sometimes term conformity, discipline, obedience. Soleá, however, had a chance that few female characters had had before. Pi, by rewriting her, was able to show how the construction of a different female character, unseen before the Second Republic, was possible. Her anxieties must have not been too different from those of the pioneering women cinéastes who worked to create the seeds of a tradition in women's filmmaking that, although discontinued in the realms of history, has as yet many stories to tell.

Notes

1 Susan Martín-Márquez, in her study of Rosario Pi's works and life, describes the *españolada* as a genre that figured Spain as an 'exotic, primitive other, by focus-ing metonymically on the technologically underdeveloped, classist and sexist Andalusia, presumably the region closest culturally to the Middle East and the Orient, and by populating this space with gypsies ... whose flamenco performance

and bullfighting tied them viscerally to the instinct realm' (1999: 64). There are many *españoladas* that would defy this classification, but it is a very appropriate one for the study of *El gato montés*.

2 Apparently (Valero: 34), Pi had a homosexual relationship with María Mercader (born in 1918), who would later marry Italian maestro Vittorio di Sica and become a film star; however, Susan Martín-Márquez denies this on the basis that Mercader must have been 21 when Pi (born in 1899) directed her in *Molinos de viento* (1939). I understand that there are insufficient data to acknowledge that relationship as a fact, but we must take into account that what we call today the 'age of consent' was very different at the time, as the film *El gato montés* itself shows. In any case, judging only the content of her film, and in the hope that future studies can develop this thesis, Rosario Pi deserves to be seen as a landmark in the prehistory of Spanish *queer* filmmaking.

3 Feminist usages of the ventriloquist theory can be found in Rich (2003: 447–59).

4 'For the "lower classes", there were other kinds of shows, of no less artistic value. People of the lower classes were not very fond of Jacinto Benavente's 'high comedies', but they saved some money to see several times *The Fair of the Dove*, *La revoltosa* (*The Naughty Lady*) and other *zarzuelas*, or melodramas, such as *The Two Rascals* or *The Soldier of San Marcial*.' *La revoltosa* had its first on-screen adaptation in 1924 and would have three more later on; as for *La verbena de la Paloma*, it was also adapted for screen four times, the most popular being the version directed by Benito Perojo in 1935, contemporarily with *El gato montés*. Unlike Pi's film, the majority of these adaptations used to be very faithful to the original text and, in many cases, the dialogues of the film would simply copy the lyrics of the songs.

5 For more on the representation of gypsies and childhood in the film, see Valero (1996: 36–44).

References

Butler, J. *Gender Trouble: Feminism and the Subversion of Identity* (London: Routledge, 1990).

Butler, J. E. *Color-line to Borderlands: The Matrix of American Ethnic Studies* (Seattle: University of Washington Press, 2001).

Caparrós Lera, J. M. *Arte y política en el cine de la Segunda República* (Barcelona: Edic. Universidad, 1981), pp. 122–8.

Fernán-Gómez, F. *El tiempo de los trenes* (Madrid: Espasa, 2004).

Gubern, R. *El cine sonoro de la Segunda República (1929–1936)* (Barcelona: Lumen, 1977).

Hollows, J. *Feminism, Femininity and Popular Culture* (Manchester: Manchester University Press, 2000).

LaSalle, M. *Complicated Women: Sex and Power in Pre-code Hollywood* (New York: Saint Martin's Press, 2001).

Martín-Márquez, S. *Feminist Discourse and Spanish Cinema: Sight Unseen* (Oxford: Oxford University Press, 1999), pp. 49–84.

Mulvey, L. *Visual Pleasure and Narrative Cinema* (London: Routledge, 2003), first published 1975.

Penella, M. *El gato montés: ópera en tres actos* (Sevilla: Cátedra, D.L. 1992).

Rich, A. 'Notes towards a politics of location', in C. R. McCann and S. Kim (eds), *Feminist Theory Reader: Local and Global Perspectives* (London and New York: Routledge, 2003), pp. 447–59.

Valero, A. 'Una española frente a la españolada. Rosario Pi, El gato montés, 1936', *Filmar en femenino, Culture Hispanique*, 20 (14) (1996), 31–53.

Deterritorialised intimacies: the documentary legacy of Sara Gómez in three contemporary Cuban women filmmakers

María Caridad Cumaná González and Susan Lord

Our contribution to this volume offers an analysis of contemporary Cuban women filmmakers in whose work we see direct and indirect conversations with Sara Gómez (1943–74), whose 1960s–1970s film practice revolutionised the way in which the gender–nation–revolution nexus could be argued cinematically. Sandra Gómez, Susana Barriga and Gloria Rolando work at the intersection of cultural citizenship, diaspora, revolutionary legacy and globalisation, and they do so through what we call 'deterritorialised intimacies'. These intimacies are afforded by their documentary practices of decolonised ethnography: a set of aesthetic and ethical documentary strategies that are expressive of historical and emotional geographies of belonging and non-belonging for the filmmaker, subject and audience. In our effort to understand the publicity of contemporary documentary subjects (that is, the viewers, the filmed and the filmmakers) in Cuba and how this intersects with the legacy of gendered citizenship practices, we turn to Ariella Azoulay's work *The Civil Contract of Photography*.

Ariella Azoulay (2009) argues for a central role for the photograph and, we suggest, by extension the documentary film, as a space within which citizenship practices may be rehabilitated. 'An emphasis on the dimension of being governed allows a rethinking of the *political sphere as a space of relations between the governed, whose political duty is first and foremost or at least also a duty toward one another, rather than toward the ruling power*' (2009: 25; our italic). For Azoulay, the history of unequal access to citizenship is linked to the politics of appearance and disappearance. With the democratisation of photographic access and, in current terms, new media access, the relationships are afforded a more extensive lateral dimension and networks of appearance develop that can never be completely subsumed by the lens of the ruling power. While there is a long history of photo- and media-citizenship, discussed in documentary and new media literature, most of it focuses on the 'society against the state' or 'citizen journalist' paradigms, where revelatory material (Halliday's Rodney King video) or confrontational exposé (Michael Moore) is modelled on a liberal-subject-

as-citizen. Or, in the global south, citizenship action against dictatorships, empires and neo-liberal economies formed the foundation of new Latin American and African cinemas. Here, the political subject is often more collectivised, but the space of the relations confronted and expressed in the films is between the ruled and the ruler. In this chapter, we wish to consider a different formation of citizenship practice, one which builds a *'space of relations between the governed'* – a virtual territory of citizenship action, recognition, care and affection.

Citizenship practices of decolonised ethnography within the context of Cuban society today – a half-century after the Revolution of 1959 and as global finance-scapes and media-scapes (Appadurai, 1996) have for nearly twenty years caused a myriad of crises and opportunities for the Cuban state and its people – provide women filmmakers with a very particular vantage for considering the past, present and future of Cuban national identity and the politics of belonging. Literally and figuratively, the filmmakers we consider here work on the thresholds of the familial, national and global spaces: Sandra Gómez lives in Switzerland and makes documentary films expressive of the emotional geographies of La Habana; Susana Barriga lives in Cuba and her film *The Illusion* (2008) is shot in London, where the filmmaker goes in search of her father who left the island when Susana was a child; Gloria Rolando lives in La Habana and travels extensively within Cuba, the Caribbean and the United States, recording the memory and living cultural practices of the Afro-Caribbean diaspora. Each of them employs a variant of ethnographic documentary – reflexive or interactive forms of *testimonio* and/or *rescate* that do not merely record an existent reality but make things happen: a spatial and historical undoing and remaking of places, their imaginaries and the identities of the filmmaker, film subject and viewer. For our purposes here, we find in these three contemporary film-makers particular manifestations of the legacy of Sara Gómez, including the history of transculturation and diaspora told through the intimate stories of belonging or not belonging to the nation–family–revolution; the street as a space of appearance; thresholds of visibility (the seawall; doorways and windows; photographs); the vulnerability of the self/filmmaker to her subjects (through either voice-over or voice-off; physical danger; embodied camera). Not all three contemporary filmmakers work with each of these themes, but together we find an important dialogue with Gómez and the times that formed her – times that remain now as heavy and complex rem-nants of a utopian imaginary that this 2000s generation cannot ignore. In all three, the gains and losses of the Cuban Revolution produce a type of parallax lens – an impossible coexistence of exclusive or divergent realities (Deleuze).

Sara Gómez was working in the 1960s and 1970s, a time of intense inter-nationalism for Cuba, a time not seen again until the 1990s and the Special Period, which itself was at the threshold of a wholly different meaning of internationalism: of globalised neo-liberal states and subjects, as well as

new networks, affiliations and world-imagining. For Cuba, the Special Period was one of intense sorrow and suffering as a result of the collapse of the Soviet Union, when tens of thousands of people left the island in the 1990s; 80 per cent of the state economy disappeared. The new generation of those who stayed and those who left adds another layer to a half-century of the Cuban diaspora and of broken families. With over 1.5 million people from the Cuban diaspora currently living in the United States alone, the discourses are often as passionately driven by concepts of loyalty and betrayal, as is the case for families: irrational and deeply felt, destructive and loving, that watery border often seems to be made more from tears than policy. *Fronteras* – what we do with them and what we cannot do with them – are horizons of engagement for this generation of filmmakers and artists. Cuban artists work with the Antilles as a metaphor of the 'infinite island' or figurations of the world composed as a puzzle of small islands shaped like Cuba (Tonel) or repeated images of rafts (Kcho) or floating beds (Sandra Ramos) or the Malecón (Havana's seawall) (Manuel Piña). These images are foundational for the imaginary of the nation or of national belonging for this generation, replacing the previous generations' imagery of Cubanidad or revolutionary iconography. In cinema, videos of the new generation, such as *Video de familia* (2001) by Humberto Padron and *(De)generación* (2006) and its follow-up *(Ex)generación* (2008) by Aram Vidal Alejandro address directly the emotional conflicts of the Special Period. Vidal says: 'To emigrate has been seen as an act of abandonment and somehow this conception is predominant in many spheres' (6 August 2009). But it is, for many, a double abandonment – this generation often expresses a sense of having been abandoned by a leadership that is unwilling to recognise their capacity and desire to contribute to the revolution and the nation in terms other than those set out in the 1960s.

As Homi Bhabha has written, 'The globe shrinks for those who own it; for the displaced or the dispossessed, the migrant or refugee, no space is more awesome than the few feet across borders or frontiers' (1992: 88). Like Bhabha, Doreen Massey works with the concept of the relational nature of space and its correlate of relational identity: 'if space is a product of practices, trajectories, interrelations, if we make space through interactions at all levels, from the (so called) local to the (so called) global, then those spatial identities such as places, regions, nations, and the local and the global must be forged in a relational way too, as internally complex, essentially unboundable in any absolute sense, and inevitably historically changing' (2004: 5). The affective nature of the politics of place (Thrift, 2004) yields new intensities in the global communication networks: the *fronteras* of belonging are virtualised and rematerialised in relation to these networks and thus practised in the context of what Appadurai calls the digital differential. This is where the digital dilemmas (Venegas, 2010) of the new Cuban cinema make a very important contribution to international, transnational and translocal understandings and affiliations. As much as this

new media activity of contemporary filmmakers participates in the flows and mediascapes of economic globalisation, they are also performing their cultural citizenship in a manner directly associated with the first generation of filmmakers.[1] We wish here to underscore how the cultural practices of the 1960s generation were acts of cultural citizenship that articulated belonging *and* non-belonging. New forms of citizenship practices emerge with the visualities of the citizen and its public spaces, particularly in the period from 1959 to 1968. New focalisations engaged in a terrain of contestation of belonging to a world where 'citizenship' was the property of fraternal, bourgeois or revolutionary whiteness. For the artists of the 1960s and echoed in the work of today, the work of citizenship is a triadic action of (a) a spatial production of new urban imaginaries of belonging; (b) a civil activity of appearance; (c) an intersectional or transversal engagement with the revolution–nation nexus. Within this political space, the point of departure for the mutual relations between the various 'users' of photography and cinema is where the photographed persons address the spectator, claiming their citizenship in what Azoulay (2009) calls 'the citizenry of photography'. In this space, they cease to appear as 'marginal' or 'dissident'; rather, this activity of appearance rehabilitates their citizenship. Citizenship is not a stable status that one simply struggles to achieve, but an arena of conflict and negotiation located in techniques and technologies of appearance. This is precisely the legacy Sara Gómez leaves for the current generation.

The encounters between tradition and modernity render an especially complicated yet productive space for the appearance of women as citizens and agents of social change and cultural expression. For, as culturally specific gender roles and temporal realities are threatened by the standard time of modernisation and commodification, a view of the gains and losses brought by the encounter becomes tangible and available for critique and reflection. The appearance of this 'new woman' of decolonising and postcolonial visual culture depends upon collectivities and new mobile formations of social relations. Sara Gómez is a foundational figure in this regard. Recognised by scholars, filmmakers and cinéastes as having made profound and lasting contributions to Cuban cinema, women's cinema and postcolonial cinema, she was until 2009 the only woman to have made a feature film in Cuba; she is one of a very few Afro-Cubans to have made films in ICAIC (Instituto Cubano del Arte e Industria Cinematográficos); her work has inspired a new generation of Cuban media artists; and her feature film presented North American and British feminist film critics and theorists with one of the first 'non-Western' films by a woman, thus marking the canon's shift away from complete Eurocentrism. Gómez died of asthma in 1974, before she could complete the editing of *De cierta manera* (*One Way or Another*, 1974/77), the only feature-length film she made after more than a decade working as a director of short documentaries. The feature was completed by Gómez's colleagues at ICAIC (Cuban national film institute) in 1977 and went on to receive tremendous critical and scholarly attention

– and it continues to focus attention and debate about Cuban culture and society. It is a remarkable film for its portrayal of complex social, racial and sexual relationships, and for its inventive strategies for giving such relations a mode of representation adequate to their complexities. The film has, in fact, become foundational to new Cuban cinema and to feminist film culture. Her documentaries were made in the period when the 'double vocation' of artistic and political experimentation was the norm (López, 1992: 46–7) and before what is referred to as 'the grey years' (the Sovietisation of culture). Each of these short films is strikingly different in style and each stretches the limits of documentary conventions.[2] This experimentation participates in the new Cuban cinema's creative revolution by signifying a response to those elements of history, memory and everyday life that are frozen out of the frame of the dominant narratives of nation and subjectivity. Whether the subject matter concerns the local cultural and political critiques of national work programmes (*Sobre horas extras y trabajo voluntario* (*Extra Hours and Volunteer Labour*, 1973)) and election processes (*Poder local, poder popular* (*Local Power, Popular Power*, 1970)) or the diaspora and differences found within a family (*Crónica de mi familia*, 1996), the films consistently bring into the frame marginal identities, respatialising and, in Azoulay's phrasing, rehabilitating citizenship. Central to both the modes of representation and the subject matter is the issue of time itself. Along with strategies that reflect on the temporality of film processes (shot duration, montage rhythm and narrative), the cultures of time represented in the films include the subjective worlds of memory and everyday life (*Crónica*), the uneven development of social chronotopes[3] (the Isle of Pines trilogy, 1967–69), and the different or contesting temporalities formed by cultural memory and practices (... *Y tenemos sabor* and *Crónica/We've Got Taste*, 1967), as well as by gender difference (*Mi aporte/My Contribution*, 1972). This temporality has its spatial extension, for in all of Sara Gómez's films, windows and thresholds or doorways speak volumes – they are spaces of emergence. They are interior frames that function to mediate or create a density of mediation by which to literally 'see' the emergence of a new subjectivity. In *Mi aporte*, women are often at thresholds; in *De cierta manera*, the privacies of race and gender enter the classless streets as the grey years were restricting the spaces of civil society. These spaces are arguably about deterritorialising the boundaries of domestic and public space through the dynamic transformation of identity and belonging.

The citizenship practices of decolonised ethnography that emerged in the 1960s are found both in Gómez and Nicolas Guillen Landrían (whose aesthetic is also directly cited in Barriga's *Patria* (Homeland, 2006) and in *Cómo construir un barco* (*How to Build a Boat*, 2006) and were connected to international networks being mobilised by the decolonising projects and new social movements: connections to black power, the left-bank film projects, feminist organising and newsreel film, which combined to remap the city as a space of world citizenship and localised histories.[4] Sara's *Ire*

a Santiago (1964) was not about *going* to Santiago; it was about Santiago de Cuba. It is about the street, and cinema's reflection on and recording of public life and cultural memory. *Crónica de mi familia* isn't just about her family, it is about the locatedness, the urban genealogy of cultural history; ... *Y tenemos sabor* is at once an Ortizian[5] ethnography of *son* and an urban soundscape. The final argument in the street in *De cierta manera* meets the demolition at the beginning: the city as the space of contestation, love and citizenship practice. The liminal spaces between home and street in *Mi aporte*; between work and street; the spaces of argument – are a public space. The urban ethnographer goes to La Isla de Juventud where people have gone *from* the city. She does not interview *campesinos* or *pineros* – she interviews youths who had become homeless (in a variety of ways) in Havana.

If we analyse the documentaries of the three contemporary women film-makers vis-à-vis the legacy of Sara Gómez, and we do so through documentary typologies developed in the North American and anglophone academy, such as those formulated by Bill Nichols, Annette Kuhn and Julia Lesage, we are given a set of meanings and values associated with consciousness-raising, interactive and reflective structures and feminist dialogics. This lens thus gives us a feminist documentary in the mode defined by Lesage as follows:

> Cinéma vérité documentary filmmaking had features that made it an attractive and useful mode of artistic and political expression for women learning film-making in the late 1960s. It not only demanded less mastery of the medium than Hollywood or experimental film, but also the very documentary recording of women's real environments and their stories immediately established and valorised a new order of cinematic iconography, connotation, and range of subject matter in the portrayal of women's lives ... The feminist documentarist uses the film medium to convey a new and heightened sense of women's identity, expressed both through the subject's story and through the tangible details of the subject's milieu ... The realist feminist documentaries represent a use of, yet a shift in, the aesthetics of cinema vérité, due to the feminist filmmakers' close identification with their subjects, participation in the women's movement, and sense of the film's intended effect. The structure of the consciousness-raising group becomes the deep structure repeated over and over in these films. (1979/84: 231, 246)

This typology yields one set of truths that are applicable to Gloria Rolando's work, Barriga's *The Illusion* and Sandra Gómez's *Las camas solas*: feminist collectivities develop a critical consciousness among partici-pants; the shift in iconography based on this critical consciousness is capable of contributing to social change; direct speech and storytelling are transmis-sible through the films' structure, which itself reflects a 'decolonised' reflex-ive structure of feminist consciousness; and, of course, the focus on gender roles as the deep structure in the determination of cultural and social value. What this perspective cannot 'see' is the critical engagement with the deep,

formal structures of Latin American documentary, and the dialectic between gender and colonialism. It is now commonplace for writers to turn to Bill Nichols' delineation of the main documentary 'modes': expository, observational, interactive and reflexive (1992). However, this is but one version of a set of articulations that he and Julianne Burton developed over the course of a decade. Burton's article 'Democratizing documentary: Modes of address in the Latin American cinema, 1958–72', first published in 1984, and Michael Chanan's 'Rediscovering documentary: Cultural context and intentionality' present a history of Cuban and Latin American documentary modes of production. In Burton's introduction, she writes:

> From the inception of the social documentary movement in the mid-to-late fifties, Latin American filmmakers began experimenting with a broad range of strategies designed to eliminate, supplant, or subvert the standard documentary mode of address: the anonymous, omniscient, ahistorical 'voice of God' ... Long before the technological innovations in sound recording associated with 'direct cinema' and 'cinéma vérité' were widely available in the region, Latin American filmmakers explored indirect and observational modes in an attempt to pluralise and democratise modes of documentary address ... In their drive to subvert or eliminate the authoritarian narrator, some filmmakers substituted intertitles ... [and ceded the voice-of-god to] on-camera and/or on-microphone presence of the filmmakers or their surrogates, and the self-presentation of social actors. (1990: 49).

The issue of voice-over and its function as a trace of the presence of the disembodied patriarchal authority has long been the subject of feminist and feminist–post-colonial critique. Clearly, feminist and decolonising cinemas overlap in their subversion of that type of authority. And this is certainly true for all of the filmmakers in consideration here. However, in the case of Latin America in general and Cuba in particular, the voice-of-god was never only, or even initially, a patriarchal figure; it was the master, the coloniser, the imperialist. Sara Gómez's contribution to an already highly politicised, specifically decolonising, formal strategy was to reveal gender as another culture of authority that oppresses women by marginalising their participation and devaluing their time (the latter point is especially clear in *Volunteer Labour*, 1973). These two critiques – the decolonising and the feminist – do not collapse into one another when viewed from the lens of Latin American documentary tradition; neither is the gendered analysis a mere supplement. As Michael Chanan writes, 'cine didáctico, cine testimonio, cine denuncia, cine encuesta, cine rescate, cine celebrativo, cine ensayo, cine reportaje, cine de combate' are expressive of the 'needs of revolutionary struggle, both before and after the conquest of power, when they become part of the process of consolidating, deepening, and extending the revolution' (2004: 37). The revolutionary legacy is highly contested and problematic in the films of Barriga and Sandra Gómez: the social subjects express this legacy in discourses as varied as direct resistance, dreaming, equivocation or alienation. But, in all three, it is the traces of utopia (the memories of utopia, as

Andreas Huyssen (1995) calls it) that are spatialised in the representational practice of citizenship as an intimacy (fathers who cannot be pictured or retrieved, neighbours who help each other in the hurricane). And they do so on the threshold of the nation and its globalised future.

While Gloria Rolando's work may appear to be the least globalised, if we understand her work from this setting, we are given a deep history of its intimacies: the contemporary encounters with spatial and historical dislocations that form the Afro-Caribbean diaspora are the content of her work and form a complex and problematic imaginary of citizenship and belonging. And, the 'Africa' of Rolando's work is based on an imaginary of and for Africa.[6] Her project, however, also records Cuba as an Antilles – or rather, as part of a fragmented emotional geography that includes the Canary Islands, Jamaica, Haiti, Harlem and, of course, Africa.[7] In Gloria Rolando's work, Cuba is also the city, the street where the *comparsa* takes place, where the history of Afro-descendant cultural appearance was made, where the exiled Black Panther can hide, where the ancestors were brought as slaves, slave owners, Galician domestic labourers and Chinese merchants. The emotional geopolitics of the street are, therefore, the places of reanimating historical memory in the everyday. Of the three contemporary directors we are focusing on here, Gloria Rolando is closer to Sara Gómez's generation, and in Rolando's work we find direct homage to her predecessor. To her absolute delight, Rolando's *Pasajes del corazón y la memoria* (*Cherished Island Memories*, 2010) received the Sara Gómez Prize at the 30th International Festival of New Latin American Cinema, Havana in 2009. Rolando was born in Havana's Chinatown in 1953. Her filmmaking career spans nearly thirty years, beginning at ICAIC. She now also heads an independent filmmaking group, Imagines del Caribe, based in Havana. Rolando has written, produced and directed nine documentaries and has worked on numerous others as assistant director, researcher and writer. She has travelled extensively in the Caribbean, the US and recently in Canada, participating in conferences, giving workshops and screening her films. Rolando's film and video practice is best understood within the traditions of *testimonio* and *cine rescate*. Committed primarily to preserving and reanimating the history and memory of Afro-Cuban and Afro-Caribbean communities, her films are based on interviews and archival research. But, more than talking heads, Rolando's films are also conceptualised through musical forms, which she understands as fundamental to Caribbean identity.

Raíces de mi corazón (2001) is a fiction–documentary hybrid about a young Afro-Cuban woman's struggle to build a memory from fragments about the 1912 massacre of thousands of members of the Partido Independiente de Color, a national party formed largely by Afro-Cubans after the struggle for Cuban independence. This highly charged and contested chapter in Cuban history returns to the question of belonging and to the ways in which intimacies and maternal family lines can reframe the story of a nation. As we see in Rolando's newest film, *1912: Breaking the Silence,*

Part I (2010), the voices of the rap group Anómino Cosejo join with soci-
ologists and historians to perform the history of Afro-Cuban struggles for
citizenship. In this way, cultural traditions of Afro-descendency are given
primacy not just in the film but in the spatial politics of belonging. In this
first of two documentaries about 1912, voice-over is minimised in favour
of testimony and archival display – producing a powerful 'field of exhibi-
tionistic and expressionistic attractions' (Beattie, 2008: 4) which highlight
the main claim, according to Michael Renov, of any documentary: 'Believe
me, I'm of the world' (in Beattie, 2008: 4). In the 2001 docu-fiction, the
photographic portraits of her family that open the story, the history, and the
present, acting as thresholds or passages between the emotional geographies
and histories of Afro-Cubans, are a direct quotation from Sara Gómez's
Crónica de mi familia.

For Barriga and Sandra Gómez, the Cuban experience of globalisation
is also expressed as emotional geography, where diaspora is not recalled
from the history of African slaves but from the post-1959 ideological crises.
Where is this actually located? The use of the island as an Antilles can be
found across the history of Cuban art. The visual culture provides emo-
tional and political keys for understanding the expression of economic and
political internationalism, from colonial through post-colonial state forma-
tions. All three filmmakers evoke this tradition and to different ends. But the
more profound expression or element at work in the gendered geopolitical
imaginary is that of deterritorialisation. Each filmmaker locates this deter-
ritorialised imaginary in geo-aesthetical terms: Barriga's camera frame in
the London Tube stop and its inability to locate the father; Sandra Gómez's
space of the borderland as a utopian open city; Rolando's living traditions
wherein the nation is dispersed and transculturated in the streets of *com-
parsa* and in the gardens of Jamaican descendents. Continuing the legacy
of decolonised cosmopolitanism found in Sara Gómez in the 1960s, Sandra
Gómez most directly and literally locates herself on the Malecón, using it as
a temporal and spatial intimate geography.

Susana Barriga, born in 1981 in Santiago de Cuba, works as a producer
of short films and she is a radio and TV journalist. Her documentary
Patria was selected by Nyon and DocBsAs, and was given an award at the
International Meeting of Film Schools in Mexico and San Sebastian. *The
Illusion* has been invited by DocBsAs and Rencontres de Documentaires
in Montreal and won the DAAD Prise of the Berlinale 2009. Barriga's *The
Illusion* has apparently nothing to do with Havana, being shot entirely in
London, where the filmmaker goes to meet the father who left her as a
young child. The film opens with the end: in the entry to a London Tube
stop where Barriga stands aiming her camera at a distant and indistinguish-
able figure – the father. This structure forms a loop, a repetitive and ines-
capable structure that mirrors her father's psychic territory. Throughout
the encounter with the father, the camera is aimed at the ground, thus never
picturing him but rather overhearing their tragic conversation. But here, the

imaginary of belonging to Havana drives the disorientation and the impossibility of focalising, because in her father we can see the crystallisation of the hatred of authority in so far as he holds the Cuban government accountable for everything that has happened in his life. Then, with this narrow-mindedness, he is unable to see that familial relations are distinct from ideological forces. That is, the inability to see/to lift the gaze is driven by the emotional geography of not being at home. The geo-politics of alienation from her father and the alienation of the father from himself in this intense paranoia of the exile makes sense both because England is not Cuba and because London is not Havana.

Sandra Gómez situates her ethnography on El Malecón: a four-mile stretch of public space (Havana's 'social living room'). If Havana is understood as a border city (based on its transcultural history), El Malecón is at once an intensely present (spatially and temporally) and illusive place, made from contesting or non-identical cultures of time occupying the same space, thus turning that space into a place. As Sandra Gómez has said in a recent interview:

> In my documentary *The Future is Now*, I tried to influence the characters' behaviour as little as possible. This also holds true for the interviews: the characters were encouraged to express themselves freely. The result is a film with seven characters: a fisherman, a security guard, a writer, a doctor/rocker, a mother and son who live at the Malecón, two children and a man who has pitched his tent on the waterfront. All the characters complement, strengthen and contradict one another. The variety of views expressed in the film is important to me, as I believe it reflects the reality of life for Cubans who at this moment in time have conflicting ideas. Some of them are hoping for change while others would like things to continue as they have been and still are. Although it is impossible to see with someone else's eyes, I was interested in showing each character's situation and hopes for the future through their own eyes and allowing the audience to draw their own conclusions. In these historic times, when opposing attitudes are vehemently expressed within a society, there arises a risk of division. The mother and son who live at the Malecón, for instance, have contrary views. From the outset, I chose characters who were in some form or another associated with the Malecón. The final scene, in which they are all united at this location, is an image which I had not envisioned from the outset, but now concludes the film like a hope – maybe utopian – that Cuban society can remain united. (Gómez, 2010)

'Una ciudad de cartón'. These words are spoken inwardly by Sergio, the main character in Tomás Gutiérrez Alea's 1968 foundational Havana film *Memorias del subdesarrollo* as he traces the Malecón with his telescope from his apartment balcony. As one moment in his running interior monologue about the changes in and his alienation from the space, place, history and social relations of Cuba one year after the Revolution, Sergio's statement reveals one of a kaleidoscope of views that comprise the Malecón as a space of representation. Arguably the foundational film of post-1959,

Memorias del subdesarrollo returns in the final scene to the Malecón from the top of Sergio's apartment at a peak moment in the Cuban Missile Crisis: the roadway is thick with military vehicles. Between these two images, Sergio is a flâneur/anthropologist, whose mobile gaze maps the city and produces space coextensive with his class, race and gender. Sergio is a type of cosmopolitan character, one who, as those familiar with these debates will remember, was a site of Alea's dialectics: a space to work out the problems of belonging, of citizenship and revolutionary consciousness and commitment, and so forth. When Ana López wrote about the film and the social space it produces, she notes that the spaces in which Sergio travels are the spaces of a specific social group – before the Revolution they were the spaces that produced bourgeois citizenship: consumption, travel, mobility. Not unlike the 'tourist gaze' that John Urry (2001) discusses, Sergio experiences his city from the position of mobile viewing, fascination and 'wanderlust'. The city to which he belonged as a *ciudadano* has been repopulated by *compañeros*, that he engages with exclusively through sex, money or the law.

In Sandra Gómez, this physical space of the Malecón is a complex place of representations, histories, possibilities, temporalities and identities: the unseen beyond the horizon is Miami; the boats are also after-images of losses, such as the Marielitos and other *balseros*. The people she interviews are between this past and an uncertain future – a social and political liminality that permits or produces the possibility for certain enunciations, such as a writer who describes capitalism as a space where the floor is filled with snakes but the ceiling is limitless, whereas in socialism the floor is free of snakes and such dangers but the ceiling is only 2 feet high. The Malecón has a complex history as representation and in representations of space and place, from Alea's work in the 1960s to Fernando Pérez in the Special Period, where he makes the Malecón a space of profound intimacy and inward/psychological subjectivity in his films *La vida es silbar* (Life Is to Whistle, 1988) and *Madagascar* (1994). Cuban artist Manuel Piña's 1993 photo series *Aguas Baldías/Water Wasteland* and his large-scale installation from that series of an extreme close-up of the wall as limit–horizon, permitting only a relative fraction of the sky, have become very important works for the critical reflection on the sign structures and social practices that produce histories and counter-genealogies of utopic spaces. Finally, tourism imagery has delivered the Malecón as commodity: as a space of light and play and freedom – signifying differently depending on which side of the Malecón you come from, ideologically, geographically, economically.

Since the Revolution, the Malecón has been the site of a range of public practices, displays of solidarity and new monuments: from Carnival and baseball celebrations to displays of military might – such as was the case during the Cuban Missile Crisis – and a farewell procession for the revolutionary 'Che' Guevara, to public demonstrations against the measures taken

during the Special Period. In 2000, while the US courts were reviewing Elián González's case, an area in front of the US Interests building on the Malecón was turned into Plaza Tribuna Anti-Imperialista. It shows the national hero, José Martí, holding a child and pointing accusingly at the US diplomatic office. Hundreds of thousands of Cubans rallied and paraded there over the issue of Elián. This is also the site where more recently a massive crowd of young Cubans came to a heavy-metal rock concert, an event that Sandra Gómez films. While these rockers are closest to her in age and sensibility, she has stated that the most important person in the film is the fisherman, whose image of persistent yet fragile existence opens and closes the film: 'Su balsa nos hace pensar en la piedra de Sísifo y verlo entrar en el mar sin saber qué es lo que va a hacer evoca la idea de una fuga. Entre los personajes es uno de los que se expresa en modo puro, radical; dice simplemente lo que piensa y su sinceridad es emotiva' (Gómez, in Ávila López, 1992) [His raft makes us think of the Stone of Sisyphus, and seeing him enter the sea without knowing what he is going to do brings about the idea of a leak. Among the social actors in the film he is one who expresses himself in a pure and radical mode, saying just what he thinks, and his sincerity is emotional]. Here, Gómez transforms the Malecón from a site of either public eventness or intimacy. It is also a place of ritual and of heterogeneous and uncontrollable forms of everyday life. The social living room and the bedroom, the *flâneur*'s boulevard and a classroom, it is also a place of grief and ritual. Gómez's careful aesthetic and ethnographic attention brings this film closest to the documentary citizenship of which Azoulay (2009) writes: a space of in-betweens, of belonging to no one and to each other, an image of responsibility at the edge of utopia.

The work of documentary in the legacy of decolonisation struggles, and the place Cuba occupies in this history forms an extended public discourse about liberation, resistance, belonging and identity. In this public space of the image, in the context of Cuba, the appearance of women as social and political subjects has often been seen as symbolic of certain victories within a national–revolutionary narrative. The intimacies afforded by intersecting questions of gender, race, family, private space, and so forth, together with the grand narratives afford women filmmakers and their audience and social subjects a complex threshold of citizenship: one within which, as Azoulay (2009) argues, the image forms the space of appearance for citizens to appear to each other. The work of Sandra Gómez, Susana Barriga and Gloria Rolando, is central to this new formation of citizenship in the era of globalisation.

Notes

1 Much has been said (Borrero; Fowler; Stock; Venegas) about the historical lineage from Julio García Espinosa's *cine imperfecto* to *cine pobre* to the young filmmakers' workshop (Muestra Nacional de Nuevos Realizadores). Likewise, Venegas in particular has written extensively on the influences of Escuela Internacional de

Cine y Televisión (EICTV) in San Antonio de los Baños on the formation of the current generation of filmmakers.

2 The titles are: *Iré a Santiago* (1964); *Excursion a Vuelta Abajo* (1965); *Crónica de mi familia* (1966); a trio of films on the Isle of Pines (1967–69): *En la otra isla, Una isla para Miguel* and *Isla de Tesoro*; *Y ... tenemos sabor* (1968); *Poder local, poder popular* (1970); *Un documental a proposito del transito*; *Mi aporte*; a pair of films about prenatal and first-year child care (1972): *Atención pre-natal* and *Año uno*; *Sobre horas extras y trabajo voluntario* (1973).

3 'Chronotope' is used in cultural theory and film theory to refer to fundamental forms of self-understanding held by identities and cultures. This term originates in Bakhtin (1981).

4 We draw attention to the tradition of the urban ethnographer such as we see in Jean Rouch and Edgar Morin's important film *Chronicle of a Summer*, Chris Marker and, of course, Agnes Varda's films, as well as the Quebec filmmakers, such as Michel Brault, who was instrumental in the making of Rouch's *Chronicles of a Summer* (Rouch was close to and worked with Michel Leiris, who came to Cuba as the leader of the French delegation of leftist artists and intellectuals in the late 1960s). This network of urban ethnographers created an aesthetic through which to express locality and urban life inside the movement of an emergent global and decolonised consciousness.

5 Ferndando Ortiz was a Cuban ethnographer who developed the concept of 'transculturation' in his 1940 ethnographic study *Contrapunteo Cubano del tabaco y el azúcar* (*Cuban Counterpoint: Tobacco and Sugar*): 'I am of the opinion that the word *transculturation* better expresses the different phases of the process of transition from one culture to another because this does not consist merely in acquiring another culture, which is what the English word *acculturation* really implies, but the process also necessarily involves the loss or uprooting of a previous culture, which could be defined as a deculturation' (102).

6 It is worth noting that during the Special Period when Rolando began her independent video group, many Cubans were leaving the island through a special immigration policy with Spain and other European countries: if one could prove one's ancestry, one could immigrate and claim citizenship. For Afro-descendent people, their slave ancestry came back to haunt them as a terrible irony in the form of a joke they told themselves: '¿Tiene fe?': If you had 'faith', you could emigrate.

7 For more on Gloria Rolando's filmography and events related to her work, see Afrocubaweb: http://afrocubaweb.com/gloriarolando/gloriarolando.htm

References

Appadurai, Arjun. *Modernity at Large: Cultural Dimensions of Globalization* (Minneapolis, MN: University of Minnesota Press, 1996).

Azoulay, Ariella. *The Civil Contract of Photography* (New York: Zone Books, 2009).

Beattie, Keith. *Documentary Display: Re-viewing Non-fiction Film and Video* (London and New York: Wallflower, 2008).

Bakhtin, Mikhail. *The Dialogic Imagination: Four Essays*, ed. Michael Holquist, trans. Caryl Emerson and Michael Holquist (Austin TX: and London: University of Texas Press, 1981).

Bhabha, Homi. 'Double visions', *Art Forum*, 30 (5) (1992), 85–59.

Burton, Julianne. 'Democratizing documentary: modes of address in the Latin American cinema', in J. Burton (ed.), *The Social Documentary in Latin America* (Pittsburgh PA: University of Pittsburgh Press, 1990), pp. 49–86.

Borrero, Juan Antonio Garcia. *Guía Crítica del Cine Cubano de Ficción* (Havana, Cuba:Editorial Arte y Literatura, 2001).

—— *Otras Maneras de Pensar el Cine Cubano* (Santiago de Cuba: Editorial Oriente, 2009).

—— *Outsiders in Paradise: Foreign Filmmakers in Cuban Cinema of the 1960s* (Cines del Sur, 2010).

—— *Cuban Cinema* (Minneapolis MI: University of Minnesota Press, 2004).

—— 'Rediscovering documentary: cultural context and intentionality', in Martin, *New Latin American Cinema: Volume One: Theory, Practices, and Transcontinental Articulations*, pp. 201–20.

Gómez, Sara. Interview by Marguerite Duras in Havana. From the Gómez file at the ICAIC Cinemateca archive, Havana, 1968.

—— 'Filmmaker's Note.' *The Future Is Now* by Sandra Gomez: Documentary Film@ Brooklyn Film Festival. Brooklyn Film Festival, 30 April 2012.

Huyssen, Andreas. 'Memories of utopia', in *Twilight Memories: Marking Time in a Culture of Amnesia* (London: Routledge, 1995), pp. 85–104.

Lesage, Julia. 'Feminist documentary: aesthetics and politics', in T. Waugh (ed.), *Show Us Life: Towards a History and Aesthetics of Committed Documentary* (Metuchen, NJ: Scarecrow Press, 1984), pp. 231–46.

López, Ana M. 'Revolution and dreams: the Cuban documentary today', *Studies in Latin American Popular Culture*, 11 (1992), 45–57.

—— 'The state of things: new directions in Latin American film history', *The Americas: A Quarterly Review of Inter-American Cultural History*, 63(2) (2006).

—— 'Film and revolution in Cuba: the first twenty-five years', in Martin, M. T. (ed.), *New Latin American Cinema: Volume Two: Studies of National Cinema* (Detroit, MI: Wayne State University Press, 1997), pp. 157–84.

López, Enrique Ávila. 'La sensibilidad poetica en los documentales de Sandra Gómez', conference paper, 2010 Congress of the Latin American Studies Association in Toronto, Canada, 6–9 October 2010.

Massey, Doreen. 'Geographies of responsibility', *Geografiska Annaler*, 86 B(1) (2004), 5–18.

Nichols, Bill. *Representing Reality: Issues and Concepts in Documentary* (Indiana: Indiana University Press, 1992).

Stock, Ann Marie. *Framing Latin American Cinema: Contemporary Critical Perspectives* (Minneapolis, MN: University of Minnesota Press, 1997).

—— 'Migrancy and the Latin American cinemascape: towards a post-national critical praxis', in Elizabeth Ezra and Terry Rowden (eds), *Transnational Cinema: The Film Reader* (London: Routledge, 2006), pp. 157–66.

—— *On Location in Cuba: Street Filmmaking during Times of Transition* (Chapel Hill, NC: University of North Carolina Press, 2009).

Thrift, Nigel. 'Intensities of feeling: towards a spatial politics of affect', *Geografiska Annaler*, 86 B(1) (2004), 57–78.

Urry, John. 'Globalizing the tourist gaze', Department of Sociology, Lancaster University, Lancaster, 6 December 2003.

Venegas, Cristina. *Digital Dilemmas: The State, the Individual, and Digital Media in Cuba* (Piscataway, NJ: Rutgers University Press, 2010).

Vidal Alejandro, Aram. Interview with Tamara Roselló Reina. 'Ex generación...'. *Cuba – Revista Alma Mater*, 1 June 2009, in 'Cuban documentary film: 'Ex generación', *Repeating Islands: News and Commentary on Caribbean Culture, Literature, and the Arts*. 6 August 2009. Available online: repeatingislands. com/2009/08/06/cuban-documentary-film-ex-generacion

Part II

Culture and conflict

According to Edward Said, 'culture is sort of a theatre where various political and ideological causes engage one another. Far from being a placid realm of Apollonian gentility, culture can even be a battleground on which causes expose themselves to the light of day and contend with one another' (Said, in Edwards, 1999: 249). This quotation from Said shows how culture, whether we define it as the artistic and intellectual practices that we produce or, in broader terms, as the social, religious, political or linguistic practices that we share, is inextricably and inherently linked to the manifestations of conflicts. The latter could be associated with the ideological antagonisms that structure our social and political systems and that form the basis of our human interactions or as a series of violent conflicts, whether sanctioned by states or not, that take place at a local, national or global level, such as wars, terrorist attacks, genocides or any other acts that violate human rights or that represent a crime against humanity. Thus, if culture is ideologically shaped and contested, constructed and deconstructed, the interconnection between culture and conflict is always made manifest at a macro-political and at a micro-political level, thereby providing a mobile cartography of power and resistance. In other words, power, as Suely Rolnik argues, does not just impinge upon concrete reality but also upon intangible reality. Nonetheless, individual and collective creativity and resistance can be intensified, even in the face of societies which harbour the risk of unleashing microfascisms (Rolnik, 2008: 155). As a mass medium, cinema becomes a means of representing such cultural conflicts as a way of self-consciously or unconsciously reinforcing those social and ideological antagonisms, vicissitudes and turbulences, mediating these individual and collective experiences and discourses or reflecting upon these processes in order to propose and to imagine alternative symbolic systems that may potentially contribute to political change and social transformation. From this perspective, if the films made by women filmmakers in Portugal, Spain, Latin America and the US intersect with conflictive and conflicting social and political issues, to what extent have these cinematic practices problematically and symptomatically represented, shaped and contested the cultural imaginaries and conflicts of the Latin American, US, Portuguese and Spanish societies in which these films are inserted? How may these women filmmakers participate in

political change or social transformation by offering alternative cultural representations that may resolve the prevalent cultural conflicts?

The chapters in Part II on culture and conflict emphasise the way in which female filmmakers on both sides of the Atlantic explore the impact of cultural conflicts in these geopolitical areas on women subjects or the way in which, through the lens of gender, we may be able to understand differently those wider cultural conflicts. The specific conflicts tackled in Part II have to do with competing and conflicting notions of national identity, such as the case of Basque nationalism, whose most violent manifestation has been for many decades the acts of terrorism carried out by the Basque separatist group referred to as ETA, the violent conflicts between the Colombian government and armed guerrillas or the patriarchal violence inflicted upon many women working in sweatshops in Ciudad Juárez, a Mexican city located near the US–Mexican border. In this Mexican city, many women are the victims of rape and death. Such violence is, moreover, symptomatic of the violence produced by an unequal global economic system that is predicated on a structure of domination of more disempowered communities. The chapters that follow, by looking at the interconnection between gender and wider cultural conflicts, such as terrorism, guerrilla violence, patriarchal violence or the conflicts produced by an unequal globalised system, demonstrate that these women filmmakers are conditioned by and are responding to specific social and political realities through the cinematic image. Their films thus forge conflicting views of and incompatible debates on social and political struggles, thereby attempting to present alternative viewpoints to the official versions and hegemonic representations of these social and political realities.

In Chapter 8, 'Ana Díez: Basque cinema, gender and the (home)land', Ann Davies rethinks the concepts of exile and the uncanny, or *unheimlich*, and thus in turn implicitly the concept of home, in relation to Basque cinema. Davies suggests that the notion of home and of Basque motherland carry potentially different resonances for female directors. Focusing on Ana Díez's most significant film *Ander eta Yul* (1988), and the questions of homecoming, homelessness and alienation from home and family that the film presents, primarily through the character of Ander, Davies argues that Díez problematises Basque nationalism in terms of the home, in order to tease out issues of engendered point of view within Basque cinema and in representations of violence more generally. According to Davies, the case of Díez suggests that the question of Basque cinema is complicated by questions of gender, but that gender itself cannot in turn be used reductively as a theoretical framework. Rather, gender becomes one route into the exploration of the fissures within conceptualisations of a Basque cinema in terms of a home and homeland that serves to marginalise.

In Chapter 9, 'Slipping discursive frameworks: gender (and) politics in Colombia's women's documentary', Deborah Martin takes a deconstructive approach to the ostensibly coherent discursive frameworks of three

woman-directed documentaries from Colombia. Martin offers a feminist rereading of the New Latin American Cinema classic *Chircales*, which has tended to be read (in line with its own overt self-proclamations) as straight-forwardly Marxist, a (public) framework that, Martin argues, dissolves in the film, giving way to the 'peripheral' issues of gender and the private, a movement which is echoed filmically, as well as by a new emphasis on tactility over visuality. *La mirada* forms part of the little-documented work of the women's film collective Cine Mujer, a group influenced by second-wave feminism. This discourse, which implies a belief in political agency, and is part of the film's self-presentation, is again exceeded, in this case by thematic and aesthetic shifts towards the postmodern, which problematise notions of testimonial authenticity and agency supposed by the feminist framework. The film is also a meditation on, and a response to, debates on female spectatorship within European theoretical discourse. In the ground-breaking documentary *La Sierra*, the film's ostensible framework is that of state-led political discourse on the armed conflict, but again this is displaced by an exploration of gender issues, a self-reflexive examination of cinematic constructions of masculinity and a probing of the nature of women's discursive relationship to these and to the masculinist political paradigm. Martin's chapter as a whole, then, examines how dominant paradigms are destabilised or undermined by elements which seem peripheral or external to them, while examining the strategic appropriation in the Colombian context of the dominant paradigm as a covert means of exploring issues deemed culturally and politically less significant.

In Chapter 10, 'The "poetics of transformation" in the works of Lourdes Portillo', Rosa Linda Fregoso argues that Lourdes Portillo's films and videos are emblematic of the broad spectrum of social, cultural and political concerns of Chicana and Latina image-makers. Fregoso examines the interplay of a poetic imaginary with social justice concerns in the works of Lourdes Portillo. While her films remain grounded in Chicana/o Latino/a concerns, Fregoso explores how Portillo embraces a broader transnational vision which positions women at the centre of her stories and documents the effects of global economic and political processes, as well as intersecting structures of domination in the everyday lives of disempowered communities.

References

Edwards, S. *Art and Its Histories: A Reader* (New Haven, CT: Yale University Press, 1999) pp. 246–51.

Rolnik, S. 'Deleuze, schizoanalyst', in C. Martínez, N. Schafhausen and M. Szewczyk (eds.), *Manon de Boer: An Informal Study of the Mind* (Frankfurt: Frankfurter Kunstverein, 2008).

8

Ana Díez: Basque cinema, gender and the home(land)

Ann Davies

With Spain's return to democracy and the granting of regional autonomy to the Spanish Basque provinces, a sustained political and cultural conflict has ensued about the right of the latter to be considered an independent nation. At the cultural level, discussion of Basque cinema of the democratic era – one of the Basque Country's most prominent cultural exports in Spain and elsewhere – has become bound up with the debate over Basque independence. Implicit in any claim to the existence of a Basque national cinema, distinct from Spanish cinema, is the potential to claim the Basque Country as a separate national entity from Spain. While cinema made in the Basque Country has drifted away from the explicit call in the 1970s to see Basque cinema as a tool in the struggle for independence (see Sojo Gil, 1997), and while new formulations of Basque cinema have been proposed (such as, for example, cinema in the Basque language Euskera, cinema produced in the Basque Country, cinema made by Basque directors: see Torrado Morales, 2004), many recent directors who come from the Basque Country fight shy of the label of Basque director and Basque cinema.

Some theorists have worked to formulate new theoretical constructions that would serve both to recuperate these directors who are apparently in denial and to reinforce the notion of Basque cinema as a specifically national theoretical concept. I have discussed these theories in detail elsewhere (Davies, 2009) to argue that these concepts are based on notions of home, a concept that is problematic in terms of gender. In particular, I focused there on the theory of Joseba Gabilondo (2002), concerning the uncanny identity of Basque cinema:

> 'Basque cinema' occupies a distinctive position among contemporary Spanish discourses of subject formation. It is characterized by an uncanny questioning of its own identity and existence which is not found in, for example, Basque literature and art. (264)

Gabilondo is here drawing on the notion of the Freudian uncanny, or *unheimlich* (literally the unhomely; that which is familiar but yet also unfamiliar). I also considered the theory of Jaume Martí-Olivella (1999) of Basque cinema as a migrant cinema:

> Basque cinema … has become a kind of dual 'migrant subject', one that is fully
> aware of and exploits its migrancy and another that is never at home since
> home is predicated as violent and/or nonexistent. (207)

Both theorisations rightly point out the difficulties that Basque cinema has
in coming to terms with itself: nonetheless, migration and the uncanny rest
on a notion of home. Martí-Olivella stresses the contrast between migration
and home in the citation above, suggesting the home as an ideal, albeit pos-
sibly unattainable. Gabilondo's theory implicitly harks back to the *heim*, or
home in Freud's concept of the uncanny, home here implying what is com-
fortably familiar. These notions of home do not, however, automatically
take gendered ideas into account. The home for women may be as much a
place of work or of domestic entrapment as the implied return to security
and to one's roots. Rob Stone and Helen Jones (2004) have pioneered the
theorisation of gender in Basque cinema, noting traditional representations
of women in Basque film such as the *ama lur*, the traditional nurturer (45–6),
or the woman as a metaphor for the land (49): they argue that women who
fall outside these ideas find themselves in an ultimately unmappable space.

Martí-Olivella specifically compares the denial of Basqueness with the
denial of gender expressed by female writers and artists, who do not wish
to see themselves confined to some sort of feminist ghetto (1999: 206).
However, the notion of home and of the Basque motherland carry poten-
tially different resonances for female directors. This chapter will consider
the case of Basque director Ana Díez in the light of this problematic theo-
risation. It does not aim to provide a comprehensive overview of her work,
not all of which is in any case readily available for viewing and study.[1]
Rather, through an examination of two keys films, it seeks to trace the
way in which some of her work problematises the equation of home with
the Basque Country. It also suggests how Díez as a female director comes
to occupy an unmappable space in discussion of Basque cinema, in Stone
and Jones's terms. While male directors such as Enrique Urbizu, Alex de
la Iglesia and Julio Medem continue to be asked about their relationship
to Basque cinema, discussion of Díez has been negligible since the impact
of her debut Basque film *Ander eta Yul* (Ander and Yul, 1988). Home/the
Basque Country ghettoises its female directors too, who become invisible
even as they problematise the foundations of such identities. Díez and her
contemporary Arantxa Lazcano have challenged the potential oppression of
Basque nationalism, but their voices are swallowed up in the simultaneous
neglect of the work of female directors and the efforts to reassert Basque
cinema over against the Spanish. What this chapter aims to show is not
that Díez's status as a female director impinges directly on the depiction of
gender relations; rather, her films suggest a recurring sense of 'not at home'
which finds a parallel in Díez's own film career.

After studying cinema in Mexico, Díez made her first documentary *Elvira
Luz Cruz: pena máxima* (*Elvira Luz Cruz: Maximum Penalty*) in 1984,

which received a Mexican Ariel for the best testimonial documentary. She then returned to her homeland of the Basque Country, became involved in the Basque film industry, and in 1988 made her first and most renowned feature film, *Ander eta Yul* (*Ander and Yul*). After the film was released, Díez spent the next few years teaching screenwriting at the Complutense University in Madrid, until *Todo está oscuro* (*Everything Is Dark*, 1997), then released the documentary *La mafia en La Habana* (*The Mafia in Havana*) in 2000 and *Algunas chicas doblan las piernas cuando hablan* (*Some Girls Bend Their Knee While They're Talking*) in 2001. The year 2002 saw the release of *Galíndez*, a documentary about the disappearance in the USA in the 1950s of a member of the Basque government in exile during the Franco regime. She also contributed a short piece, 'Madrid mon amour' to the portmanteau film *Hay motivo* (*There's a Reason*, 2004) that compiled the reactions of different Spanish directors to the policies of Spain's ruling party of the time, the Partido Popular. Her most recent film was *Paisito* (*Small Country*) in 2008.

Díez made *Ander eta Yul* towards the end of the first wave of Basque cinema in the late 1970s and during the 1980s, as changes in both national and regional government in Spain allowed the Basque Country not only the freedom to use their own language and express their own culture, but also a certain amount of autonomous government that included the capacity to fund cultural production. Basque cinema quickly became a focal point of debate concerning the need to lay claim to Basque cultural identity over and against the Spanish. Cinema, more than many other cultural forms, however, is heavily dependent on financial considerations, given the cost of actually making a film, and distribution demands meant that Spanish sensibilities, including the use of the Spanish language, often had to be taken into account. Díez and Lazcano (with the film *Urte ilunak/The Dark Years*, 1992) are two of the few directors that used Euskera in their first feature films, although Spanish versions were also in distribution.[2]

Much of this surge in Basque cinema in the 1980s focused directly on Basque issues, including terrorism and the struggle over national identity. As time went on, a more critical approach began to develop, in which Basque national identity became problematised, beginning with Uribe's *La muerte de Mikel* (*The Death of Mikel*, 1983) which considered the hostility within Basque nationalism and Basque society to homosexuality. Díez's first film is recognisably a part of this problematisation. However, as the 1980s turned into the 1990s, Spanish cinema began to undergo changes which were paralleled in cinema by Basque directors: indeed, it could be argued that Basque directors were instrumental in inducing the Spanish-wide change towards more commercial vehicles (see Heredero, 1999: 12). Directors such as Urbizu and de la Iglesia rejected the concept of, and the imperative to make, Basque cinema, seeing themselves as filmmakers who happen to be Basque. Their filmmaking also contributed to a drive to make more generic and commercial cinema in which location was often incidental. Many

directors moved their camera – and sometimes themselves – outside the Basque Country. Díez herself appeared to undertake a move towards Latin America, with the feature film *Todo está oscuro*, set partly in Colombia, and the documentary *La mafia en La Habana*, studying the intricate relationship between the mafia and the Cuban and US governments prior to the revolution of 1959. Her documentary *Galíndez* also has Latin American elements, given that the subject of her documentary was eventually assassinated at the command of the then dictator of the Dominican Republic.

Key to Díez's work has been her professional relations with Basque producer Ángel Amigo, a journalist, writer and former member of ETA, the terrorist group fighting for Basque independence. Her contact with Amigo led her to work as director's assistant on other Basque films, including Montxo Armendáriz's *27 horas* (*27 Hours*) of 1986, and subsequently on José Antonio Zorrilla's *A los cuatro vientos* (*To the Four Winds*, 1987) (Filmoteca Vasca). Amigo subsequently produced *Ander eta Yul* as well as *Todo está oscuro*, *La mafia en La Habana* and *Galíndez*. Amigo has been a crucial figure in the debate over Basque cinema, arguing for a definition of the term as cinema *produced* in the Basque Country: he sees it in terms of a cultural industry, with the emphasis on the latter word, rather than as a political tool, although he recognises that actually establishing such an industrial basis is no easy task (Torrado Morales, 2004: 195–6).

Of all Díez's films, *Ander eta Yul* speaks most directly to the issues of home and exile posited within the theories of Basque national cinema, encompassing as it does questions of homecoming, homelessness and alienation from home and family that the film presents primarily through the character of Ander (Miguel Munarriz). The story concerns the forced repatriation of Ander, a drug dealer newly released from prison, to his home town of Rentería in the Basque Country, where he searches for Yul (Isidoro Fernández), his old friend and companion from their days spent in the seminary training for the priesthood. Yul, however, is a member of ETA who will eventually assassinate Ander as part of ETA's policy to execute drug dealers as a form of social cleansing. For Ander, the return home therefore means his death.

Ander is insistent in his rejection of the Basque Country, and Rentería as his home, a fact emphasised in the opening scene when he asks why he has to return to his home town from prison, and stressed still further in the long distance that he must travel in order to get there, suggesting the great gulf that has opened up between Ander and his homeland prior to this. The early sequence that depicts his coach journey home takes up little screen time, but economically it conveys a sense of a long journey not only through the fact that Ander is asleep for much of it but through the obvious cuts and ellipses that draw attention to the length of the journey. The sense of alienation from the Basque Country continues once he has arrived in Rentería. He is a stranger to the owners of the bar where he goes to in search of Yul, although there is a photo of himself with Yul hanging on the wall of the bar.

When the barman asks him if he is from a particular area of the town, Ander replies that he *was*, emphasising the past tense. Later, when Ander and Yul talk together in the countryside, Ander says he left the town because he couldn't bear the life there; and as far as he is concerned he continues to be on the outside, 'sigo fuera'. When Yul asks him why he came back, he replies that he has not: he is simply passing through.

Martí-Olivella claims Ander as an example of the 'migrant subject' in Basque cinema: 'Basque cinema becomes a "migrant subject" always already alien, a cultural and political stranger to itself' (1999: 209). This estrangement works both ways: if Ander rejects his homeland, his homeland rejects him likewise. It is through the character of Yul that Díez links the alienation of Ander from home to Basque nationalism. The photo in the bar that Ander originally spotted – and the first time that Yul is mentioned after the title credits – depicts Ander and Yul in mountain gear: mountain climbing had previously come to symbolise Basque nationalism, since many Basque nationalists used to meet under the disguise of mountain-climbing clubs (Clark, 1979: 50–1, 117–18). The tentative link to Basque nationalism hinted at through this motif is repeated in their past training for the seminary: the Catholic Church in the Basque Country also has had a strong link to Basque nationalism, whose founding father Sabino Arana identified Catholicism as a component part. From these shared nationalist roots, the two friends have moved in opposite and opposing ways. Yul now identifies himself closely with the Basque cause through belonging to ETA, while Ander has become one of nationalism's scourges. But this past friendship also has a familial connection. As María Pilar Rodríguez observes, the friendship of Ander and Yul is based on a past relationship that involved family (2002: 156). For Yul, Rodríguez comments, 'Personal and affective ties are replaced by the stern discipline of the organization [ETA], which imposes obedience to the cause of the independence of Euskadi over any other matter' (156–7). The equation of home with *patria* overrides the sense of the home as a place of close relationships and ties among family and community.

There is also an association between home – in this case the nation or *patria* – and the law: national law is one marker of national identity (Smith, 1991: 10–11). In Rentería, the law of the nation is disputed. Ataun (Joseba Apaolaza), the leader of Yul's operations team, defends the policy of eliminating drug dealers by saying that ETA is now the real police, the true state. And he claims it is recognised as the true law by the people, since ETA is carrying out the will of the people who like the campaign of elimination: 'esa gente ahora es nuestra' ('these people are ours'). ETA do the job that the police are incapable of doing: as the police inspector Bernardo (Ramón Barea) ruefully comments, if ETA continue with their policy of executing drug dealers, soon the police will be out of a job. In fact ETA and the police cancel each other out in terms of the law when Ataun and Bernardo simultaneously shoot each other dead. And for all Ataun's confident claim to the

law, he himself earlier comments that he is rescinding his command of his unit and exiling himself to France, since the ETA command feel he is burnt out. The matter of the law in this film is thus problematised. But for all this it serves to eliminate Ander: both the parties who lay claim to the law act to ensure his death. The Spanish state repatriates him, and once 'home' he falls foul of the ETA elimination policy. On the other hand, Ander is clearly not of the people as Ataun would define it, since he is one of those very drug dealers who must be eliminated, one of those the people wish to cast out. We could also argue that Ander's persistence in drug dealing demonstrates his insistence on being separate from these two forms of the law that lay claim to the nation, particularly that of ETA (though the fact that there is a market for his merchandise suggests that not all the people of the town wish to see an end to the drug trade). The notion of drug dealing as not of the nation is emphasised by the name of the chief dealer, el Flamenco, suggesting a stereotypical Spanish elsewhere that is underscored by the outsize Spanish fan that adorns the walls of el Flamenco's house. The fact that Yul shoots Ander by mistake for el Flamenco also suggests that drug dealing implies an otherness, a sense that no dealer belongs and thus that they are interchangeable. Ander's occupation of el Flamenco's house, where he will die, further suggests his estrangement from his actual home town, marked as the house is by a sense of the foreign.

The concept of the home also refers to actual houses, a concept celebrated in the presence of the Basque word for house – *etxe* – within many Basque surnames; and this notion, too, implies Ander's alienation from home. His own childhood home is now abandoned by his mother: it is run-down and dilapidated, and the only recall of the family home is the accusatory letter left him by his mother, who is not there to welcome her son home. This letter implies that the estrangement from home derived from Ander, who refused to accept letters from home, or to see his father, while in prison. But the reproachful tone of the letter shows that the estrangement is mutual, his mother's last words being simply 'What did we do to you?' The letter is given to us in voice-over using Ander's own voice: we do not hear her directly. This fashioning of the voice-over suggests further the lack of communication – and communion – with his mother, and stresses the sense of alienation from home. When Ander meets Sara (Carmen Pardo) later that evening, with whom he will begin an affair, he comments more than once that he is homeless and that it is a dreadful thing. Yet the attempt to find a home merely underlines the link between home and death, since, when el Flamenco hands Ander the keys to his home, he signs his death warrant: el Flamenco himself is abandoning his home since ETA's anti-drug policy means it is no longer safe for him to stay there.

The reception of *Ander* in the Basque Country was not positive. The reviewer of the film for *El País* noted that the Basque-language press accused Díez of fabricating paranoias, of bedroom scenes that were unconvincing and obscene in their very purity, while the daily bulletin for that

year's film festival in San Sebastián labelled her an opportunist (Martí, 1989). The reviewer himself praised the film, occasionally finding fault with it but generally lauding its realism. Such praise of course runs the risk of a sort of Manichaeism, in that anything the Basque nationalists do not like, the Spanish might praise to the skies. However, the reaction of sectors of the Basque press seemed not only harsh but linked to perceptions of national identity. In the report of her interview with the director, Ángeles García quotes the review of the daily paper *Deia*, linked to the ruling Partido Nacionalista Vasco (Basque National Party), in which the film was castigated for poor characterisation and fatalism, which appeared to view half of the Basque Country as zombielike. The review also questioned if the Basque Country is really there in the film at all, since the ordinary working people are absent, betraying a distaste for the portrait of the Basque Country as simply a land of violence, criminality and bohemian indulgence. But *Deia* observed that *foreign* critics would like the film, being romantics at heart and having a romantic view of the Basque Country (García, 1988).

Díez herself later commented that part of her crew saw her as leaning too much towards the Spanish side: she did not explain why, though it may have been because of a perception that she painted the Basque Country in negative colours (Hermoso, 2000). In the same interview she felt that the definitive film about ETA was yet to be made, suggesting that she did not see her own *Ander eta Yul* as definitive. These comments from both Díez herself and the critics suggest the danger of returning home, not only for Ander but for Díez herself, after her Mexican sojourn. This may explain why she 'retreated' to Latin America as the setting and subject for her other films, although Basque motifs were sometimes retained; and more particularly Díez continued to obtain Basque funding and production, the latter from Amigo who continued to work with her. The difficulties encountered by both Ander and Díez suggest that, while Díez's cinema exemplifies Martí-Olivella's (1999) concept of migrant cinema, it also makes more explicit the fact that migration may occur precisely because home is a troubled place and a troubling idea.

In 1997, on the release of her next film, Díez expressed relief that being a female director was no longer news, since other Spanish female directors had by now become prominent, such as Icíar Bollaín, Gracia Querejeta and Isabel Coixet (Villena, 1997). Her relief implies a distaste for ghettoisation that coincided with her move towards overtly Latin American subjects and away from the dangers of a Basque ghetto in which neither she nor her protagonist were made welcome. Nonetheless, for her next film Díez turned to a female-centred narrative, thus serving to illustrate that the problematisation of the concept of home can be figured through either gender, although the resonances in each case might be different. *Todo está oscuro* takes place in the Colombian capital of Bogotá, where Juan (Kike Díaz de Roda), a Spanish journalist, is killed by *sicarios* (young hired killers). His sister Marta (Silvia Munt) travels from San Sebastián to Bogotá to reclaim

his body and, as the film unfolds, discover why he died. In the process of her investigations she encounters Óscar (Diego Achury), the *sicario* who in fact shot Juan, and his sister Jenny (Valeria Santa), children who live in a run-down barrio of the city and who survive as best they can in a violent world. It turns out that a criminal organisation known simply as 'the office' are searching for a videotape left behind by Juan that contains information damaging to their interests, and they pursue Marta, Óscar and Jenny as potential possessors of the tape. Marta eventually finds the tape in Juan's deposit box and discovers on watching it that Juan himself had become involved in the drug-trafficking rings of the city. But her discovery is not enough to save Óscar and Jenny, who are both murdered.

Todo está oscuro functions as a thriller with a thread of social realism in the depiction of the ways in which poor children must survive in Bogotá. In keeping with the title, the film includes a number of very dark sequences, where characters can only be distinguished with difficulty in the murk, or where the cityscape is reduced to numerous indistinct points of light in the darkness. Although the reality of Spain and of the Basque Country appears to have been omitted from the film, the latter implicitly traces itself onto the film from the very beginning. The first shots of the film are the opening credits against a black background emphasising Spanish, Portuguese and above all Basque involvement in the film's production, which contrasts with the bright Latin American musical theme that then begins to play over the credits and the opening action sequences. These credits (including the title) clash with the music that we subsequently hear, suggesting that Colombia, for all that the film barely shifts from the place, is alien, foreign to the film's roots. This also explains why later there is the otherwise unnecessary aerial shot of San Sebastián immediately prior to introducing Marta at work in her office in the town. There is no direct reference to San Sebastián again, and no emphasis on its geography; but this brief flash of a quintessentially Basque city serves to remind us of the film's origins. As Marta pursues her investigations around Bogotá, others stress her for-eignness: Jenny asks her why she talks in a funny way, while arch-villain Francis (Robinson Díaz) implies that since she is Spanish she has no idea how life in Bogotá works.

The reasons why Marta stayed in Spain while Juan went to live in Colombia seem rooted in domesticity and timidity: Marta comments to Juan's partner Leonor (Klara Badiola) that somebody, i.e. herself, had to stay at home to look after her father, and she was in any case too much of a coward to leave. Home in the Basque Country becomes a place of igno-rance and isolation, linked in terms of gender to the fact that women at home often suffer from such isolation and lack of awareness and that family care often falls on the woman, trapped at home while male members of the family are able to get away. However, the film posits a strange parallel between Marta's life in San Sebastián and the introductory sequences that show her in charge of an office, and the mysterious organisation behind the

killings in Bogotá, also known as the office. This indicates that Marta is not able to distinguish as readily as she might like between home and abroad: eventually she herself holds Francis at gunpoint and kills him when he lunges for her. Her brother, too, is implicated in the corruption and violence that pervades Bogotá. Thus, as the title suggests, everywhere is dark and home is no refuge, as corruption in the form of the brother still lies at its heart, even as the brother is estranged from both home and homeland, thus coinciding with Martí-Olivella's theorisation of Basque cinema as estranged from itself (1999). Juan, semi-ironically, argues that his collaboration with the traffickers demonstrates his patriotism towards his adopted country, since any country would act to guarantee the export of its principal product. Love of a homeland, on his reading, automatically implies corruption.

Thus home – figured through the family – is not trustworthy. Marta's loss of her brother extends beyond his physical death to his self-assassination of his own character: his confession to her is the climax of the film. It leads Marta to abandon her brother's ashes in the taxi to the airport: she will not return them home. Instead she tries to form a new bond resembling a family with Óscar and Jenny after Óscar takes her at gunpoint to his home. Despite the initial hostility when they first meet, in Óscar's home the relationship turns gentle as they look at each other, as Marta smiles to herself and as Óscar looks over her shoulder while she works on her laptop. Díez shoots this scene in almost total darkness, the only light coming from a lamp in the house: this time, darkness contains tenderness. Díez dwells at some length on scenes such as the three characters eating together in a café, or waiting for time to pass in the car before the rendezvous with Francis. Indeed, she almost overdoes it, with the use of saccharine music as Jenny draws on the windows of the car, the picture of innocence. The heavy-handed coding of these scenes suggests not only the new family bonding but also its precarious nature, as if the overstatement of the scenes is asking to be undermined. Ultimately, this alternative family also proves unsustainable, as both children die: this family, too, is bound up with violence and corruption, which leads to its demise.

At the time of the release of *Todo está oscuro*, Miguel Ángel Villena remarked that any form of violence frightened Díez, who experienced physical discomfort to the extent of wanting to vomit (Villena, 1997). The film reflects this discomfort to the extent that violent acts are never seen but only implied: the deaths of the young *sicarios* Chino (Moisés Rodríguez) and Óscar, for instance, are signalled only by a shot off-screen and a subsequent cut to an inert body. The most distressing acts of violence for Marta, the deaths of her brother Juan and Óscar's sister Jenny, occur when Marta is not present and she only discovers their deaths afterwards. We can recall a similar phenomenon in *Ander eta Yul* to some extent, given that when Yul shoots Ander – the most significant of the acts of violence that occur within the film – we do not see Ander fall dead: instead the camera continues to focus on Yul's face at the point where we would normally expect to see

Ander die. In *Ander*, then, the oppression caused by home erupts directly into violence and yet, like much of the oppression of home, it is hidden. In *Todo*, the violence demonstrates the weakness of home as protection and shelter against the world outside: it provides no solution. Gabilondo rightly notes the dangers of too easily conflating Basque cinema with violence, and argues that 'Basque cinematic violence follows an uncanny pattern that defies representation; that is, Basque cinema does not represent violence but rather *performs the violence of the process whereby its identity is represented as other*' (2002: 268), posited on a Basque/Spanish basis that rests on the Spanish state as the ultimate source of this othering process. Certainly Díez bypasses the representation of violence, and the Basque Country is rendered as other in her films, but her work also suggests home in all its myriad meanings as other. The violence in her films renders the concept of home as negative and alien on a personal rather than a national level.

To a great extent, the work of Díez outlined here serves to remind us of Martí-Olivella and Gabilondo's theorisation above, in which the idea of the Basque Country as home and as the homeland is not automatically tied to representation of a specific geographical territory but floats geographically free; but it also questions the implicit idealisation of home in these theories. Díez's films do not automatically disprove the validity of such theories, and indeed the latter can aid our appreciation of both Díez's films and of the position of the director, suggesting as they do the potential estrangement of director and of subject matter and style from attempts to create a Basque national cinema, a potential which seems clear in Díez's case. But the multiple meanings of the concept of home reveal a need for further theoretical nuance that takes account of gender among other concepts. And yet we cannot talk here simply of replacing notions of nation with those of gender. Home can be a gendered concept, but as the work of Díez demonstrates, not reductively so: she does not necessarily privilege a female viewpoint (though she does not neglect it either), or traditionally female subject matter. But notions of both gender and home appear to render Díez and her work unmappable in Stone and Jones's sense: no one wishes to recuperate Díez's voice for the Basque Country, in contrast to the male directors who are more to the fore in contemporary cinema in Spain. Instead, Díez's work hovers in an indeterminable space between the Basque Country and Latin America, a space where neither the director nor the characters in her two principal films can truly embrace the idea of home.

Notes

1 I would like to thank Dr Carmen Herrero, who was able to grant me access to some of Díez's films.
2 I have used the Spanish version of *Ander eta Yul* in writing this chapter.

References

Clark, R. P. *The Basques: The Franco Years and Beyond* (Reno: University of Nevada Press (1979).

Davies, A. 'Woman and home: Gender and the theorization of Basque (national) cinema', *Journal of Spanish Cultural Studies*, 10(3) (2009), 359–72.

Filmoteca Vasca, 'Ana Díez', www.filmotecavasca.com/index.php.es/personajes/00151. Accessed 12 June 2007.

Gabilondo, J. 'Uncanny identity: violence, gaze and desire in contemporary Basque cinema', in J. Labanyi (ed.), *Constructing Identity in Contemporary Spain: Theoretical Debates and Cultural Practice* (Oxford: Oxford University Press, 2002), pp. 262–79.

García, Á. '"Sólo quiero contar historias actuales y de Euskadi", afirma Ana Díez', *El País*, 21 September 1988.

Heredero, C. F. *20 nuevos directores del cine español* (Madrid: Alianza, 1999).

Hermoso, B. 'ETA en el cine: el tabú se ha roto', *El Mundo*, 1 April 2000.

Martí, O. 'La realidad sube a la pantalla', *El País*, 13 January 1989.

Martí-Olivella, J. 'Invisible otherness: from migrant subjects to the subject of immigration in Basque cinema', in W. A. Douglass *et al.* (eds), *Basque Cultural Studies* (Reno: Basque Studies Program, University of Nevada, 1999), pp. 205–26.

Rodríguez, M. P. 'Female visions of Basque terrorism: *Ander eta Yul* by Ana Díez and *Yoyes* by Helena Taberna', in O. Ferrán and K. M. Glenn (eds), *Women's Narrative and Film in Twentieth-Century Spain: A World of Difference* (New York: Routledge, 2002), pp. 155–67.

Smith, A. D. *National Identity* (London: Penguin, 1991).

Sojo Gil, K. 'Acerca de la existencia de un cine vasco actual', *Sancho el Sabio*, 7 (1997), 131–8.

Stone, R. and H. Jones 'Mapping the gendered space of the Basque Country', *Studies in European Cinema*, 1(1) (2004), 43–55.

Torrado Morales, S. 'La evolución histórica del concepto del cine vasco a través de la bibliografía', *Sancho el Sabio*, 21 (2004), 183–210.

Villena, M. Á. 'Ana Díez viaja en su nuevo filme "del orden al caos de la violencia"', *El País*, 21 April 1997.

9

Slipping discursive frameworks: gender (and) politics in Colombian women's documentary

Deborah Martin

This chapter examines women's documentary in Colombia, where pioneers such as Gabriela Samper began production in the 1960s, and where key female figures, notably Martha Rodríguez, Gloria Triana and, more recently, Silvia Hoyos, have continued to the present day.[1] Paulo Antonio Paranaguá has emphasised the need for a new critical paradigm, pointing out that, in Latin America, 'the tendency to focus on militant revolutionary politics has meant the downplaying of other types of commitment, such as feminism's prolonged impact on cinema' (2003: 76).[2] Here I begin to address this question with regard to Colombia, taking a deconstructivist approach to the discursive frameworks of three important films: *Chircales* (*Brickmakers*), by Rodríguez (with partner Jorge Silva, 1965–72), *La mirada de Myriam* (*Myriam's Gaze*) by Clara Riascos with Colectivo Cine Mujer (1986), and *La Sierra* (Margarita Martínez and Scott Dalton, 2005).[3]

All three films deal with marginal spaces, the edges of cities which have increasingly characterised Colombia's social geography during the period they span, and all in some way interrogate the absence of the father, as the dissolution of patriarchal structures precipitated by accelerated urbanisation takes place. These documentarists strategically appropriate dominant contemporary political discourses, in order to foreground marginal gender issues, often using a 'public' framework, and moving (aesthetically or thematically) towards the private. Gender is in various ways imbricated in the national: in *Chircales* and *La Sierra* either desire for a woman (in the former) or woman's desire (in the latter) becomes bound up with desired versions of the nation, constituting a major discursive shift.

The films' self-positioning within discourses of materialism and feminism is a crucial issue in a region where the rhetoric and visual strategies of the New Latin American Cinema (of which *Chircales* is very much a classic) are a blueprint. As Ella Shohat has pointed out, the aesthetic concerns of the New Latin American Cinema were partially shared with those of first-world feminist independent film:

> The project of digging into 'herstories' involved a search for new cinematic and narrative forms that challenged both the canonical documentaries and

mainstream fiction films, subverting the notion of 'narrative pleasure' based on the 'male gaze' ... [P]ost-Third-Worldist feminist films and videos conduct a struggle on two fronts, at once aesthetic and political, synthesizing revisionist historiography with formal innovation (2003: 55).

Chircales' disruption of 'narrative pleasure' and privileging of feminist visual strategies prefigures *La mirada*'s more overt criticism of the cinematic apparatus and its dominant constituents. The discursive shifts which happen in each film do so on a formal as well as a thematic level, and questions are raised about whether documentary is necessarily about a masculinist drive to knowledge, or whether 'feminine' emotional and empathetic approaches (De Bromhead, 1996: 3), or sensorial and tactile ones are also valid. Within each documentary, a hegemonic discourse unravels and the filmmakers take advantage of the resulting space to attempt a different politics from that which the film overtly claims, and to foreground aesthetic or theoretical concerns.

Chircales

Chircales is a canonical text of the New Latin American Cinema, a movement which, 'by underscoring class as the primary instance of social relations [has] rarely taken into account gender-specific forms of social and political oppression' (Pick, 1993: 66). *Chircales*, though, with its insistent focus on some of the basic tenets of second-wave feminism, is in this sense somewhat *atypical* of the New Latin American Cinema movement. Criticism has given little attention to the way that heroic, revolutionary and patriarchal discourse becomes conspicuously flawed as the film continuously displaces onto women's lives and relationships, and *Chircales* is forced to confront the absence of a transcendental signified, here the father/worker, the *logos* around which Marxist discourse revolves. It does not, however, ultimately resist the desire to re-fix meaning through the reification of woman.

The film centres on the Castañeda family, who are brickmakers (*chircaleros*) suffering extreme poverty and horrific labour conditions in an 'urban latifundium'[4] of Bogotá. Anthropologically oriented, it combines still photography of the workers and haunting periods of silence, a God-like narrator and intertitles for information and rhetorical effect. Marxist issues of production relations, for example the overt political analysis of *compadrazgo* (godfather–client relations), are displaced by the silent inherence of *reproductive* relations, such as images of a breastfeeding mother for which the political analysis is conspicuously absent. Feminist issues, such as the mother's role in passing on mechanisms of patriarchy to daughters and women's lack of control over their bodies (and the way that constant reproduction benefits the bosses) are thematically predominant, but not acknowledged, either by the film itself, or by the directors. This silencing of gender has been maintained for the most part in critical work on it. Pick

acknowledges that women are 'given a metaphoric quality' (1993: 46) in the film, but does not explore this.

The film progresses quickly from its public framework to the private. The public squares of Bogotá at election time give way to the interior of the Castañeda home, while visual aporia in an otherwise strident Marxism seem to link women across classes; a bourgeois woman's glove is highlighted in the initial sequences and is later echoed by the glove belonging to Leonor Castañeda's communion outfit. Such details are typical of *Chircales'* filmic language, a nascent feminist aesthetic which privileges the edges of the frame, that which Clara Riascos would later call 'el bordadito', 'la pende-jadita' (Cine Mujer, 1987: 12).[5] Ideological displacement is thus echoed aesthetically by a decentring of the filmic frame, and takes place in the filming of the brickmakers: a straightforward shot of a worker carrying out the labour that the film is criticising pans down to a minute detail of the body, perhaps a hand or a foot, drawing attention away from ideology and towards aesthetics. The movement from totalising picture to detail effects (in both message and medium) a displacement of the iconic image by the repressed elements of discourse, a displacement that can be coded as feminine if we take the detail as the repressed, feminine-coded element of the Western aesthetic tradition (Schor, 1987: 3–4).

Moving from the general to the particular, from masculine to feminine, the film also evokes a sense of touch by foregrounding limbs engaged in various activities of rubbing or washing, echoing the contact the *chircaleros* have with their materials. The film's respectful, almost loving, treatment of the labouring body and materials dignifies this work, without denying its harshness and inhumanity. In *Touch*, Laura Marks suggests that a 'haptic, visceral intimacy engenders an ethical relationship between viewer and viewed, by inviting the viewer to mimetically embody the experience of the people viewed' (2002: 8). Through these images, *Chircales* evokes a comple-mentarity between the materiality of skin, clay/mud and film itself. Jane M. Gaines notes the lack of 'discussion of the sensationalized body in radical documentary films, perhaps because one tends to think of sense and body in terms of sexuality, and the committed documentary has always been seriously asexual' (1999: 90), but claims that such films 'often make their appeal through the senses to the senses' (1999: 92). Perhaps, then, we can see *Chircales'* appeal to sense perception as an engendering of an 'ethics of shared embodiment' (Marks, 2002: 8).

The idea of 'Touching, not mastering' (Marks, 2002: xii), can also be understood in terms of a feminist subversion of the eye/I, following the thought of thinkers such as Luce Irigaray, who associates the feminine with nearness (1985a: 205–18), and visual regimes with the phallic (25–6). Though Marks prefers to see the haptic as 'feminist visual *strategy*, an underground visual tradition in general' (2002: 7), in either case the film's displacement of traditional, patriarchal politics is echoed aesthetically, its political framework of meaning unravels parallel to the dissolving

ocular-centric frame. Both systems of meaning are displaced by a feminine element, as exemplified by the intimate hair-brushing scene between the two Castañeda sisters, with its new focus on surface, touch and 'feminine' closeness. Female–female relationships are emphasised, while Alfredo, the father who drinks and is therefore unable to work, becomes what Kuhn might describe as a 'structuring absence' at the film's centre (1994: 83). The symbolic death of the father is echoed in the film by the death of another male community member, and the crescendo-like effect of voices during the funeral reflects a general cultural preoccupation with the lack of anchor for still-existent patriarchal structures, and a sense of loss and nostalgia linked to the dissipation of patriarchal grounding narratives in the context of modernisation.

The communion of Leonor gives the film its most important sequence, in terms of both aesthetics and feminist critique. David Wood points to 'the poetic escape of Leonor's dress' (2005: 94) in this scene. I would suggest that not simply the dress, but Leonor herself, her beauty, apparel, virginity and whiteness (emphasised by the lighting) – her momentarily imagined idealised ethnicity and femininity – functions not only as a means of escape from the drudgery of the Castañedas' existence (and hence as capitalism's handmaiden), but that the body of the young woman becomes the nexus through which cinema channels fantasies of race, class and gender. This goes against the grain of existing criticism, which emphasises the directors' unimpeachable political commitment, but the film, as a cultural text and a product of ideology, invests woman with transcendent meaning, troping her, and therefore participating in discourses of gender, in spite of itself.

Nira Yuval-Davis has claimed that 'Gendered bodies and sexuality play pivotal roles as territories, markers and reproducers of the narratives of nations' (1997: 39), and furthermore that 'women especially are often required to bear this "burden of representation"' (1997: 45). In *Chircales*, in the absence of a male revolutionary father-hero, desire for nation is mapped onto an idealised femininity, through woman's cinematic to-be-looked-at-ness,[6] a desire which in the film is exposed by the insistent gaze of Leonor's diegetic audience, the family and community members to whom she 'appears' in her communion dress. This element of *mise en abyme* – a diegetic gaze which refers to the extra-diegetic one – alludes to wider structures of cinema itself, alerting us to the ideological aspects of cinema.

La mirada de Myriam

La mirada de Myriam is a short film by Clara Riascos and the collective Cine Mujer. It combines interviews with Myriam Ramírez, single mother and edge-city dweller, with documentary-style footage in the present, and fictionalised flashbacks of her childhood, which are accompanied by the adult Myriam's narration. Its modernist belief in agency and in women's power to mobilise testifies to the legacies of the New Cinema and of

second-wave feminism and Cine Mujer's understanding of film as a political tool.[7] This politics, however, merges with an aesthetics which leans towards the postmodern: the film's reflexivity and blurring of fictional and documentary elements create a filmic language which muddies its seemingly straightforward political waters; the questioning of a unified subject and the refusal to adhere to a linear form do not allow for an unproblematic understanding of historical subjectivity. The use of flashback, too, privileges subjective, over objective, truth (Hayward, 2006: 153), and deliberately introduces an element of meaning–construction, complicating any categorisation of the piece as a documentary, a move which Riascos justifies through reference to the 'magical' elements in Myriam's past (Cine Mujer, 1987: 18), claiming that its *intimismo*[8] and partial fictionalising gives it 'a stronger ... and more effective political content' (Cine Mujer, 1987: 11). Riascos, then, effects a feminist re-politicisation of documentary, as a response to contemporary calls for the inclusion of desire and fantasy as a legitimate political tool in women's film. The making of *La mirada* coincided with a heightened debate in film theory around female spectatorship, particularly in Britain, where members of the collective had spent time (Cine Mujer, 1987: 11). Particularly relevant is Johnston's essay 'Women's cinema as counter-cinema' which advocates combining an emphasis on the conditions of production, with a focus on women's fantasy and desire, a goal seemingly shared by this film (1976: 215–17).

Myriam has taken part in an *invasión*, or dwelling-creation, on the edge of Bogotá, recalled in her commentary. Events from her childhood, where a lack of motherly affection caused her pain and anger, are also narrated and dramatised in the flashback. The film's reflexive elements are exemplified by the title, and Myriam tells us that as a child she came to believe she had the 'evil eye', an ability to cause harm to others through looking, an affliction which is 'cured' in the film, as part of the flashback, by an elderly indigenous man. The film ends, back in the present day, with Myriam achieving her goal of 'being somebody' through community endeavours. The film, then, blends an emphasis on present-day grass-roots politics with a past in which fantasy, magic and desire dominate, leading to a displacement of the film's modernist framework of political and historical agency.

The motif of the mirror is crucial to the construction of meaning in the film. During the flashback, the child Myriam is shown looking into a mirror and, shortly afterwards, we see the adult Myriam doing the same. Myriam's mirror-gazing is closely linked to the mother's (bodily) presence and her diegetic gaze effects a staging of the female spectator's dilemma. Film theorists such as Metz have likened the spectator's relationship to the screen to that of infant to mirror during the Lacanian 'mirror stage'.[9] Metz also points to the mother's body as the object in the mirror 'par excellence' (1982: 45), perhaps accounting for the particularity of the visual figuring of woman in cinema. Myriam's narrative of longing, in which she describes her childhood desperation for motherly affection, is accompanied by images

which acutely suggest a relationship between the daughter's longing for her mother and vision/looking. The mother herself is positioned at the edges of the frame, her face mostly hidden from view, suggesting the absence of symbolisation of the mother–daughter relationship (Irigaray, 1985b: 71) and the absence of identificatory position for the female spectator. The relationship of Myriam to her mother is itself an important symbolisation of the type for which Irigaray calls. For example, Myriam states that 'I decided to "invade" for ... I think it was for the same reasons as my mother', linking maternal genealogies with processes of land occupation.

Teresa De Lauretis (1984) argues that the female spectator is positioned bisexually, as a result of the problematic mother–daughter relationship, and her unrelinquished desire for the mother. Myriam's longing for the mother in the mirror is counterpointed by her meeting of Don José, a witch doctor, whose curing of Myriam's 'evil eye' seems symbolic of the turning of the little girl/spectator towards the father, since her 'evil eye' has been associated by Myriam with her anger towards the mother as well as with another little girl whose death she believed she had caused by looking at her. Riascos seems to be highlighting the culturally forbidden female gaze and its neutralisation by patriarchal cinema. De Lauretis argues that 'the real task [of women's cinema] is to enact the contradiction of female desire, and of women as social subjects, in terms of narrative' (1984: 156). Whereas some films must 'kill off' the mother to resolve the Oedipal trajectory and neutralise a problematic double desire, the presence of the adult Myriam *herself* in the narrative's back-and-forward movement between past and present means that, structurally, the film maintains mother–daughter identification/desire, and a unification with self and with the mother which takes place upon becoming a mother (Kristeva, 1980: 239), creating a textual mirroring between Myriam in the present and her own mother in the flashback. But while Myriam's (nameless) mother is silent, Myriam speaks.

In *The Acoustic Mirror* Kaja Silverman differentiates between the male authoritative, disembodied voice-over (1988: 48–9) and the 'sonorous envelope' fantasy of the maternal voice, often conflated with the female body in cinema (63). While the mother of *La mirada* is reduced to the corporeal, the adult Myriam assumes an authoritative maternal voice, at times disembodied (accompanying the flashback), at times embodied (in direct address), allowing the spectator of *La mirada* access to a voice denied her by dominant cinematic practice. Flashback is a gendered device in dominant cinema, in which the combination of female subject–enigma and male narrator–investigator is frequent (Hayward, 2006: 157; Turim, 1989: 160). Riascos's use of flashback is counterhegemonic and implies female agency, as it takes Myriam as both subject and narrator. In doing so, the film itself becomes a new 'mother', a visual *and* acoustic mirror. Through a visual language which displaces the straightforwardly political feminist documentary with self-reflexivity, intimacy, desire and fantasy, the film effects a re-politicisation of the genre.

La Sierra

Like *Chircales*, *La Sierra*, the first film of journalist Margarita Martínez and cameraman Scott Dalton is the product of a long period of investigation and living with the community being depicted. This film centres on a paramilitary-run *barrio*, La Sierra, on Medellín's easternmost edge, and on inhabitants Edison Flórez, a paramilitary commander, Jesús Martínez, under his command, and Cielo Muñoz, a 15-year-old widow displaced from her former home by left-wing guerrillas. Neither anthropological document, nor fictive construct, the film contains elements of both of these, and presents the cultural critic with the dilemmas associated with such hybrid media, entailing a necessarily interdisciplinary approach. Like *Chircales*, *La Sierra* strategically straddles different categories, gaining space for marginal issues by appropriating the dominant political paradigm – in this case, the legitimising framework of a documentary on paramilitaries and demobilisation.[10] As well as inhabiting generic borderlands, the film's authorship – Colombian director/interviewer (Martínez) and US cameraman (Dalton) and producer (Andrew Blackwell) places it in an interesting terrain between the global and the local. There is an intensely local specificity to the *barrio* which is partially cut off from its surroundings, socially and geographically. As Martínez says of the film's subjects: 'Because they were kind of closed in – it was that Medellín full of borders – they couldn't leave. They were always there' (Alzate Vargas, 2005: 57; my translation). On the other hand it is globally connected, made with an international audience in mind, with the first cut being subtitled in English and a website where the protagonists' stories can be followed in Spanish or English. The film has been shown all over the world, and it was equally well received in Colombia. The fact that it has been widely viewed in Colombia as well as abroad, that the cameraman was from the US and that the subjects knew the film was destined for export all create interesting tensions between the global and the local.

A tension between circularity and progress dominates the film, and while it often seems to be describing a transition from war to peace, in reality it is more prescriptive than descriptive, since the transition it concentrates on is partial, temporary and woefully inadequate. The film never mentions the human rights abuses of which paramilitaries are routinely accused, although this may be inevitable in a film which attempts to have an immanent relationship to the community portrayed. It relies on irony to subtly expose the subjects' ideology around human rights and war, particularly where paramilitary violence conflicts with the demands of parenting, a crucial issue in a film where competing versions/performances of masculinity come under scrutiny as part of a wider focus on gendered performance.[11]

Robert Connell has underlined the existence of a range of 'hegemonic masculinities', rather than a single one (2002: 249). In Colombia the warrior or violent male competes with the category of 'father', though

fatherhood and violence are linked in the film by the founding narratives of the *barrio*, which are based on the violence of Edison's father. Edison himself speaks about the killings in which he has participated, dandling his newborn baby on his knee, the kind of jarring moment through which the film creates an ironic commentary on its subjects. Paranaguá sees a 'dialogue with the father' as a central trope in recent Latin American documentary (2003: 77). In *La Sierra* the roles of law provider and father become *literally* synonymous, as Edison populates the *barrio* with his offspring through his impregnation of teenage girls. The film highlights the copying and/or replacement of fatherhood models on the part of both Edison, and other subjects, in ways that entail performativity. Both Edison's violence (he is killed at the end of the film) and his polygamous model of fatherhood (his female counterparts greatly outnumber, as well as outlive, him) make for a displacement of the male perspective by the end of the film, which ends with the image of Jazmín, the mother of one of his children. In *La Sierra*, idealised or phantasmatic family structures are performed or imagined by the subjects, for example where the teenage mothers call Edison 'my husband', or say of him 'he gives me everything'. The simulation of such roles within relationships strikingly different from those imagined rearticulates the spectral nuclear family but in a context which manifestly exposes the copy's failure, thus opening up the ground for a kind of resistance.[12]

The male body becomes a palimpsest over which the film plays out the transition from a bellicose to a peaceful masculinity: Jesús gives exaggerated illustration to the idea that scars and wounds are an index of masculinity (Badinter, 1995: 68), when he describes injuries caused by a grenade exploding in his hand: 'my face, my genitals, my body, but nothing serious'. The bodies of the paramilitaries are an image of containment and separation: 'only a hard, visibly bounded body can resist being submerged into the horror of femininity' (Dyer, 2002: 265). The film constantly suggests the fluidity of masculinity, however – Jesús's giggly, playful drug-taking scenes, and his tending of baby chicks and his child contrast sharply with his fighting sequences. By the end of the film, Cielo has a new boyfriend who is not a paramilitary, *el Gato* ('cat' so named because of his extreme hairiness), whose languidity and nakedness in scenes where he is preened by Cielo are a way of highlighting peaceful corporeal masculinity as a closing image. An interesting commentary on the performativity of masculinity is provided by a member of the Bloque Metro. Donning his fighting apparel and weapons, he turns to the camera with a comical grin and pose, comparing himself to an action hero with the line 'Look, Rambo, a real tough guy!'. If the film is partially positioned for a US audience, then the 'American Imaginary' – Hollywood as medium for the projection of US masculinity to the world (Craig, 1992: 218) – is here refracted back to the US through the visual production of the Latin American periphery. The built, Rambo-style body is a wealthy one which embodies, literally, US cultural values (Dyer, 2002: 266). This acknowledgement of the peripheral

performance of US paradigms constitutes a subversive 'talking back' of the periphery.

The process of demobilisation is a central narrative, with corresponding shifts in models of masculinity over the course of the film; the exaggerated masculinity of the paramilitary is replaced by the 'tireless worker' and 'nation-builder', required for modernisation and demanded of the reintegrated paramilitaries in a demobilisation ceremony at the end of the film. The names of the paramilitary factions themselves, 'Bloque Metro' (the city's transport system is the symbol of Medellín's modernity *par excellence*), and 'Cacique Nutibara' (an indigenous regional leader at the time of the conquest) symbolise these conflicting discourses. Men like the peaceful *el Gato* take precedence over former paramilitaries at the end of the film, making Cielo's journey (she begins the film with a paramilitary boyfriend) imitative or allegorical of that which the film is prescribing–describing. Feminine desire allegorises desire for nation, and in an arena where a bellicose hegemonic masculinity conflicts with modernising discourses, cultural ambivalence around 'civilisation' and 'barbarism' is figured through the ambivalence of feminine desire for the peaceful or violent male.

The discursive field which exists around the identity and desire of 'woman' is the site of power struggles in the film, and is characterised by fissures and contradictions which disrupt gender norms. Men give geographically based accounts of the characteristics of women; as Edison puts it: 'the women from around here are very … how can I put it? They're very desperate for sex … and all the more if it's a commander or someone who has a car or a motorbike, or a gun … women are … they like adrenaline, extreme things'. He describes femininity as the exact mirror image of the dominant form of masculinity already discussed, of which he is the major proponent. While this is perhaps unsurprising, even comical, the way this discourse is circulated, appropriated and counter-appropriated by women in the film constitutes a territorialisation of women's desire by models of masculinity, a mirroring which has interesting parallels with the idea that woman, as man's 'other' has been constructed as a kind of negative mirror image. Irigaray argues that discourse has 'a power to reduce all others to an economy of the Same … to eradicate the difference between the sexes in systems that are self-representative of a "masculine subject"' (1991: 123). However, she continues, woman may subvert 'ideas about herself, that are elaborated in/ by a masculine logic … by an effect of playful repetition' (124). She states:

> [Women] should not put it, then, in the form 'What is woman?' but rather, repeating/interpreting the way in which, within discourse, the feminine finds itself defined as lack, deficiency, or as imitation and negative image of the subject, they should signify that with respect to this logic a *disruptive excess* is possible on the feminine side (1991: 126).

Editing and montage is used to highlight disruptive excess and contradiction, in a way that draws attention to interpellative failure. From

Edison's comments above, the film cuts to an introductory shot of Geidy, his 16-year-old girlfriend (and one of the four girls pregnant with his children). She effectively denies his claims: she would never have got together with him, she says, if she had known he was a paramilitary, because of the risks it brings, but now she is in love with him, and having his child, so 'now it's harder to leave him'. However, when speaking about *other* women, Geidy repeats almost word for word the hegemonic discourse uttered by Edison, therefore producing a kind of discursive contradiction or fissure, as she simultaneously confirms and denies what he says. Montage and editing, then, highlight power struggles within the discursive field, and the film knowingly participates in simultaneous confirmation and denial of hegemonic gender discourses. Edison's words can be seen as a kind of interpellative call to which the women of the film respond (or do not) in different ways. As discussed by Butler, interpellation regularly fails, and may be 'turned around' in a number of ways, opening up possibilities for resistance (1993: 122–4). Women's desire, which is territorialised by models of hegemonic masculinity, is reterritorialised, that is to say cited and re-cited in ways which expose discursive vulnerability, an example of 'affirmative deconstruction' in which 'a concept may be put under erasure *and* played at the same time' (Butler, 2000: 264). Again, the film engages in a subtle critique of male discourse towards its close when Don Jairo, the (now) late Edison's father, describes the 'closeness' of himself and his wife to the girls who are the mothers of Edison's children. By highlighting the faces of the young mothers, and particularly that of Jazmín, whose strained, unhappy expression as she distractedly attempts to quieten a restive baby is the film's closing image, the film again – here through a slippage between soundtrack and image – creates a 'jarring moment' to undermine would-be discursive coherence.

Through female desire, then, the film performs Colombian undecidability surrounding violent masculinity. The female subjects both sanction and reject masculine violence, meaning that the difficulty in denying its cultural attraction is played out through female desire. As I have described, the overall narrative is one which charts the reinsertion of these factions into civil society as part of the Uribe administration's (failed) attempts at demobilisation, not only in Medellín but throughout the country.[13] By the same token, the film attains most 'resolution' through the narrative of Cielo, which resists circularity to some extent, as during the course of the film she moves from having a boyfriend who has been jailed for his paramilitary activities, to a civilian one, who, she delightedly informs us, is not involved in the illegal groups. Whereas, in 1972, nation was figured in *Chircales* through a cinematic desire *for* woman (or idealised femininity), in 2005 there is a reversal: in *La Sierra* the desiring woman allegorises the desired nation (the renunciation of violence, or perhaps the desire for its continuation) through masculinity.

Each of these three documentaries attempts to move the political away

from dominant paradigms, to 'do politics' differently, whether this be through aesthetics (*Chircales*), through the exploration of desire (*La mirada de Myriam*) or through a strategic appropriation of public discourse as a means of exploring the private (*Chircales, La Sierra*). In them, women emerge from their status as objects of desire, and begin to figure as subjects of desire. In *Chircales*, a self-proclaimed Marxist framework is displaced by a focus on gender issues, but the film still participates in the construction and perpetuation of woman as the visual bearer of the burden of representation. In *La mirada*, we see a progression from silent mother to speaking subject, whereas *La Sierra* attempts the subjectification of women's desire, making it a vehicle for dreams of the nation. Besides the strategic appropriation of mainstream politics to gain space for feminist politics which occurs in both *Chircales* and *La Sierra* and the shift from a straightforward to a more complex feminist politics in *La mirada*, the slipping discursive framework of each film suggests a wider mistrust of the logocentric and the totalising, of a metaphysics of presence.[14]

Notes

1 For a full history of women in Colombian cinema, see Arboleda Ríos and Osorio (2003).
2 All translations are my own.
3 For a fuller analysis of *La Sierra*, see Martin (2009).
4 Quasi-feudal estates which originated in colonial times and which have continued to allow economic exploitation.
5 Diminutives meaning 'the edge' and that which is 'silly' or 'unimportant', respectively.
6 This term is taken from Laura Mulvey's seminal essay 'Visual pleasure and narrative cinema', in which Mulvey argues that '[i]n their traditional exhibitionist role women are simultaneously looked at and displayed, with their appearance coded for strong visual and erotic impact so that they can be said to connote *to-be-looked-at-ness*' (1989: 19).
7 For a fuller history of Cine Mujer, see Goldman (2000).
8 An artistic tendency to focus on the intimate or private sphere.
9 In which the child becomes aware of its separateness from the mother and develops a sense of its own identity and mastery over its body, but also its alienation.
10 Since Uribe came to power in 2001, the government has pursued a demobilisation process of paramilitary groups, which was well under way by the time of the making of the film (2003). The film can be seen as a document of this process.
11 The issue of competing versions of masculinity which must be balanced by the male subject has been explored in another context in Colombia by anthropologist Mara Viveros (2002).
12 I am echoing the argument of Judith Butler in her essay 'Gender is burning' (1993: 121–40), an analysis of the documentary *Paris Is Burning*, which deals with a far more self-conscious simulation. Butler argues that 'the resignification of the symbolic terms of kinship in *Paris is Burning* ... raises the question

of how precisely the apparently static workings of the symbolic order become vulnerable to subversive repetition' (138), although here such simulation empowers the sexual minorities who participate in it, which is not the case in *La Sierra*.

13 Demobilisation has been widely acknowledged to have been unsuccessful. Amnesty International found that '[p]aramilitaries continued to commit human rights violations in areas where they had supposedly demobilized. More than 3,000 killings and enforced disappearances of civilians were attributed to paramilitary groups since they declared a "ceasefire" in 2002' ('Amnesty International Report 2007: Colombia', http://thereport.amnesty.org/eng/Regions/Americas/Colombia). (Accessed 14 August 2007), subheading 2.

14 For Derrida, '[t]he history of metaphysics, like the history of the West, is the history of … metaphors and metonymies. Its matrix … is the determination of Being as *presence* in all the senses of this word. It would be possible to show that all the names related to fundamentals, to principles or to the center have always designated the constant of a presence' (2002: 353).

References

Alzate Vargas, C. '¿Demasiada realidad?: Margarita Martínez, directora de *La Sierra*', *Kinetoscopio*, 15 (72) (2005), 54–9.

Arboleda Ríos, P. and D. P. Osorio, *La presencia de la mujer en el cine colombiano* (Bogotá: Ministerio de Cultura, 2003).

Badinter, E. *XY: On Masculine Identity*, ed. L. D. Kritzman, trans. L. Davis (New York: Columbia University Press, 1995).

Butler, J. *Bodies that Matter: On the Discursive Limits of Sex* (New York: Routledge, 1993).

—— 'Dynamic conclusions', in J. Butler, E. Laclau and S. Žižek (eds), *Contingency, Hegemony, Universality: Contemporary Dialogues on the Left* (London: Verso, 2000), pp. 263–80.

Cine Mujer, *Cinemateca: Cuadernos de cine colombiano*, 21 (Bogotá: Cinemateca Distrital, 1987).

Connell, R. 'The history of masculinity', in R. Adams and D. Savran (eds), *The Masculinity Studies Reader* (Oxford: Blackwell, 2002), pp. 242–52.

Craig, S. *Men, Masculinity and the Media* (London: Sage, 1992).

De Bromhead, T. *Looking Two Ways: Documentary's Relationship with Cinema and Reality* (Hojberg: Intervention Press, 1996).

De Lauretis, T. *Alice Doesn't: Feminism, Semiotics, Cinema* (London: Macmillan, 1984).

Derrida, J. 'Structure, sign and play in the discourse of the human sciences', in *Writing and Difference* (London: Routledge, 2002), pp. 351–70.

Dyer, R. 'The white man's muscles', in Adams and Savran, *Masculinity Studies Reader*, pp. 262–73.

Gaines, J. M., 'Political mimesis', in J. M. Gaines and M. Renov (eds), *Collecting Visible Evidence* (Minneapolis, MN: University of Minnesota Press, 1999), pp. 84–102.

Goldman, I. S. 'Latin American women's alternative film and video: The case of Cine Mujer, Colombia', in C. A. Noriega (ed.), *Visible Nations: Latin American*

Cinema and Video (Minneapolis: University of Minnesota Press, 2000), pp. 239–62.

Grimshaw, A. *The Ethnographer's Eye: Ways of Seeing in Modern Anthropology* (Cambridge: Cambridge University Press, 2001).

Hayward, S. *Cinema Studies: The Key Concepts*, 3rd edn (Oxford: Routledge, 2006).

Irigaray, L. *This Sex Which Is Not One*, trans. Catherine Porter (New York: Cornell University Press, 1985a).

—— *Speculum of the Other Woman*, trans. G. Gill (New York: Cornell University Press, 1985b).

—— 'The power of discourse and the subordination of the feminine', in M. Whitford (ed.), *The Irigaray Reader* (Oxford: Blackwell, 1991), pp. 119–39.

Jay, M. 'The rise of hermeneutics and the crisis of ocularcentrism', in *Force Fields: Between Intellectual History and Cultural Critique* (New York: Routledge, 1993).

Johnston, C. 'Women's cinema as counter-cinema', in B. Nichols (ed.), *Movies and Methods: An Anthology* (Berkeley: University of California Press, 1976), vol. 1, pp. 208–17.

Kristeva, J. 'Motherhood according to Giovanni Bellini', in *Desire in Language: A Semiotic Approach to Literature and Art*, ed. L. S. Roudiez, trans. T. Gora, A. Jardine and L. S. Roudiez (New York: Columbia University Press, 1980), pp. 237–70.

Kuhn, A. *Women's Pictures: Feminism and Cinema*, 2nd edn (London: Verso, 1994).

Marks, L. U., *The Skin of the Film: Intercultural Cinema, Embodiment and the Senses* (Durham, NC: Duke University Press, 2000).

—— *Touch: Sensuous Theory and Multisensory Media* (Minneapolis, MN: University of Minnesota Press, 2002).

Martin, D. 'Paraíso terrenal, mujeres bellas, gente cordial: gender performances and narratives of modernity in *La Sierra*', *Bulletin of Latin American Research*, 28 (2009), 381–93.

Metz, C. *Psychoanalysis and Cinema: The Imaginary Signifier*, ed. S. Heath and C. MacCabe, trans. C. Britton *et al.* (London: Macmillan, 1982).

Mulvey, L. 'Visual pleasure and narrative cinema', in *Visual and Other Pleasures* (Houndmills: Macmillan, 1989), pp. 14–26.

Paranaguá, P. A. 'Orígenes, evolución y problemas', in P. A. Paranaguá (ed.), *Cine documental en América Latina* (Madrid: Cátedra, 2003), pp. 13–78.

Pick, Z. *The New Latin American Cinema: A Continental Project* (Austin, TX: University of Texas Press, 1993).

Schor, N. *Reading in Detail: Aesthetics and the Feminine* (London: Methuen, 1987).

Shohat, E. 'Post-Third-Worldist culture: gender, nation and the cinema', in A. Guneratne and W. Dissanayake (eds), *Rethinking Third Cinema* (London: Routledge, 2003), pp. 51–78.

Silverman, K. *The Acoustic Mirror: The Female Voice in Psychoanalysis and Cinema* (Bloomington: Indiana University Press, 1988).

Turim, M. *Flashbacks in Film: Memory and History* (New York and London: Routledge, 1989).

Viveros Vigoya, M. *De quebradores y cumplidores* (Bogotá: Universidad Nacional de Colombia, 2002).

Waldman, D. and J. Walker (eds). *Feminism and Documentary* (Minneapolis, MN: University of Minnesota Press, 1999).

Wood, D. M. J., 'Revolution and *Pachakuti*: political and indigenous cinema in Bolivia and Colombia', doctoral thesis, King's College London, 2005.

Yuval-Davis, N. *Gender and Nation* (London: Sage, 1997).

10

The 'poetics of transformation' in the works of Lourdes Portillo*

Rosa Linda Fregoso

Lourdes Portillo is a highly regarded filmmaker who works on the borders between two or more cultures and film traditions. In the span of thirty years, Portillo has made over twenty films and videos that give voice to the social, political and cultural concerns of Latina/o communities across the Americas. Her first film, *Después del terremoto* (*After the Earthquake*), is a narrative short co-directed with Nina Serrano in the late 1970s that deals with gender conflicts in the life of a Nicaraguan refugee in California who fled during the Somoza regime. Portillo established her reputation as a documentary filmmaker with the award-winning *Las Madres* (*The Mothers of the Plaza de Mayo*) (co-directed with Susana Muñoz, 1986), a film that focused on the plight of the mothers of the disappeared in Argentina. In *La ofrenda* (*Days of the Dead*) (also co-directed with Muñoz, 1988), Portillo turned her focus on to the realm of cultural practices, documenting the Day of the Dead celebration in Mexico and its reinvention by Chicanas and Chicanos in the US. In 1992, Portillo collaborated with the comedy trio Culture Clash to produce the experimental video *Columbus on Trial* for the counter-celebration of Columbus's voyage to the Americas. Later in *The Devil Never Sleeps* (1994) Portillo turned her concerns to the domestic sphere, scrutinising both the death of her uncle Oscar and Mexican familial–political dynamics. With *Corpus: A Home-movie for Selena* (1999) Portillo extended her enquiry into the family by weaving the story of Selena's legacy and death around fandom, the body and Latino patriarchy. Portillo's most highly acclaimed documentary to date is the award-winning *Señorita Extraviada* (*Missing Young Woman*, 2001), a compelling investigation of the phenomenon of feminicide – the murder and disappearance of hundreds of women – in the border city of Ciudad Juárez Chihuahua, Mexico.

From her perspective as a US-based Latina, Portillo has developed a uniquely transnational feminist optic that positions women at the centre of her stories and documents the effects of intersecting regimes of domination and violence on their lives. Beginning with her earliest works, Portillo has crafted a uniquely hybrid style that combines realism with a poetic, meditative aesthetics for contemplating and reflecting upon rather than for simply

*Parts of this chapter were published in Fregoso (2001).

informing about social reality. In terms of their activist politics, Portillo's films and videos are part of the Latin American film movement dedicated to an insurgent, aesthetic/political project that Fernando Birri once called the 'poetics of transformation of reality'.

During the final years of the military dictatorship in Argentina, Portillo and Susana Muñoz started working on *Las Madres: The Mothers of the Plaza de Mayo* and, later, in the first hundred days of the country's return to democracy, the filmmakers recorded the interviews for the film. Unlike her earlier fictional short, *Despues del Terremoto*, Portillo opted this time for the genre of political documentary to tell the story of women's oppositional struggles. It was a powerful drama indeed, one depicting the toll of state-sponsored terror against the Argentinean people. The documentary narrates the dirty war waged by a military regime that ruled Argentina from 1976 to 1983, disappeared when members of the security forces and over 11,000 members of the opposition. Yet the film primarily portrays the courageous struggle of mothers who defied the dictatorship by staging illegal demonstrations in the most guarded public plaza of Argentina, the Plaza de Mayo, thereby explicitly defying the military junta's authority. Reconstructing the drama of the mothers' ordeal with cinematic intensity, *Las Madres* blends realist strategies of interviews with news footage and voice-over narration, in order to tell the riveting tale of a gendered form of contestation and resistance that stems from the social role historically assigned to women: motherhood.

In the hetero-patriarchal nation state, motherhood is the traditional form through which the modern state produces women as subjects of the nation by reinscribing women's role in reproduction and confining them to the private, domestic sphere of childrearing. Symbolically and biologically, the modern state defines woman in terms of her role in the biological and cultural reproduction of citizen-subjects (Fregoso, 2003: 64–70). Yet it is from their social location as 'mothers' that the women of Argentina staged their bold defiance, acting in the public sphere at a time when most people, including the media, remained indifferent or ignored the military's dirty war. Even though the military junta retaliated against these mostly middle-aged mothers, arresting them repeatedly and disappearing one of their founders, Azucena De Vicenti (the originator of the idea of demonstrating in the Plaza) along with two French nuns and an artist, the mothers continued their public acts of defiance and resumed their demonstrations wearing their iconic white headscarves.

Portillo and Muñoz depict how women, like the mothers of the disappeared, can redefine and reappropriate motherhood as a model of resistance for unifying women across various social backgrounds in their opposition to state terrorism and patriarchal nationalism. The narrative emphasis of *Las Madres* on the process of 'radicalisation', rather than 'victimisation', proves inspirational for viewers around the world, for it exemplifies how middle-aged women cultivated a collective politics and channelled their

own personal pain as mothers into radical action. By claiming the streets of Argentina, these women transformed their previously private, gendered identities as 'mothers' and reinvented 'motherhood' as a political identity for the nation. As the vice-president of the Mothers, Adela Antokaletz, puts it: 'We decided to take to the streets, and it was the streets that taught us … That was what gave us our political strength' (Simpson and Bennett, 1985: 169).

Las Madres ends its painstaking drama of women's opposition and resistance with a collage of images of mothers who wage similar struggles on behalf of disappeared children throughout the world. Once the dictatorship had ended, the mothers continued their campaign for 'the punishment of the people who carried out the torture and disappearance of their children' (Simpson and Bennett, 1985: 169–70). In fact, during the transition, the democratic government had neglected the mothers' demands for justice by capitulating to the former military rulers and granting amnesty to members of the military junta, including General Jorge Videla who was pardoned by then President Carlos Menem in 1990. Although the amnesty was passed off as a gesture of national reconciliation (a 'decision to pardon dictators in the interest of peace'), it was mainly aimed at appeasing Argentina's right-wing forces. Yet even as crimes against the murdered and disappeared were pardoned, crimes against the children of the disappeared were not covered by the amnesty. In July of 1998, Videla was charged with stealing the babies of pregnant prisoners and offering them for adoption mostly to officers and friends of the military (Faiola, 1998).

Portillo collaborated with Argentinean-born Susana Muñoz in one other project, once again charting the complex and variable points of contact among the various communities in the Americas. As Portillo recalls: '*Las Madres* made me feel so bad that I wanted to feel good and in order for me to feel good, [I said to Susana Muñoz] I want to think about death the way my people think of death, not the way your people think about death.'

The documentary *La ofrenda* traces the continuities as well as the discontinuities in cultural practices criss-crossing the border, beginning its story in Mexico, where the cultural practice and ritual associated with the Day of the Dead celebration takes place annually on 1–2 November. A festivity dating back to pre-Conquest Mexico, the Day of the Dead continues as a vital cultural tradition, despite centuries of efforts by colonial authorities to eradicate the practice. The second half of the documentary focuses on the revival of the festivity in San Francisco, California, dating back to the 1970s when the Chicana/o cultural arts movement began organising exhibitions and planning an annual parade on the streets of the Mission district. Whereas the celebration continues across time and space, the meanings and rituals differ in each context.

In Oaxaca (Mexico), the film portrays the Day of the Dead as organically linked to the way of life of a community mobilised for the festivity: from cooking the traditional foods to selling and buying the necessary items on

the marketplace; from artisans making the *calaveras* (skulls) to the devout praying before home altars; from visits to the grave-yard to the cleaning of gravestones and dining in honour of the dead. For the indigenous people of Oaxaca, the Day of the Dead forms an integral part of a community's traditions, its daily spiritual, cultural and material practices.

The California-based celebration, on the other hand, appears to be more nostalgic and less linked to an organic way of life. Yet its revival by the Chicana/o arts community in San Francisco locates the practices in institutional spaces like museums, classrooms, universities and cultural centres, as an expression of cultural difference. In portraying this contextual contrast between Oaxaca and California, however, the filmmakers offer students of culture an important lesson about the process of cultural transformation. For *La ofrenda* refuses to fetishise cultural tradition as a static object handed down unchanged from one generation to the next or across geopolitical space. Instead, the documentary represents 'tradition' as an active and dynamic process. As immigrants leave their homeland, they take their cultural traditions with them; however, these do not remain intact but are transformed through processes of rupture and dislocation that modify, transform and reinvent culture. The film thus portrays a universe of dynamic cultural change across geopolitical spaces.

In mapping the continuities and discontinuities in cultural practices across the Mexico–US border, *La ofrenda* also evidences how cultural tradition is reimagined by immigrant communities who live in racially hostile environments, as a strategy for affirming cultural difference and resistance. And it is in this context that the revival of the Day of the Dead in the US by Chicanas/os responds to different needs from those in Mexico. In the face of social anxieties, the 'browning' of US national identity, the Day of the Dead celebration performs an oppositional, political function of affirming Latina and Latino cultural and racial differences in the United States.

With both *The Devil Never Sleeps* and *Señorita Extraviada*, Portillo's documentary forays across the border take a turn towards 'the poetics of transformation' in ways that contribute to symbolic processes of social change. In the case of *The Devil Never Sleeps*, Portillo's investigation into the death of her beloved Tio Oscar, who died under mysterious circumstances in Mexico, advances a critical perspective on the artificial divide between the private (familial) space and the public (political) space, unmasking the entanglement of both within the nation state. Portillo crosses the border to lead a probe into the unresolved death of her uncle, Oscar Ruíz Almeida, utilising his life to weave the strands of her enquiry. Official accounts rule that his death was a suicide, whereas some family members and friends suspect murder. In the process of her investigation, Portillo pierces through the veneer of the family's secrets and through the conflicting testimonies she uncovers many surprising contradictions in the life of her favourite uncle. The murder-mystery-detective theme in *The Devil* serves as a ruse for a more probing glimpse into politics and secrets, not just of the

domestic, private family (represented by Portillo's) but also of the public, national family, embodied in Mexico's ruling party, the PRI. Starring as the niece-detective-documentarian, Portillo narrates the story in terms of intrigue, deception, hypocrisy and through the cultural values of 'honour', 'loyalty' and 'familism', foregrounding complex issues about *la familia* for Chicanas/os and Mexicans on both sides of the border.

As a Chicana Catholic, Portillo transgresses the public–private divide reinforced by both Catholicism and patriarchal nationalism, by portraying and making visible for public scrutiny the truths and falsities behind the familial veil of secrecy and privacy upheld by her family (Fregoso, 1999). She thus violates a cultural taboo around the public disclosure of family matters, one so sacred that even Mexican *políticos* are bound by its strictures. Known as *la mordaza* (the muzzle), this cultural taboo requires that former presidents of Mexico maintain silence around political matters pertaining to the *familia* of the PRI. To the extent that the political apparatus of the PRI is based on the model of *la familia*, Portillo's foray into the intimate realm of family affairs undermines the very patriarchal foundation of Mexican nationalism.

Transgressing the sacred covenant regarding public discussions of private family matters, *The Devil Never Sleeps* blurs the distinction between the private and the public and links the documentary's concern with feminist critiques of *la familia* as an element in power relations and as a form of gender domination. Given its centrality in the sphere of domesticity, *la familia* plays a fundamental role in upholding the law of the father and the subjugation of women. Feminist critics of US third-world nationalism have argued that the naturalisation of male privilege and hegemony derives its force from a reluctance to contest the 'idealised notion' of a monolithic community and by extension 'the family romance upon which this notion of community relies' (Smith, 1994: 381). In order to weigh the significance of Portillo's submerged engagement with Chicana feminist discourse, one must first understand the centrality of family values in Chicano nationalist politics.

Portillo breaks the silence around family unity and the family myth-making enterprise so central to Mexican and Chicana/o nationalism and deconstructs the values associated with Chicana/o (and Mexican) families, 'including familism (beliefs and behaviour associated with family solidarity), *compadrazgo* (extended family via godparents), *confianza* (a system of trust and intimacy)' (Segura and Pierce, 1993). Since the Chicano movement of the 1960s, Chicana/o nationalists have conjured up *la familia* as the foundation of oppositional politics, insisting upon a single, coherent representation of *la familia*, namely the heterosexual, nuclear family. Traced to the master narrative of Mexican nationalism (Franco, 1986: 135), *la familia* figures as the ground for a protonationalist discourse on 'community loyalty'. To speak out against the sexism and abuse perpetrated by Chicano males was tantamount to violating the *confianza* of the 'community' which, because it

was invested with all the emotional trappings of 'familism', meant one was also betraying *la familia*. The mechanisms for reproducing this nationalist discourse on 'community loyalty' are located in the strict division between the private and public spheres that undergirds a nationalist fantasy about *la familia* as an internal sanctuary against external, outside threats.

Single-handedly targeting the normativity of the attributes of familism and *confianza*, *The Devil Never Sleeps* serves as an instrument for criticising Chicana/o and Mexican nationalism, for these very principles also operate as twin pillars for endowing family mythologies, effacing their contradictions and naturalising male privilege. By taking her favourite uncle as subject matter, Portillo breaks Chicanos' and Chicanas' investment in the 'intertwined notions of family and community', or *la familia* as a sacred institution. Positioned simultaneously as an insider-outsider, Portillo liberates the family from its shroud of secrecy and publicly unveils its private face, exposing, not the idealised Holy Family (rooted in Catholicism) but *la familia* as a site of conflict and contestation.

Apart from its thematic intervention, the documentary pushes the boundaries of documentary realism by gesturing to and simultaneously dismantling the generic conventions of documentary film in self-reflexive ways. For example, Portillo interrogates the documentary's criteria for truth and accuracy, along with its reliance on visual evidence, drawing attention to the partial and constructed nature of images and to the plurality of truths. While resorting to well-established techniques for communicating documentary evidence (i.e. interviews, actuality footage, home-movies, narrator's voice), Portillo does not ground truth outside of its constructedness nor does she privilege one version of Tio Oscar's death over another. Each interviewee's account, each of the narrator's digressions, each visual form of evidence (verité, home movies, telenovela) is granted as much validity as the others.

Portillo thus refuses to constitute a realistic discourse based on a singular interpretation but instead formulates a plurality of truths. The strategic overlap of multiple modes of representation derived from distinct genres illustrates Portillo's refusal to privilege the documentary as the singular mode for interpreting and apprehending reality. This plurality of truths is reconstructed both by the use of modern techniques for gathering and classifying knowledge in the documentary (the interview, footage from home-movies, photo-stills, actuality footage, narration), as well as from other, culturally specific forms of knowledge more properly associated with the space of the 'popular'. In other words, Portillo pursues clues and facts from popular forms of knowledge and experience, namely those 'disqualified' or 'inadequate' sources of knowledge passed on in the form of legends, gossip, *telenovelas*, *canciones rancheras*, myths, proverbial wisdom, in sum, forms that according to the philosopher Michel Foucault represent 'a particular, local, regional knowledge, a differential knowledge incapable of unanimity' (Barbin, 1980: 82). These sources of knowledge are at odds with the

modernist project of certainty, uniformity, absolute truth, associated with 'official' documentary discourse, for 'popular' knowledges are often partial, contradictory, ambivalent and at odds with a dominant, singular interpretation of social reality. Portillo pursues the task of producing 'truth' concerning Tio Oscar's death by juxtaposing 'popular' with 'official' forms of knowledge and refusing to privilege one form over the other.

This strategy is evident in the scene in which Portillo interviews Tia Luz about Tio Oscar's conjugal relations. Pursuing a lead that implicates Ofelia (Oscar's widow) in the murder/suicide, Portillo begins her enquiry with a question regarding the sexual affairs of the couple. The scene opens on a shot of Tia Luz, expressing her visible reluctance to entertain such an intimate question. Portillo continues the probe until Tia Luz confesses the 'truth' about the couple's intimacies, including a conversation she had after Ofelia's honeymoon in which she reveals the proof of her virginity in 'bloody panties'. What is striking about this scene is the manner in which Tia Luz's 'official' testimony (interview) is thematically and formally framed between two other 'popular' modes of representation: a telenovela and a legend. Tia Luz's off-screen voice accompanies a sequence of shots depicting a mannequin dressed in a wedding dress, shot through a bridal store's showcase while public spectators gaze adoringly at the mannequin. The scene culminates in a shot of Tia Luz watching the Brazilian telenovela, 'Roque Santeiro'. From her confession about Ofelia's 'indiscretions', Tia Luz turns with ease to a frivolous interpretation of plot details from the telenovela, thus supplanting the narrative value of the former, since for Tia Luz one account has the same relevance as the other. As the camera zooms in on a television set, visual and narrative focus shifts away from the interview to the telenovela, affecting a slippage between two forms of discourse, the 'official' interview and the more properly 'popular' discourse of the telenovela.

In this instance, as well as in other places throughout the film, the strategic use of the telenovela blurs the distinction between 'reality' and 'telereality'. Yet, closure is not anchored to the telenovela but rather slides to a distinctly popular discourse, the legend, thereby further complicating the status of truth in this film, as illustrated by Portillo's voice-over narration: 'There's a legend that the owner of a Chihuahua bridal shop had a daughter she dearly loved. On the day of her wedding the daughter died in an accident. The bereaved mother had her embalmed, dressed up as a bride and displayed in her store window. A tribute to virginal love.'

Carefully crafted shots of people looking up intently at the bridal mannequin suggest that the legend of the embalmed virgin captivates these spectators, just as it secures their alignment with those of us outside the screen who have been nurtured on Mexican fantastic stories of ancestral ghosts, the macabre flavour in legends of enchanted statues and embalmed saints, as we too wonder about the legend's uncanny truth. The final shot of this scene depicts store attendants raising the mannequin's (the embalmed virgin's?) bridal gown, allowing us to get a glimpse beneath her dress as if

to substantiate the truth behind the legend, for depending on one's belief system the truth of the legend of the embalmed virgin seems just as plausible as the truth behind Tia Luz's testimonial regarding Ofelia's own account of her virginity.

In some respects, the legend's location in this scene has less to do with the process of gathering empirical evidence or 'knowledge' for documentary truth and more to do with underscoring the veracity of popular forms of knowledge for making sense of one's own reality. Reading the scene against the grain, the legend appears in a conflictual relation to the interview, mapping the centrality of the cult of virginity in Mexican society. In so far as Tia Luz's interpretation of Ofelia's virginity gains significance within the ideological framework of patriarchy, the scene highlights the interpellation of gendered subjects by familial and political discourses, and in particular the extent to which Mexican women can be both victims and agents of the patriarchal sublimation of female sexuality onto the figure of the Virgin. By relying on a plurality of truths, *The Devil Never Sleeps* parodies and deconstructs the transparency of documentary realism. Although relying on realist strategies, the documentary's critical vocabulary worked to make 'audiences aware of the process of production as a limitation of the film's neutral stance, its ability to document objectively' (Allen, 1991: 103) and by doing so, Portillo, like many filmmakers of the 1990s, pushed the generic boundaries of documentary realism and contributed to the evolution of the genre.

With *Señorita Extraviada*, Portillo bears witness to and sheds light on a phenomenon that is considered Mexico's number one human rights problem: feminicide in the border city of Ciudad Juárez. Since 1993, over 600 women and girls have been murdered and more than 1,000 have disappeared in the state of Chihuahua, Mexico, alone. Of those murders, approximately one-third of the victims were assassinated under similar circumstances: they were held in captivity, raped, sexually tortured and mutilated; their bodies were discarded in remote, sparsely populated areas of the city. Ciudad Juárez is the largest industrial city on the Mexican side of the border. It has a population of roughly 1.3 million inhabitants and roughly one-third of the city's population has migrated from other parts of Central Mexico and from Central America to work in the *maquiladora* industry and cross over to the US.

The documentary poignantly echoes the strategies of grass-roots activists, mothers, sisters, relatives of the disappeared in their ongoing struggle against state-sanctioned terrorism; the struggle of those who continue to demand justice despite threats against their lives and the use of disappearance as a mechanism of social control. *Señorita Extraviada* may be content driven, focused primarily towards delivering an issue-oriented message; yet it is the manner of the delivery of its message that is most eloquent and groundbreaking.

Making a film about an event that is ongoing and that continues to unfold

is an inherently challenging undertaking; all the more so if the subject matter is as horrid and terrifying as widespread violence, murders and disappearances. Given the absolute abjection of women through death, as well as the desecration of their bodies in public discourse, Portillo confronted an enormous problem of representation. In the course of several trips to Ciudad Juárez, Lourdes faced quite a challenge. Not only did she experience at first-hand the social trauma that these murders have produced throughout the region but she also bore witness to the psychic trauma that family members are living under and continually relive with each new report of a murder or a disappearance. The film is thus motivated by these inextricable conditions: the problem of representation and the social and psychic traumas. How does one represent the dead in a respectful manner, in a way that does not further sacrilise their bodies, but honours the memory of their former existence? How does one do so in a manner that is respectful of the families, that honours their grief?

Drawing from the discursive strategies of grass-roots groups such as Voces Sin Eco, Lourdes employs religious symbolism and iconography subversively. She enshrouds her film in the discourse of religiosity. The strategic placement of images of crosses, montages of crucifixions and home altars, the crescendo musical score of Gregorian chants, including the solemn chant for the dead ('Kyrei Eleison'), all work to establish a meditative, hieratic rhythm in the film. Lourdes describes *Señorita Extraviada* as a 'Requiem'. She has in effect resignified the 'Requiem' into an artistic composition for the dead. To her credit, not a single dead body appears in the film. Nonetheless, the haunting presence of the victims is summoned both literally through the placement of photographs and figuratively through Portillo's reworking of the Requiem.

As in her earlier film, *Las Madres, Señorita Extraviada* emphasises the process of radicalisation rather than victimisation. The narrative gives voice to women's agency, to the mothers and sisters who have emerged as protagonists in grass-roots movements. Through their agency and determination, poor women have shouldered the work of detection and forensic investigation, searching for missing daughters or sisters, combing the desert for bodies and identifying remains. The film portrays women on the border neither as passive victims, nor as dependent on the patriarchal state, the family or international human rights groups for protection. Instead, the film underscores the agency of mothers and women activists on the border, as women who affirm the continuity of life, grieving and mourning, while acting as political agents, demanding the rights of women within the nation state. It is the mothers and women activists, and not the secondary sources nor the experts, who are the film's ultimate guarantors of truth.

Informed as it is by a women's rights framework, *Señorita Extraviada* emphasises an intersectional methodology that in my estimation has generated a new understanding of feminicide among Mexican intellectuals, not

simply as class and gender motivated, but as *racially* motivated as well. Since the release of *Señorita Extraviada*, I have noticed references to the 'racial' nature of the killings on the editorial pages of *La Jornada*, a national daily based in Mexico City, where emphasis on the 'misogyny', 'classism' and 'racism' of the killings has now become common.[1] Although Portillo draws from experimental and realist techniques, unlike conventional documentaries, *Señorita Extraviada* does not provide any singular cause for feminicide nor does it provide a contrived resolution. Instead Portillo draws attention to a confluence of intersecting and overlapping forces, including but not limited to broader structural processes of economic globalisation and the neo-liberal policies of the patriarchal state, as well as more localised virulent forms of patriarchal domination.

Ultimately, Portillo turns her critical gaze onto the patriarchal state, a feature that some audience members have criticised for de-emphasising the structures of global capitalism. But it is also clear from Portillo's investigation that, in the words of a women's rights activist in the film, 'the state is ultimately responsible'. The film draws attention to the role of state agents as actual perpetrators of the murders; to the state's complicity for failing to investigate, prevent and prosecute the crimes against humanity; and to the state's role in creating the conditions of possibility (the state of exception) for the patriarchal expression of a sexual politics of extermination in the region. If Portillo's critical gaze on the state bothers some audiences, what is even more disturbing is how the filmmaker ultimately turns the critical gaze back onto its viewers, for its powerfully unsettling and disturbing ending implicates the viewer in responsibility.[2] The narrative closure points to our complicity, not as a literal implication or responsibility for the murders, but as an ethical one. The film ends on the note of moral outrage and in so doing calls for our ethical political engagement, summoning us to take action.

Since the release of *Señorita Extraviada* in 2001, Portillo has made video copies of the film readily available to grass-roots groups throughout the Southwest, the Mexico–US border and Mexico City, for the raising of public awareness and in fundraising campaigns for families of the murdered and disappeared women. Besides serving human rights activists in their appeals beyond the state to international forums, *Señorita Extraviada* has helped to raise international awareness about the murders of women in European, US and Latin American contexts through its exhibition at major international film festivals, where it has won dozens of awards, including the prestigious 'Nestor Almendros' award from Human Rights Watch and a FIPRESCI Award at Thessaloniki's Documentary Film Festival.

As in her previous films, Portillo has created a cutting-edge documentary that speaks truth to power and embraces the poetics and politics of social justice. Without sacrificing compassion and conviction, *Señorita Extraviada* is an activist film in the tradition of the New Latin American

Cinema movement: it is driven by a project of social transformation and of awakening of conscience that aims to move its viewers to political action. Here, it should be noted that by the new Latin American cinema movement, I am referring to its 'sweeping redefinition', to what B. Ruby Rich has called 'An/other view of new Latin American cinema' that she traces to Matilde Landeta's groundbreaking, racial/sexual melodrama *La negra Angustias* (1949), Fernando Birri's treatment of identity and subjectivity in *Los inundados* (1962), and Sara Gómez's formally innovative, feminist feature film, *One Way or Another* (1974) (Rich, 1998: 127–40).

A few years before he died, the Palestinian activist-scholar and writer, the late Edward Said wrote that he 'considered the true role of the artist and the intellectual in our times to be "speaking truth to power, being witness to persecution and suffering, and supplying a dissenting voice in conflicts with authority"' (2003: 4). Said's words remind us of the intimate and grand connection between politics and culture for social justice and activism today. *Señorita Extraviada* is an activist political documentary that bears witness to 'persecution and suffering' and supplies 'a dissenting voice in conflicts with authority'. In so doing, it explicitly takes a position on the side of the grass-roots activists and the family members of the victims who, for almost twenty years, have been denouncing governmental complicity through its negligence in investigating the killings – a complicity that has in fact engendered the culture of terror, misogyny and impunity on the Mexico–US border, as much as it has transformed the border into a gendered war zone.

Señorita Extraviada's local and global resonances derive from its commitment to 'supplying a dissenting voice in conflicts with authority' and from assuming the obligation of 'speaking truth to power'. In embracing a poetics and a politics of justice, Portillo's documentary is grounded in the genealogy of Latin American cultural politics, an insurgent, activist tradition described by the Argentinean filmmaker, Fernando Birri, as the 'poetics of transformation of reality', that characterised the formation of the New Latin America Cinema movement during the 1960s.

Notes

1 For example: 'Almost all of them because they are the domestics, the workers, the ones with dark skin, from the working-class neighbourhoods, the poor ones, therefore, the exclusive targets of this sexist and classist genocide'. My translation of: 'Casi todas porque son las muchachas, las trabajadoras, las de color moreno, las de las colonias populares, las pobres, pues, el blanco exclusivo de este genocidio sexista y clasista.' V. M. Quintana, 'Los feminicidios de Ciudad Juárez', *La Jornada*, 23 November 2001, p. 23; See also, 'Ciudad Juarez: Parar los homicidios,' *La Jornada*, 13 December 2001, p. 13.
2 I am indebted to students at the University of California, Santa Cruz for this insight; forty students on the course entitled Transnational Cinema and Feminism (LALS 176) wrote critical essays on *Señorita Extraviada*.

References

Allen, J. 'Self-reflexivity in documentary', in R Burnett (ed.), *Explorations in Film Theory*, pp. 103–09 (Bloomington and Indianapolis: Indiana University Press, 1991).

Barbin, H. *Herculine Barbin: Being the Recently Discovered Memoirs of a Nineteenth-century French Hermaphrodite*, introd. M. Foucault, trans. R. McDougall (New York: Pantheon, 1980).

Faiola, A. 'Argentina dictator runs out of pardons', *Washington Post*, 8 July 1998, A24.

Franco, J. 'The incorporation of women: a comparison of North American and Mexican popular narrative', in T. Modleski (ed.), *Studies in Entertainment: Critical Approaches to Mass Culture*, pp. 119–38 (Bloomington and Indianapolis: Indiana University Press, 1986).

Fregoso, R. L. 'Sacando los trapos al sol', in D. Robin and L. Jaffe (eds), *Redirecting the Gaze: Third World Women Filmmakers* (New York: SUNY Press, 1999), pp. 307–29.

—— *Lourdes Portillo: The Devil Never Sleeps and Other Films*, Chicana Matters Series (Austin, TX: University of Texas Press, 2001).

—— *Mexicana Encounters: The Making of Social Identities on the Borderlands*. (Berkeley: University of California Press, 2003).

Newman, K. and B. R. Rich. 'Interview with Lourdes Portillo', in R. Fregoso (ed.), *Lourdes Portillo: The Devil Never Sleeps and Other Films*, pp. 48–73 (Austin, TX: University of Texas Press, 1990).

Rich, B. R. 'An/other view of Latin American cinema', in N. Iglesias and R. L. Fregoso (eds), *Miradas de Mujer*, pp. 127–40 (Berkeley/Tijuana: Chicana/Latina Research Center and Colegio de la Frontera-Norte, 1998).

Said, E. 2003. *The Nation*, 20 October, p. 4.

Segura, D. A. and J. L. Pierce. 'Chicana/o family structure and gender personality: chodorow, familism, and psychoanalytic sociology revisited', *Signs*, 19(1) (1993), 62–91.

Simpson, J. and J. Bennett. *The Disappeared and the Mothers of the Plaza: The Story of the 11,000 Argentinians Who Vanished* (New York: St. Martin's Press, 1985).

Smith, V. 'Telling family secrets: narrative and ideology in *Suzanne Suzanne* by Camille Billops and James V. Hatch', in D. Carson, L. Dittmar, and J. R. Welsch (eds), *Multiple Voices in Feminist Film Criticism*, pp. 380–90 (Minneapolis, MN: University of Minnesota Press, 1994).

Part III

Migration, transnationalism and borders

Implicit in the very idea of bringing together the work of women film-makers from Hispanic and Lusophone contexts is the notion that these cultural categories must necessarily be viewed in terms of their migratory and transnational histories. This is so simply by dint of the vast geographical and geopolitical spaces and networks that constitute the Hispanic and the Lusophone worlds. In this sense, all the chapters in this volume, when considered together, point also to the inherently fluid, interconnected and shifting categories of that which is Hispanic or Lusophone. Indeed, in the work studied here, that which is migratory, crossing transatlantic and national boundaries, refers not merely to the colonial history of the Hispanic and Lusophone worlds, but also, and as Paul Julian Smith's chapter has highlighted, to a central feature of the cinematic industry as it functions in this day and age. In this sense, migration, transnationalism and the crossing of borders must be seen as key aspects of contemporary Hispanic and Lusophone cinema. This is so both as a cultural manifestation of globalisation and as one of many key industries that maintain and propel the latter.

If the notions of migration, transnationalism and borders refer as much to the present as to the past, then it must be borne in mind that these contexts of colonial expansion and of our contemporary global economy are fundamentally tied to questions of capital – and, by extension, to maintaining the power of global hegemonies. The question of borders surfaces here, for power must by definition be enclosed or else it will dissipate. In this sense, any study of migration, transnationalism or, for that matter, of borders must take this into account and understand the uneven geopolitical and geo-economic terrains that constitute Hispanic and Lusophone filmmaking, both internally and with regard to their relation to the dominant cinematic industries, such as Hollywood. These issues are also major concerns that many Hispanic and Lusophone filmmakers explore in their work. The key term here is transnationalism, understood as a series of links across national boundaries that both displaces the centrality of the national and also establishes important economic, political and cultural connections. Inevitably, what come into view are the networks, power hierarchies and crossings of globalisation. What also becomes clear is the fact that cinematic

representation offers a space not solely for portraying such issues, but also for critiquing them and so forging agency for the marginal.

There is also something inherently linked to the crossing of borders in the fact that this volume centres upon the work of women filmmakers. Marginal by dint of gender, the filmmakers who form the focus of this book use cinema as a route to empowerment, thereby crossing the very political boundaries that assign them to the margins. At play here is, of course, the power of cinema and of filmmaking to transgress, to empower and to subvert.

From their relatively borderline position as women, the filmmakers whose work is analysed in Part III all take active part in foregrounding mobility as central to their work. By exploring such mobility, their films question, by logical extension, the supposed stabilities of key referents of identity and belonging, such as nationhood, memory and cultural roots. In this sense, when viewed in terms of migration, transnationalism and the question of borders, what comes to light is the contingency and alterability of that which is apparently solid or is generally assumed to be fixed. This reconfiguration of signifiers of collective and individual identity leads inevitably to a sense of displacement and to the awareness of the preponderance of that which is migratory. Equally, it opens a space for the latter. By the same token, cinema, as seen here, forges a frame for the migrant, the borderline and the displaced. The three chapters in Part III all deal with these issues, albeit in different ways.

In Chapter 11, 'A disjunctive order: place, space and the gendered body in Isabel Coixet's *The Secret Life of Words* (2005)', Helena López considers the tensions that arise between the local and the global in this film through a focus on displaced subjectivities. Indeed, López argues that there are, in fact, two levels at which the idea of displacement is explored in this film. Over and beyond the questions surrounding the central characters in this film is the fact that the film itself is emblematic of a kind of displacement suffered by national (i.e. local) cinema when it becomes reliant upon transnational production. Diaspora and transnationalism become both contradictory and parallel processes that are at once culturally manifest, subjectively experienced and shaped within the framework of global economies.

Migration, the transnational and borders feature largely in the films studied in Chapter 12 by Parvati Nair, 'Reconfiguring the rural: fettered geographies, unsettled histories and the abyss of alienation in the work of Spanish women filmmakers'. This chapter examines the work of three Spanish women filmmakers, namely Icíar Bollaín (*Flores de otro mundo*, 1999), Chus Gutiérrez (*Poniente*, 2002) and Ariadna Pujol (*Aguaviva*, 2005), in order to analyse the dissonant encounters between immigrants and locals in rural areas of Spain. The genres of social realism and documentary reveal common concerns here, thereby revealing an inherent fluidity and connection between supposedly diverse forms of filmmaking. All three films engage with problems of integration when immigrants seek resettle-

ment in the Spanish countryside. Thus, rural areas reveal themselves to be spaces that are intrinsically linked to global flows of people and capital and hence subject to alterability. What ensues in each of these films, but in very diverse ways, is the alienation of individuals as they struggle between past and present, self and other, here and there.

Sofía Ruiz-Alfaro in Chapter 13 entitled 'Tracing the border: the "frontier condition" in María Novaro's *Sin dejar huella*', analyses the ways in which this filmmaker explores the complexities of border identities. The US–Mexico border serves here as the locus where national identity and questions of belonging can be refigured in terms of fluidity, contingency and negotiation. As this chapter reveals, from the setting of the border, frontier identities, always on the move, always on the point of crossing, never fixed, become normalised for Mexicans. Both intimately connected to the US and disempowered by this proximity of the economic giant, Mexicans, even those who live deep in the interior of the country, internalise this borderline and migrant position, thereby experiencing it as a state of being. Interestingly, Ruiz-Alfaro connects this to questions of gender, suggesting that the space of the border is feminine in its power to gather together diverse feminine identities and bring forth in them the agency of womanhood. In turn, the border zone, as explored in this film, becomes a metaphor for women's filmmaking, and also a borderline medium.

A disjunctive order: place, space and the gendered body in Isabel Coixet's *The Secret Life of Words* (2005)

Helena López

This chapter aims to explore what happens to national cinemas and visual representation under a global mode of economic and cultural production which Arjun Appadurai has conceptualised as 'a disjunctive order' (2000: 101). Film studies are taking on board these intensified disjunctures between economics, politics and culture through the notions of transnationality and world cinema. In order to investigate these questions, I will focus on the cinema of Isabel Coixet (paying particular attention to her film *The Secret Life of Words*), a Catalan-born filmmaker whose work provides an excellent case study for testing the impact of transnational economic and symbolic structures on the modern notion of national cinema as well as on filmic representation. Now the social realities resulting from globalisation are always inscribed in the material and semiotic contexts of place and space. In the pages to follow, I will look at the gender dimensions of this inscription, drawing on Linda McDowell's theorisation of spatiality:

> [I]n the focus on change and simultaneity, on the overcoming of space and distance, it is important that we do not forget permanence, solidity, meaning and symbolism, what we might refer to as attachment to place. For space is not just a set of flows, *pace* Castells, but also a set of places, from a home to national territories, with associations and meanings for individuals and groups. Here the distinction between space as relational and place as a location, as a fixture, the geographer's 'sense of place' or 'genius loci', what the literary and social critic Raymond Williams termed a 'structure of feeling' centred on a specific territory is a useful one. This is not to argue, of course, that the meaning and symbolism of place is unvarying – this is clearly absurd – but to emphasize that spaces and places are not only sets of material social relations but also cultural objects (McDowell 1996: 31–2).

I have organised my arguments into three sections. First, I will map Isabel Coixet's filmography to determine both the thematisation of gender discourse and the overlap between different national and transnational regimes. Second, I propose an examination of her film *The Secret Life of Words* in two different contexts: the specific political theme addressed and

the external conditions of production, marketing, distribution, exhibition and critical reception. Finally, I will look at the representational strategies used to visually construct the gendered displacement of subjectivity.

Isabel Coixet's filmography: questions of gender and (trans)nationality

Isabel Coixet (Barcelona, 1962) started her career in the audiovisual industry working as a creative director for different advertising agencies. She is the founder of two production companies: Eddie Saeta in 1989 and Miss Wasabi Films in 2000. Her first feature film in 1988, *Demasiado viejo para morir joven*, was a critical and box-office failure:

> El término *políticamente correcto* no existía. Entonces, el hecho de ser joven, tener 24 años, haber hecho una película y ser mujer era como una suma de horrores. Y yo creo que mi película tuvo críticas atroces que se han ido luego suavizando … O sea, mi primera película, *Demasiado viejo para morir joven*, no es una buena película; pero desde luego no es tan mala como en su momento se percibió. ¡ (Camí-Vela, 2005: 67)
> [The term *politically correct* didn't exist. Back then, the fact of being young, 24 years old, having made a film and being a woman was a sum of horrors. And I think that my film got awful reviews that got milder in time … By this I mean that my first film, *Demasiado viejo para morir joven* [Too Old to Die Young], is not a good film; but of course it's not as bad as was thought at the time author's translation.]

Her second work, *Things I Never Told You*, was filmed in 1996 in Oregon (USA) with an English-speaking cast. *A los que aman* (*To Those Ones Who Love*, 1998), a stylised costume drama located in a literary eighteenth century, replicates the placeless atmosphere that was already present in *Things* and that would become, in her following two films, one of Coixet's recurrent auteurist traits. In 2003, she shot the Spanish–Canadian co-production *My Life Without Me*.

As she has admitted numerous times, her filmic imagination is very much indebted to American independent cinema and European auteurism. I will return to this point. Suffice it to say that her adoption of these traditions has been read by some critics as a failed attempt, due to the anonymous (i.e. not nationally loaded) landscapes of her films. Thus, Hilario Rodríguez writes in the Spanish film journal *Dirigido* about *My Life Without Me*:

> Al final, unos y otros se convierten en autómatas en manos de Isabel Coixet, a quien se le escapa una relación más íntima con el entorno y con las circunstancias de la historia, despojando el cine independiente norteamericano de su personalidad. Pues donde un cineasta estadounidense habría descrito su país y habría visto a sus personajes como habitantes de un mundo determinado, la cineasta catalana sólo ha sabido ver una mujer que antes de morir constata lo mucho que la echarán de menos sus seres queridos y un par de amigos cuando haya muerto. (2003: 10)
> [In the end, everyone becomes an automaton in the hands of Isabel Coixet,

who is unable to establish a more intimate relationship with the environment and the circumstances of the story, depriving American independent cinema of its personality. Where an American filmmaker would have described her country and would have seen her characters as inhabiting a particular world, the Catalan director has only been able to see a woman who, before dying, confirms how much her loved ones and a couple of friends will miss her when she is dead.]

What is particularly revealing about this quotation is how the lack of a nationally loaded visual vocabulary can automatically result, following this journalist's reasoning at least, in the weakness of the filmic construction. It might well be the case that the national instability of the *mise-en-scène* is weakening our own cognitive frameworks and expectations.

Coixet's *The Secret Life of Words* (2005) has most definitely consolidated her as an unclassifiable director. Núria Triana-Toribio, in a text about the transnational dimension in Isabel Coixet's cinema, highlights that her trajectory points towards a 'resistance to narrowly prescribed ideas of national cinemas and to labels such as "Spanish"/"Catalan"/"European"/"woman" filmmaker' (2006: 47). With regard to this destabilisation of normative categories mentioned by Triana-Toribio, I will now explore certain questions about gender, nationality and cinema.

Women filmmakers' reluctance to be identified with feminism has been a constant in Spanish cinema. Like many of her colleagues, Isabel Coixet has declared:

Yo, esto de la mirada de mujer ... siempre que estamos en una mesa redonda acerca de este tema, procuro no acudir ... No me parece mal hablar de esos temas, pero me parece que las mujeres debemos orientar nuestra energía en producir cosas, en seguir adelante, encontrar una voz, expresar cosas que queremos expresar a través de esa voz, que es una voz que siempre estás buscando. (Camí-Vela, 2005: 68)
[This business of a female gaze ... whenever we are at a round table on this topic I try not to attend it ... I am not against talking about these topics, but I think that women should focus their energy on producing things, on carrying on, finding a voice, expressing things that we want to express with that voice, which is a voice that you are always looking for.]

This reluctance could be interpreted either as an underestimation of how gender/sexual discourse works or as a more or less conscious resistance to being pigeon-holed in a category that could produce unwanted effects in the film market. Consider, however, Coixet's comments, quoted above, on the hostile reception of her first film in 1988 by Spanish critics. Or consider the recently created CIMA (Asociación de Mujeres Cineastas y de Medios Audiovisuales), of which Isabel Coixet is a founding member, whose objectives are both to increase the presence of women and to 'dignify [their] public image' in the audiovisual sector.[1] It would be counter-intuitive not to recognize a feminist impulse in the collective attempts and filmic works of Spanish women directors (Pérez Millán, 2003: 54).

The second question in Núria Triana-Toribio's quotation above relates to how one is to respond to a director who is not interested, for whatever reasons, in both the Catalan/Spanish-inscribed industrial structures and the symbolic repertoires available to her. This question mainly emphasises the limitations of the theoretical vocabularies that have been designed to suit modernity. As far as film studies are concerned, national cinemas have undoubtedly been a structuring principle, more often than not, closely attached to that of auteur and art cinema. In engaging with national cinema, either as an essentialist category or a constructed one, film studies have tended to overlook the inherent transnational quality of this modern technology par excellence. This effect, as Rey Chow convincingly argues, stems not only from the expansionist tendency of the film industry but also from the very technological constitution of cinema as a 'transcultural phenomenon' transcending verbal communication (1998: 174–5). Thus the editors' introduction to a special issue of the *Journal of Hispanic Research* on the transnational in Iberian and Latin American cinemas' opens with a reminder to the readers that '[t]ransnationalism is as old as cinema, which since its earliest days has been a hybrid art' (Perriam et al., 2007: 3). This said, the digital revolution, together with the transformation of industrial capitalism, has resulted in an intensification of transnational economic, political and social structures, in turn resulting in both the erosion of the old notion of the modern nation state and the global circulation of flows of financial capital, commodities, information, people and images.

This cross-national intensification is the core of current debates in film studies concerning the obsolescence of the national scale, inasmuch as 'the modern nation-state as a compact and isomorphic organization of territory, ethnos, and governmental apparatus is in a serious crisis' (Appadurai, 2003: 337). The constant reworking of more suitable notions, such as transnational cinema (Ezra and Rowden, 2006) or world cinema (Dennison and Hwee Lim, 2006), is committed to highlighting the fundamental interconnectivity of cinema (Nagib, 2006: 34). These notions too easily risk turning into buzzwords. But they also present the advantage of undermining misleading binary approaches that obscure the inherently transnational quality of cinema.[2]

Isabel Coixet has repeatedly acknowledged a mixed cultural background. Her work pertains to the stylistic tradition of independent American cinema which, and as Núria Triana-Toribio has rightly pointed out, in turn is inspired by European auteurism while, at the same time, not renouncing certain Hollywood tactics, such as having recourse to the star system (2006: 57). This is quite an interesting phenomenon as it already indicates the dubious validity of binarisms such as Hollywood–other cinemas. The label 'international auteur cinema' (Elsaesser, 2005: 42) could be used to account not only for common imaginaries but also for common commercial strategies. Thomas Elsaesser conceives international auteurism as the cinema emerging from the new conditions of globalisation and aimed at global

audiences other than those targeted by mainstream Hollywood produc-
tions, popular national films and/or big-budget European projects (2005:
44, 497).

And what are the strategies of international auteur cinema, other than
those of cultural capital owned both by filmmakers and their global audi-
ences? Elsaesser identifies three main strategies: small-scale production
involving cooperation with other partners, 'staging' authorship and the
international film-festival circuit (2005: 69, 506). How does Isabel Coixet
meet the conditions proposed by José Enrique Monterde, in the vein of
Elsaesser, to depict contemporary Spanish cinema as '[el] cine asimilable al
internacionalismo autoral que sabe sacar provecho de su carácter minori-
tario y de las sinergias culturales en cuyo marco se hace posible'? (2007: 37).
('The cinema fitting into an auteurist internationalism that knows how to
derive benefit from its minority character and the cultural synergies which
make it possible'.)

The Secret Life of Words: contextual approaches

Isabel Coixet's fifth feature film was a production of El Deseo with the par-
ticipation of Mediapro. This is Coixet's second film with Agustín and Pedro
Almodóvar's company, which has been promoting young Spanish directors
since the 1990s and is increasingly interested in international collaboration
at different levels. Mediapro is a Spain-based company dedicated to film
production services. It has a presence in Europe as well as in North and
South America through its subsidiaries Promofilm and Media World. The
film was shot in English with an international cast including Sarah Polley,
Tim Robbins, Julie Christie and the Spanish actor Javier Cámara.

The film tells the story of Hanna (Sarah Polley), a solitary young woman
who works in a factory. While on holiday she decides to take care of Josef
(Tim Robbins), a man who is badly burned as a result of an accident on the
oil rig where he is employed. Her experience with Josef and other workers
in the oil rig will finally reveal that Hanna was tortured during the conflict
in the Balkans and that she has received medical assistance in the past from
the IRCT (International Rehabilitation Council for Torture Victims) and its
medical director Inge Genefke (Julie Christie).

The story is inspired by the real Copenhagen-based NGO of the same
name as the one appearing in the film, established in 1985 by Doctor Inge
Genefke. Prior to this fictionalisation, Coixet made a documentary, *Viaje
al corazón de la tortura* (*Journey to the Heart of Torture*, 2003), follow-
ing the testimonies of both victims and personnel involved with the IRCT.
On its website, the IRCT has launched a comprehensive section about *The
Secret Life of Words* covering three interrelated types of material: about the
film itself (notes by Isabel Coixet, reviews, release dates worldwide), about
the impact of the film (a special screening in Brussels for members of the
European Commission and Parliament, a special screening in The Hague

to commemorate, on 26 June 2006, the International Day in Support of Torture Victims) and about what the IRCT's objectives are and how it operates internationally. An intelligent communication policy is fundamental for the success of organisations that work independently and are in need of a wide range of promotion strategies – mass culture and cinema being important ones – to win public attention and funding for their causes.[3]

The Secret Life of Words was first screened at the sixty-second Venice Film Festival in 2005, where it was awarded the Premio Lina Mangiacapre, which was created in 2003 to recognise the film which best represents the role of women today. It was commercially released in Spain in October 2005[4] and was awarded several prestigious national prizes and received critical acclaim. Here is an excerpt from the review of *The Secret Life of Words* in the Spanish cinema magazine *Fotogramas*, which recalls the previous discussion on the validity of national and supranational labels:

> Equilibrado e inteligente recurso, el de lo ligero trocado en dramático, que acerca, aún más si cabe, a la cinta a lo mejorcito del cine europeo, con el francés como modelo reconocible, aunque la presencia de una radiante y crepuscular (otra paradoja) Julie Christie asimismo evoca a la luminosa, y umbría, *Petulia*, de Richard Lester. Del escenario del cual se aleja, un poco, es el de la película indie USA, de la cual quedan algunas formas estilísticas, pero mutadas en aras a volver a los orígenes. (Fernández, 2005: 15)
>
> [A balanced and intelligent tactic, turning lightness into drama, which takes the film closer still to the best examples of European cinema, of which French cinema is an established model, although the presence of a radiant and waning (another paradox) Julie Christie likewise evokes the luminous and sombre *Petulia*, by Richard Lester. The film distances itself from the US indie film, of which it retains some stylistic forms but is transformed in order to return to the origins.]

What is interesting in this text is the recourse to a vocabulary of the origins and the nostalgic celebration of a European filmic tradition. This is something that Isabel Coixet herself takes up in an interview in the same issue of *Fotogramas*:

> IC: Hay un abismo entre lo que uno dice y lo que uno siente y quiere. Y mis películas siempre hablan de eso, aunque ésta está enmarcada dentro de un contexto más amplio que tiene que ver con Europa respecto al mundo en el momento actual.
> [There is a chasm between what one says and what one feels and wants. And my films always talk about that, although this film is inscribed in a wider context that has to do with Europe with regard to the world at present.]
>
> F: ¿De dónde sale esta conciencia europea? ¿Por qué ahora?
> [Where is this European consciousness coming from? Why now?]
>
> IC: No lo sé, pero siento una responsabilidad, a veces me pregunto si absurda, del hecho europeo, de lo que somos respecto a los ameri-

canos, esa sociedad que no sabe llegar a la esquina si no es con un café de Starbucks en la mano. También tengo la sensación de que lo más aproximado a una vida real se siente más en Europa que en USA (Coixet, 2005: 109).

[I don't know, but I feel a responsibility, sometimes I wonder if this may be absurd, towards that which is European, towards who we are versus the Americans, that society unable to get to the corner without a Starbucks coffee in the hand. I also have the impression that we are closer to real life in Europe than in the US.]

Regardless of the actual transnational structure of the film industry at large and of our own exposure to globalised mediascapes, national and supra-national (i.e. European) categories do have, as the above examples demonstrate, a symbolic and affective value (as well as an economic one) at play in the way we see or want to see ourselves. The various regimes involved in the different uses of a politics of identity within the film industry indicate why one has to be wary when engaging too readily with an unproblematic notion of transnational cinema.

Coixet seems to share with other filmmakers a few other strategies, in addition to small-scale co-production (Triana-Toribio, 2007: 158), which according to Elsaesser allow us to talk of an international auteur cinema. The minority target market of a film like *The Secret Life of Words* and the subsequent difficulties in securing distribution and exhibition channels make international film festivals a marketing priority, to the extent that the festival circuit, where the most important distribution companies for independent cinema are present, has become a powerful alternative to the Hollywood studio system (Elsaesser, 2005: 88 and 93). Art house cinema festivals act as sites that add cultural value to films and, it is hoped, put them into circulation in the global market. It is within this logic of value addition that the 'European dimension ... makes [films] enter into global symbolic economies, potentially re-writing many of the usual markers of identity' (Elsaesser, 2005: 83). So European self-affirmation, as we have seen in the case of both the critics and Coixet herself, might go beyond genuine affective and cultural attachments and function as a primordial marketing tool. Hand in hand with the role of festivals as promotion opportunities is what Elsaesser calls 'staging' authorship (2005: 51). That is to say, the personal effort for self-promotion made by individual directors using a wide range of strategies (Triana-Toribio, 2006: 50).

The negotiation between different economic and symbolic strategies, ranging from the national to the transnational (small-scale co-production, the international film-festival circuit, 'staging' authorship, the investment in an European tradition, an international cast, the choice of a political theme with global impact), makes Isabel Coixet's *The Secret Life of Words* part of the so-called international auteur cinema. In the last section of this chapter,

I intend to examine how the conditions of production of this emergent international authorship might affect regimes of representation.

Visual representation: place, space and the gendered body

What happens to visual representation when a film is not only produced under the transnational conditions of world auteurism previously discussed, but also aims to construct on-screen the itinerary of a diasporic subjectivity (Hanna's journey from the former Yugoslavia to Western Europe)? I will contend in what follows that 'placelessness', which I argue is one of the most distinctive traits in Coixet's *mise-en-scène*, is not the consequence of the alleged universalism of her intimate cinema (Maurer Queipo, 2007). Instead, a more satisfactory explanation for the placeless atmosphere of her filmography, as I will examine in relation to *The Secret Life of Words*, lies in the 'disjunctive order' underpinning her cinema.

Three main locations organise Hanna's story: a factory and an oil rig – epitomising the dissemination of late-capitalist production – and the IRCT archives in Copenhagen where numerous stories from victims of torture are filed. All three places are the effect of economic and political deterritorialisation and, therefore, deconstruct conventional territorial tropes about a coherent identity founded on the isomorphism of the nation state (Appadurai, 2003: 346–7) and offer a new topology of displacement. John Berger, to whom this film is dedicated,[5] identifies in *The Secret Life of Words* a postmodern realism speaking about the extreme inequalities of our time.[6]

These spaces of invisible labour and politics, constitutive of globalisation, are produced as embodied practices. The shooting of the factory where Hanna is an immigrant worker displays a succession, accompanied by extra-diegetic electronic music, of bodies in automatic circulation. This objectification of the human body is excessively performed by Hanna herself. The traumatic experience of war, and the physical and psychological wounds that this has inflicted on her, turns her own body into the unbearable manifestation of the disciplined body. The visibility of the invisible quality of exploitation, conveyed on the screen by her compulsive behaviour among her fellow workers, is felt by the latter as socially disruptive in so far as the docility–utility relation of waged work is bodily exacerbated and, therefore, made symbolically intolerable. In the development of the plot this will lead to the suggestion from her line manager, based on a collective complaint, that she take a few weeks off in order to restore social order.

The oil rig where Hanna spends her vacation taking care of Josef, a blind man seriously injured after a work accident, will play a fundamental role in the spatial organisation of the narrative. The aesthetic possibilities of such a site (including the allusion to the environmental impact of capitalism) facilitate a privileged space to situate the experience of abjection. The abject subject constitutes an uncanny excess threatening the symbolic order

(Kristeva, 1980). We have already seen how this abnormal excrescence in the social tissue, incarnated by Hanna's communicative problems at the workplace, encourages her expulsion from the social body. But this repulsion does not necessarily imply an absolute differentiation between the abject subject and others. Rather, the abject bears witness to the inherently abject nature of workers in postmodern societies. And it is precisely the acting-out of this constitutive quality of the relations of production that disturbs the normal functioning of the social machinery. In the case of this film, the structure of abjection is not only informed by capitalist exploitation but also by sexual and ethnic violence.

Coixet never unravels the stories behind the group of men in the oil rig. She decides to sketch fragmented and problematic elements of these characters in order to replicate the traumatic experience of Hanna as well as her guilty response to it. But what is her story? And more importantly, where does it happen? These questions structure the film's narrative by reworking the conventions of romantic melodrama. Isabel Coixet has declared about *The Secret Life of Words* that '[u]ltimately, this story is a fairy tale. There is a woman whose baggage of suffering is unbearable, but who finds her prince charming on that rig.'[7] Let us examine in some detail the textual construction of what the filmmaker herself has called 'una versión moderna y muy propia de *Blancanieves y los siete enanitos*' (Coixet, 2005: 107). ('A modern and very apt version of *Snow White and the Seven Dwarfs*'.)

Hanna was raped during the war in the Balkans. The appalling frequency of sexual abuse, mostly of women by men, in violent political conflicts indicates to what extent violence is culturally rooted in gender domination. Sexuality then becomes a field where political antagonisms are displaced and transformed into a brutal and gendered way of annihilating the other. Or, and taking up again the concept previously introduced, a way of abjecting women's bodies as essentially incarnating the hated other.[8] The system sex/gender provides the abusers with an ambiguous regime of otherness: on the one hand, this regime is constituted by a long cultural history of oppression, and at the same time it proves the meaningless status of violence. The abjection of women's bodies stands as the ultimately empty (but culturally inscribed) gesture of brutality. The absolute violence of this gesture is not a language; it does not stand for anything. It is pure self-reference aimed at disintegrating the other's self. And this disintegration inflicted by a cruel demonstration of power that disturbs the victim's relation to others through a complex process of shame, guilt and denial. As a result of this immensely traumatic experience the subject renounces verbal communication and relates to others and reality through the compulsion of bodily enacted rituals: Hanna's scarce and monotonous daily diet, her obsession with repeatedly washing her hands, etc.

The relationship that Hanna establishes with Josef will progressively allow the coming to terms with her unspeakable pain. To a certain extent, the affective attachment to Josef reverberates with Hanna's relationship

with Inge, her counsellor at the IRCT where she had been admitted as a victim of torture. Both relations are marked by a tension between what is visible/speakable/present and invisible/unspeakable/absent and the possibility of Hanna regaining control over this conflict. But this possibility is recurrently deferred: silent calls from Hanna to Inge; Hanna's recorded testimony of violent abuse piled up in the IRCT archives; Hanna's inability to socially relate to others. Only the sharing of her pain with Josef, and the love relationship between them, redeems Hanna from horror. So far, there is nothing unconventional about this narrative. However, Coixet chooses to revisit one of the structuring motifs of melodrama: the regime of gendered filmic representation. In his inspiring *Ways of Seeing*, John Berger talks about how sexual difference organises the visual field:

> One might simplify this by saying: men act and women appear. Men look at women. Women watch themselves being looked at. This determines not only most relations between men and women but also the relation of women to themselves. The surveyor of woman in herself is male: the surveyed female. Thus she turns herself into an object – and most particularly an object of vision: a sight (1972: 47).

Coixet makes an interesting narrative decision in her representation of Hanna and Josef. The bond between them breaks down, at least at a representational level, the dominant code of visibility described by Berger. In one of the key scenes of the film Hanna tells Josef the truth about her traumatic past. When Hanna finishes her story she opens her blouse and takes Josef's hand over her scars. The healing process of witnessing Hanna's pain will be represented on the screen as a pure verbal–tactile act which cannot be appropriated by Josef's masculine gaze. At this point Hanna's abject body has become the instrumental place to situate Hanna's story. An embodied place haunted not only by the injustices of the global economy but also by the constitutive violence of national, ethnic and gender discourses.

Nonetheless, there are two aspects that limit the subversive potential of Coixet's narrative revisitation of *Snow White*. First, the alteration of the dominant gendered visual code at a representational level does not mean that the spectator's gaze identifies with Hanna. On the contrary, spectatorship identification mainly remains in the male fantasy of the blind character in so far as his intervention elicits the transformation of Hanna and, therefore, controls the filmic diegesis (Mulvey, 1989: 20–1). And, second, the choice of a melodramatic narrative focused on a love story underestimates the public dimension of personal suffering and, therefore, the core aspect of its legal reparation.

Final considerations

In this chapter I have discussed some of the material and symbolic elements of the current intensification of transnationalism affecting cinema.

On the one hand, Coixet's cinema is produced within a global–local network that Kevin Robins defines as follows: 'What we are seeing in the cultural industries is a recognition of the advantages of scale, and in this sphere too, it is giving rise to an explosion of mergers, acquisitions, and strategic alliances' (1997: 245). These economic arrangements resulting from the dynamics of globalisation are most definitely reorganising the spaces of the film industry: from a narrower labour spatiality within national frontiers to a transnational industrial network. This reconfiguration has provided young directors in Spain (especially women) with new opportunities unavailable to them within a more rigid and nation state-controlled cultural economy (Rodríguez, 2006: 278). Now all these strategic alliances, crucially involving delocalisation and different international agents (co-production, casting and film festivals among the most important), should not overestimate the role of the so-called postmodern geographies. As we have previously seen, place matters when it comes to adding cultural and economic value. Hence, Coixet's interest during the promotion of *The Secret Life of Words* in ascribing her film to a European tradition.

On the other hand, I have argued that the disjunction between culture and territory can be observed in this case study not only in material terms but also in semiotic ones. First, international auteurism results from a transnational cultural capital, shared by artists and their public, produced and consumed according to the interplay between the trajectories of different regimes: ethnoscapes, mediascapes, technoscapes, finanscapes and ideoscapes (Appadurai, 2000). These five landscapes incarnate an '"imagined world", that is, the multiple worlds which are constituted by the historically situated imaginations of persons and groups spread around the world' (Appadurai, 2000: 101). In this respect, the aesthetics of Coixet's filmography aligns itself with a new and boundless cosmopolitanism (Robins, 1997: 254; Belausteguigoitia, 2009). Second, the visual representation in *The Secret Life of Words* of the impact on gendered subjectivity of the current international division of labour, migration and war shows a complex relationship between place and space. Displacement and mobility resulting from economic and political crisis are embedded in postmodern spaces shaping social relations; the factory, the oil rig and the archive epitomise in Coixet's film the spatiality both of the abusive power (economic, environmental, political, ethnic, sexual) of late capitalism and of the cooperation and resistance against it. However, spatialised social relations are experienced by gendered and socially situated bodies. I have examined the filmic representation of Hanna's embodied subjectivity – her sense of place – and made a critical reading of its gender ideology as well as of its limited political message. In short, I think that the visual organisation of this film's narrative demonstrates the analytical relevance of taking into account the interplay between space, place and the body which Linda McDowell has termed global localism (1996: 38).

Notes

1 cimamujerescineastas.es
2 For an insightful discussion about the notion of transnational cinema, see Triana-Toribio (2007).
3 In an interview with Rafael Cerrato, Isabel Coixet has said: 'Estoy contenta con *La vida secreta de las palabras* porque para mí es un orgullo que hubiera un pase en el Parlamento Europeo, en Bruselas, y que gracias a ese pase, que se hizo para todos los eurodiputados, la organización [IRCT] tenga una subvención de la Unión Europea' (Cerrato, 2008: 40) ['I am happy with *The Secret Life of Words* because I am very proud of its exhibition in the European Parliament, in Brussels, and that thanks to that exhibition, addressed to all Euro MPs, the organisation [IRCT] has an EU subsidy']
4 In the light of target market of *The Secret Life of Words* it is not surprising that of all Spanish films released in 2005 it gained twelfth position with respect to the number of spectators, 510,711. First position went to *Torrente 3*, with 3,573,065. More telling about spectators' habits is the fact that Spanish films in 2005 had 21.29 million spectators, while foreign films had 106.95 million (76,962,023 corresponding to US films). See www.mcu.es/cine/MC/CDC/Anio2005.html. As for the exhibition abroad of Coixet's film, admissions in Europe have been, since 2005, 1,029,939 (of which, since 2005 to date, 682,551 were in Spain). Information available at the database Lumière of the European Audiovisual Observatory http://lumiere.obs.coe.int/web/search
5 The film is dedicated to both Inge Genefke and John Berger.
6 www.mongrelmedia.com/data/ftp/Secret%20Life%20of%20Words,%20The/SECRET%20LIFE%20-%20Press%20%20kit.pdf
7 In www.cineuropa.org/interview.aspx?lang=en&documentID=62975
8 Films by different ex-Yugoslavian women filmmakers have addressed the war in the 1990s in relation to different aspects of sexuality. Jasmile Žbanić's *Esma's Secret* (Bosnia, 2006) or Teona Strugar Mitevska's *How I Killed a Saint* (Macedonia, 2003) are examples of the conflation between political violence and sexuality.

References

Appadurai, A. 'Disjuncture and difference in the global cultural economy', in K. Nash (ed.), *Readings in Contemporary Political Sociology* (Oxford: Blackwell, 2000), pp. 100–14.
——— 'Sovereign without territoriality: notes for a postnational geography', in S. Lowand and D. Lawrence (eds), *The Anthropology of Space and Place* (Oxford: Blackwell, 2003), pp. 337–49.
Belausteguigoitia, M. 'Frontera', in M. Szurmuk and R. McKee Irwin (eds), *Diccionario de estudios culturales latinoamericanos* (México: Instituto Mora/Siglo XXI, 2009), pp. 106–11.
Berger, J. *Ways of Seeing* (London: Penguin, 1972).
Berger, J. 'Some notes on *The Secret Life of Words*', available at www.mongrelmedia.com/data/ftp/Secret%20Life%20of%20Words,%20The/SECRET%20LIFE%20-%20Press%20%20kit.pdf (accessed 6 May 2010).

Camí-Vela, M. *Mujeres detrás de la cámara. Entrevistas con cineastas españolas 1990–2004* (Madrid: Ocho y medio, 2005).

Cerrato, R. *Isabel Coixet* (Madrid: Ediciones JC, 2008).

Chow, R. 'Film and cultural identity', in J. Hilland and P. Church Gibson (eds), *The Oxford Guide to Film Studies* (Oxford: Oxford University Press, 1998), pp. 169–75.

Coixet, I. '*La vida secreta de las palabras*. El amor según Isabel Coixet. Entrevista'. *Fotogramas* 1944 (October): (2005), 107–11.

Dennison, S. and S. Hwee Lim (eds). *Remapping World Cinema: Identity, Culture and Politics in Film* (London: Wallflower, 2006).

Elsaesser, T. *European Cinema: Face to Face with Hollywood* (Amsterdam: Amsterdam University Press, 2005).

Ezra, E. and Rowden, T. (eds). *Transnational Cinema: The Film Reader* (London: Routledge, 2006).

Fernández, F. '*La vida secreta de las palabras*', *Fotogramas* 1944 (October): (2005), 15.

Kristeva, J. *Pouvoirs de l'horreur: Essai sur l'abjection* (Paris: Éditions du Seuil, 1980).

Maurer Queipo, I. 'Isabel Coixet y su vida sin mí', in B. Pohl and J. Türschmann (eds), *Miradas glocales. Cine español en el cambio del milenio* (Madrid/Frankfurt, Iberoamericana/Vervuert, 2007), pp. 249–66.

McDowell, L. 'Spatializing feminism: geographic perspectives', in N. Duncan (ed.), *Body Space: Destabilizing Geographies of Gender and Sexuality* (London: Routledge, 1996), pp. 28–44.

Monterde, J. E. 'Miradas hacia el cine español contemporáneo', in B. Pohl and J. Türschmann (eds), *Miradas glocales: Cine español en el cambio del milenio* (Madrid/Frankfurt: Iberoamericana/Vervuert, 2007), pp. 29–37.

Mulvey, L. 'Visual pleasure and narrative cinema', in *Visual and Other Pleasures* (Basingstoke: Palgrave, 1989), pp. 14–26.

Nagib, L. 'Towards a positive definition of world cinema', in S. Dennison and S. Hwee Lim (eds), *Remapping World Cinema: Identity, Culture and Politics in Film* (London: Wallflower, 2006), pp. 30–7.

Pérez Millán, J. A. 'Women are also the future: women directors in recent Spanish cinema', *Cinéaste*, 29(1) (2003), 50–5.

Perriam, C., Santaolalla, I. and Evans, P. 'The transnational in Iberian and Latin American cinemas: editors' introduction', *Hispanic Research Journal*, 8(1) (2007), 3–9.

Robins, K. 'Tradition and translation: national culture in its global context', in L. McDowell (ed.), *Undoing Place? A Geographical Reader* (London: Arnold, 1997), pp. 243–57.

Rodríguez, H. '*Mi vida sin mí*. Lo que piensan las mujeres', *Dirigido*, 321 (2003), 10.

Rodríguez, M. S. 'Le cinéma d'Isabel Coixet: de la conception à la création', in F. Etienvre (ed.), *Regards sur les espagnoles créatices: XVIII–XX siècle* (Paris: Presses Sorbonne Nouvelle, 2006), pp. 269–78.

Triana-Toribio, N. 'Anyplace North America: on the transnational road with Isabel Coixet', *Studies in Hispanic Cinemas*, 3(1) (2006), 47–64.

Triana-Toribio, N. 'Journeys of El Deseo between the nation and the transnational in Spanish cinema', *Studies in Hispanic Cinemas*, 4(3) (2007), 151–63.

Internet sources (last consulted in May 2010)

cimamujerescineastas.es
http://lumiere.obs.coe.int/web/search
www.cineuropa.org/interview.aspx?lang=en&documentID=62975
www.mcu.es/cine/MC/CDC/Anio2005.html

12

Reconfiguring the rural: fettered geographies, unsettled histories and the abyss of alienation in the work of three Spanish women filmmakers

Parvati Nair

A long shot in Ariadna Pujol's *Aguaviva* (2005) shows a winding road that leads to the village of Aguaviva, on the *franja*, or border strip where Aragón blurs into Catalonia. A small and marginal place by dint of its very location, it looks still, almost timeless from afar, not dissimilar to so many villages in northern Spain. The silhouette of the village, the church spire standing tall and overlooking the houses, rests against a static horizon. The landscape appears motionless, forever the same. In the local schoolhouse, however, a little Romanian boy is one of several non-Spanish children in the classroom. When asked by his teacher if he will allow people from Spain into his country in the same way as he, a Romanian, is allowed into Spain, he looks surprised that anyone would ever wish to visit Romania, the country he comes from and has left. With disarming candour, he replies, 'Pero en Romania, no hay euros'. This funny, but poignant, scene of a Romanian child in a Spanish village raises numerous questions about Spanish rural life, social change, human migration and the consequences of the prioritisation of the economic over local cultures and identities.

The village of Aguaviva, with its limited amenities and rustic homes, epitomises the gulf that separates the rural from the urban. Indeed, in many parts of the world, modernisation and its attendant capitalist drives have conspired to privilege the urban to the exclusion of the rural. Nowhere is this more evident than in Spain, a country consumed by urbanisation in the course of the last century. Behind the veneer of Spain's many urban successes is the sad reality of a depopulated countryside, where communities are waning and abandonment is rife. What is at stake or, indeed, already lost, is not merely a way of life. The disempowerment of the rural marks an alarming cultural turn in Spain, whereby age-old markers of identity – the landscape, a sense of place, communal belonging, orally communicated narratives and a specific, culturally inflected set of values – face extinction. Displacement, it would seem, affects even the most 'rooted' in rural Spain, as the changes wrought by globalisation take hold uninvited. As the writer Julio Llamazares is known to have noted (1988), the decline in rural life has

led not solely to the loss of oral traditions, narratives and collective memory, but to a profound alienation of the rural. Yet, seldom is this brought to the fore in the country's mass media.

Ironically, and although the film industry, like others, must be seen to be part of such cultural alterations, it is precisely some recent Spanish cinema – that most modern of cultural media – that has focused on this marginalisation of the rural. Notable examples of recent socially engaged cinema present the repeated trope of abandoned rural spaces, where isolation and the violence of the margins are most keenly felt. Three women filmmakers, in particular, stand out for their nuanced explorations of the dynamics of displacement that afflict rural areas: in her documentary *Aguaviva* (2005), Ariadna Pujol teases out the complexities of cohabitation when the mayor of the village of Aguaviva puts out a call for immigrants from abroad to come and settle down in a bid to fight depopulation; in *Poniente* (2002), Chus Gutiérrez focuses on tensions in the region of El Ejido, where a largely immigrant workforce toil in sub-standard conditions to sustain the agricultural production that fills much of northern Europe's salad boxes; and in *Flores de otro mundo* (1999), Icíar Bollaín focuses on the dynamic of unsettlement that arises when lonely men in an isolated village forge relationships with immigrant women from Latin America who seek economic and personal security. What we see in these films is the paradoxical face of development within capitalism, whereby villages in Spain, which have become increasingly relegated to an ageing 'native' population and to disregard, are revived and fundamentally altered by immigration from poorer and less economically affluent nations.

This chapter will seek to examine three key themes that are common to the work of these three women filmmakers in their treatments of rural Spain and immigration: the geopolitics of power and disempowerment, the fracture of historical cohesion and questions of alienation. All three themes are central to understanding the impact that globalisation has had on the Spanish countryside. Looming large in the backdrop of all three films, although seldom explicitly mentioned as such, is the overriding force of capital that reallocates human resources and redraws social, cultural and economic mappings. While the emergence of films showcasing the increasing, and much debated, phenomenon of immigration to Spain has led to the creation of a new and growing genre of cinema on this topic, the three films mentioned above are notable for transporting the immigrant out of urban settings into rural ones. Here, the underbelly of Spanish modernisation reveals two intertwined areas of marginalisation that both arise from and sustain the ruthless moves of capital empowerment: the uprooted scene of the rural and the errant and contradictory figure of the immigrant seeking to lay new roots in new places, while still being umbilically attached, in an emotive and imagined sense, to the idea of roots 'back home'. Both embody the critical abandonment of the human, the natural and the communal that arises in the wake of the prioritisation of capital. Both also highlight

cultural improvisation, hybridity and the pliability of the human in the face of enormous change. What we see is a fragmented social landscape that afflicts every nook and cranny of Spain, as it does the rest of the planet, but it does so by injecting mobility and change into even the most remote parts of the country, as globalisation and transnationalism, twin contemporary processes of capitalism, remap and redefine the country.

In the context of studying these films, it is important to bear in mind the position of women filmmakers in the Spanish film industry. As Tatjana Pavloviç has pointed out (2009: 189), women have encountered considerable resistance in Spain with regard to carving out spaces for themselves as serious filmmakers. The vast majority of Spanish film directors are male. The three women directors mentioned here must therefore be seen as in a minority, a fact that no doubt colours their approaches, priorities and interests as regards filmmaking. While Bollaín and Gutiérrez have over the years established themselves as important directors within the panorama of post-Francoist Spanish cinema, Pujol was little known prior to making *Aguaviva*. This marginality of the female director leads, in the films mentioned here, to an upstaging of cinema's established role in forging the imaginations of the nation (Hjort and Mackenzie, 2000). The emergence of these three women filmmakers breaks this latter mould, as their films reveal both nation and locality in flux and embroiled in larger global currents. Their focus on the figure of the immigrant subverts any myth of the nation as a stable field of identity and belonging or as a closed and protected space. Instead, what the work of these three women filmmakers does, as we shall see, particularly by depicting the rural, is that they touch upon the 'heart of Spain', and thereby interrogate some of the most 'essential' markers of identity. In so doing, they show these once supposedly stable signifiers of location and belonging as floating, subject to the dictates of capital and the larger socio-economic forces that engulf Spain, city and country alike. Within this context, these directors highlight the predicament of the human and the social, charting their responses in the everyday to economic forces beyond their control, but to which they are, nevertheless, subject.

Curiously, these filmmakers straddle a fine line between documentary and socially engaged cinema, whereby either genre melds into the other, rendering documentary rich in metaphoric potential and fiction deeply embedded in the existing social fabric. Through this borderline genre, the margins come into view via a focus on the rural, revealing deep fissures in the jagged cultural landscape of contemporary Spain. The choices of social realism, on the one hand, and documentary, on the other, converge on a common concern with place, history and identity that dominate all three films. Indeed, my rationale in selecting these films as the focus for this chapter centres upon the ways in which fiction and documentary offer complementary perspectives on a common theme, foregrounding, as Paul Ricœur *et al.* have shown us (1990), the importance of both forms of narrative, fictional and documentary, in the constructions of 'history', and by extension, of knowledge.

Furthermore, the challenges of cross-cultural filmmaking are often best met by formal methods that centre on and around documentary (Barbash and Taylor, 1997: 4). From a formal point of view, documentary has often taken as its subject the figure of the marginal. Such cinema has, above all, an empathising force with social subjects, prioritising as they do the everyday and the ordinary, as opposed to grand narratives of mythical dimensions. This is particularly apt for a cinema that seeks to examine the fractures and disruptions caused by large-scale processes that affect localities and ways of life. It creates a hybrid genre of cinema that conjoins storytelling with documentary and/or social realism and that explores the ethnographic and geographic alterations and perplexities arising from globalisation and its mobilising forces. Such work touches importantly on questions of social justice and recognition within the larger, and all encompassing, context of the geopolitics of global capitalism.

What all three films have in common, of course, is the trope of the immigrant in rural Spain, whose point of view becomes an important lens through which changes in Spain can be viewed and assessed. Furthermore, the framing of the immigrant as 'other' serves to foreground the tenuous nature of the social fabric, of that which is local, its alterability and its contingency on larger economic and socio-political factors. This becomes all the more poignant when seen in rural settings, for if the city has long been accepted as the locus of change, mobile in its adaptations to modernity, then, by contrast, rural Spain has often been seen as the heartland of an apparently unchanging and reliable national identity. As the poet Antonio Machado reiterated in his *Campos de Castilla* (1973), the Spanish heartland remained in the modernist imagination the touchstone of 'authenticity' and stable identity, and it was to this that he and many others of the Generation of 1898, engaged in the heated debate on the identity of Spain that characterised the end of the nineteenth century, turned to seek out the imagination of the nation. The arrival of immigrants to rural zones, as seen in these three films, confirms the unsettlement of the rural, by extension a deep and irrevocable dislocation of nation and identity as imagined.

Always in the backdrop of these films is the larger scenario of globalisation, a phenomenon that has engulfed Spain, and that Spain in turn has duly embraced with zeal, in the wake of the repressive years of the dictatorship. Globalisation, and the attendant processes of transnationalism, cut across an imaginary frontier that has traditionally separated the rural from the urban, by mobilising capital and destabilising communities. The transnational mobility of capital layers itself over any binary opposition of city and country, turning the latter into the underbelly of global economic and cultural processes that mobilise and scatter peoples and places. What is curious, of course, is that if rural areas remain relatively unmodernised in comparison to urban centres, they are nevertheless linked to the latter in their marginality and so are prey to the uncertainties and alterations wrought by globalisation. Also in the backdrop to these films is the unan-

swered question of development in the modern world. These films showcase economic migrants from the developing world (a euphemism for a global majority that inhabits spaces of economic and political disadvantage in comparison to the West, many parts of which once colonised them and continues to hold them in the grip of capital-driven Empire), seeking empowerment in Spain, a developed nation. Their presence in rural areas underlines the uneven nature of development outside the 'First World', as well as the jagged profile of development in Spain, once a poor Mediterranean neighbour of northern Europe. Geographical mappings become complicated through such movements and unevenness, as human migration leads to an unsettlement of the singularity of place and any unbroken imagination of history. Instead, and as this chapter argues, what we see in the work of these three women filmmakers is the contingency of the rural and the many strategies for survival that migrant subjects undertake in a bid to steer the unsteady course of their lives lived in transit.

What emerges is the relevance of geography to questions of power. In his *Spaces of Capital: Towards a Critical Geography* (2001), David Harvey connects the discipline of geography to the growth and spread of global capitalism, raising critical questions about the discipline itself. He argues that geographical knowledge has, in the history of its development as a discipline, been allied to political power. Space, Harvey, shows us, is central to the ongoing survival of capitalism, as it spreads, consuming new grounds that were previously on the margins. Harvey tells us that 'capitalism can open up considerable breathing-space for its own survival through pursuit of the "spatial fix", particularly when combined with temporal displacements ... It is rather as if, having sought out to annihilate space with time, capitalism buys time for itself out of the space it conquers' (338). Most importantly, the spread of capitalism as ideology and praxis in the modern world means that space itself is determined and recognised through capitalist production. Within capitalism, spaces and places become commodified, defined by their economic value and productivity. By extension, then, this also affects the inhabitants of these places. This determining power of capital has tremendous consequences on spaces formed in pre-modern contexts, such as age-old villages like Aguaviva, with an attendant impact on questions of temporality. In turn, this throws into deep disarray the cohesion of local communities and raises questions about the singularity and coherence of landscape, identity, belonging and memory. What becomes clear, then, is that geography is never simply about the mapping of space, but also about the mapping of both empowerment and disempowerment in the predominantly capitalist context of the globe.

The question of geopolitics – and by this, I mean geography understood as a cartography of power, or a mapping not merely of space, but of the inextricable web of places, people and politics – whereby new economic configurations are constantly being produced, creates deep fissures and instabilities in local spaces, especially in those spaces which are outside

global centres. Capital determines the movements of people and the way places are used. This forms a key theme in the work of Pujol, Gutiérrez and Bollaín. In *Aguaviva*, the arrival of immigrants is fuelled by the failure of economies in their own countries – Eastern Europeans escaping economic hardships, two Chilean women looking for opportunities in Europe and a group of Argentinians fleeing a broken economy. Their main interest in living in the village is to find means of economic stability. Aguaviva, once a traditional Aragonese/Catalan village, has turned into a place of relocation for the displaced. As for the locals, the younger generation have left and only return to visit the elders, who cling as they can to an increasingly precarious way of life. The result is a complex mapping of peoples and connections, as traces of different points on the global map and diverse ethnicities and cultures conjoin in the unlikely location of this village. The same is true in an even more intense way in *Flores de otro mundo*, when immigrant Latin American women form relationships with men in the village. Their motivation in forging these ties is primarily economic. On the men's part, these women allow them a lifeline into the future for themselves and their families (Nair, 2002). Ironically, then, the sole route to survival for the outlying community is through a difficult, if necessary, embracing of alterity. A curious interdependence emerges where the economic layers itself over the human and the communal. Through this jagged encounter, deep social and cultural transformations take place in what had hitherto been a part of Spain that has seen little change over the centuries. In many ways, *Poniente* is the most resonant of these films as regards the geopolitics of the rural, for this film echoes the real-life violence that took place in 2000 in El Ejido. Moroccan immigrants, many without papers, form the workforce that ensures the economic well-being of the locality. As such, a deep chasm separates them from the Spanish managers and owners of the greenhouses, many with links to transnational corporations that deal in the export and import of fresh produce. An invisible border demarcates the empowered from the disempowered. Despite having crossed over to Europe, the worker without papers remains marginal, a human resource put in the service of the mass production of food. He is dispensable, for there are numerous others to take his place, all of them also displaced, as he is, from their places of origin. In all of these films, the migrant bodies of the displaced, both immigrant and local, trace through their forced mobility the shifting contours of the geopolitical spaces they cross. They take with them the trail of the border that isolates them and maintains their otherness. The double irony, of course, lies in the fact that the borders they map are themselves formed in the marginal spaces of the rural.

The complication of geography has a direct impact on the sense of history through which individuals and collectives construct and interpret their identities. Historical experience and the coherence of narratives of identity are also disturbed by the crossings made by migrants from one part of the

world to the other, especially when this occurs in the context of economic uncertainties. All three films represent the rural as a space of historical unsettlement. This is most obviously so for those who have arrived as immigrants, but, in the context of the rural, even more so than in that of the urban, immigration displaces, shifts and alters historical understandings of the local, of the self and the other. In *Flores de otro mundo* and in *Aguaviva*, this is felt in a most extreme way, bearing in mind the reliance of dying rural communities on immigrants to build a lifeline into the future. Large questions loom about memory – how can immigrants, who bring with them their own cultural inheritance, maintain the predominantly oral traditions of these places? What sense can immigrants make of their own cultural inheritance in 'foreign places'? What hybridised identities will result from the mixings of the local and the foreign, both by definition marginal and disempowered? A deep irony surfaces in *Aguaviva* in a scene where a group of elderly ladies, native to the village, watch the wedding of Spain's Crown Prince on television, reciting the vows along with him and his bride, while their own lives, lived on the edge at the best of times, are rendered increasingly precarious by the many alterations to their social and cultural milieux. The same is true in *Flores de otro mundo*, when Damián's mother refers – surprisingly when taking into consideration the fact that she has only ever lived in this village and is therefore unaccustomed to foreigners – to his Dominican wife and her two children from her previous marriage as 'his family'. Clearly, even the older generation realise that they must accept the immigrants as a lifeline to an uncertain and culturally hybrid future. In *Poniente*, history takes an apocalyptic turn, as the violence that arises from the marginalisation of immigrants, their harsh economic and social conditions and the injustices of class erupt in flames of hatred. The violent ending of the film evokes in the viewers' memory the events of El Ejido in February 2000, when rioting broke out over three days in an explosion of ethnic violence against Moroccan workers, resulting in the torching of greenhouses, the burning of local points of immigrant gathering and the desperate flight of the Moroccans for safety. Always present in this film is the recollection of Almeria's transformation from an arid land to a place of fertile capitalist production. The course of this transformation has imposed on this rural area the violence of capital that prioritises economic profit over social concerns. It disrupts historical coherence and leads to the fracture and the scattering of communal structures that, at best, as in *Flores de otro mundo* and in *Aguaviva*, may be temporarily reassembled. In this sense, there is a deeply pessimistic note in *Poniente*, as the violence spreads from the hothouses to homes and from workers to management alike in an apocalyptic finale that condemns once and for all the prioritisation of capital over human rights, recognition and justice.

In their indictment of the economic forces – most of which have their historical bases in European colonialism in North Africa and in Latin America – that impact on communities and places, these three women

filmmakers also isolate and bring into the spotlight the question of aliena-
tion. As is well known, Marx (1998) foregrounded alienation as a key
result of capitalism. While he describes it as the separation between the
worker and the product, whereby the worker ceases to have a claim on
the fruit of his or her labour, alienation clearly strikes also at the heart
of communities and collective identities. Indeed, this separation of the
worker from the product places the former at the service of the latter,
and thus renders him or her susceptible to the shifts and instabilities of
the market. Ultimately, the labour force too is reduced to a commodity,
objectified in the prioritisation of capital over humankind and nature. The
result is that collective and communal bonds must be severed or lost in the
process. In the context of all three films, we see that all the rural settings
represented are implicated in global market forces. Thus, communities are
displaced and spaces exploited, as in *Poniente*, for the sake of an economic
enhancement that has little impact on the subjects involved. What ensues
is a profound alienation that afflicts all those involved. In *Flores de otro
mundo*, the final scene depicts the new mixed-race family in their village
home at Christmas. Despite this scene of an apparently coherent unit, the
film has also revealed the many fractures and chasms that the subjects daily
negotiate in order to keep this family going. The very location of this outly-
ing village of Santa Eulalia, as a place that struggles to survive and yet is
attractive to women from even poorer Latin American countries, reveals
the constant attempts made by these characters to overcome the alienation
that engulfs them. In *Poniente*, the female protagonist Lucía struggles in
vain to overcome the growing bedrock of dehumanisation that accompa-
nies capitalist expansion. She makes small attempts to deal fairly with her
workers, but fairness and justice are hard to forge from structures that
aim not to recognise workers, but to tie them to the chain of production.
Ultimately, she is herself too deeply embroiled in the structures of local
and global commercial interests to be able to alter the latter. In *Aguaviva*,
vastly diverse communities cohabit without speaking to one another.
Invisible borderlines separate the elderly from the immigrants. The elderly
form a generation on the wane, stubbornly clinging to the only place they
know, despite the awareness that the village is long past the cusp of change.
The Latin Americans bring with them homesickness, troubled pasts and
uncertainties regarding the future. They have not come to lay down roots
necessarily, but to rebuild lives thrown into chaos by displacement. As for
the Romanians, alienation afflicts them to such an extent that even the film-
maker, Arianda Pujol, despite her very evident efforts to create a frame in
which this diversity and displacement can be contemplated, fails to include
them to the same extent as she does the other groups. The Romanians
who live in the village have a fleeting presence in the film. Their isolation,
linguistic, cultural and economic in its sources, comes through poignantly
through their absence on-screen.

In writing about capitalism and alienation, Marx called for revolu-

tion. He wrote *The Communist Manifesto* in 1848, when the disunities of the modern world had yet to be theoretically acknowledged. In our contemporary age, equipped as we are with a heightened awareness of the many ruptures of space and time that must be taken into account when putting forward the case for a fairer, more just world, it may well be argued that revolution, as understood by Marx, is hard, if not impossible, to accomplish. This is also so because we – like the female protagonist of *Poniente* – work from within modernity and its inseparable alliance with the ideology and projects of capitalism. This is not to say, however, that change, spelled out in small but important ways, is not possible. In his book *The Enigma of Capital* (2010), David Harvey outlines both the problems that arise from this system and also the ways in which activism, specific cultural and social gestures and the circulation of alternative discourses and practices, can mitigate in localised ways the overriding forces of capitalism. The work of Bollaín, Gutiérrez and Pujol must be seen in this light. Theirs is not a mainstream cinema, even if both Bollaín and Gutiérrez have come to enjoy considerable measures of success, for what they put forward is not solely a representation, either fictional or documentary in nature, but also a vision that can include the often disregarded. This in itself is, in small measure, an act of political relevance, for what these filmmakers have put out through their work is a call for re-vision, if not for revolution. By this, I mean that through a focus on the margins of development, an important shift of focus from mainstream emphases on capitalist production and profit takes place. What is most important about the efforts made by these three women filmmakers to unravel the geopolitical and historical displacements fuelled by globalisation is the fact that, by doing so, they construct on-screen a space of recognition for people and places on the margins. It is interesting to note that empathy and the politics of the margins should be so embraced by women filmmakers, themselves a minority, and that they should choose to do so from the interlocked and often blurry borders of documentary and realism. From this standpoint, their filmmaking offers a revised vantage on questions of identity, belonging and community in terms of historical rupture, mobility and geopolitical dependency.

References

Barbash, Lisa and L. Taylor. *Cross-Cultural Filmmaking* (Berkeley: University of California Press, 1997).

Harvey, D. *Spaces of Capital: Towards a Critical Geography* (Edinburgh: Edinburgh University Press, 2001).

Harvey, D. *The Enigma of Capital: And the Crises of Capitalism* (Oxford: Oxford University Press, 2001).

Hjort, M. and S. Mackenzie (eds). *Cinema and Nation* (London: Routledge, 2000).

Llamazares, J. *La lluvia amarilla* (Madrid: Seix Barral, 1988).

Machado, A. 1973, *Campos de Castilla* (London: Grant and Cutler, 1973).

Marx, K. and F. Engels. *The Communist Manifesto* (New York: Signet Classics, 1998).

Nair, P. 'In modernity's wake: transculturality, deterritorialization and the question of community in *Las flores de otro mundo*', *Postscript* (2002), 38–49.

Pavloviç, T. *100 Years of Spanish Cinema* (Oxford: Wiley-Blackwell, 2009).

Ricœur, P., K. McLaughlin and D. Pellauer. *Time and Narrative*, vols 1, 2 and 3 (Chicago: University of Chicago Press, 1990).

13

Tracing the border: the 'frontier condition' in María Novaro's *Sin dejar huella*

Sofía Ruiz-Alfaro

Points of departure

Considered one of the fastest-growing regions on the American continent and defined as the locus of endless socio-political, economic, linguistic and cultural interchanges, the US–Mexico border has, since the second half of the twentieth century, been used as a recurrent physical and metaphorical scenario in Mexican cinema. Analysed from different points of view, critical approaches and generic conventions, the borderlands have historically become a space in which notions of identity and citizenship are persistently redefined; the border creates cultural, economic and social spaces that are in constant negotiation. The new economic order deepened the economic interdependence between the two countries and highlighted the United States' role as the superpower and Mexico as its subordinated and developing neighbour.[1]

More importantly, the global order within which Mexico's economic alliance to the United States is situated has changed Mexicans in profound ways. Carlos Monsiváis, one of the most influential and contemporary cultural critics in Mexico today, talks of *la frontera portátil* – 'the portable border' – as the new constituent of *mexicanidad* – Mexicanness – due precisely to the economic disparity between the two neighbouring nations. For Monsiváis, the northern border cities and their inhabitants represent the desire for 'full integration with the North American economy' in order to attain a material well-being and consumerism that for Mexicans symbolise life on the other – northern – side (2003: 40). This dream has transformed every aspect of daily life in border cities that reflect the uprootedness from Mexicanness, precisely because of their insistence on resembling the United States not only economically but also culturally. Despite the many problems this transformation has created in the border cities – the violence and chaos of the world of drug trafficking, illegal immigration and feminicide at the border, as well as the ecologically damaging sweatshops, or *maquiladoras* and the 'fiercely chaotic' urban settlements, or *colonias* – it is not a phenomenon that belongs only to the border cities but to the entire nation, to the point that Mexico is today 'a nation of border-dwellers' who have

become more and more Americanised through the pleasures of consumerism and technology (2003: 41). For this critic, the border is thus not just an economic and political construct, but also and more importantly a state of mind and a mode of being in the world. This is the '*frontier* condition' that becomes the defining element present in contemporary Mexican subjectivity: Mexicans do not need to actually cross the borderline to experience a consciousness of perpetual crossing and symbiotic cultural, social and economic exchange with their northern and mighty neighbour.

Sin dejar huella, the 2000 film of acclaimed Mexican director María Novaro, revolves around the concept of the portable border and problematises the frontier condition in the story of two Mexican women, Marilú and Aurelia, who embark on a road trip from the border city of Ciudad Juárez to one of Mexico's most touristy destinations, Cancún. Novaro first captured the attention of international critics and audiences with her film *Danzón* (1991) and later with *El jardín del Edén* (*The Garden of Eden* 1994), her first movie about the US–Mexico border. *Sin dejar huella* (*Without a Trace*) resorts formally and thematically to the core components of her previous work by turning to the themes of travelling and the border in order to explore female subjectivities and identities in contemporary Mexico. As a point of departure here, I argue that Novaro's vision of the border is transgressive in relation to the superficial and negative portrayal of the US–Mexican borderlands and its people, particularly the rather simplistic cinematic representation of women, often secondary characters and/or victims of the stereotypical border conditions – violence and crime – traditionally found in Mexican cinema. Instead, Novaro posits the borderlands as a feminine and feminist place in a way that rejects a pure victimisation of women at the border; in doing so, she also challenges the male-dominated narratives about the state of the nation that appeared in Mexican cinema at the turn of the century.

It is precisely in the year 2000 that Novaro released *Sin dejar huella*, a Mexican and Spanish co-production that won the Sundance prize in the international category of that year's festival. However, what seemed to be a promising and successful beginning turned out, in the end, to have a very disappointing box-office performance both in Mexico and elsewhere. Film scholar Carl Mora comments on how poorly the film did in Mexico City and how 'puzzling' in his view was 'its lack of distribution in the United States and Europe', especially given that the next Mexican blockbuster 'was also a road movie that also commented on the country's social and economic problems' (2005: 243). He is referring, of course, to Alfonso Cuarón's *Y tú mama también* (*And Your Mother Too Loves a Bitch*, 2001), the megahit whose success caused it to be considered by many critics as the leading example of the so-called 'renaissance' of Mexican cinema (Muñoz, 2002: 82). In addition to Cuarón, this renewal of cinema south of the border included directors Guillermo del Toro and Alejandro González Iñárritu, whose *Amores perros* (2000) was the other megahit that received national and international praise.[2]

The fact that Novaro's film disappeared quickly and ironically 'without a trace' while Cuarón's film became the epitome of the new era of Mexican cinema is not by chance or just another instance of, as Mora says, the 'vagaries of the movie business' (2005: 243). What I venture here as another point of departure to be considered is an explanation of why Novaro and her film were lost among the uplifting reviews and positive commentaries that Cuarón and his *Y tu mamá también* received in the media. The films' similarities in form and content seem remarkable, both as road movies that take two Mexican protagonists of the same sex – two male friends in Cuarón's film and two women in Novaro's – through a cross-country journey that serves diegetically to show the development of the protagonists' relationship and thematically to present a critical view on the social, political and economic situation of Mexico entering the twenty-first century. The question then becomes: why the films had such antithetical trajectories. I believe the difference resides in the textual negotiations these films pose with regard to the intersections of ethnic, class and sexual differences taking place in both texts and the types of pleasures these representations of difference create for the audiences.

Tracing the border through cinema

The presence of the US–Mexican border in Mexican cinema dates back to as early as the 1930s. Since then, border cinematic images and themes have become so numerous and relevant that border cinema started to be considered a genre of its own around the 1970s. For film scholar Daniel Maciel, border cinema is 'unique as compared to other national, thematic, or regional cinemas' in the sense that it encompasses three different 'perspectives': Mexican and North American commercial cinema as well as independent cinema (1990: 3). In its definition of border cinema as a genre, it is particularly important to note the presence of certain and recurrent themes: the causes and consequences of Mexican migration to the United States, the life and culture of the borderlands and crime and violence in the area (1990: 7). In reference to the Mexican perspective, critic Norma Iglesias points out that border cinema is a complex genre whose definition is 'constantly shifting and reorganizing' as it entails many components: 'types of characters, a production form, a specific geographic space, a question of limits and a confrontation between "us" in relation to the "other"' (1999: 234–5). Also, border cinema differs greatly in meaning for Mexicans who are not from the border and for those who reside there; these differences can be seen in the comparison between commercial and independent cinema. She argues that Mexican commercial cinema about the US–Mexico border has historically and generally misrepresented and simplified the borderlands and their inhabitants through the construction and repetition of certain themes and stereotypes. The theme of migration and the anxiety of losing one's Mexican identity are at the core of this type of cinema; more importantly, the border

has represented this threat to Mexicanness and consequently this contact zone is usually portrayed as a place of crime, prostitution, corruption and violence. Men, who are in most cases presented as the main characters of these films, embody the tension of suffering the loss of Mexican identity, while women are generally portrayed in a very simplistic and polarised way, either as exemplary, e.g., as suffering, maternal wives or as 'bad girls' whose freedom, especially in their sexual mores, embodies 'the pernicious influence of the north and its modernity' (Iglesias, 2003: 195).

Maciel agrees with Iglesias on the noticeable absence of key political and social issues in border Mexican (and US) commercial cinema, cinemas that have preferred the use of more entertaining genres such as westerns, action films, comedies and melodramas that favour the repetition of border themes and stereotypes (Maciel, 1990: 5). In contrast, both critics praise independent film productions as cinemas that present the border as a site of positive cultural affirmation and identity, as well as the means of projecting a more 'truthful' representation of the situations encountered in daily life at the border.

However, María Novaro's *El jardín del Edén* challenged the commercial–independent dichotomy proposed by scholars on border cinema. Neither commercial nor completely independent, Novaro's first film on the border garnered the attention of critics and scholars who, with some exceptions, praised this film as constituting a 'positive new direction' (Maciel and García-Acevedo, 1998: 184) and a 'rupture with stereotypes' (Castillo and Córdoba, 2002: 208). The most positive remarks referred to the inclusion of unique cultural aspects of border life absent from traditional border cinema – e.g., music, dance – as well as the presentation in the film of a diverse group of characters who represented different ethnic backgrounds, socio-economic levels and multifaceted personalities. More importantly, as Andrea Noble states, Novaro's *El jardín del Edén* presented the border as a 'specular frame' that allows a more complex understanding of difference as the trope that informs the border experience (Noble, 2005: 163–4). But other critics have also reflected on the 'broad generalizations' (Rashkin, 2001: 190) and 'troubling aspects' (Fox, 1999: 10) of the filmic representations of the life and people of the borderlands in Novaro's film. Claire Fox, in reference to Novaro's film, pointed out not only the utopian vision of the border as a 'borderless continent' at the end of the film, a vision that contradicts the harsh reality of border crossing, but also criticised the rather simplistic representation of the indigenous people that exists for her in the film (1999: 9–10). Particularly important for some of these scholars was the film's treatment of the border and, in particular, Tijuana as a utopian place, a 'mythic setting' (Rashkin, 2001: 190), as the film's title reflects.[3]

It seems paradoxical, then, that after the critical attention and feedback *El jardín del Edén* received, Novaro's insistence on the theme of the border with her following film *Sin dejar huella* went mostly unnoticed by critics, a film that, however, proves the relevance that Novaro gives to the US–

Mexico border in her film career and to her own rewriting/refilming of this key genre from the Mexican cinema perspective. This is surprising precisely because this second film, relocated visually and diegetically from utopian Tijuana to dystopian Ciudad Juárez, defines itself as more critical of the political and social climate surrounding the new economic order established between Mexico and the United States by focusing more decisively on Mexico's female subjectivities and indigenous communities in the twenty-first century. Novaro here adds another twist in her remapping of the border by looking not so much to the other side, but deep inside Mexico's own territory.

The first establishing shots of *Sin dejar huella* offer an introductory view of Novaro's conceptualisation of the geopolitical structure of the US–Mexico border. These first images respond to the criteria of 'hard' and 'soft' borders, categories that define the border as composed not only by a physical infra-structure created by men, but also by a human network of personal interac-tions and alliances. The latter represent the 'soft' border, the responses that people formulate in order to deal with and survive the conditions resulting from the political and economic situations of the area (Dear and Leclerc, 2003: 7–8). In *Sin dejar huella*, the hard borders are presented within a cinematography of long takes of the Mexican landscape – the desert, the jungle, the ocean – that sharply contrast with the built infrastructure that uses and abuses the natural and human resources of the land. Throughout the film these images form the visual backbone of a diegesis that develops the relationship between Marilú and Aurelia, the two female protagonists. The narrative of the encounter between the two and the vicissitudes of the road trip they take become the soft border of the film's structure.

Marilú and Aurelia are introduced as characters who are visually situ-ated and defined from the start by the border. Marilú is shown in the first scene of the film illegally crossing the fence that divides the Arizona desert and its Mexican counterpart, the Desierto de Sonora. Once she crosses into Mexican territory, she is detained by Mexican police officers patrolling the border. The film cuts to Aurelia, who, in contrast, is visually introduced in a domestic scene, at her home located in the outskirts of Ciudad Juárez. Inside the house, a quotidian scene develops: Aurelia and her two children are getting ready for an ordinary day. Aurelia drives her family towards downtown, an urban conglomerate that the film graphically identifies with arrows and letters as Ciudad Juárez and El Paso. Interestingly, in Aurelia's case, the introductory scene ends with Aurelia feeding her baby in a rather bucolic setting: sitting on a rock by the riverside that constitutes the geo-graphical border of the Rio Grande/Río Bravo. More importantly, the camera, focusing first on Aurelia and the baby, slowly pans to the left to show viewers the elements of daily life at the border: a US van patrolling the area, the ominous physical presence of a factory and an anonymous man getting ready to cross the border, his actions as familiar as Aurelia feeding her baby and the officer patrolling the border.

The fence, the river, the desert that divides the two countries and the urban conglomerate are the physical, hard components of the border, the world surrounding the main characters. The film's narrative also provides information about who these women are and their life in relation to the border. After Aurelia's introductory scene, the film again cuts to Marilú. Marilú is now at the police station being interrogated by the chief of the federal police, Mendizábal, a secondary character who, along with his subordinate, the so-called *chaparro* – 'shorty' – embodies a law enforcement system that is corrupt, powerful and very violent. The way Mendizábal treats the detainees and his subordinates reveals him to be a brutal and unscrupulous man; moreover, he is sexually aroused by Marilú and violates interrogation protocol as he verbally harasses her with sexual insinuations. Spectators gather essential information about Marilú from the interrogation: she is a well-educated woman, born in Mexico but raised in Spain, an expert on Mayan art who smuggles fake works of art from the Yucatan peninsula to be sold in the United States. Because none of this can be proved, Marilú is free to go; however, Mendizábal and his men will chase her thousands of miles beyond their jurisdiction, a fact that becomes one of the main threads of the film's plot.

In contrast with Marilú's international background, Aurelia's life is rooted in Ciudad Juárez, with her home and with her children. We also see her with Saúl, her boyfriend, who is a member of a narco cartel operating in Ciudad Juárez. Saúl uses Aurelia's home to hide money and drugs from his clients. Aurelia wants Saúl to quit dealing drugs and she resents having to return to work after her short maternity leave. She represents the cheap economic labour of the sweatshops and is a potential victim of the feminicide in Ciudad Juárez: at home she watches with her horrified elder son the news that one more young woman has been raped and mutilated in the city and that no suspects have been arrested. This literal framing of women at the border by television news correlates with the framing of Aurelia's life in Ciudad Juárez and her unhappiness with the way that her life is unfolding. She thus decides to escape: the next day she takes the cartel's money, her children, her jeep and runs away from Saúl, from her job and from her home town. She wants to start all over again in the Yucatan, with dreams of a better life and a better future. Aurelia promises this to her elder son as well as her intention to reunite with him at the Cancún airport in several weeks, the time it will take her to arrive at her destination, look for a job and settle down.

Above all, *Sin dejar huella* presents the border as a gendered space: from the start the female body in Novaro's text is framed by the border condition, one in which women are in constant danger of being violated, exploited, harassed. The danger comes from powers embodied by men who consider women to be objects, men like Mendizábal and Saúl who are presented as hypermasculine, macho figures. Despite being on opposite sides of the law, they and the organisations they work for are quite similar: the police and the

drug cartel are shown as hierarchical systems, competitive, fierce and, above all, male-dominated worlds. With the inclusion of the news clip on the murder of another woman in Ciudad Juárez, as well as the fact that during the interrogation at the police station Marilú points out to Mendizábal that the police should be investigating these murders and not her, Novaro brings to the fore the vulnerable situation that women at the border experience every day. These attacks show the defencelessness and the threat that women feel and, moreover, the fear that, with no clear culprits, danger is lurking everywhere and at all times. However, Novaro does not present her female protagonists as victims; on the contrary, they are women who understand the danger the border entails and the corporate and patriarchal entities that create a differential in power. Therefore, and as a starting point, the film renders plain how the border becomes a place and a situational marker of socio-sexual difference. But by becoming fugitives and allies in contesting and resisting the power that Mendizábal and Saúl represent, Marilú and Aurelia make of the border a place that not only limits and oppresses but also, and more importantly, a locus of female subjectivity and empowerment throughout the film.

The border: routes of identity and difference

Sin dejar huella is a story about travelling physical and psychical roads, a narrative of individual and collective identity. The film speaks of the construction of female identities in Mexico today through the particular story of the two female protagonists, as well as the destruction of the natural resources of the nation and the establishment of a global economic order that is changing Mexico for ever. Novaro's critical commentary on the nation as a whole is one of the salient characteristics that define the road movie genre that gives shape to the film's structure. The roads taken from Ciudad Juárez to Cancún are, going back to Monsiváis and literally and metaphorically speaking, a portable border. In fact, the road is another type of *línea* or border line, a physical line that demarcates the various territories and landscapes that Marilú and Amelia cross by car. Here the hard borders continue to exist even in the most remote and inconceivable places: the film's cinematography presents the high fuming chimneys and giant refineries along the way. This occurs in the diegesis as well: near the Caribbean coast in the state of Campeche, Aurelia comments to Marilú that she has been in the area before, specifically and coincidentally in a small town called Frontera where she worked one summer in a factory assembling scuba-diving equipment. Later, towards the end of the film, Aurelia realises that Cancún resembles her dystopic home town of Ciudad Juárez, even though the two cities are separated by thousands of miles. Her brief new job as a waitress in a 'Mexican' restaurant – a thematic restaurant full of plastic artefacts and fake dresses in the Mayan tradition – exemplifies another face of globalisation in Mexico: Cancún symbolises Mexico's fake exoticism at

its best by transforming its indigenous roots and heritage to the point of ridicule. With this image of Cancún, Novaro reiterates the idea that the frontier condition persists throughout Mexico and that the country, more than ever before within this global economic order, seems to be for sale.

The idea of the portable border also exists throughout their trip, since the road is like the border they left behind: the danger and threat that Mendizábal and Saúl represent increases as the chase gets closer once they approach Cancún. But, more importantly, the road is metaphorically a contact zone, a border in the sense that it produces an intercultural encounter between two different personalities and between two women who experience each other as different. In the unfolding of the film's story, Marilú and Aurelia are presented as having very different social, cultural and ethnic backgrounds; they differ in the way that they speak (Marilú has a Castilian accent and lexicon, while Aurelia has a Norteña, or northerner's pronunciation and slang) and the way they dress (Marilú adopts a European style, while Aurelia wears cowgirl boots, jeans and a tight blouse). These are the most visible differences that they comment on and laugh about during the road trip, differences that they play with by exchanging clothes and by speaking about themselves and their past.

On the other hand, travelling becomes the means of negotiating difference; the film's journey means for the two protagonists the intercultural encounter between two different female subjects and two distinct ways of life. However, the film does not present an ideal negotiation or an immediate and easy friendship between its protagonists; in fact, neither woman confides in the other their real motives for being fugitives; each hides essential information about their reasons for hiding away, creating a personal tension that builds up in the relationship. This emotional strain only disappears at the end of the film. And although their differences create stress between them, they also play out in their favour. It is due to the different knowledge they possess that they are able to survive and elude Mendizábal and Saúl. Aurelia has the money, the vehicle and the driving expertise that Marilú does not have; Marilú, unlike Aurelia, knows the Mayan territory, its people and its language, a knowledge that is essential when they drive through the state of Campeche and the Yucatan Peninsula.

It is precisely in Mayan territory that *Sin dejar huella* takes another turn, another route to explore difference, as the diegesis unfolds the theme of the politics of alliance between the two women and the Mayans. This alliance means mutual protection: for the two fugitives, finding a much-needed refuge – they hide for a while in an old hacienda run by a Mayan family – to trace a plan of action for fighting the police and the drug cartel, and for the Mayans receiving information from Marilú about the federal police's plans for raids on their town to close down their business of crafting fake Mayan antiques. Although not before being transgressed and violated by the violent force of the police officers, in the end the cooperation between the women and the indigenous people also means they have the agency to fight back

against the system's power. Marilú and the Mayans continue smuggling art that will be sold to museums and collectors in the United States. For the Mayans, resistance to the existing economic order thus comes by subversion and by taking political control of their town, as we see at the end of the film, just as Marilú and Amelia will successfully escape Mendizábal and Saúl with plenty of money to start their lives anew. They retire together to an abandoned place in the Caribbean to establish their own little hotel. In sum, *Sin dejar huella* addresses Mexico's subaltern class by acknowledging that they can take control of their own destiny by playing 'locally' within the rules of the 'global' game for their own benefit and survival.

The film ends with the song 'El mundo se va a acabar' ('The World Is Going to End') as spectators see the loose ends of the story tied up: the Mexican police and the drug dealers have allied themselves to continue their aggressive and corrupt power in an unspecified location that could be anywhere in Mexico; and we also see how the economic power and natural resources are managed by transnational corporations. The border, everywhere as it informs the Mexican nation today, is not only a place for the hypervirile and macho world of violence and corruption, but also a site where the convergence and alliance of subaltern identities take place. For Novaro, the border allows agency and resistance for Mexico's subaltern class, a radical proposition, I believe, that places Novaro and her film on the margins – another type of border – with respect to the male-dominated narratives that attracted great international acclaim and achieved commercial success around the time of *Sin dejar huella*'s distribution and exhibition.

Final destinations

As we noted earlier, the beginning of the twenty-first century witnessed two Mexican directors who each presented their own view of a nation facing relevant social, political and economic challenges. Both Alfonso Cuarón and María Novaro chose to present road movies whose protagonists and journeys examined their view of Mexico today by exploring the interpersonal relationships of their films' main characters and by their travels through the Mexican territory and by their encounters with its peoples. However, the final destinations of the two journeys and the antithetical trajectories of the two films at the box office point to the alternative reading that *Sin dejar huella* creates for its audience.

The final destinations of *Y tu mamá también* and *Sin dejar huella* parallel the direction taken by the relationships portrayed during their respective journeys: in Cuarón's film, the two male teenagers finalise their trip by reinstating their opposite social and economic status and position in Mexican society, a society that represents in the end a dystopia. *Y tu mamá* reaffirms the idea that everything happening in Mexico in the twenty-first century revolves around men by placing the core of the diegesis in the unfolding of a love triangle between the two male protagonists and their female

counterpart. The love triangle is a structure that reveals, beneath its surface of male rivalry and competition for a woman, a powerful male homosocial bond (Sedgwick, 1992: 27), present in Cuarón's film through the close friendship between Julio and Tenoch, the two male teenagers. In the end, the film shows that male homosocial desire ultimately determines the position of these two male protagonists in Mexican society and confirms it to be the most powerful force in forming and informing Mexico as a patriarchal society. Therefore, thematically speaking, *Y tu mamá* offers spectators a new version of the same 'guiding fiction' about Mexico that popularised Octavio Paz's vision in the mid-twentieth century of the Mexican ethos: it seems like it is all about women but, in reality, it is all about and decided between men.[4]

In 2000, Maria Novaro and her film *Sin dejar huella* proposed another take on Mexico entering the new century, one that reflects Monsiváis's idea that the portable border indeed informs the entire Mexican nation in the twenty-first century. Novaro agrees with Cuarón that dystopia exists in Mexico, but offers, unlike Cuarón, a feminine and feminist take on it. *Sin dejar huella* presents the idea that the border is, in a constructive way, all about women and decided also by them. The border is presented, despite its dangerous conditions and risky transactions, as an integral part of the female protagonists' existence. Marilú and Aurelia understand the dangers and take the risks the border puts on their everyday lives, but unlike the male characters in *Y tu mamá*, they are able – despite their economic and social differences – to ally themselves: this is a female homosocial bond that successfully wins over the forces that continually threaten their safety and freedom.

Finally, *Sin dejar huella* is a female-dominated story in which women's desire is to escape normative notions of femininity in a patriarchal society like Mexico. Marilú and Aurelia are complex characters that break the traditional cinematic female roles of the 'good, saintly' mother or the simplistic virgin–whore dichotomy frequently found in Mexican cinematic history (Haddu, 2007: 87–90). What spectators see is that Aurelia and Marilú do not form or want a nuclear family, that they are independent women who do not need men to be 'complete' or happy and that, throughout the film, they are able to express her sexuality without prejudice. In the end, spectators see two women who go on with their lives without men and without being castigated[5] for their way of living their lives as they wish, ultimately asserting that women's imprint on the border is, indeed, indelible.

Notes

1 For recent and in depth studies on the US–Mexico border and region, see Romero (2008) and Vila (2003).

2 Cuarón, González Iñárritu and del Toro, a group popularly known as 'los tres

amigos', confirmed their entrance in the sphere of 'global directors' by signing in 2008 a lucrative contract for five films with Universal.

3 The film's representation of Tijuana and of the interplay of the personal conflicts of the film's characters were criticised by scholars as too clearly following Néstor García Canclini's view of Tijuana in the 1990s as 'everybody's place', 'a post-modern laboratory', and of hybridity as the quintessential quality of this border city. See Castillo and Tabuenca (2002: 208); Fox (1999: 11); and Noble (2005: 148).

4 In his seminal work *El laberinto de la soledad* (1950), Octavio Paz's essentialist view of Mexican society as a patriarchal system places women in a subservient category to men. His essay privileges the figure of Mexican men and their socio-sexual power in Mexican society. This 'model' of manhood in society and in gender relations is exemplified by the two male protagonists in Cuarón's film.

5 Carl J. Mora quotes Novaro through an indirect source in which the filmmaker 'acknowledged her film's resemblance to *Thelma & Louise*, but added that she wanted to make a movie "in which women don't get punished"' (2005: 242).

References

Castillo, D. A. and M. S. T. Córdoba. *Border Women: Writing from La Frontera* (Minneapolis, MN and London: University of Minnesota Press, 2002).

Dear, M. and G. Leclerc (eds). *Postborder City: Cultural Spaces of Bajalta California* (New York and London: Routledge, 2003).

Fox, C. F. *The Fence and the River: Culture and Politics at the US–Mexico Border* (Minneapolis, MN and London: University of Minnesota Press, 1999).

Haddu, M. *Contemporary Mexican Cinema, 1989–1999: History, Space, and Identity* (United Kingdom: Edwin Mellen, 2007).

Iglesias, N. 'Reconstructing the border: Mexican border cinema and its relationship to its audience', in J. Hershfield and D. R. Maciel (eds), *Mexico's Cinema: A Century of Film and Filmmakers* (Lanham, MD: SR Books, 1999), pp. 233–48.

—— 'Border representations: border cinema and independent video', in Dear and Leclerc, *Postborder City*, pp. 183–213.

Maciel, D. R. *El Norte: The US–Mexican Border in Contemporary Cinema.* (San Diego, CA: Institute for Regional Studies of the Californias, 1990).

Maciel, D. R. and M. R. García-Acevedo. 'The celluloid immigrant: the narrative films of Mexican immigration', in D. R. Maciel and M. Herrera-Sobek (eds), *Culture Across Borders: Mexican Immigration and Popular Culture* (Tucson: University of Arizona Press, 1998), pp. 149–200.

Monsiváis, C. '"Where are you going to be worthier?" (The border and the postborder)', in Dear and Leclerc, *Postborder City*, pp. 33–45.

Mora, C. J. *Mexican Cinema: Reflections of a Society, 1896–2004*, 3rd edn (Jefferson, NC: McFarland & Company, 2005).

Muñoz, L. 'A new Mexican revolution', *Los Angeles Times*, 10 March 2002.

Noble, A. *Mexican National Cinema* (London and New York: Routledge, 2005).

Paz, O. *El laberinto de la soledad. 1950* (México: Fondo de Cultura Económica, 1993).

Rashkin, E. J. *Women Filmmakers in Mexico: The Country of Which We Dream* (Austin, TX: University of Texas Press, 2001).

Romero, F. *Hyperborder: The Contemporary US–Mexico Border and Its Future* (New York: Princeton Architectural Press, 2008).

Sedgwick, E. *Between Men: English Literature and Male Homosexual Desire* (New York: Columbia University Press, 1992).

Vila, P. (ed). *Ethnography at the Border* (Minneapolis, MN: University of Minnesota Press, 2003).

Part IV

Subjectivity

As is well known, since the intellectual revolution in the late 1960s and early 1970s, new theoretical methodologies, mostly associated with post-structuralism, have opened up the possibility of articulating a challenge to the prevalence of humanist perspectives in Western culture. Humanist thought advocated the autonomy of a transcendental individual, namely a man, who was in control of his thought and vision. From this elevated, distanced and neutral position, the disembodied mastering (male) subject could understand the outside world. New theoretical methodologies have challenged this common model of the subject that we had inherited from the Enlightenment by exploring how subjectivity intersected with wider issues related to gender and sexuality, race and ethnicity, class, the local and the global or modernity and postmodernity. Hence, subjectivity has been a crucial concern for cultural theory in general and, more relevant in the context of this volume, feminist theory for the past decades. If psychoanalysis is the epistemological framework, par excellence, which rationalises how subjectivity is perceptually and cognitively constituted, other important theoretical paradigms, including Marxist theory, post-colonial theory, feminism or even post-structuralist theories that advocate the deconstruction of the subject have focused on how individual and collective subjectivities are thought, represented and contested in cultural practices, including film, thereby exploring how structures of power, which are reiterated, reinforced or subverted in cultural productions, impinge on the subject. In Lacanian psychoanalysis, which has been deeply influential in psychoanalytic film criticism and feminist film theory since the 1970s, subjectivity is constituted through a process of entering the imaginary phase, which is associated with our misrecognition of a reflected image outside us that produces consciousness of our own self. Subsequently, the self enters the symbolic order through the acquisition of language, which implies that the splitting of the subject into the conscious and the unconscious is necessary for subjectivity. Thus, although some theorists are now exploring how analogy may be integral to subjectivity, it is often thought that the constitution of subjectivity is based on lack and castration and that it is always rooted in sexual difference. If, in order to enter the symbolic order, we need to acquire a language that is already shaped by patriarchal ideology and, in Lacanian terms, associated

with the phallic signifier, which associates femininity with lack and castration and relegates it to the space of the psychotic, how can non-hegemonic subjects, including women, contest those linguistic and ideological mechanisms of interpellation and subjugation through which our subjectivity is constituted in the symbolic order? Does cinema, as a mass medium, become a means of reproducing and of reinforcing those linguistic and ideological mechanisms that become 'naturally' entrenched in our consciousness or unconsciousness, or can cinema offer alternative representations that may point to a rearticulation of subjectivity beyond hegemonic systems and structures of psychic and ideological subject formation? The chapters in Part IV on subjectivity emphasise the way in which these Hispanic and/ or Lusophone female filmmakers explore how subjectivity intersects with wider ideological and theoretical issues and debates or the way in which, through a concern with subjectivity, we may be able to understand differently questions of gender and sexuality, in particular, or wider ideological and theoretical issues and debates in general.

Chapter 14, 'Genealogies of the self: (auto)biography in Sandra Kogut's *Um Passaporte Húngaro* (2001) *and* Albertina Carri's *Los rubios* (2003)', by Charlotte Gleghorn explores how filmic autobiography brings aural and visual elements to the fore in its construction of selfhood on the screen. Kogut's quest to obtain a Hungarian passport reveals the family and state as key factors in defining one's identity while pointing to the marshalling of citizenship by nation states. *Los rubios* uses an actress to represent the director on film, while simultaneously depicting the true Albertina Carri wielding the camera as she explores her 'disappeared' parents' identity and her past. Gleghorn suggests that these films illustrate an autobiographical impulse, which has at its centre the director as the historical subject of the film. Additionally, the two films interrogate genealogy as a constructing force in identity politics, highlighting the relationship between the concerns of the family and those of the nation. Furthermore, the autobiographical impulse in the Argentine and Brazilian cases acquires, Gleghorn argues, particular relevance as a result of the countries' respective histories of migration and authoritarian regimes. Given the turbulent events of the twentieth century in both countries, the discussion of the directors' lives on film instigates a dialogue between personal and collective memory, the private and the public, the individual and the nation. These films characterise the variety of representational strategies that women directors draw on in order to explore notions of identity and selfhood. Finally, Gleghorn contends that the films' recurrent themes of family and negotiations of space propose the body as a site of convergence of power relations and cultural encodings, and provide potent comments on the complex interrelationships between corporeality, identity and societal forces.

In Chapter 15, 'Filming in the feminine: subjective realism, social disintegration and bodily affection in Lucrecia Martel's *La ciénaga* (2001)', Julián Daniel Gutiérrez-Albilla explores the way that Lucrecia Martel's *La ciénaga*

represents family and social disintegration in the context of the decadent world of traditional rural Argentine society through the use of a subjective realistic cinematic style. This subjective realism emphasises, thus, how what is eluded returns as an invisible trace haunting the cinematic space and producing bodily sensations divorced from referents that affect our senses, reacting, thus, to the film on a corporeal level. Martel allows the viewer to experience the film less through signification than through the materiality of the film. Gutiérrez-Albilla argues that this bodily affection is inextricably, and traumatically, linked to the materiality of the body, particularly in the context of a society in which political violence has been exercised upon the body. Gutiérrez-Albilla suggests that Martel's 'corporeal cinema', which is associated with affective vision as incorporating touch, makes the film a space of co-emergence and co-affecting, creating, thus, intersubjective encounters that point to the traces of the matrixial process which is spread across the threshold of culture via art, thereby expanding the symbolic itself. Finally, Gutiérrez-Albilla proposes that the film calls for a thinking of the working of the film that produces the filmmaker in the feminine.

Chapter 16, 'Everything to play for: renegotiating Chilean identity in Alicia Scherson's *Play* (2005)', by Sarah Wright focuses on *Play*, a debut feature by Alicia Scherson, described as one of the members of a new wave of Latin American filmmakers, and of the *nuevo cine chileno*. *Play* has been lauded for its cinematic inventiveness and highly crafted visual style. Wright suggests that Scherson appears to belong to a new generation of Chilean filmmakers who have moved away from the trauma of Chile's historical past to focus aggressively on the present. Wright explores how the film's main protagonist, the city of Santiago de Chile, is chosen precisely for its lack of an immediately recognisable cinematographic identity, a city that is, arguably, cinematographically without memory, while Cristina, the female lead, is *mapuche*, female and poor, but with her mp3 and Japanese video arcade games as her guides she becomes a *flâneur*, a *voyeur* and a *bricoleur* of her own identity. Focusing on questions of Chilean identity, exploring the experience of the city, social mobility, rural versus urban and global versus local alongside questions of narrativity and the interface between video game and cinema, Wright examines how far Scherson's experimentations with film form influence the central theme of identity and explores the current climate, critical and financial, for film-makers in contemporary Chile.

In Chapter 17, 'The politics of pathos in Pilar Miró's *Gary Cooper, que estás en los cielos* (1980)', Tom Whittaker focuses on Pilar Miró's film, which has long been regarded as one of the key films of Spain's transition to democracy. In focusing on the position of women in the workplace, the film, on its release was also heralded as one of the most important Spanish films to explore female subjectivity. Challenging common views of the film as successfully articulating a female voice, Whittaker argues that it is in fact the genre of melodrama to which the film owes a debt. Melodrama

has traditionally been constructed as a female genre, which usually divests the female protagonist of both her voice and her narrative agency. Female subjectivity, therefore, finds its expression not within dialogue or plot, but within the formal aspects of the melodramatic film itself, most notably in an excessive use of music, camerawork and symbolic *mise-en-scène*. This dynamic, Whittaker argues, resounds strikingly with Miró's film. On discovering that she has a life-threatening disease, the female protagonist of *Gary Cooper* finds herself incapable of communicating her fears to those who surround her. Denied both bodily agency (through the disease) and discourse (through her inability to communicate), her female consciousness is articulated within the body of the text itself. In closely analysing the visual language of *Gary Cooper, que estás en los cielos*, Whittaker shows how in drawing on the conventions of melodrama, Pilar Miró presents an altogether more problematic and ambivalent construction of female identity. In so doing, Whittaker stimulates debate on the relationship between gender and genre, an area which has received little attention in Spanish film studies.

Chapter 18, 'Icíar Bollaín's "Carte du Tendre": mapping female subjectivity for the turn of the millennium', by Jo Evans refers to Giuliana Bruno's term 'carte du tendre', which Bruno takes from a map, the *Carte du pays de Tendre*, drawn by a female character in Madeleine de Scudéry's seventeenth-century novel, *Clélie*, to foreground the bodily and emotional (the haptic and the affective) responses engaged in our appreciation of art, architecture and film. According to Evans, Bruno's approach provides an evocative framework for her macroscopic *tour de force* of creative and critical 'site-seeing', demonstrating that films, art and architecture do not just provide new 'sights', but new 'sites' of subjectivity, new spaces for emotional, bodily and intellectual engagement. Drawing on Bruno's theoretical framework, Evans focuses on three of Icíar Bollaín's films (*¿Hola, estás sola?*, *Flores de otro mundo* and *Te doy mis ojos*) in order to argue that Bollaín's modest, collaborative and often deceptively transparent approach to filmmaking maps an affective cartography of female desire (from city and coast to rural village, to Spain's patriarchal and cultural heartland). This affective cartography produces, Evans argues, democratic 'cartes du tendre' that remap on-screen femininity (geographically and generically) and provide new ideological spaces for, and new memories of, turn-of-the-century female subjectivity.

Part IV concludes with 'Murmuring another('s) story: histories under the sign of the feminine, *pre-* and *post-* the Portuguese Revolution of 1974', in which Rui Gonçalves Miranda states that women's liberation in Portugal is intrinsically linked to the democratic Revolution of April 1974. In this chapter devoted to Portuguese cinema, Gonçalves Miranda focuses on Maria de Medeiros's *Capitães de Abril* (2000) and Margarida Cardoso's *A Costa dos Murmúrios* (2004) to argue that both films address in different ways the constructs of femininity promoted by the right-wing, conservative dictatorship of the *Estado Novo* (New State), revising, at a distance of decades of

democracy, the histories of the women characters whose visions, different and differently expressed in each film, shape a revised understanding of the historicity of women's (non-)place. Gonçalves Miranda argues that it is precisely under the sign of difference that the renegotiation of paradigms of femininities will take place, as enacted by Antónia (the unsuspecting wife of a revolutionary) and her young daughter, on the day of the revolution of the Carnations in 1974, and by Evita and Helena in Mozambique, the wives of soldiers in a long colonial war which took place up to the Revolution, a last gasp of a crumbling Portuguese imperialist *ethos*. Drawing on Jacques Derrida's reflections on the 'feminine', Gonçalves Miranda looks at ways in which both films ultimately reject the assignment of a woman's place in war, in revolution, and in history, rather performing a rewriting of femininities from the margins, necessarily out of step with the prescribed evolution and revolutions of the times.

Genealogies of the self: (auto)biography in Sandra Kogut's *Um Passaporte Húngaro* (2001) and Albertina Carri's *Los rubios* (2003)

Charlotte Gleghorn

In his article 'Nietzsche, genealogy, history', Foucault argues for a decentred approach to the writing of history, which opposes versions of the past that proclaim a pure source, figure or identity ([1971] 1991: 76–100). Examining Nietzsche's *The Genealogy of Morals* (1887), Foucault reiterates that *Ursprung,* to use the original German term, appears as an essentialist pursuit of origins, the underwritten rule by which hegemonic versions of the past are legitimised (1991: 78). Instead, Foucault proposes a version of genealogy which basks in the interstices, disruptions and forgotten bodies that History (with a capital H) papers over, thus reaffirming Nietzsche's original differentiation between the two terms, *Ursprung* and *Herkunft.* Unlike teleological versions of history, *Herkunft* emerges in a non-linear fashion, accommodating multiple branches and irruptions along the way. The body – biological, cultural and social – stands at the core of this genealogical impulse, highlighting the interconnectedness of history, identity and the self. Foucault writes:

> The body is the inscribed surface of events ... the locus of a dissociated self ... and a volume in perpetual disintegration. Genealogy, as an analysis of descent, is thus situated within the articulation of the body and history. Its task is to expose a body totally imprinted by history and the process of history's destruction of the body. (1991: 83)

Here, the body's centrality to genealogy lies not only in the ways in which it clearly exposes the various forces which come to play in the writing of history, but also in its very biological materiality. Indeed, genealogy is most commonly represented through the family tree, as patrilineal and heteronormative understandings of the family unit create a body armoured with patriarchal notions of bloodline, inheritance and property.

This discussion of genealogy finds a renewed relevance to contemporary developments in subjective and autobiographical filmmaking, particularly concerning those films which excavate family history at the intersection of private and public realms. As the films that I discuss amply demonstrate,

family history need not be a linear, essentialising gesture in search of a pure origin. Rather, *Um Passaporte Húngaro* (Sandra Kogut, 2001) and *Los rubios* (Albertina Carri, 2003), from Brazil and Argentina respectively, experiment with autobiography in order to discuss identity, memory and history, thus bringing Foucault's genealogical model to fruition with remarkable effect. In demystifying the notion of foundational origins, Kogut and Carri challenge the law of the father which propels classical genealogical quests.

Autobiography and film

Subjective and autobiographical filmmaking has recently attracted sustained critical attention, not least in the literature devoted to the cinematic revivals experienced in Brazil and Argentina since the mid-1990s, dubbed the *retomada* (renaissance) and the *nuevo cine argentino* (New Argentine Cinema), respectively. For a long time, however, autobiographical film was considered a corruption of its literary counterpart. During the 1980s, literary critics such as Elizabeth Bruss and Philippe Lejeune argued that both the visual and the collaborative nature of filmmaking reconfigured the autobiographical act in such a way that it no longer adhered to some of the genre's central tenets. Bruss (1980: 308) suggests that 'film makes us impatient for a direct inscription – an actual imprint of the person, unmediated and uncreated' and on the basis that this process was entirely different from that which occurs in the literary autobiography, vehemently opposed the use of the term autobiographical in relation to film. In a similar move, Lejeune (1987, cited in Gabara, 2003: 336) asserts that 'it is not possible to be on both sides of the camera at the same time, in front of it and behind it, whereas the spoken or written first-person easily manages to mask the fact that ... I am an other (*je est un autre*)'. Prior to the 1980s, critical perspectives on filmic autobiography principally studied the rise of auteur theory and the notion of the 'caméra-stylo' as an articulation of the director's personal vision in fiction film (Gabara, 2003: 335; Gernalzick, 2006: 2). Recent scholarship on autobiographical film, however, is firmly embedded in more generalised discussions of the documentary genre, in what has been termed the 'subjective turn' in filmmaking (Renov, 1995).

In Renov's sustained analysis of first-person filmmaking, subjectivity can be inscribed in multiple, overlapping ways – different 'autobiographical *modalities*' as he calls them (2008: 44) – which draw on varied sources and techniques to create life stories on-screen. This range of methods of inscribing subjectivity at once challenges the perceived conditions of documentary practice, tarnishing the presumed purity of the observational mode with traces of an embodied self, and asserts the 'coalescence of outer and inner histories', the personal *as* political (Renov, 1995). On a formal level, first-person narratives frequently collapse the distinction between documentary and fiction film, as autobiography stages the splitting of identities and,

alongside this splitting, an experimentation with the boundaries of genre. As Gabara (2003: 333) notes, 'autobiography is always a locus of contact among many different genres, at once representation and invention, non-fiction and fiction, in the present and the past and in the first and third persons'. Although documentary has never been an impartial barometer of reality, Renov (1995) contends that the 1990s constitute a turning point in the objective–subjective tensions embodied within the genre, suggesting that 'subjectivity is no longer construed as "something shameful"'. Certainly, while documentary films have long experimented with forms which stage the dissolution and performance of the real – Stella Bruzzi (2006: 2) offers Vertov's reflexive filmmaking as an early example of such innovation – recent criticism seems more accepting of the slippage between documentary and fiction modes. A key component of these discussions, autobiographical film emerges as a crystallisation of generic hybridisation and postmodern identity politics. Moreover, these autobiographical projects are often intimately related to the writing of history, as 'film has the power to stop and even reverse time's inexorable passage' (Renov, 2008: 43), thus resonating with the genealogical project.

Concomitant to the increased theorisation of autobiographical film is the rising integration of women's autobiographical narratives in both literary and filmic realms. Indeed, the recent democratisation of the documentary genre and the intensified participation of women filmmakers should not go unnoticed.[1] As Barbara Kosta (1994: 29) remarks on women's autobiographical filmmaking from Germany, 'autobiographical filmmaking engages in the process of "deaestheticization" by breaking through the boundaries of the traditional fictional frame as well. The necessity of breaking through fixed conventions is axiomatic to the feminist project.' In addition, autobiography shares the feminist precept that the personal is expressly political (Everett, 2007: 133), articulating the individual within the public sphere. This mapping of commonalities between autobiography and feminist projects is not meant to suggest a programmatic approach to interpreting women's autobiographical film, but to emphasise what the field of autobiography 'can offer to female directors, no matter how disparate their backgrounds and objectives' (Everett, 2007: 134). In this light, the following analyses demonstrate how Sandra Kogut and Albertina Carri exploit the genre for their own political purposes.

Um Passaporte Húngaro

Um Passaporte Húngaro follows the stages of an application for a Hungarian passport by the Brazilian director Sandra Kogut (1965–). As the granddaughter of Hungarian Jews, both of whom fled to Brazil in 1937, Kogut is able to apply for dual nationality, a journey which is initiated at the start of this documentary. This narrative of bureaucratic procedures is juxtaposed with the touching anecdotes the director's grandmother gives on camera,

as she relates her escape from a Europe on the brink of war and her arrival in Brazil at the time of Getúlio Vargas's authoritarian *Estado Novo (New State*, 1937–45). Coinciding with the rise of Nazi Germany and the Second World War, this period was characterised by the influx of European immigrants, many of whom were seeking to escape the anti-Semitic regimes of Europe. The *Estado Novo*, however, was also markedly anti-Semitic. As is demonstrated in *Um Passaporte Húngaro,* many Jews fled to Brazil and were forced to change their names, and their nominal faith, on arrival, for fear of revealing their Jewish identity. By interweaving her grandmother's memories and her own present during the application process, Kogut effectively layers different temporalities which undermine a linear imperative, thus suggesting a conversation between individual experience and collective memory (Lins, 2004). This cross-generational encounter drives Kogut's reassessment of the historical archive and its relationship to contemporary identity politics, simultaneously constituting a homage to her grandmother's life.

The documentary is divided into sections, each detailing a separate part of the passport application procedure. Each section is named after one of the Hungarian questions on the form that Kogut must complete: *Kérelem* (the application), *3/b./mellékletek* (related documents) and so forth, until the procedure comes to an end and Kogut is granted her passport. The film is linguistically and culturally hybrid, with much of the dialogue delivered in French but with parts in English, Hungarian, Portuguese and written Hebrew, according to the people with whom Kogut interacts. Indeed, the director's experience of living abroad and her Judeo-Brazilian cultural heritage is often seen to inflect her videoart and films. As Jardim Raymond (1998: 37) writes, Kogut's 'prolonged investigation of the status of "foreign" as a more permanent marker, the possible assimilation of a Jewish heritage conditioned by a culture formed in foreign lands, and the actual experiences of a wandering artist, living and working in a globalised world, are elements that we find reflected in her work'. This multiplicity of languages also exposes the film's funding as an international co-production, and to this degree the form mirrors *Passaporte*'s finance practices. Perhaps more importantly, however, the film's polyglot nature is replicated in its many different registers of cinematic representation through video, super 8 footage, text, voice and music.

This diversity and layering of filmic form is echoed in the director's views on genre. *Passaporte*, as a film which expressly discusses identity and its regulation, uses language – filmic, textual and oral – to resist generic confines. The combination of diverse spoken and written languages in the film, which reflects the positioning of the director towards different cultures, and the varied film stock used to represent the passing of time, sustains the heterogeneous construction of the documentary. While the film is generally considered a documentary, Kogut explains in an interview with the Brazilian film critic José Carlos Avellar that she does not understand the obsession with differentiating documentary from fiction: 'a separação entre documentário

e ficção não me interessa' (2001) ('the distinction between documentary and fiction doesn't interest me'). Nor can the label of autobiography be comfortably applied to the film, since in many ways the core subject of *Passaporte* is Kogut's grandmother's life, not her own, although the material is obviously informed by the director's gaze and her encounter with others.

Despite the film's reluctant categorisation, *Passaporte* is undeniably subjective and constructs this viewpoint from the onset. The opening scene, while not presenting Kogut physically before the camera, both establishes the documentary's premise – the Hungarian passport application – and gives corporeal form to the director through her voice from behind the camera (Avellar, 2004: 28). The sound begins before the image, and Kogut's voice emerges from behind the camera, which rests on a close-up of a telephone, as she asks in French, 'une personne dont le grand-père est hongrois, peut avoir droit à un passeport hongrois?' ('is someone with a Hungarian grandfather entitled to a Hungarian passport?').[2] Kogut's voice authenticates the identity of which she speaks on the phone and which is elaborated in the film, yet it is interesting to note that she speaks of herself in the third person, and not the intimate 'je' (I) which one would expect of a first-person documentary. The distancing effect of this pronoun signals Kogut's reluctance to offer a finite image of herself as the central subject of the film, since the documentary is precisely about her interactions with those around her, principally with the staff working in the archives and consulates and, of course, with her own grandmother, Mathilde, to whom the film is dedicated. While the first-person pronoun is absent in Kogut's opening question, the dedication note to her grandmother which follows shortly after ('à ma grand-mère' – to my grandmother) reiterates the director's subject position. The spectator is continually aware that Kogut is the person behind the camera, with her hand reaching out through doors and to receive papers, yet we are rarely privy to a picture of the director's body. In Kogut's words, 'num filme sobre identidade, teria sido redutor ter uma imagem, um corpo' (Kogut [n.d.]) ('in a film about identity, it would have been limiting to have an image, a body'). In place of her body, Kogut's gaze and voice emphasise her role as the prime interlocutor, constructor and agent of the film. Indeed, the disembodied female voice, according to Kaja Silverman's theorisation of the cinematic medium, is one of the fundamental ways in which female authorial subjectivity may mark itself on the film and the spectator (1988: 141–86).

There are, however, significant moments where Kogut vigorously asserts her selfhood and her physicality impinges on the edge of the frame. The most striking example appears when the director is confronted with anti-Semitic comments from an employee at the archives in Budapest. The employee, based on the director's physical appearance, suggests that she cannot be *entirely* Jewish in origin, for which she should be grateful. When challenged with this prejudice, Kogut's authority over her identity becomes particularly flagrant as she announces from behind the camera that she is

indeed 'one hundred per cent' Jewish. So, while glimpses of Kogut's body are always partial and fleeting, refusing to grant a complete image of the director on-screen, her identity positioning situates the narrative firmly in the autobiographical realm.

By initiating her application, Kogut simultaneously brings her grand-mother's stories to the screen. In this way, the film appears as a partial autobiography and a partial biography of her grandmother, representing the overlapping and divergent aspects of their respective histories with passports. The reconstruction of her grandmother's stories on-screen, using the modern technologies of the present, anchors the film within the realm of memory, underlining the ongoing repercussions of the past on the present and the future, as demonstrated in the voyage Sandra Kogut will undertake. This reversal of Mathilde's journey is integral to the circular force which is present in the director's quest to obtain a Hungarian passport and which structures the film. In this respect, Kogut's film is reminiscent of other recent examples of first-person filmmaking, wherein 'the difference between gen-erations is written across the filmmaker's own inscription in technology, and thus it is precisely an ethnographic distance between the modern and the premodern that is dramatized in the encounter – through interview or archival memory or both' (Russell, 1999: 278).

On a visual level, these parallel migrant situations are beautifully highlighted as shots of boats approaching Recife and trains pulling in to Budapest station are interspersed with footage and reminiscences of Kogut's grandmother. At first sight, these melancholic travel sequences appear to be found footage, the product of research in the archives, a common strategy in documentary film. However, on closer scrutiny, we see a world that does not resemble that of 1930s Europe or Brazil, with high-rise tower blocks in the background and numerous cars and vehicles in the frame. In fact, these sequences are simulated and filmed in the present with a Super 8 camera, endowing the images with a grainy quality. Accompanying these travel sequences is the recurrent sound of the film's signature melody, 'Papir Iz Dokh Vays', a plaintive Jewish love song played on woodwind. This melody is intrinsic to the representation of time and the stitching together of memo-ries in the film, and it always appears with images of boats, trains or the sea, often played simultaneously with Kogut's grandmother's testimony. The repetitive nature of the melody, and the culture from where it came, attests to the persistence of memory and stands as a reminder of the survival of Eastern European Jewish cultural traditions, despite being violently and irrevocably disrupted by a long history of persecution.

Beyond the melody's role in representing the cultural heritage of both Mathilde and the director, the music also performs a structural role in the film, seamlessly blending the interview with Kogut's grandmother, the fal-sified 'found footage' of the travelling scenes and the contemporary quest for a passport in the corridors of Budapest, Paris and Rio. Each and every time the melody sounds, the spectator is transported into the past, only to

witness the image on-screen as an illusion, a reconstruction of the director's design. These traces of memory – the musical leitmotif and the repeated and poetic images of the sea – reiterate the film's dialogue with the past through Mathilde. They materialise a past that the director did not live, creating some form of tangible evidence, alongside the passport, for her grandmother's memory and simultaneously performing the director's affective interpretation of her relative's stories. In this way, Kogut delicately channels her grandmother's stories into images of her own journey, mapping the past onto the present.

In an interview, Kogut rejects the suggestion that the process of making the film constituted a return to her roots, responding that in actual fact she was doing the precise opposite, 'inventando um futuro ... um presente e olhando para um futuro' (DVD) ('inventing a future ... a present and looking towards a future'). While on the one hand Kogut films the stories and documents which have in some senses moulded her existence, her exploration of the country of her grandparents is not a nostalgic search for an origin. Indeed, as becomes clear early on in the film, her grandmother is in fact Austrian, not Hungarian, although she assumed Hungarian nationality when she married. Furthermore, the relationship that an individual holds with a passport is radically interrogated as, once Kogut acquires the passport and attends the citizenship ceremony, it is revealed that it is not a permanent document and it does not give the bearer full rights as a citizen. In an ironic twist, Kogut can become a Hungarian citizen for a probationary period of one year only. This flattening of identities by geopolitical borders and political demands is ultimately what Kogut's film seems to repel; the director exposes the mechanisms of official identity formation, while simultaneously emphasising the more personal aspects of her genealogical research.

Kogut draws on her own life experience to illustrate the fractured notion of identity through a multiplicity of locations, languages and citizenships. While the film is irrefutably subjective, Kogut's autobiographical discourse almost seems to disown the director. As Cléber Eduardo ([n.d.]) commented in his review, 'Sandra Kogut filma a própria história como se fosse de outra pessoa' ('Sandra Kogut films her own history as if it belonged to another person'). Kogut effectively becomes an *other* in the film, assuming multiple identities and emphasising that identity is a collaborative act produced in dialogue with one's environment. Additionally, her personal story represents that of many Brazilians; as one of the archivists in Rio comments in the film, it is common for Brazilians to assert their European ancestry in order to obtain additional passports, 'quanto, mais melhor' ('the more, the better'). During the 1990s, Brazil underwent a huge demographic shift, becoming, for the first time, a country of *emigration*. Kogut's perspective on global relations, then, is also intimately linked to demographics and discourses on hybridity in Brazil. As Mariana Baltar (2007: 105) has insightfully pointed out, *Passaporte*'s subtle recognition of the anti-Semitism of the *Estado*

Novo and the difficulties the director's grandparents' encountered on their arrival to Brazil considerably debases the country's myth of *cordialidade* (cordiality), a social contract most clearly acknowledged in Brazil's image as a racial democracy. In this way, the film asserts the multiple identities which can be assigned to the director in different spaces and times, implying that identity is always mutable and transitory, while fully cognisant of the fact that states, dictatorial or otherwise, impose restrictions on identity and movement.

Los rubios

If *Passaporte* implicitly draws on Kogut's grandmother's memories to project her own present and future, creating a bridge between individual and collective memory, *Los rubios* interrogates the construction of collective memory itself, critiquing its potentially homogenising effect on understandings of the past and identity. Albertina Carri (1973–), in her third film, *Los rubios*, examines the loss of her militant parents, who disappeared during the last military dictatorship in Argentina (1976–83). As the film informs us, on 14 February 1977, Ana María Caruso and Roberto Carri, were abducted and later that year killed. The youngest of the three daughters they left behind, Carri explores memory and identity as a theme, from different viewpoints, by interlacing extracts from the director's diary, interviews with friends and family, footage of the shooting of the film, the crew's discussions, and animation sequences which metaphorically enact episodes recounted in the voice-over. Perhaps most importantly, the film uses an actress, Analía Couceyro, to enact Carri, thus emphasising performance as a constituent part of identity and significantly challenging the language of autobiography.

Following Nouzeilles (2005) and Page (2005), I suggest that *Los rubios* resembles Stella Bruzzi's description of performative documentary. According to Bruzzi (2006: 185–6), 'the performative element within the framework of non-fiction is … an alienating, distancing device, not one which actively promotes identification and a straightforward response to a film's content'. Indeed, the actress's performance of the director forecloses any facile identification with the figure of Albertina, limiting the sense of closure the spectator may gain from 'a narrative that produces easy emotional identification but ultimately results in political complacency' (Page, 2009: 169). Towards the beginning of the film, the actress directly addresses the camera and states that she will play the role of Albertina Carri. The cinematography underlines this doubling, repeatedly showing a tracking shot of the actress Couceyro against a fence. This splicing of bodies, reflected in the the director's and the actress's identical initials (AC), is then immediately reinforced when the actress goes to interview a woman about 'her' (Albertina's) parents and verbally asserts her new identity over the intercom, stating 'soy Albertina' ('it's Albertina'). Thus, the spectator is

encouraged to merge their identities while being fully aware that we are not witnessing the 'real' Albertina on-screen, but her celluloid double.

This device is problematised on a number of occasions in the film when we see the 'real' Albertina Carri appearing as the director of the film. Indeed, while the logic of doubling prevails throughout *Los rubios*, there is in fact a third Albertina present. As Nouzeilles has identified:

> there are at least three 'Albertina Carri': Albertina, the author behind the frame; Albertina the *auteur* inside the film, who appears holding the camera, giving instructions and discussing the movie with the crew; and Albertina, the daughter in a state of memory, who stands before the camera delivering a rehearsed testimony. (2005: 269)

The difference between the fictional (Analía Couceyro) and the non-fictional Albertina is generally distinguished by using colour 16 mm film for the 'copy' and black-and-white video for the 'authentic' figure. This use of different types of film stock points to the possibilities of the cinematic medium to conjure up notions of multiplicity, echoed in the film's thematic through the treatment of the celluloid double. However, as Page (2005: 30) remarks, 'these distinctions are not respected throughout the film and this blurring serves to demonstrate the contamination of narrative by metanarrative, a theme of particular significance in the film's exploration of memory'.

The merging of fictional and non-fictional characters is most explicitly realised in the scene where the crew visit the Centre for Forensic Anthropology in Buenos Aires, and the fictional Albertina is required to give a blood sample. Although this is a logical extension of the performance of the director through the actress's body, it is immediately belied by the fact that the 'real' Albertina emerges from behind the camera, at once recognising her status as subject of the film and orchestrator of the performance before the camera. Reasserting her position as the true heir of her parents, she steps forward to give her own blood accordingly, in order to pursue this strain of genealogical research. Yet this biological investigation is undermined by the immediate lack of a sample from the parents' bodies with which to compare her own (Page, 2009: 175). This scene provides not only the basis for authenticity in the figure of Albertina, alluding to the impossibility of the actress being able to perform some aspects of her doubling due to biological concerns, but also explicitly draws attention to the fact that the fictional Albertina that we are constantly presented with on-screen is always playing a role (Page, 2005: 32). The legitimisation of the director's bloodline relationship to her parents, moreover, proves redundant in the director's examination of her own identity.

The artifice of both Carri's autobiography and the presumed truth discourse inherent in documentary comes to the fore on several occasions when the actress Couceyro mediates testimonies given by other people, most notably in the scene where the actress draws a diagram of a torture centre, based on her memory of someone else's recollection. The actress's poor

reconstruction of a sketch that a woman drew for her, depicting the layout of a torture centre, reveals nothing about the structure or purpose of the place, highlighting the failure of memory to convey what really happened (Page, 2005). Here, the process of relaying information is revealed to be fragmentary and inadequate, significantly questioning dominant discourses surrounding memory in Argentina which prioritise the testimonial. Indeed, while *Los rubios* incorporates testimonies of friends and family, they are not given centre stage in the film. In fact, Couceyro only gives passing attention to these interviews, with her back to the footage, physically shunning the testimonies which play on a small television screen in her studio. These testimonies do not lead the spectator to a better understanding of what happened and who her parents were, underlining instead the fracturing of memory and plurality of voices integral to the film's construction.

According to Nouzeilles, Carri's 'desacralisation of testimony' (2005: 274), challenges the dominant discourses on collective memory in Argentina, namely the elegiac accounts which celebrate the efforts of the militant resistors of the dictatorial regime, and the statements that form the *Nunca más* (CONADEP) report which documented the atrocities of the regime (Nouzeilles, 2005: 266). This rejection of existing and dominant memory frameworks in Argentina chimes with Erhart's (2001: 3) suggestion that 'first-person documentary prefers to subject conventionally trustworthy material (interview/testimony, archival footage) to interrogation, with the aim of altering, denaturing, and, it would seem, ultimately de-authorizing it'. This strategy is also employed in the film's treatment of family photographs, which offer little more than fragmented and fleeting images of the family's past, resisting the temptation to offer an image of the parents which would facilitate an approximation of what they were *really* like. Indeed, Carri herself has commented on this decision to omit documentary evidence which would satisfy the spectator's desire to know:

> Quería impedir que los diversos elementos como los testimonios, las fotos y las cartas dejen esa sensación tranquilizadora, ese 'ya está, conozco a Roberto y a Ana María y me voy a mi casa'. Lo que yo planteo es precisamente que no los vamos a conocer, que no hay reconstrucción posible. (Carri, cited in Moreno, 2003)
>
> (I wanted to make sure that the various elements like the testimonies, the photos and the letters didn't provide that reassuring feeling, the sense that 'that's it, I've got to know Roberto and Ana María and now I'm going home'. What I am suggesting is precisely that we can't get to know them, that there is no possible reconstruction. They are inaccessible because they aren't there.) (trans. Page, 2005: 34)

In this way, *Los rubios* represents the impossibility of reassembling Carri's parents by illustrating the shortcomings of typical documentary devices. In place of trust in the indexical nature of the archive, Carri employs performance, altogether more fluid, to demonstrate the instability of memory and identity.

Performance is pushed to its extreme in the sequences which directly refer to the film's title. In one scene, a woman from the neighbourhood where the family used to live describes the whole family as blond. Following the interview, the crew discuss this description of the Carris, its misrepresentation and the woman's distorted memory of the family. This account of the family as blond has been interpreted as an attempt to mark the 'subversive' family as other, thus differentiating them from the rest of the community (Aguilar, 2006: 180; Lerer, 2003; Nouzeilles, 2005: 268; Page, 2005: 35). This moment both exposes the fallacy of memory and points to identity's performative nature, a theme manifestly visualised towards the end of the film when the entire crew, including the actress Albertina and the 'real' Albertina, don blond wigs.

The pantomimic excess displayed in the scenes where Analía Couceyro is acting out the director, and in the closing scenes when the crew all assume a superficial 'blondness', points to the shifting nature of identity. As the blond crew run into the distance, parodying a typical Hollywood ending (Page, 2005: 36), Carri effectively suggests that constituent parts of identity may exist outside the family, among alternative communities such as her peers (Nouzeilles, 2005). *Los rubios* both recognises Carri's status as a child of the disappeared and simultaneously asserts her identity in other senses, in particular as a director, thus echoing her own comments on her identity: 'yo no quiero ser hija toda la vida. Quiero ser otras cosas y en el medio también soy hija' (cited in Moreno, 2003) ('I don't want to be a daughter for ever. I want to be other things and among them also a daughter').

The film's suggestion of an alternative community, in particular Carri's film crew, is repeated throughout at moments where the film lays bare its own construction (Page, 2005: 36). In one scene, the actress reads out a letter from the INCAA – the Argentine national film institute responsible for a large part of film funding in the country – rejecting the director's request for financial support. The institute decided that while *Los rubios* was a worthwhile project, it lacked the documentary rigour appropriate to represent the memory of her disappeared parents. Following the reading of the letter, the whole crew participate in a discussion about the verdict, emphasising both the collaborative nature of filmmaking and the controversial site of memory in Argentina. During the crew's discussion, Carri insists that she understands why 'they' would need a documentary which celebrates the militants' efforts and that would lend greater importance to testimony, but, she continues 'es una película que la tiene que hacer otro, no yo' ('that's for somebody else to make, not me'), implying a generation gap between her and the authorities who have ruled on the film's funding. The documentary rigour, and attendant truth discourses, which the INCAA demands is precisely what *Los rubios* rejects in its reluctance to provide a comprehensive idea of *who* her parents really were.

The indexical nature of the real in documentary is also debased in the Playmobil stop-motion animation sequences which intermittently appear

throughout the film. These animation sequences metaphorically re-enact family life in the countryside, constructing Albertina's memories and imagination from a child's perspective and emphasising the fact that the director experienced her parents' abduction as a very young child. Considered inappropriate by some, the animation in the film has generally been framed as an innovative contribution to a growing emphasis on the children of the disappeared in Argentine film, both in fiction and documentary modes (Aguilar, 2006; Amado, 2004; Nouzeilles, 2005; Page, 2005).[3] Moreover, these sequences distil the film's general concern with the generational aspects of memory recall, which has led critics to consider *Los rubios* within the parameters of postmemory, as theorised by Marianne Hirsch in her study, *Family Frames* (1997).

In Hirsch's formulation, postmemory is employed to describe a second-hand memory, a transmitted memory of what happened from an eye witness to a later generation. Hirsch's examples draw from the transference of Holocaust stories and experiences, where the children of survivors inherit an intimate relationship to that same traumatic event. Here postmemory signifies 'the experience of those who grew up dominated by narratives that preceded their birth, whose own belated stories are evacuated by the stories of the previous generation shaped by traumatic events that can neither be understood nor recreated' (Hirsch, 1997: 22). While the processes of identity and memory construction investigated in *Los rubios* resonate with this idea, in particular with regard to Carri's 'imaginative investment' (*ibid.*) in memories of the event and saturation with secondary sources, it is also important to recognise the differences between the two contexts at hand. Indeed, while Hirsch herself recognises that the term may be transplanted to other contexts, she uses postmemory to refer to the transmission of memories from one family generation to the next and, in the case of Carri, the trauma – the disappearance of her parents – forecloses the possibility of that transmission, since they are no longer there. In other words, the conditions which create her (non-)memory of the event were not passed down from parents to daughter but rather constructed from a plethora of different sources, many of which appear in the film. By underlining the open wound of her parents' absence, Carri does not unquestioningly uphold the militants as heroes of the previous generation but rather indicates that the option of resistance to the dictatorial regime, in itself political, had infinite political repercussions for the individual and family unit. In this way, their absence permeates the form and content of the film from start to finish, underlining the rupture of continuity in the family and limiting the potential for cross-generational transfer.[4]

In many ways, Carri's intervention in memory work appears to self-consciously resist her classification as 'hija de desaparecidos' ('daughter of disappeared parents'). The film acknowledges the huge importance of her parents' disappearance in her life but does not suggest that it should be the totality of her experience of the world; her work as a filmmaker in part

seems to attempt to redress this balance. Carri's commitment to exposing the collaborative nature of *Los rubios* simultaneously locates her body and identity at the centre of interrogation and representation. The very biological determinism which she undermines in her ineffectual forensic research and in her suggestion of an alternative family, namely that of her friends and peers, is the same determining factor which facilitates her status as the director of the film. Far from being a classical genealogical quest which would follow in the path of the father's name, however, *Los rubios* recognises that 'descent attaches itself to the body' (Foucault, 1991: 82), while nonetheless demonstrating that in lieu of the plenitude of the origin, there is merely incertitude, dissipation and loss.

Conclusion: journeys of self-discovery

Viewed in conjunction, both *Um passaporte húngaro* and *Los rubios* are built around the structuring principle of the journey as a powerful cinematic motif of identity formation. As Kogut navigates international borders and archives in her pursuit of a Hungarian passport, Carri moves between the different locations which characterised her childhood years – *barrio* (neighbourhood), *ciudad* (city) and, most importantly, *campo* (the countryside), 'donde empieza mi memoria' (*Los rubios*) ('where my memory begins'). In addition, Carri's investigation into her identity both begins and ends with a shot of a country path winding into the distance, perhaps a metaphor for the self-realisation she has undergone.

Although haunted by the spectre of patrilineage and bloodline, these genealogical journeys, 'operate[s] on a field of tangled and confused parchments, on documents that have been scratched over and recopied many times' (Foucault, 1991: 76), thus probing the relationship between the archive, history and identity on film. By highlighting fissures in the past and the absence of certain documents, information or individuals, the directors purposefully use genealogical research in an attempt to challenge dominant versions of history, assuming multiple, overlapping identities along the way. These films, unlike the cinematic journeys portrayed in *El viaje* (*The Voyage*, Fernando Solanas, 1992) and *Central do Brasil* (*Central Station*, Walter Salles, 1998), which Ruffinelli (2002: 448) suggests are craving for an absent father, 'una certidumbre a partir de la cual tomar fuerza para continuar viviendo y dar sentido a la vida' ('a certitude from which to draw strength to go on living and give meaning to life'), challenge the search for origins which is premised on an inherently positive understanding of the father figure, an idealistic assumption based on traditional notions of the family unit. While neither film dwells on the gender implications of contesting received history and the regulation of memory and identity, the films contribute to destabilising patriarchal and hegemonic interpretations of the past and identity, highlighting the interrelated nature of private and public spheres. As such, they delineate the diverse layers of female authorship in

film – theme, gaze, voice and body – suggesting that 'the purpose of self-inscription is not the construction of a coherent subject position for the author, but the construction of a viable speaking position which, nonetheless, mirrors and enacts the author's experience of selfhood and embodiment as multiple and fragmented' (Butler, 2002: 61). Here the diversity of filmic form deftly negotiates the polyphonic nature of identity and its imbrication in hegemonic discourses, demonstrating that cinematic autobiography is particularly suited to illustrating the splitting of narrative voices and the illusory cohesion of the self. At once inheriting and disowning their autobiographical ventures, these directors remind us that 'effective history studies what is closest, but in an abrupt dispossession, so as to seize it at a distance' (Foucault, 1991: 89).

I would like to thank Claire Taylor and Lisa Shaw, along with the editors of this volume, for their comments and suggestions on earlier versions of this text. This chapter is dedicated to the memory of my stepfather, Alan Cohen, who taught me to enjoy, question and interpret films.

Notes

1 It is striking, particularly in the Argentine case, how many directors of films which explore the family in terms of the last dictatorship (1976–83) are women. See, for instance, *Papá Iván* (María Inés Roque, 2004); *En memoria de los pájaros* (Gabriela Golder, 2000); *El tiempo y la sangre* (Alejandra Almirón, 2004); *Encontrando a Víctor* (Natalia Brusvhtein, 2005); *Panzas* (Laura Bondarevsky, 1999); *HIJOS* (Marcelo Céspedes and Carmen Guarini, 2002); *Pasaportes* (Inés Ulanovsky, 1997); and the short film *En ausencia* (Lucía Cedrón, 2002).
2 At the time of filming, Sandra Kogut was residing in Paris and her passport application was initiated there.
3 One such animation sequence, which portrays Carri's parents' disappearance as an alien abduction, elicited criticism from Martín Kohan (2004), who suggested that this fantastical rendering of the kidnapping undermined the real effects of the dictatorship on family members, thus depoliticising the event.
4 This discussion of the adoption of postmemory as a way to interpret *Los rubios* also warns us of the crucial slippage that occurs when Holocaust terms and concepts are transposed onto the Argentine dictatorship, without sufficient treatment of the contextual differences which separate the two traumas and subsequent developments in memory work. Hugo Vezzetti (2002: 160) has called for a more thorough examination of the connections and disconnections between the two contexts, in light of 'la incomparable potencialidad del Holocausto en la producción de *metáforas* del mal radical' ('the incomparable potential of the Holocaust in the production of metaphors of extreme evil').

References

Aguilar, Gonzalo. *Otros mundos: un ensayo sobre el nuevo cine argentino* (Buenos Aires: Santiago Arcos Editor, 2006).

Amado, A. 'Órdenes de la memoria y desórdenes de la ficción', in Ana Amado and Nora Dominguez (eds), *Lazos de familia: herencias, cuerpos, ficciones* (Buenos Aires: Paidós, 2004), pp. 43–82.

Aveller, J. C. 'Entrevista com Sandra Kogut', on DVD extras of *Um Passaporte Húngaro*, div. Sandra Kogut (Videofilmes, 2001).

Avellar, J. C. 'Eu sou trezentos', *Cinémas d'Amérique Latine*, 12 (2004), 27–51.

Baltar, M. 'Engajamento afetivo como marca de autenticidade: as performances da memória em *Um Passaporte Húngaro*', *Revista eco-pós*, 11(2) (2007), accessed 1 August 2008, www.compos.org.br/data/biblioteca_251.pdf

Bruss, E. 'Eye for I: unmaking autobiography in film', in James Olney (ed.), *Autobiography: Essays Theoretical and Critical* (Princeton: Princeton University Press, 1980), pp. 296–320.

Bruzzi, S. *New Documentary*, 2nd edn (London and New York: Routledge, 2006).

Butler, A. *Women's Cinema: The Contested Screen* (London: Wallflower, 2002).

Eduardo, C. [n.d.], '*Um Passaporte Húngaro* de Sandra Kogut', *Contracampo*, 53, accessed 22 February 2007, www.contracampo.com.br/53/umpassaportehun-garo.htm

Erhart, J. 'Performing memory: compensation and redress in contemporary feminist first-person documentary', *Screening the Past* (2001) accessed 18 June 2008, www.latrobe.edu.au/screeningthepast/firstrelease/fr1201/jefr13a.htm

Everett, W. 'Through the I of the camera: women and autobiography in contemporary European film', *Studies in European Cinema*, 5(2) (2007), 125–36.

Foucault, M. 'Nietzsche, genealogy, history', in P. Rabinow (ed.), *The Foucault Reader* (London: Penguin, 1991), pp. 76–100.

Gabara, R. 'Mixing impossible genres: David Achkar and African autobiographical documentary', *New Literary History*, 34(2) (2003), 331–52.

Gernalzick, N. 'To act or to perform: distinguishing filmic autobiography', *Biography*, 29(1) (2006), 1–13.

Hirsch, M. Family Frames: *Photography, Narrative and Postmemory* (Cambridge, MA: Harvard University Press, 1997).

Jardim Raymond, A. T. 'Brazilian video works: diversity and identity in a global context' D. Phil. thesis, University of Sussex, 1998, accessed 2 March 2008, http://tede.ibict.br/tde_busca/arquivo.php?codArquivo=173

Kogut, S. ([n.d.]) 'Entrevista com Sandra Kogut', accessed 4 January 2010, from www.republicapureza.com.br

Kohan, M. 'La apariencia celebrada', *Punto de vista*, 78 (2004), 24–30.

Kosta, B. *Recasting Autobiography: Women's Counterfictions in Contemporary German Literature and Film* (Ithaca and London: Cornell University Press, 1994).

Lejeune, P. 'Cinéma et autobiographie: problèmes de vocabulaire', *Revue belge du cinéma*, 19 (1987), 8–10.

Lerer, D. 'La fábula de la reconstrucción', *Clarín: Espectáculos*, 23 October (2003) accessed 21 April 2006, www.clarin.com/diario/2003/10/23/c-00909.htm

Lins, C. '*Um Passaporte Húngaro*: cinema político e intimidade', *Galáxia*, 7 (2004) accessed 17 July 2008, www.pos.eco.ufrj.br/docentes/publicacoes/clins_2.pdf

Moreno, M. 'Esa rubia debilidad', *Página 12: Radar*, 23 October (2003), accessed 24 April 2006, www.pagina12.com.ar/suplementos/radar/vernota.php?id_nota=1001

Nouzeilles, G. 'Postmemory cinema and the future of the past in Albertina Carri's *Los rubios*', *Journal of Latin American Cultural Studies*, 14(3) (2005), 263–78.

Page, J. 'Memory and mediation in *Los rubios*: a contemporary perspective on the Argentine dictatorship', *New Cinemas*, 3(1) (2005), 29–40.

Page, J. *Crisis and Capitalism in Contemporary Argentine Cinema* (Durham, NC: Duke University Press, 2009).

Renov, M. 'New subjectivities: documentary and self-representation in the post-verité age' (1995) *Documentary Box*, accessed 8 June 2007, www.yidff.jp/docbox/7/box/7-1-e.html

Renov, M. 'First-person films: some theses on self-inscription', in Thomas Austin and Wilma de Jong (eds), *Rethinking Documentary: New Perspectives and Practices* (Maidenhead: Open University Press, 2008), pp. 39–50.

Ruffinelli, J. 'Telémaco en América Latina: notas sobre la búsqueda del padre en cine y literatura', *Revista iberoamericana*, 68(199) (2002), 441–57.

Russell, C. *Experimental Ethnography: The World of Film in the Age of Video* (Durham, NC and London: Duke University Press, 1999).

Silverman, K. *The Acoustic Mirror: The Female Voice in Psychoanalysis and Cinema* (Bloomington and Indianapolis: Indiana University Press, 1988).

Vezzetti, H. *Pasado y presente: guerra, dictadura y sociedad en la Argentina* (Buenos Aires: siglo veintiuno epitores, 2002).

Websites

República Pureza Filmes, accessed 4 January 2010, from <www.republicapureza.com.br>

Filming in the feminine: subjective realism, disintegration and bodily affection in Lucrecia Martel's *La ciénaga* (2001)

Julián Daniel Gutiérrez-Albilla

Lucrecia Martel's *La ciénaga* (*The Swamp*) challenges and points to the collapse of the institutional power, representational modes and subjectivity of the traditional Argentine bourgeoisie in late modernity. Working at a kind of micro-political rather than a macro-political level, Martel's film represents family and social disintegration, which is caused in part by the failure of communication or emotional dysfunction and annihilation, in the context of the decadent world of the traditional rural Argentine society, through the use of what could be defined as a subjective realistic cinematic style.[1] In *Narration in the Fiction Film*, David Bordwell (1985) distinguishes between the narrative and filmmaking strategies used in classical Hollywood cinema and those explored in art cinema. For instance, in opposition to Hollywood's emphasis on linearity, on character causality, conditioned by individual motivations, goals and drives, and on a three-act structure leading towards a pronounced denouement, the characters in art cinema, Bordwell argues, are typically without clear-cut traits, motives and narrative goals, wandering as passive observers through a certain social milieu in a series of unconnected episodes (207). If Hollywood cinema has traditionally posited a rational agent who is in control of his own destiny, Bordwell suggests that the art film's thematic crux depends on its formal organisation, creating unfocused gaps and facilitating an open-ended approach to causality. Although the dichotomy established by Bordwell is predicated upon the homogenising of Hollywood cinema, neglecting the different ways in which Hollywood cinema has experimented with visual and narrative forms, his insightful understanding of the film medium is useful for an attempt to think about how the textual system in *La ciénaga* resists a rational and oversimplified explanation that is produced in reaction to the absence of narrative coherence and Martel's rejection of the conventional cinematic codes that govern chronology, which is itself based on an implicit logic that combines succession with consequence.

Hence, such a subjective realistic cinematic style is not associated with the objective or mimetic representation of reality through the use of narrative

continuity, which is based on traditional cause-and-effect sequences and on spatial coherence as providing the organising structures of reality. Instead of such an effect of seamlessness, by which spectators are 'stitched' into the reality with which they are presented through the techniques of suture, Martel's subjective realistic cinematic style is achieved by the fragmented treatment of a narrative that precludes any possibility of epiphany or revelation, thereby creating permanent gaps in the narrative and soliciting a parallel reading, which requires a highly complex level of interpretation, by relying often on ambiguity and on making us wonder. For instance, the film ends by provoking in us an uncertainty about life and death which is evoked by the final action of Luciano, Tali's son, falling to the floor from the ladder resting on the wall that divides Tali's house from that of her neighbour in which, according to the young members of these two families, an invisible African rat lives. Martel's film seems to advocate a belief in the fundamentally random and yet strangely meaningful structure of reality, which leads to a loosening of the cause–effect relation (Sconce, 2002). *La ciénaga* consists of dialogues which privilege the exposition of mental processes, emphasised by the unselfconscious performances of the actors, as if the meaning of language existed less in the signification of words than in the interstices between words and as if the meaning of language faded through those same folds, thereby disarticulating linguistic utterance and pointing it in the direction of non-signifying sound (Powell, 2002: 63). The lack of linearity is also emphasised by means of obsessive and disorienting repetitions of pieces of dialogue or actions within the film. For instance, Mecha and Tali, the two female protagonists of the film, continuously discuss a plan to travel to Bolivia in order to free themselves from their imprisoned and tedious existence, which is associated with their scars and traumas in relation to the domestic sphere.

Martel's cinema uses close-ups which fracture the scarred, mutilated bodies of the film's characters to the extent of transforming each of these pieces into isolated elements, thereby turning them into corporeal fragments of sensation and affect (del Rio, 2005). Avoiding establishing shots, the film starts with a drunken Mecha accidentally falling to the ground while a trembling, mobile camera seems to reflect in cinematic terms Mecha's psychological and emotional disturbance and her physical fragility and disorientation, as we listen to the strident sounds of a storm and of ice cubes clinking and deckchairs clattering over the patio (Smith, 2001: 45). The action of Mecha falling to the floor is not graphically shown – we see her already on the floor as the camera focuses on a close-up of the pieces of glasses that have cut her now bleeding chest. Throughout the film, Martel emphasises the situation of the characters' confinement, whether humans or animals, by having them repeat the action of lying horizontally on the floor, in swamps (we see a cow trapped in a swamp),[2] or on beds that become the equivalent of tombs, as if these were spaces from which they could not escape, thereby remaining, in the same way as Mecha does, petrified in their own stasis. The emphasis

on horizontal bodies here is also noticeable when, as already mentioned, Luciano falls from the ladder, while the camera focuses on the sunlight shimmering on the patio and the empty and silent spaces of the house, as we see the possible corpse of Luciano in the background as if Martel wanted to leave the possible, but anticipated, death of this child outside the frame.

What interests me here is the way that the film reinforces the loss of the verticality that had previously distinguished humans from animals. As is well known, most animals are situated along the horizontal axis, even if they strive to raise themselves up to the vertical position. For instance, in his 1929 article 'The big toe', Georges Bataille, who suggested that human structure has remained strictly subjected to the vertical axis, argues that the very definition of humanity is inextricably entangled with that most base of human features, the foot. The toe separates humans from other primates by allowing them to stand erect. Thus the toe determines the hierarchies of the body and of society, which are based on clear-cut distinctions between the high and the noble and the low and the ignoble. In Bataille's account, the toe exceeds such distinctions by 'developing bunions, corns, and callouses. It becomes splayed, bulbous. It refuses to be ennobled or even to be ignoble. It is, simply, base' (Lastra, 1999: 57).

In *La ciénaga*, the film's characters are bound up with a drive to declassify and to undo verticality by falling to the ground. In other words, this horizontal space is indicative of a fall from the dizzy heights of civilised bourgeois society to a primal state of abandon. The privatised family is conventionally seen as a morally imposed construct, which regulates the telos of human sexual behaviour, condemns indecency and perversion and creates an anti-homosexual paranoia (Deleuze and Guattari, 1984). Although the film never shows explicit sex scenes, the members of this decadent bourgeois family may be able to satisfy their uncontrollable fantasies, such as an incestuous relationship between the brothers (José and Vero) or a lesbian relationship between the indigenous maid (Isabel) and Mecha's daughter (Momi), which are repressed within the vertical social space that they would normally inhabit. Shooting the lying and sweaty bodies from a low angle or recreating the animal axis, a hand-held camera moves slowly in order to search out details of the *mise-en-scène* that point to the decadence and disorder of these bourgeois households in the province of Salta, such as, for instance, the peeled walls, the dirty telephone or the dysfunctional alarm clock, thereby giving a tangible quality to the objects that are presented to the spectator. Martel's cinematic language is often characterised here by long takes and by a shift from showing a lot of movement within the frame to an almost static composition. Some examples of the former would be the sequence where the characters suddenly start dancing by Mecha's bedside or the sequence showing a local party in which, as an event less of social confluence or harmonious cohabitation than of social and racial antagonism, José ends up fighting people from the other side of the social frontier (Amado, 2006: 51). The almost static composition allows the spectator to

observe closely the provocative or bizarre objects that are presented on-screen. These representational devices foster a sense of clinical observation, thereby reinforcing the powerful visual impression of mounting chaos and confusion and generating sensations in the spectator's body. The expanding duration of slow shots and the use of long takes suspend the action and produce a sense of claustrophobia in the spectator that is parallel to that of the characters.

Although there are exterior shots, especially when Martel wants to convey an image of nature as less idyllic than threatening, which is further emphasised by the sounds of shooting or by the image of the cow trapped in the swamp, to which I referred above, the film induces a feeling of temporal and spatial confinement in the spectator due to its taking place in interior spaces that are shown as bounded and limited spaces. These frayed interior spaces reflect the precariousness of the emotional and material conditions of the characters' existence. While the orderly progression of time has been abolished, as epitomised by the dysfunctional alarm clock by Mecha's bedside, endlessly marking the same time, the film characters move as if they were caged animals or fishes in an aquarium. Hence, the members of this decadent bourgeois family escape from logicality and lodge themselves within the bodily and the obsessive. Desire, which is absent in the parents but which flows endlessly in all sorts of directions, is thus not proposed here as the desire for form and thus for sublimation. Rather, desire, which works at a micro-political level, is defined in terms of transgression against form, thereby provoking changes in the tissue of our sensibility and a resultant crisis of meaning in our references (Rolnik, 2006). In psychoanalytic terms, the emphasis on horizontality here could imply an aggression against Lacan's association of vision with the vertical axis in his article 'The mirror stage as formative of the function of the I'.[3] Horizontality defies the meaning of the bounded, flattened plane of the screen, which functions like the mirror described by Lacan, reflecting back to the subject a flattering picture of herself/himself.

Throughout the film, Martel also makes use of diegetic on-screen and off-screen sound, such as the constant sound of thunder, the buzzing of the crickets, the barking of dogs or the explosion in Tali's house, which acquires a relative autonomy vis-à-vis the image and produces a corporeal and haptic resonance in the spectator, thus transferring the responsibility for visualisation from the filmmaker to the spectator (Hallas, 2007: 39), as well as inverting the hegemony of image over sound that has shaped the history of both popular narrative and experimental cinema (Ragona, 2004). According to Michel Chion, the very notion of a 'soundtrack' misleadingly implies the autonomy of the perception of sound during the viewing of a film (cited in Hallas, 2007: 42). Chion argues that 'a film's aural elements are not received as an autonomous unit. They are immediately analysed and distributed in the spectator's perceptual apparatus according to the relation each bears to what the spectator sees at the time' (1999: 3). From

this perspective, many aspects of film sound become subordinated to the image's appearance of depth, thereby enhancing a conventional narrative film's impression of realistic spatio-temporality (Hallas, 2007: 42). Chion also refers to those unanchored, seemingly disembodied sounds, which he calls the 'acousmêtre', that make us feel in our body the vibration of the other. Commenting on how sound functions in *La ciénaga*, Gonzalo Aguilar seems to associate the use of sound in the film with Chion's notion of the 'acousmêtre' by explaining that:

> El sonido no está tan estratificado (música, diálogo, sonidos ambientales) sino que se genera una verdadera red, una masa sonora en la que lo indiscernible está en tensión con la diferenciación. Así, por ejemplo, los diálogos son trata- dos como banda de sonido y muchas veces su textura sonora tiene tanta o más importancia que la comprensión del significado de las palabras. (2006: 95)[4]

The film is also characterised by the predominant use of off-screen space, as in the scenes which have been previously described of Mecha's fall at the beginning of the film and that of Luciano at the end. If what is framed is visible, the off-screen space designates what exists elsewhere, testifying to an infinite invisible presence outside the space. According to Briony Fer, infin- ity is that which exceeds representation. It is not a place or even a point, but it exists only in the imagination. The idea of infinity has been conventionally attached to the transcendental subject or the sublime. Infinity is, however, a concept that is uncertain about its objects. If infinity is something that exists in the mind, as that which is beyond representation, it breaks the bounds of a totality, thus opening onto a future doubt, and the possibility of revelation is lost (Fer, 2004: 58). The self-conscious reflection on the film medium here makes us think of the conditions of visibility. In the Lacanian paradigm, vision is strictly bound up with the sense of a lack of wholeness, because viewing depends on an illusory wholeness and mastery. If Martel's self- reflexive cinema makes us think of the conditions of visibility, it ultimately reveals how our encounter with the film is experienced in a discontinuous way, as if to be in the encounter is to be out of the encounter. This is further emphasised by the predominant use of indeterminate ellipses. For instance, we never know when José, Mecha's son, who lives in Buenos Aires with his father's former lover, arrives or leaves the family house. Likewise, when Momi, who is in love with the indigenous maid, plunges into the swim- ming pool filled with stagnant, dirty water and covered by dried leaves, we never see her coming out of the pool, even if in subsequent sequences she is already shown outside the pool. *La ciénaga* reveals, therefore, the fragmen- tary and disorienting conditions of perception of our precarious and frayed subjectivity. Our contemplation and all-perceiving gaze disintegrates in the process of viewing the film (Fer, 2004).

Thus, conventional empathy-inducing film techniques, such as point-of- view editing, shot–reverse shot structures, eyeline matches or the presence of emotionally engaged music are avoided throughout *La ciénaga*. Instead,

deviating from classical norms, Martel attempts to give the camera its own autonomy, exploring the *mise-en-scène* or the characters' actions without falling into the dynamic of subjectivisation and ideal identification. The 'invisible witness' canonised by Hollywood precepts becomes overt. Instead of continuity, which suggests a mirroring or empathetic identification, the emphasis here is on something that is lacking. In symbolic terms, if the cinematic screen has been conventionally associated with the mirror, here it has become a threshold; a place of exchange and movement.

This subjective realist cinematic language conveys the traumatic inner life of the characters and emphasises the way in which what is negated, repressed or eluded returns as a disturbing reminiscence, as a violent atrocity, as an invisible trace haunting the cinematic space (Oubiña, 2007). These representational devices, which are traces of the process of narration, allow Martel to redefine established systems of meaning by reordering the perceptions of the spectator without reconciling the contradictions between the failures or excesses of our perceptions and narrative coherence. I contend, moreover, that Martel's cinematic style produces bodily sensations that may be divorced from any referents, thereby affecting our senses and forcing us to react to the film on a corporeal, bodily, perceptual and affective level, which ambivalently inscribes the dialectic between opacity and transparency as fundamental conditions of vision and perception. This is made explicitly manifest when some balloons filled with water are splattered all over the glass windows behind which we see a blurred image of the faces of some girls who are playing with some indigenous boys during their visit to the shops in the nearest city. The water running down the windows thus produces a disturbing opacity in the spectator's field of vision and allows us to rethink vision as incorporating touch. In a different context, Fer suggests that hapticality becomes an index of vision, a temporal imprint of looking (2004: 20).

Hence, what is expressed by the cinematic image is not totally explained or exhausted by the spatio-temporal connections that the plot establishes as sufficient rational causes. From this perspective, Martel does not allow the viewer to experience the film solely through linguistic signification, through the mimetic properties of cinema or through a rationalist epistemology. One needs to pay attention to how Martel allows the viewer to experience the film through the materiality and the psychical assemblage of the body of the film. As Jill Bennett argues in relation to affect, trauma and contemporary art: 'we need to examine how affect is produced within and through a work, and how it might be experienced by an audience coming to the work' (2005: 7). Martel's cinema, then, has the capacity to restore belief in the world via what Suely Rolnik defines as 'the resonant body' (2007) and yet 'this pure event of perception is the seeing that sight cannot see, a blindness that is the condition of all sight as well as its limit. This enabling interruption, as the potentiality of visuality (to see and to not-see), is a lure that draws out perception by incessantly withdrawing vision and the visual' (Ricco, 2002: 67).

However, is this bodily affection defined as a total rupture from the sym-

bolic order or as the way that the signifier (language) is inextricably – and traumatically – linked to the materiality of the body, particularly in the context of a society in which political violence (on the part of the state) has been exercised upon the body as a mechanism of social control, which functions as a primordial ground of semiosis? It would be problematic to reduce the signification of the film to an allegorical representation of the toxic effects of the military repression and the state-sanctioned terrorism that took place in Argentina during the 1970s and early 1980s, which resulted in the murder and disappearance of many Argentine civilians,[5] or the economic, social and political collapse suffered by Argentina in recent decades.[6] As Joanna Page rightly suggests, the film does not 'provide sufficient grounding for a fully allegorical interpretation that would allow us to read it straightforwardly as a political or social commentary' (2009: 184). Nonetheless, following Rolnik's definition of state terrorism in the context of the military dictatorship that Brazil suffered from the 1960s up to the early 1980s, I would like to emphasise that our subjectivities and bodies can actualise, as Rolnik suggests, the sensory mark or trace of the pervasive presence of state terrorism whose remaining toxic effects are perceptibly or imperceptibly inscribed in our body's memory and in our psyche in the present (2008: 132–7). From this perspective, I contend that body and language could point to the traumatic collective psychological mechanism which partakes in a complex process of abreaction through which the traumas of the Argentine post-dictatorial society are dispelled and, more importantly in the context of our discussion, the failures of Argentina's ambivalent insertion into economic globalisation and the neo-liberal policies of the patriarchal state since the period of redemocratisation.[7]

If power circulates transversally, getting disseminated in a micro-physical manner, the omnipresence of neo-liberalism in Argentine society has contributed to the production of an almost hypnotic identification with the sanitised and pre-established images of the world broadcast on the part of advertising and mass culture.[8] In *La ciénaga*, we could argue that the constant news about a possible apparition of the Virgin on the top of a tank of water or the advertisements shown on the TV which is often turned on in Mecha's room are examples of Martel's condemnation of the mass media, making us aware of the discontents and vicissitudes of late modernity. Calling for the urgent need to invent new forms of expression that can mobilise new sensations that will incorporate themselves in our sensible texture, Rolnik concludes that the signs of the presence of the other in our resonant body and their reverberation in our subjectivity may possibly open up our individual and collective existence (2006). Following Rolnik's attention to the forces that shape reality at a micro-political level, I would suggest that Martel's film does allow us to apprehend the world as a field of forces that affect us through different levels of intensity and make themselves present in our bodies in the forms of sensations, thereby helping us to construct the territories of our existence.

If this corporeal cinema produces sensations that may be divorced from referents,[9] I suggest that Martel's film cannot be interpreted as a mere condemnatory critique of family, sexual, social, generational or racial mis-communication and hostility, which lead to total social disintegration. On a more philosophical and metaphysical level, the film deals with the ethical question of the fragility of the film characters' existence. As Martel herself has put it:

> Somos humanos frágiles y, en consecuencia, el desamparo es una cuestión existencial. Es como si una criatura hubiera sido lanzada a la vida y ya nadie más se hiciera cargo de ella. Tengo una visión muy católica sobre este asunto (aunque soy atea, mi formación es católica), que proviene de la idea del desamparo divino: siento como si Dios hubiera creado la humanidad y luego se hubiera olvidado de ella, se hubiera ido. Entonces todos estamos como niños desamparados, en medio de una humanidad donde ni los adultos ocupan sus roles de adultos ni los niños ocupan los de los adultos (una humanidad donde nadie puede cuidar a nadie). (2002: 17)[10]

However, despite Martel's pessimistic vision of the present and the future, which exemplifies the general lack of the ability to imagine a more satisfying future in Argentine cinema at the time of writing, the film does not fall into a kind of sentimentality or provide us with a moral judgement or critique of the stagnant society that Martel portrays, a society that is doomed to feel the ambivalent fear of repeating the same situation, thereby turning human agency against itself. Yet, this same fear is symptomatic of a resistance to escape from the same, to experience new beginnings. The film's lack of judgement allows us, in turn, to benefit from the uncertainty and unintelligibility beyond the masks of ideology and politics. Martel is more interested in providing us with a kind of experimental *écriture* that may undermine the law of the symbolic order than in attacking political power directly, as in orthodox feminism. The latter inevitably remains within the very discourse of power that it seeks to undo. As Julia Kristeva suggests:

> What has emerged in our postwar culture, after the wave of totalitarianism [or a military dictatorship in the specific case of Argentina] is these peculiar kinds of speeches and *jouissance* directed against the equalising Word, even when it is secular or militant. This is something ignored by the machinery of politics, including that of the left, which has been caught up in a large history that excludes the specific histories of speech, dreams and *jouissance*. (1986: 294)

This quotation by Kristeva implicitly suggests that both our critical and theoretical frameworks and our ideological and political positions have failed to respond to new realities due to the fact that we have not allowed ourselves to invent new categories that may define and capture those changing realities. Hence, if neither the avant-garde nor what is referred to as 'women's cinema' guarantee the expression of 'radical possibility' (Cheu, 2007: 8), the poetics of Martel's 'corporeal cinema', does, indeed, 'experiment with the limits of identity, where the law is overturned, violated and

pluralised, a law upheld only to allow a polyvalent, polylogical sense of play that sets the being of the law ablaze in a peaceful, relaxing void. As for desire, it is stripped down to its basic structure: rhythm, the conjunction of body and music, which is precisely what is put into play when the linguistic *I* takes hold of this law' (Kristeva, 1986: 295). However, Griselda Pollock makes us aware of the fact that, although Kristeva advocates a radical feminist signifying practice, 'she remains bound with an imaginary that only partially conceives how to disrupt the law of subjectivity ruled by the phallus' (1996: 77).

I would suggest that Martel's 'corporeal cinema', which, as has previously been suggested, is associated with affective vision as incorporating touch, makes the film a space of co-emergence and co-affecting, a transitory and transitional space of fluid co-relation, thus creating intersubjective encounters that point to the traces of what Bracha Ettinger has defined as the matrixial process which spreads across the threshold of culture via art, thereby expanding the symbolic itself in which the 'Outside' is beyond any 'inside–outside'[11] spatial oppositions. It is thus important to engage deeply with Ettinger's (1996) theoretical paradigm in order to understand the way in which Martel's film could point to a rearticulation of feminine subjectivity beyond a patriarchal ideological framework. More interestingly, by establishing a connection, or by working at the intersection, between Martel's cinematic practice and Ettinger's groundbreaking theoretical propositions, I will explore how *La ciénaga* offers a representational and critical alternative to an orthodox feminist political project, which remains confined to the subject of women's rights, bodies, histories and oppressions, in the form of an identity-based representational mode of politics (del Rio, 2008: 103).

Ettinger reflects on the possibility of thinking of the feminine in human subjectivity as remaining outside the dominant economy of symbolic representation associated with the phallic signifier without relegating femininity to the realm of the psychotic. From this perspective, an alternative feminine sub-symbolic sphere continuously affects the symbolic and it is less based on undifferentiated desires and subjectivity, associated with pre-Oedipality, or on differentiated desires and subjectivity, associated with Oedipality, than on what Ettinger defines as a 'matrixial subjectivity'. For Ettinger, subjectivity is conceived of as an encounter between the 'I' and the 'non-I' at shared borderspaces where several partial-subjects, composed of the known as well as the not-rejected and not-assimilated unknown, become vulnerable and fragilised through erotic borderlinking. Ettinger explains:

> *Matrix* is an unconscious space of the simultaneous co-emergence and co-fading of the *I* and the uncognised *non-I* which is neither fused, nor rejected. [Matrix] is based on feminine/pre-natal interrelations and exhibits a shared borderspace in which what I call *differentiation-in-co-emergence* and *distance-in-proximity* are continuously rehoned and reorganised by

metramorphosis created by – and further creating – *relations-without-relating* on the borders of presence and absence, object and subject, me and the stranger' (1996: 125).

Moreover, according to Ettinger, in the matrixial borderspace, 'we metabolise mental imprints and traces for one another in each matrixial web whose psychic grains, virtual and affective strings and unconscious threads participate in other matrixial webs and transform them by borderlinking in metramorphosis' (2005: 705). The matrixial borderspace thus creates a redistribution in the shared field and a change in common subjectivity, offering a transformational potentiality for trans-subjective transactions.[12] In the light of Ettinger's redefinition of subjectivity as encounter, we may think of Martel's film as proposing a radical notion of feminine subjectivity within the matrixial sub-symbolic psychic sphere, which comes neither after the founding cut of castration and splitting nor by means of a regression to the pre-Oedipal, archaic psychic stage, as the latter would still be haunted by its relativity to the dominant phallic signifier. Thus, we need to move beyond the Freudian Oedipal semantic universe and/or Lacanian phallocentrism in order to understand how the film could be associated with a more complex articulation of the feminine in human subjectivity within Ettinger's matrixial paradigm.

Following Ettinger's notion of 'matrixial subjectivity', I suggest that, instead of thinking of the pre-existing status of the filmmaker, who confers her 'femininity' on the film, which would cast the author in the role of transcendental signified, thereby perpetuating the metaphysics of presence associated with the patriarchal epistemological tradition, I want to propose that the film calls for a thinking of the working of the film that produces the filmmaker in the feminine without relegating the latter to the moment of rupture and negativity. If art could be interpreted less as an object than as a process that creates the subject (de Zeguer, 1996: 23), we could theorise the filmmaker in the feminine beyond a modality which is based, as Catherine de Zeguer rightly suggests, on rejection–assimilation, self–other, love–hate or aggression–identification (1996: 22). These dichotomies do structure Martel's film. Nonetheless, Ettinger's theoretical, ethical and aesthetic project allows us to repair what is seen as suspicious hermeneutic practices, thereby transcending the negativity that prevails in much of our critical practices. The filmmaker in the feminine is linked to a different kind of gaze which, according to Ettinger, does not replace the phallic gaze but aids it in its moving aside from its destructive aspects. The film traps or supports this 'matrixial gaze', because the filmmaker accepts her own fragilisation to open herself onto a primary affective knowledge of the other, thus working through traces coming from others to whom she is borderlinked. This ethical and aesthetic process of reaccessing the 'matrixial gaze', which for Ettinger implies a risk of failure, guilt, shame and failure again, advances a theoretical notion of the film less as a part

of social production than as productive and as a producer of theory (de Zeguer, 1996: 23).

From this perspective, *La ciénaga* functions as what Mieke Bal defines as a 'theoretical object' (1999) which reflects on the feminine in human subjectivity, thereby reconceptualising the film as the producer of the filmmaker in the feminine, instead of the female filmmaker producing a feminist film. Martel's film thus offers the possibility of a transformative potentiality, associated with the matrixial paradigm, in which the feminine does not succumb to the logic of the phallic signifier and, by extension, to that of patriarchal ideology. Martel does not explicitly identify herself as a feminist filmmaker and, as Page reminds us, *La ciénaga* could express the failure of Argentine cinema to interact with the political, testifying to the collapse of collective identities and utopian discourses (2009: 191). Perhaps it is the huge ethical and aesthetic impact that the almost imperceptible and yet expansive marks that the matrixial produces and cross-imprints, as articulated and retraced in the creative possibilities that her film opens, which become associated with a feminine embodied vision of our being-in-the-world. Martel's 'cinema of sensation' thus impregnates and transforms the social, psychic and affective fields of our existence.

Notes

1 I borrow this term from Gabriela Halac (2005).
2 Swamp is the term that gives the film its title. The literal image of being trapped in a swamp can also be symbolically associated with the situation of entrapment suffered by the members of this decadent bourgeois family.
3 For a fine historical study of psychoanalysis, see Roudinesco (1990).
4 'Sound here is not so stratified (music, dialogue, ambient sounds). Instead, sound generates a real net, a resonant mass in which that which is indiscernible is in tension with that which is differentiated. Hence, the dialogues, for instance, are treated as part of the soundtrack and often its resonant texture has as much or more significance than the comprehension of the signification of words'. Translations throughout this chapter are mine.
5 See Diana Taylor for an analysis of the ways in which narratives of state violence in Argentina were written on the present or absent body (Taylor, 1997).
6 For a complex theorisation of the extent to which Argentine cinema can function or fail to function as a national allegory, see Page (2009).
7 Although I tend to agree with Page's problematisation of allegory, I am indebted to Adrián Pérez-Melgosa's allegorical reading of Argentine cinema (Pérez-Melgosa, 2004).
8 See Christian Gundermann for an understanding of *La ciénaga* vis-à-vis the failures of the neoliberal project (2005).
9 For a fine study of the cinematic image from a non-representational angle, see del Rio (2008).
10 'We are fragile human beings and, as a consequence, abandonment is an existential question. It is as if a baby had been thrown into life and nobody could any

longer take care of him. I have a very Catholic understanding of this issue (even if I am an atheist, I have a Catholic upbringing), which comes from the idea of Divine abandonment; I feel as if God had created humanity and, subsequently, he had forgotten it, he had disappeared. Therefore, we are all like abandoned children, in the midst of a human environment where adults cannot perform their roles and where children cannot perform the roles of adults (a human environment where no one can look after anyone'.

11 I engage with Ettinger's theories of the matrixial in relation to maternal relationality and trans-subjective encounters in my forthcoming article on Almodóvar's *Todo sobre mi madre* (*All About My Mother*, 1999a). See Gutiérrez-Albilla (2012).

12 As I explain in my forthcoming article on *Todo sobre mi madre*: Griselda Pollock remains, to my knowledge, one of the most important interpreters of Ettinger's artistic work, aesthetic theory and of her psychoanalytic focus on the 'matrixial bordespace'. Although Pollock has extensively written on the work of Ettinger, a fine introduction to Ettinger's complex theories is her article on feminine aesthetic practices and Ettinger's concepts of 'matrix' and 'metramorphosis' (Pollock, 2004) and her introduction to Ettinger's *The Matrixial Bordespace* (Pollock, 2006; Ettinger, 2006). Connecting the philosophy of art and psychoanalytic theory, Ettinger undoes psychoanalysis from within by shifting from the focus of psychoanalysis on subjectivity and intersubjectivity to 'subjectivity as encounter' or trans-subjectivity. Ettinger provides us with an alternative language to account for psychic 'borderspaces' and trans-subjective, affective transactions that relate back to prenatal experiences and that are associated with the realm of the feminine. This was previously unthought in the phallocentric psychoanalysis of Freud and Lacan, as well as in the psychoanalysis of Kristeva, Cixous and Irigaray. These psychoanalytic theorists still emphasise a language of objects which remain haunted by their relationship to the cut of castration and to the Lacanian phallic signifier. See Ettinger (2005).

References

Aguilar, G. *Otros mundos: Un ensayo sobre el nuevo cine argentino* (Bueno Aires: Santiago Arcos Editor, 2006).

Amado, A. 'Velocidades, generaciones y utopías: a propósito de *La ciénaga*', *Alceu*, 6 (2006), 48–56.

Bal, M. 'Narrative inside out: Louise Bourgeois' spider as theoretical object', *Oxford Art Journal*, 22(2) (1999), 101–26.

Bataille, G. 'Le gros orteil', in B. Noël (ed.), *Documents* (Paris: Mercure de France and Éditions Gallimard, 1968), pp. 75–82.

Bennett, J. *Empathic Vision: Affect, Trauma, and Contemporary Art* (Stanford, CA: Stanford University Press, 2005).

Bordwell, D. *Narration in the Fiction Film* (London: Methuen, 1985).

Cheu, H., *Cinematic Howling* (Vancouver: University British Columbia, 2007).

Chion, M. *The Voice in Cinema*, trans. C. Gorbman (New York: Columbia University Press, 1999).

Deleuze, G. and F. Guattari *Anti-Oedipus: Capitalism and Schizophrenia*, trans. R. Hurley, M. Seem and H. R. Lane (London: Athlone, 1984).

del Rio, E. 'Alchemies of thought in Godard's cinema: Deleuze and Merleau-Ponty', *Substance*, 108 (2005), 62–78.

—— *Deleuze and the Cinema of Performance: Powers of Affection* (Edinburgh: Edinburgh University Press, 2008).

de Zeguer, C. 'Introduction', in C. de Zegher (ed.), *Inside the Visible: An Elliptical Traverse of 20th Century Art in, of, and from the Feminine* (Cambridge, MA: MIT Press, 1996), pp. 19–41.

Ettinger, B. 'Metramorphic borderlinks and matrixial borderspace in subjectivity as encounter', in John Welchman (ed.), *Rethinking Borders* (New York: Macmillan, 1996), pp. 125–59.

—— 'Co-poiesis', *Ephemera*, 5(10) (2005), 703–13.

—— *The Matrixial Bordespace* (Minneapolis, MN: Minnesota University Press, 2006).

Fer, B. *The Infinite Line: Re-making Art after Modernism* (New Haven: Yale University Press, 2004).

Gundermann, C. 'The stark gaze of the New Argentine Cinema: restoring strangeness to the object in the perverse age of commodity fetishism', *Journal of Latin American Cultural Studies*, 14 (2005), 241–61.

Gutiérrez-Albilla, J. D., 'Becoming a queen mother in and through film: trans-sexuality, trans-subjectivity, and maternal relationality in Almodóvar's *All About My Mother*', in J. Labanyi and T. Pavolic (eds), *Blackwell Companion to Spanish Cinema* (Oxford: Wiley-Blackwell, 2012).

Halac, G. 'Lucrecia Martel: poética pura', in M. Paulinelli (ed.), *Poéticas del cine argentino* (Buenos Aires: Comunicarte, 2005).

Hallas, R. 'Sound, image and the corporeal implication of witnessing in Derek Jarman's *Blue*', in F. Guerin and R. Hallas (eds), *The Image and the Witness: Trauma, Memory and Visual Culture* (London: Wallflower, 2007), pp. 37–51.

Jagoe, E. L. and Cant, J. 'Vibraciones encarnadas en La niña Santa de Lucrecia Martel', in V. Rangil (ed.), *El cine argentino de hoy: entre el arte y la política* (Buenos Aires: Biblos, 2007).

Kristeva, J. 'A new type of intellectual: the dissident', in T. Moi (ed.), *The Kristeva Reader* (New York: Columbia University Press, 1986).

Lacau, J. 'The mirror stage as formative of the function of the "I"', in A. Sheridan (ed.), *Écrits: A Selection* (London: Routledge, 1977), pp. 1–7.

Lastra, J. 'Why is this absurd picture here? Ethnology/equivocation/Buñuel', *October*, 89 (1999), 51–68.

Martel, L. 'He sentido mucho dolor haciendo La ciénaga', *Kinetoscopio*, 61 (2002), 14–17.

Oubiña, D. *Estudio crítico sobre La ciénaga* (Buenos Aires: Picnic Editorial, 2007).

Page, J. *Crisis and Capitalism in Contemporary Argentine Cinema* (Durham, NC: Duke University Press, 2009).

Pérez-Melgosa, A. 'Imaging crisis in contemporary Argentina: mothers on the streets and mothers on the screen', *Studies in Hispanic Cinemas*, 1 (2004), 151–68.

Pollock, G. 'Inscriptions in the feminine', in C. de Zegher (ed.), *Inside the Visible: An Elliptical Traverse of 20th Century Art in, of, and from the Feminine* (Cambridge, MA: MIT Press, 1996), pp. 67–87.

—— 'Thinking the feminine aesthetic practice as introduction to Bracha Ettinger and the concepts of matrix and metramorphosis', *Theory, Culture and Society*, 21(1) (2004), 5–65.

—— 'Femininity: aporia or sexual difference?', in Bracha Ettinger (ed.), *The Matrixial Bordespace* (Minneapolis, MN: Minnesota University Press, 2006), pp. 1–38.

Powell, A. 'Kicking the map away: Deleuze and the Blair witch project', *Spectator*, 22 (2002), 56–68.

Ragona, M. 'Hidden noise: strategies of sound montage in the films of Hollis Frampton', *October*, 109 (2004), 96–118.

Ricco, J. P. *The Logic of the Lure* (Chicago: University of Chicago Press, 2002).

Rolnik, S. 'The geopolitics of pimping', *Documenta 12 Magazine Project* (2006).

——, 'The body's contagious memory: Lygia Clark's return to the museum', *Transversal* (2007).

——, 'A shift towards the unnameable', in G. Brett (ed.), *Cildo Meireles* (London: Tate Publishing, 2008), pp. 132–7.

Roudinesco, E. *Jacques Lacan & Co: A History of Psychoanalysis in France, 1925–1985*, trans. J. Mehlman (London: Free Association, 1990).

Sconce, J. 'Irony, nihilism, and the new American "smart" film', *Screen*, 43(4) (2002), 349–69.

Smith, P. J. 'La ciénaga', *Sight & Sound*, 11 (2001), 45.

Taylor, D. *Disappearing Acts: Spectacles of Gender and Nationalism in Argentina's 'Dirty War'* (Durham, NC: Duke University Press, 1997).

Everything to play for: renegotiating Chilean identity in Alicia Scherson's *Play* (2005)*

Sarah Wright

In Silvio Caiozzi's 1998 documentary, *Fernando ha vuelto* (*Fernando's Return*), we follow the identification by Chilean forensic scientists of the skeleton of Fernando Olivares Mori, an activist during the Allende years who was disappeared during the Pinochet regime. His body was exhumed from Patio 29, the infamous collective burial site in Santiago General Cemetery. The cemetery recapitulates the social segregations of the history of Chile and spatially reflects its political divisions (Wilde, 2008). Patio 29, proclaimed a national monument in 2006, continues to be a site for the improperly buried. In Caiozzi's documentary, we witness the extraordinary encounter between Agave Díaz and her husband's skeleton. What relation can the skeleton have, for Agave Díaz, to Fernando's identity? Its role may be to create a space – collective and private – for affective engagements with Chile's problematic past (Wright, 2012). But after re-interment (the assignment of a space for Fernando to rest in peace and for his relatives to mourn), in 2005 the body was re-exhumed after the identification was called into question. Caiozzi added a coda to his film, musing on difficult questions of identity, memory and forgetting within consensus politics. In this 'dismembered landscape', Nelly Richard writes, the challenge facing 'a community divided by the trauma of homicidal violence' is for it to be 'reunited on the post-dictatorial stage' (2004a: 1).

While memory continues to be a vital theme for filmmakers at the turn of the century (Villaroel; Estévez Baeza), recent years have witnessed a 'new generation' of cinéastes who, while not speaking directly of memory – arguably they wish to move on from the past – nevertheless engages with identity politics in post-dictatorship Chile. An edition of the journal *Cinémas d'Amérique Latine* delineates two generations of filmmakers, those who trained in the 1960s, reaching their peak in the 1990s, and those who were studying in the 1990s. The creation of film schools, government grants introduced in 1999 and the passing of the Ley de Cine (cinema law) have

*I am extremely grateful to Alicia Scherson, Silvio Caiozzi, Charlotte Gleghorn, Toti Beltrán García, Alejandro Escobar, Ruth Aedo-Richmond, Francisca Lucero who all generously afforded time to this article.

meant more opportunities for filmmakers, while the rise in low-cost digital filmmaking and the opportunities to screen films in the multiscreens of the *Cine Hoyts* represents another important change (Flores Delpino, 2006: 71). In 2005, *Cahiers du cinéma* offered a focus on the 'nuevo cine chileno' (New Chilean Cinema): 'après l'espoir déçu du début des années 70 et le conservatisme des années 90, le cinéma chilien renaît de ses cendres. Une jeune génération de cinéastes émerge' [after the clashed hopes of the 1970s and the conservatism of the 1990s, Chilean cinema has risen from its ashes. A young generation of filmmakers has emerged] (Azalbert, 2005: 60–2). Matías Bize, Sebastián Campos, Francisca Schweitzer and Pablo Solís are cited, as is Alicia Scherson, whose first feature, *Play*, had made its debut that year.

Play is shot in HD digital in bright, pristine colours that appear to present a robust focus on the present ('I didn't want nostalgia', Scherson has remarked).[1] If memory is not an obvious theme – although it is arguably made manifest through the question of indigenous rights and the muteness of its protagonist – questions of identity politics in post-Pinochet Chile pervade it. Caiozzi speaks of censorship and minimal distribution and promotion in a city (Santiago) where the media is controlling, but where Scherson has achieved an international platform for her work. After studying film in Cuba and Chicago, she returned to Santiago to make *Play*, winning awards at Tribeca (the *Village Voice* and *New York Times* singled it out for praise) and at La Habana, Montreal and Nantes. Foreign interest generated a buzz back home – 'it is often said about this type of films that they have to be brought to Chile on the back of an international festival' (Fernández, 2005) – where distribution is dominated by Hollywood and the audiences can be small.[2] Following recognition at the Chilean Academy Awards, *Play* was presented as the Chilean entry at the Oscars 2006.

Cristina (Viviana Herrera), a young Mapuche working in domestic service to an ailing Hungarian, Milos, spends her free time playing video games. She finds a briefcase belonging to Tristán (Andrés Ulloa), a yuppie architect who enters a crisis when his wife leaves him. Cristina stalks him, crossing the city in pursuit. When Milos dies, Manuel, a municipal gardener, asks Cristina to return with him to the countryside but she refuses. She finally returns the briefcase to Tristán, as he lies in hospital following a fall from a construction site. But Cristina's future is not intertwined with his. Rather, we leave her surveying Santiago from a high vantage point.

Here, I consider the ways in which this film reflects on identity in post-Pinochet Chile. By centring on the experiences of a marginalised Mapuche woman, the film contemplates the ways that present-day Santiago reflects or refutes social divisions. Through the image of the *flâneur*, the walker in the city, the film meditates on the possibilities of social cohesion, identity politics and the right to space.

The invisible *flâneuse*?

The film begins to the image and sound of knuckles being cracked in preparation for a video game. Hands take the gearstick and frantically press the buttons. A cut to the video screen reveals that this is *Streetfighter II*, a Japanese game featuring a girl kick-boxer. We cut to Cristina's face, absorbed in the game – a smile crosses her features as she (or Chun-Li, the game's protagonist) wins a round. Drawing back, the camera reveals that this is one of the arcades ('los *flipper*') in town. Following Cristina's gaze, the hand-held camera takes us through the arcade, taking in her surroundings. In a fluid tracking shot, we follow Cristina as she walks through the shopping mall which houses the arcade. Shopkeepers stand in their doorways and invite her inside but she shakes her head. Once outside in the sunlight she is part of the crowd in a bustling Santiago street.

Theorists have expanded Walter Benjamin's writings on the *flâneur*, the urban stroller around nineteenth-century Parisian arcades, to include the visitor to the shopping mall and, with a mobilised gaze, the spectator in a cinema (Friedberg, 1993; Bruno, 2008). *Play* explores the fluid affinity between video arcade, shopping mall and cinema as Cristina traverses the virtual worlds of the game, then observes the wares offered in the mall and finally moves with the throng in the city. In a further parallel, some of the branches of *Cine Hoyts* in Santiago, where this film screened, are housed in shopping centres (such as the Parque Arauco, named after the Mapuches). If the *flâneur*, as conceived by Benjamin, has to do with 'freedom, the meaning of existence (or the lack of a meaning of existence) and being-with-others in the modern urban spaces of the city' (Tester, 1994: 8), then Cristina fits this description. If there is something of the *flâneur*'s alter ego, the 'rag picker' about the way that she drags the briefcase out of the skip, then the way she explores its contents might recall the detective, another interpretation of the *flâneur*. 'Botanising on the asphalt' (Benjamin, 1973: 36), Cristina's observations of the curios around her are emphasised in fluid pan shots, from the girl picking a scab to the man in the loud Hawaiian shirt poking at his ear with a cotton bud. The *flâneur* was all about leisure and freedom – personified by Baudelaire in *Paris Spleen* and 'The painter of everyday life' – but these were male pursuits (Wolff, 1985; Wilson, 1992). Feminist discussions have centred on the dialectic between visible and invisible, with Wolff suggesting that the very existence of a *flâneuse* was unthinkable, owing to her invisibility, not just in terms of a spatial presence but in the sense of having being ignored by theoretical accounts. But Bowlby (1985) has shown how the department store and later the shopping mall allowed for the creation of the *flâneuse*, a space for window-shopping and browsing display cases designed to entice the female consumer.

In *Play* the division between private and public and the right to space in relation to the *flâneuse* gains new vigour in twenty-first century Chile as Cristina is a Mapuche domestic worker. Domestic servants, like

nineteenth-century Parisian women, are assigned to the domestic arena, to the kitchens and nurseries within houses. They are practically invisible and yet at the core of family life, 'marginal[s] on the inside' (Carroll, 2005). Cristina's invisibility to the bourgeoisie is such that even when she follows Tristán for days and he glimpses her, she goes unnoticed. This is sent up in a scene which has Tristán following his wife with Cristina following them both, all in single file, filmed in profile. In another scene, Cristina stands next to Irene on a crowded underground train, getting close enough to sniff her body scent without being noticed (the intimacy and isolation of cities). Later, when Cristina introduces herself to Tristán in hospital, he wonders whether he might have seen her before, while Irene, Tristán's wife, fails to recognise her. The invisibility of the city walker takes on political significance as a metaphor for the marginalisation of a sector of the population. With its roots in the colonial period, the system of employing *nanas* (nannies) and *criadas* (maids) partly as a way to display wealth flourished under Pinochet and shows no signs of abating.

The city offers exciting freedoms, as we see Cristina roaming now by a change of definition, *incognito* (cf. Baudelaire's incognito poet) rather than invisible, an observer of city life. In the crowd she is one of many, anonymous, unnoticed. In the shopping mall she is brought into visibility as a potential customer – the shopkeepers stand in their doorways and attempt to make eye contact. She is a window-shopper, but there is little evidence that she is a consumer. Her room where she works as a *puertas adentro* (live-in) maid/nurse is almost bare. The fabric of her dress, emblazoned with American food brands, is faded and retro and suggests less her colonisation by US multinationals than the imported used clothing prevalent in Chile, which Richard notes submerges the 'clothing of the urban poor into a kind of dyslexia of un-coded articles that circulate thanks to the cheapness and casualness of the mixtures' in which 'bastard remainders of imported clothing, cheap leftovers of metropolitan serial fashions … are reassembled by popular bodies that stroll in them, forming a visual spectacle of a collage identity without coherence of style or a unified vocabulary' (2004b: 76–7). Visually, 'the used clothes function as a concept-metaphor of a peripheral identity plotted by discontinuous languages' (Richard, 2004b: 80). The shopping mall is, nevertheless, a democratising space. Stillerman has found that, unlike US malls which 'undermine public space in two ways: they exclude poor citizens through aggressive policing, surveillance and architectural design that hinders pedestrian access; and they discourage social interactions among shoppers', malls in Santiago offer permeability to the street, promoting social interaction and the blending of social classes (2005). Under the neon lights everyone is a potential customer.

Doubly marginalised, Cristina is also a Mapuche. Rooted in their cultural imaginary to the land ('mapuche' means 'people of the earth'), the Mapuche have suffered deterritorialisations from successive governments. Constituting around 5 to 10 per cent of Chileans, from 1881 to 1920 the

Mapuche were gradually relegated to just 3,000 'reductions': 6.4 per cent of their original territory (Park and Richards, 2007: 1321). The Pinochet regime practised a form of ethnic cleansing by privatising indigenous lands. Dissenters were tortured or disappeared. During successive regimes of the *Concertación*, including the government of Michelle Bachelet and, at the time of writing, that of Sebastián Piñera, the 'anti-terrorist laws' used by Pinochet to criminalise the Mapuche were still in force. After successive deterritorialisations it is estimated that half of the population of Mapuches in Chile live in Santiago. In *Play*, Cristina has a Mapuche surname and speaks Mapudungun to her mother on the telephone. The actress playing Cristina is not Mapuche, but conversely the *mestizaje* present in Chilean society often goes unrecognised – a 'European' Chilean can often present visually a racial mix. The 1992 census included the indigenous population for the first time, revealing that at 7.7 per cent of the population, the Mapuches are Santiago's largest ethnic group. Despite this, the urban Mapuches – in the 1990s the terms 'urban indigenous', 'urban Mapuche' and 'Mapuche warriache' ('warria = city', 'che = people') were coined, while the 2002 census included 'urban Mapuches' – do not maintain a highly visible presence in the city (Imilán Ojeda, 2009). Some Mapuches express their ethnicity only at home, preferring to 'enmascarar' (disguise) their identity elsewhere (Gissi, 2004: 9). In *Play*, Manuel, the local municipal gardener, has a romanticised view of the south, but for Cristina it signifies poverty and the 'smell of wet wool'. Cristina is often silent, speaking little, a manifestation of the 'atmosphere of generalised melancholy' surrounding post-reduction Mapuches (Ancán Jara, 1997). Cristina reads aloud an article in *National Geographic* about an Amazonian tribe wiped out by colonisers. But set against this melancholy is a display of power, as Cristina imagines herself to be a video-game kick-boxer. In a crude analogy, a Mapuche (a proud indigenous group of fighters) is transposed into an electronic girl-warrior. The virtual and the real collide, as Cristina imagines herself, with comic-book violence, taking on a mother who is cruelly chiding her daughter in the street. Cristina's anger speaks to her marginalisation.[3] In this game-world turf war Cristina earns her right to dominate space.

In the arcade and in virtual reality, Cristina is 'sovereign' (Chun Li is credited with being the first female fighting avatar). The *unseen seer* who manipulates the controls, Cristina also identifies with its highly visible avatar.

Characters in search of an identity

With its narrative detours and hyperreal aesthetics, *Play* explores the interface between cinema and the video game in a 'post-Playstation cinematic style' (Longworth, 2005). Cristina finds a briefcase in a skip and investigates its contents. Wearing the mp3 headphones, she sets out (the detective *flâneur*) in search of Tristán, in a game of her own making, to the coordinates of another, moving through the different spaces/levels of her

environment. This, we soon realise, is a game of identity. Cristina takes out the lighter from the briefcase, lights one of the cigarettes and, Garboesque, blows smoke rings in the mirror. The other characters are an assortment of the post-dictatorship upper classes; characters in search of identities.

Tristán, the melancholic architect, suffers from a decadent ennui. As his wife leaves him, in excruciating scenes we witness their break-up shower and the break-up meal of artichokes (he is emotional, while Irene quotes Pliny – a mocking of the urban sophisticate). Tristán loses his briefcase as the result of mistaken identity – he is attacked by someone who thinks he is 'Walter'. He begins binge-drinking in less salubrious parts of the city, before returning to his mother's home, where he plays dejectedly with a boyhood toy, drawing hair and eyes on an empty template. Cristina and Tristán are the only characters who traverse different places and spaces in Santiago: the rest are firmly corralled according to their socio-economic grouping.

Irene, Tristán's wife, is coldly intellectual, using an array of fabulous clothes to mask her boredom. Her new boyfriend is a post-Soviet nouveau riche Russian who takes her to the opera and indulges in risqué sex. If Irene is moving on from Tristán to a more sophisticated lover, her boyfriend is ascending socially. At his mother's house, Tristán discovers that Ricardo (Jorge Alis), a young Argentinian magician (the stereotypical trickster) has moved in with his mother. During a party at the house, when Tristán and his mother surprise Ricardo having sex with a female guest, she wilfully ignores the scene – she is metaphorically as well as physically blind.

Manuel, the gardener, is more sympathetic. He tends the greenery in the plaza outside the apartment of don Milos and, we learn, lives in La Cisterna, a poor district. He dreams of escape to the countryside, hoping to encourage Cristina to settle down there. Scherson's inventive cinematic style cuts rapidly to digitally mastered scenes representing individuals' psyches: butter melting at speed; a giraffe chewing; the sound of seagulls in a bar. The gulls are reminiscent of Buñuel's eagles in the close in *El angel exterminador*, but here the surreal sequences serve not to interrupt the formal fabric of the film, but to draw attention to its constructed nature. They may flesh out two-dimensional characters, but they are hyperreal, reminding us of the video game where texture and perspective create false depth. Continuing with Buñuel, these are characters whose bourgeois lives are trivial, whose dreams serve to close down meaning. They suggest the kind of vacuousness produced by industrialised nations where privileges rather than economic problems seem to be the source of dissatisfaction.[4]

The city as protagonist

Filmed in digital brilliance, Santiago rises up as the film's glittering co-protagonist. Scherson has noted that Santiago 'has no identity, has no sense of itself, it isn't comfortable in any particular area' (Greene, 2005). Part of Scherson's project was to depict Santiago cinematically.[5] The portrayal is

leafy, with wide boulevards and buildings drenched in oranges and blues. The downtown business district, the gated communities with pools of Las Condes, the bustling Mercado Central, are lovingly reproduced. It is a sanitised view: the plazas tended; the gardens manicured. Scherson's motivation stems from a pride in Santiago and a desire to place it on the same footing as New York or Paris (Greene, 2005). But is this image of Santiago a picture for foreign consumption, dispelling the Latin American stereotype of 'chaos and disorder'? Where a mugging is featured on-screen (the street resembles a stage set) the female cop arrives on her motorbike and neatly dispatches the crook. The characters enjoy post-Pinochet freedoms – the only operation of surveillance comes from Cristina. Santiago is the modern metropolis – from Irene's swanky apartment to the glistening glass buildings of the business quarter – and an unmitigated economic success.[6] The cinema–video-game interface suggests an aggressive present, 'in *Play* we're always in the present, always absorbed, the game is always in play' (Knipp, 2005), a 'representation in itself' (Sobchack, 2004).[7] In its focus on the present, does this view of Santiago threaten to sweep away important questions concerning its past?[8] In its quest to find new Chilean models, *Play* may tread a difficult line between representation and sanitisation. Scherson notes that for the final panorama scene, where Cristina surveys the city, she had originally wanted to touch it up, digitally removing a huge M for McDonald's seen as the camera pans: but 'finally I realized that it is such a part of Santiago that it would be shameful to take it out, unethical. In the end it became the final frame of the film' (Greene, 2005: 11). Ironically, in this hyperreal vision of the city, where copy refers only to copy, it is the mass-produced image of the McDonald's sign which breaks through, an imperfection disrupting the smooth panorama, reminding us of the indexicality of this image, a real referent among the hyperreal images. But if this is an imaginary or symbolic construction of Santiago, then perhaps we could read it as the Chile described by Manuel Castells (2005). With decreasing poverty levels and new housing, Castells confirms Chile's economic success, but unlike common accounts which attribute this to Pinochet's neo-liberalism dreamed up by the 'Chicago Boys', Castells suggests that rather than the 'authoritarian liberal exclusionary model' of the dictatorship, it is the 'democratic liberal inclusive model' since democratisation that is responsible. Scherson's focus on the present may, then, underscore democracy as the 'hidden story' behind economic success. There is nothing wrong with national pride in success – this is far from the 'favela effect' (Mennel, 2008) which has brought some Latin American films international recognition. Furthermore, Greene is correct that the portrayal of Santiago in *Play* is very different from the cosmetisation of the city in a film such as *Secuestro* (*Kidnapped*), which he describes as 'an exercise in urban marketing, diametrically opposed to what Scherson is doing: she speaks of those small, residual, everyday spaces, but curiously without falling into a pro-commercial gentrifying gaze' (2005). The focus

on everyday experience (de Certeau, 1984) saves *Play* from accusations of an attempt to create strategically beautified images of the city. The individual and her immediate environment is the film's concern. Scherson has mentioned Franz's (2001) book *La muralla enterrada* (*The Buried Wall*), which analyses the importance of the *barrio* (Greene, 2005). For Franz, Santiago is groups of territories governed by subcultures, a fragmented city divided by invisible, socially constructed walls. Franz raises the question of how these groups communicate with one another. Where Castells suggests that unequal distribution of wealth and the marginalisation of Mapuches are questions that still need to be addressed, it is through the focus on everyday experience that in *Play* the possibility of social cohesion is expressed visually.

Walking in the city

Filmed in flat expanses of colour, the aesthetics of this film lends it a stasis which contrasts with the movement of *flânerie*. Cristina speaks little, yet she walks endlessly, which may remind us that de Certeau describes walking as a 'pedestrian speech act' (1984). De Certeau explains that the pedestrian speech act has a 'triple "enunciative" function': 'an *appropriation* of the topographical system on the part of the pedestrian (just as the speaker appropriates and takes on the language)'; 'a spatial acting-out of the place (just as the speech act is an acoustic acting-out of language); and it implies "contracts" in the form of movements (just as verbal enunciation is an "allocution", "posits another opposite" the speaker and puts contracts between interlocutors into action. It thus seems possible to give a preliminary definition of walking as a space of enunciation' (1984: 98). In *Play* Cristina and Tristán walk across Santiago in criss-cross fashion, walking 'turns of phrase' and 'stylistic figures'. From mall to market, opera house to cemetery, they walk in a 'chorus of idle footsteps'. Thus, in a series of 'contracts in the form of movements', we find a performed linking between Las Condes and La Cisterna, Providencia and the Mercado Central, centre and periphery, affluent and deprived areas. Imilán Ojeda writes of the contradictory spaces of Santiago, a 'dual city' of rich and poor, where the urban structure is transformed into islands divided according to their function: residential, commercial, leisure, or education for a social group. He explains that 'social housing policies have promoted the segregation of the poorest communities'. Gated communities for the middle classes have intruded into poorer neighbourhoods, but these are 'fortresses isolated from their immediate surroundings' (2009: 22). But under the democratising gaze of the digital camera, a 'spatial acting-out of the place', Santiago blends its opposites. If Tristán is *à la dérive*, in a spree of new places and sensations, then Cristina, in his wake, wanders, wide-eyed, absorbing new experiences. Together they explore 'emotional contours of one's environment, playful and anti-authoritarian places and journeys' (Ruggeri, 2001: 54). When

she enters Irene's apartment, tries on her clothes and, perhaps particularly, sits naked on her toilet, Cristina creates a *détournement*, an unexpected configuration.[9] Cristina and Tristán 'enter the residual, interstitial, 'banal' spaces that are ignored by tourist narratives' (Ruggeri, 2001: 53) reshaping the city.

In his essay entitled 'Walking in the city', de Certeau contrasts the experience of walking in the city to the authoritarian, organising panoptic gaze (voyeur-god) of one who views the city from on high (1984: 91–3). We end *Play* with a high vantage point, as Cristina surveys the city. This scene draws together strands developed earlier. With her thick eyebrows and dark stare, Cristina can be described as being in possession of the 'power of the look'. Cristina places Tristán under surveillance in an attempt at control. This is an uneasy power relationship, however. Domestic workers are employed to observe (unobserved) their employers, while Cristina's surveillance of the other characters means that she is beholden to them. But we see a development from the somnambulistic, trance-like *flânerie* (her headphones look in silhouette like huge bug eyes) to the understanding gaze of the final scene. Cristina has experimented with a new identity: trying on Irene's clothes at her apartment, stealing a dress and applying her make-up to visit the cemetery where Milos is buried. We might draw parallels with Sebastián Silva's *La nana* (The Maid, 2009) where the protagonist, Raquel (Catalina Saavedra), a maid to a bourgeois Chilean family, goes to a shop to find the same top that her employer wears, using spending power to emulate the upper classes. But while that film draws out the 'spatial ambiguity' of the maid's position, it uses a hand-held camera, which serves either to lose the spectator in tense immediacy – Raquel's vengeful attempts to dispatch a series of maids brought in to help her – or else to spy on Raquel as she works or, intrusively, as she bathes. This scopophilic technique is not used on the mistress of the house, so that the camera is complicit in robbing the protagonist of her privacy, her right to space – we occupy the spectatorial role of the intrusive master/mistress. *La nana* resolves Raquel's frustrations by helping her to know her place – she finally identifies with a maid who jogs in the evenings and is satisfied with her lot. In *Play* Cristina realises that emulating the upper middle classes will not liberate her but she also rejects settling down in the country with Manuel. Piñera's pledge that his indigenous policy will help urban Mapuches into work, rather than returning contested lands means that Cristina's options lie in carving out new spaces for herself in the city. Through scatological references – Manuel's riff on 'caca' as an eccentric courtship, Cristina's desire to smell the city on the subjects under her gaze – the film draws out Cristina's desire to express locatedness in the city. Imilán Ojeda writes that 'first and second generation Mapuche currently living in the city build hybrid forms with the urban society at large more than they reproduce or reterritorialize their society of origin' (2009: 25). The panoramic image at the end of the film suggests a longed-for mastery of the city, not as a replication of an authoritarian dominance, but rather as

an attempt at an understanding of the social processes at work. Interviews with Scherson emphasise her training in biology. She has the *flâneur*'s eye for detail 'presenting a beguiling range of specimens for our inspection' (Young, 2009), able to focus on the minutiae of the confusions, ambiguities and, in some instances, the exhilarations of daily life. Yet in that final scene, we see Scherson's ability to bring out the big picture, allowing us space for reflection. In *Play*, Scherson has created an absorbing and yet contemplative gaze to draw out the spatial ambiguities facing a female Mapuche domestic worker in the contemporary era.

Abandoning her MP3, Cristina starts to whistle, a suggestion that she is starting to access her own resources of power. Has anything changed for Cristina? The film makes no promises. But, following de Certeau, what is more important for Cristina than the ability to view Santiago with the gaze of understanding is the ability to express the 'right to occupy space' (Lefebvre, 1991). In *Play*, this is to be found in the enunciatory acts of the everyday twists and turns of the lone walker in the street.

Notes

1 E-mail exchange with Alicia Scherson, July 2009. Translations mine.
2 According to the director of *Cine Hoyts*, Francisco Schlotterbeck, only *El chacotero*, *Sexo con amor* and *Machuca* have had box-office success. Carlos Hansen, head of Bazuca films says 'it's worrying that Chilean films aren't selling. Only those Chilean films that appeal in some way to the idea of the nation work. *Play* and *Se Arrienda* have therefore been too 'international' to be Chilean' Contardo (2006).
3 See Andrea Aravena Reyes, 'Shadows in the big city', *The Courier*, UNESCO, www.unesco.org/courier/2001_09/uk/doss11.htm. Accessed 02.01.10. Mapuches are not restricted geographically in the city, but are located in certain professions, such as, for example, bakeries (Imilán Ojeda, 2009).
4 Pino-Ojeda (2009) makes the same argument for Schweitzer and Solís's film *Paréntesis* (2005) and Gabriel Díaz's *La sagrada familia* (2005).
5 Santiago clearly has cinematic precedents, such as the palace of La Moneda in Guzmán's *La batalla de Chile* (1977), which records the military coup, or more recently *Taxi para tres* (Lübert, 2001), which takes us around Santiago's poorer districts, or *Machuca* (Wood, 2004), which depicts slums during the Pinochet regime.
6 Cf. Richard's analysis of the iceberg representing Chile at Expo '92, an exercise in the sanitisation of national symbols (2004b: 109–18).
7 For Sobchack, digital 'constitutes a system of *simulation*, a system that constitutes copies that seem lacking an original ground' (2004: 154).
8 It would be possible, for example, to construct a cartography of Santiago based on landmarks used for detention and torture or the subsequent reappropriation of space by protest movements.
9 Cf. Sebastián Silva's film *La nana* (2009) where the Chilean maid, Raquel, scrubs the (maids') bathroom after it has been used by the Peruvian maid – a recapitulation of racism's association with fears about hygiene.

References

Azalbert, N. 'Nouveaux espoirs chiliens' *Cahiers du cinéma*, September (2005), 60–2.

Benjamin, W. *Charles Baudelaire: A Lyric Poet in the Era of High Capitalism* (London: Verso 1973).

Bowlby, R. *Just Looking: Consumer Culture in Dreiser, Gissing and Zola* (London: Routledge, 1985).

Bruno, G. 'Motion and emotion: film and the urban fabric', in A. Webber and E. Wilson (eds), *Cities in Transition: The Moving Image and the Modern Metropolis* (London: Wallflower, 2008), pp. 14–39.

Carroll, J. 'The marginal on the inside: nannies and maids in Chilean cultural production (1982–2000)', in S. Nagy-Zekmi and F. Leiva (eds), *Democracy in Chile: The Legacy of September 11, 1973* (Brighton, Portland: Sussex Academic Press, 2005), pp. 163–77.

Castells, M. *Globalización, desarrollo y democracia: Chile en el contexto mundial* (Santiago, Chile: Fondo de cultura económica, 2005).

Cavallo, A. P. Douzet and C. Rodríguez *Huérfanos y perdidos: relectura del cine chileno de la transición, 1990–1999* (Santiago, Chile: Uqbar Editores, 2007).

Contardo, O. 'Taquilla en declive?: Cine chileno butacas a medio llenar', *El Mercurio*, 13 August 2006, http://diario.elmercurio.cl/detalle/index.asp?id={c41fc2c3-0e3b-49e5-869b-91f9f0d42a99. Accessed 05/01/10.

de Certeau, M. *The Practice of Everyday Life*, trans. S. Randall (Berkeley, CA: University of California Press, 1984).

Estévez Baeza, A. *Luz, cámara, transición: el rollo del cine chileno de 1993 al 2003* (Santiago, Chile: Ediciones Radio Universidad de Chile, 2005).

Fernández, A. (2005) 'Otra forma de llorar', www.laventura.cl/play/pdf/MABUSE%5B1%5D.playtribeca.pdf. Accessed 05.01.10.

Flores Delpino, C. 'Excéntricos y astutos', *Cinémas d'Amérique Latine: revue annuelle de l'Association Recontres Cinémas d'Amérique Latine de Toulouse*, 14 (2006), 70–80.

Franz, C. *La muralla enterrada: Ensayos sobre literatura urbana e identidad* (Santiago, Chile: Planeta, 2001).

Friedberg, A. *Window Shopping: Cinema and the Postmodern* (Berkeley and Los Angeles: University of California Press, 1993).

Gissi, N. 'Los mapuche en el Santiago del siglo XXI: desde la ciudad política a la demanda por el reconocimiento', (1 August 2004) www.cultura-urbana.cl, www.cultura-urbana.cl/archivo/los-mapuches-en-el-santiago-del-siglo-xxi-gissi.pdf. Accessed 01.01.10.

Greene, R. 'La ciudad y las alcachofas' 4(2005) *Bifurcaciones: revista de estudios cutlurales urbanos*, www.bifurcaciones.cl/004/Scherson.htm. Accessed 05.01.10.

Imilán Ojeda, W. A. 'Urban ethnicity in Santiago de Chile: mapuche migration and urban space' (2009), http://opus.kobv.de/tuberlin/volltexte/2009/2269/pdf/imilan_walter.pdf. Accessed 05.01.10.

Jara, J. A. 'Urban mapuches: reflections on a modern reality in Chile', *Abaya Yala News*, 10(3) (summer 1997) www.mapuche.Info/mapuint/anacn00.htm. Accessed 03.01.10.

Knipp, C. 'Play' (2005), www.keswickfilmfestival.org/media/KFFPlayFilmNotes.pdf. Accessed 05.01.10.

Lefebvre, H. *The Production of Space* (London, Wiley-Blackwell, 1991).

Longworth, K. 'Tribeca 2005: review' (2005), www.cinematical.com/2005/04/18/tribeca-2005-review-play. Accessed 05.01.10.

Marchessault, J. and S. Lord (eds). *Fluid Screens, Expanded Cinema* (Toronto: University of Toronto Press, 2007).

Mennel, B. *Cities and Cinema* (London: Routledge, 2008).

Park, Y. and P. Richards. 'Negotiating neoliberal multiculturalism: Mapuche workers in the Chilean state', *Social Forces*, 85(3) (March 2007), 1319–38.

Pino-Ojeda, W. 'Latent image: Chilean cinema and the abject', *Latin American Perspectives*, 168, 36(5) (September 2009), 133–46.

Reyes, A. A. 'Shadows in the big city', *The Courier*, 2001, UNESCO, www.unesco.org/courier/2001_09/uk/doss11.htm. Accessed 02.01.10.

Richard, N. *The Insubordination of Signs: Political Change, Cultural Transformation and Poetics of the Crisis*, trans. A. A. Nelson and S. R. Tandecíarz (Durham, NC and London: Duke University Press, 2004a).

—— 'Dismantlings of identity, perversions of codes', in N. Richard, *Cultural Residues: Chile in Transition* (Minneapolis, MN: University of Minnesota Press, 2004b), pp. 73–81.

Ruggeri, L. 'Abstract tours operator', in I. Borden and S. McCreery (eds), *New Babylonians* (London: Wiley, 2001), pp. 52–5.

Sobchack, V. *Carnal Thoughts: Embodiment and Moving Image Culture* (Berkeley: University of California Press, 2004).

Stillerman, J. 'Social dimensions of shopping in Santiago', *Consumers, Commodities and Consumption*, 6(2) (May 2005), http://csrn.camden.rutgers.edu/newsletters/6-2/stillerman.html. Accessed 05.01.10.

Tester, K. (ed.). *The flâneur* (London: Routledge, 1994).

Villaroel, M. *La voz de los cineastas: Cine e identidad chilena en el umbral del milenio* (Santiago: Cuarto Propio, 2005).

Wilde, A. 'Avenues of memory: Santiago's General Cemetery and Chile's recent political history', *A contra corriente*, 5(3) (spring 2008), 134–69, www.ncsu.edu/project/acontracorriente/spring_08/Wilde.pdf. Accessed 01.08.10.

Wilson, E. 'The invisible *flâneur*', *New Left Review*, 191 (Jan.–Feb. 1992), 90–110.

Wolff, J. 'The invisible *flâneuse*: women and the literature of modernity', *Theory, Culture & Society*, 2(3) (1985), 37–46.

Wright, S. '*Noli me tanger*: memory, emobidiment and affect in Silvio Caiozzi's *Fernando ha vuelto* (2005)', *Journal of Latin American Cultural Studies: Travesia*, 21(1) (2012), 37–48.

Young, N. 'Turistas', *Hollywood Reporter* (2009), www.hollywoodreporter.com/hr/film-reviews/film-review-turistas-1003938243.story. Accessed 01.05.10.

The politics of pathos in Pilar Miró's *Gary Cooper, que estás en los cielos* (1980)

Tom Whittaker

Pilar Miró's *Gary Cooper, que estás en los cielos* (*Gary Cooper Who Art in Heaven*, 1980) has long been regarded as one of the key films of Spain's transition to democracy. Unlike her previous films, the period drama *La petición* (*The Request*, 1976) and the *tremendista* polemical drama *El crimen de Cuenca* (*The Cuenca Crilme*, 1980), *Gary Cooper* is firmly grounded in the contemporary social reality of Spanish women in the work-place during the transition to democracy. Its narrative centres on Andrea (played by Mercedes Sampietro), an ambitious television director who dis-covers she has a life-threatening tumour. It has long been considered Miró's most personal film: like Andrea, the director worked as a television director for Televisión Española and the genesis for the screenplay was inspired by a heart attack that she suffered in 1975. Although Miró's film has received a great deal of critical attention, this chapter looks at a crucial aspect of the film that has been largely overlooked: its complex and contradictory engagement with pathos. While Rikki Morgan and others have suggested that Andrea's 'lone quest' echoes that of Gary Cooper (1999: 179), the star most readily associated with the western, Kathleen Vernon has more recently considered the film as a 'chilling update of the medical discourse film', a subgenre among Hollywood women's films of the 1940s (2002: 108–9). Indeed, in its use of a heavily invested soundtrack, close structure of identification and, most crucially, emphasis on the failure of the female body, the film has much more in common with the woman's film of classical Hollywood than at first meets the eye. Mary Ann Doane has more recently pointed out that 'the etymological affinity of pathos and pathology indicates a semiotic slippage among intense affect, suffering and disease' (2004: 14). The intersection of pathos and pathology is central to *Gary Cooper*: in its unflinching representation of bodily pain and illness, the film seeks to appeal to our emotions.

As I will show, the affective structure of Miró's film is a particularly revealing framework for exploring the ways in which female citizenship and identity were renegotiated during the transition. Although the Spanish Constitution recognised women as 'equal' citizens, women were still not

socially and culturally recognised as such at the time of the film. The melo-
dramatic mode in *Gary Cooper*, which typically draws its source material
from social conflicts and inconsistencies, serves to work through these con-
tradictions. As such, Miró's recourse to pathos has an important political
dimension, in that it articulates the ambivalent location of female identity
during the transition. This chapter will explore the ways in which pathos
can be read as a political strategy in the film, paying particular attention
to its relationship with the body, silence, music and the crucial role of the
stardom of Gary Cooper.

Although *Gary Cooper* was generally well received on its release, certain
male critics were uncomfortable with the perceived sentimentality of the
film. Francisco Marinero, the film critic of *Diario 16*, wrote that in its rather
mawkish handling of Andrea's illness '*Gary Cooper* no es una tragedia, sino
una reducción a un drama sentimental de costumbres' ['*Gary Cooper* is not
so much a tragedy, as it is a sentimental drama of local customs'] (1980).
Moreover, Peter Besas, writing for *Variety*, referred to the film as a 'lach-
rymose' and 'self-centred study of a career woman's coming to grips with
what she considered to be an unsuccessful life', complaining that it brushes
'uncomfortably close to the maudlin' (1981: 20). This is similarly observed
by Vidal Estévez of *Contracampo*, who attributes this apparent shortcom-
ing to the fact that it does not provide a sufficient distance between the
viewer and the protagonist. In setting up an intimate level of identification
with Andrea, therefore, the film cuts against the serious and contemporary
subject matter of the film, thereby foreclosing a more measured and serious
examination of 'la condición humana frente a la muerte' (1980: 56) ('the
human condition facing death'). Thus, he writes that although Miró is
clearly an accomplished and respected auteur, she 'hubiese preferido un
sentido más crítico y menos llorón en lo que respeta a su personaje' (1980:
56) ('would have preferred a more critical and less maudlin approach to
her character'). Awkwardly poised between failed tragedy and unconvinc-
ing realism, the film – according to these critics – fails in what it sets out to
achieve.

If the critics were pejorative about the pathetic elements of Miró's film,
this is because melodrama is frequently conceived in pejorative terms.
Although the term 'melodrama' is notoriously fluid and elastic, it is fre-
quently synonymous with the label 'the woman's film' – a term which
encompasses a number of classical Hollywood films such as *Stella Dallas*
(dir. King Vidor, 1937), *Now, Voyager* (dir. Irving Rapper 1942), *All That
Heaven Allows* (dir. Douglas Sirk, 1955) which centred exclusively on
women's experiences and were designed for female audiences.[1] Otherwise
known as 'weepies', these films hinged upon stories of family conflict,
maternal sacrifice and bodily illness, which were largely played out within
the domestic sphere of the bourgeois home. The films generally establish an
over-identification with the female protagonist, so that the audience engages

with her emotional world and sympathises with her plight. Because of their subsequent emphasis on affectivity and pathos, the films have been dismissed as trashy and trivial; they have been viewed as products of emotional manipulation that align spectators as passive consumers. Their 'low' cultural status is symptomatic of a greater tradition in which the pull towards emotion and affect has been discredited as 'feminine'. In his influential essay 'Mass Culture as Woman: Modernism's Other' Andreas Huyssen has written, 'it is indeed striking to observe how the political, psychological, and aesthetic discourse around the turn of the century consistently and obsessively genders mass culture and the masses as feminine, while high culture, whether traditional or modern, clearly remains the privileged realm of male activities' (1987: 191). Excluded from the realm of high culture, women instead have been inscribed within one that has been marked as inferior, artificial and therefore less 'authentic'.

A very similar discourse arguably rears its head in the reviews cited above. According to the critics, the failure of the film appears to be ascribed to its 'feminisation' – a dynamic which according to Vidal Estevez (who appears to know best what Miró herself would have preferred) hinders the potential for a more 'authentic' exploration of female subjectivity. Yet, within its contemporary national context of the transition to democracy, an anxiety towards excess and artificiality is perhaps understandable: melodrama, after all, was one of the dominant registers of Francoist filmmaking, particularly during the years of Spain's autarchy, when cinema was used as tool for naturalising the values of National Catholicism.[2] Jo Labanyi has recently argued that Spanish melodramatic genres offered resistant reading positions for women. For instance, popular stars such as Aurora Bautista and Lola Flores, who appeared in domestic genres such as the folkloric musical and the missionary film, offered their audiences possibilities of identification that worked against the dominant ideology that the films transmitted (2000: 166–7). However, with perhaps the notable exception of *De mujer a mujer* (*From Woman to Woman*, dir. Luis Lucia, 1950), there have been relatively very few Spanish 'women's films' in the mould of Hollywood.

Miró's film, in both its subject matter and form, owes a far clearer debt to the melodramas of Hollywood than it does to its Spanish counterparts. Indeed, on the release of *Gary Cooper*, the director commented that the film she would most like to have directed was *Gone with the Wind* (dir. Victor Fleming, 1939) and that the form that most interested her was classical narrative cinema (Anon., 1980: 5). As Martin-Márquez has pointed out, the director's favourite films as a child were Hollywood films such as *Bambi* and *Little Women* (1999: 146) – a preference which reflects the fact that, in spite of the anti-American discourse of the Spanish authorities of the time, Hollywood films dominated Spanish screens in the 1940s and 1950s (Bosch and Rincón, 1998). Yet the strongest evidence of the film's homage to Hollywood can be found in its idiosyncratic title. *Gary Cooper, que estás en*

los cielos refers not only to one of classical Hollywood's greatest stars, but alludes to the magical and mythical appeal of the Hollywood star system, where stars were elevated to a quasi-religious status.

As a key film of the transition to democracy, *Gary Cooper* was made when the relationship between Spanish women and the state was in the process of renegotiation. While, under Franco, women were culturally restricted to the private roles of nurturing mothers and doting wives, the transition signalled a decisive shift towards a legal framework based upon equality. The democratic model for citizenship within the 'new Spain', for instance, was set out in the Constitution of 1978, just two years before the release of *Gary Cooper*. Article 14 of the Constitution forbade discrimination on the basis of gender; article 32 recognised equal rights for men and women in the institution of marriage, and article 35 enshrined in law the right for both sexes to work.[3] However, the historian Pamela Beth Radcliff has observed that the emerging model of female citizenship during the transition was fraught with tensions and contradictions and therefore largely problematic. Radcliff explains that whereas the boundaries between the public and private spheres were becoming increasingly less important in post-war democratic societies, they carried a particular degree of political symbolism in Spain during the transition (2002: 505). Whereas the private sphere of the home and the family was symbolically identified with the dictatorship, the 'recovery of the "public" and the freedom to participate in it were linked to democracy' (Radcliff, 2002: 506). However, Radcliff goes on to argue that the relationship between women, the domestic sphere and the Francoist nation was so deeply ingrained in the Spanish consciousness that it remained largely unquestioned. As such, women's access to politics and citizenship, and thus the public sphere, continued to come via the family. For instance, she shows how even in the pro-democratic *El País*, the newspaper which is most readily associated with the transition, women rarely figured in the 'political' news, unless they happened to accompany male political figures as their spouses. Subsequently, there was no conceptual framework which made sense of feminism. Radcliff writes that feminists 'were women outside the family metaphor and the private sphere, but they were not perceived as truly 'public' because of their pursuit of 'selfish' interests at a moment when Spaniards were building a historic consensus' (2002: 509). The emerging model of female citizenship during the transition was therefore at odds with the cultural and social definitions of female identity that pervaded society at the time. Precariously poised between the public sphere and the private, the democratic and traditional, difference and assimilation, the formation of female identity was a site of contradiction. Located within this context, therefore, it is not surprising that Miró's film is indebted to melodrama, the genre most explicitly and ambivalently associated with domesticity.

Perhaps the most evident way in which the film engages with melodrama is through the representation of Andrea's body. In a well-known scene,

after recently discovering that she is pregnant, Andrea undergoes a routine medical examination, where she discovers that her pregnancy has been complicated by a potentially cancerous tumour in her uterus. She is told that her survival urgently depends on a life-threatening operation. As Vernon has perceptively observed, '*Gary Cooper* portrays Andrea's illness as a kind of divine judgment – a literal "corporal" punishment – against her challenge of traditional female behaviour and roles, one that takes the form of a return of the repressed body' (2002: 109). But the return of the repressed also plays itself out within the text, where Andrea's heightened emotion is displaced onto the formal structure of the film itself. For instance, the image track of Andrea's examination is accompanied by the dialogue of the following scene, where the doctor is announcing his diagnosis *after* the ultrasound. The highly unusual mismatch between image and sound sits in contrast with much of the film, which is generally unobtrusive in its film language. As Geoffrey Nowell-Smith has famously written, just as the repressed thoughts of the hysteric 'return' in the displaced form of a bodily symptom, so the moments of emotional excess are 'siphoned off' onto the body of the text (1987: 73). As a result, these hysterical moments can lead to the breakdown of realism and narrative coherence. Vulnerable and silent, Andrea's unspoken anxiety is similarly displaced onto the contours of the film, where the incoherent mismatch between image and sound becomes a substitute for Andrea's excess of emotion. As the moment of hysterical conversion in the film is quite literally linked to the failure of Andrea's reproductive body, the relationship between body and text is strikingly reified, where they both point to their own materiality.

In the words of Simone de Beauvoir, Andrea's body is therefore 'weighed down by everything peculiar to it' (1957: 146). Locating the film more closely within its social and historical context, the corporeality of her body would also appear to carry a good deal of ideological weight. As is well known, under Franco women were defined by the 'natural' role of their procreative bodies; above all else, they were nurturing and healing mothers, whose primary function was to reproduce. Their identity was therefore inescapably tied to what Foucault has famously termed their 'docile bodies', loci of internalised regulation, discipline and control (1995). Given the centrality of the family and the private sphere to Francoist ideology, child-bearing women not only served their families, but contributed towards the shaping of the Spanish state and nation. Their reproductive bodies therefore also served to reproduce not only children, but the ideology of the nation. Andrea's womb, a generative and nurturing space, has been invaded by a 'mole', an unarticulated growth that both debilitates and deforms. Denied her reproductive capacities, Andrea's abject body can be read as a symbolic corruption of the Francoist construction of womanhood. The celebrated role of the nurturing mother is held up as one that has become deformed and dangerous. However, at the same time, as Martin-Márquez has argued, her defective pregnancy would also appear to symbolise her difficulties with authorial

creativity and control (1999: 170). Her operation, for instance, prevents her from committing herself to future plans, such as the opportunity to direct her first feature length film, an adaptation of Emilia Pardo Bazán's novel *Los pazos de Ulloa*. Foreclosed from both the domestic sphere of motherhood *and* the public sphere of work, Andrea's body eloquently articulates the contradictions and anxieties that surrounded the new configuration of democratic female citizenship. It presents itself as both an agent and a symptom of the wider struggle for female self-definition during the transition. In the very final scene, we see the hospital staff preparing Andrea for her operation. As she slowly slips out of consciousness, we are left with the final close-up shot of the doctor tightly holding onto Andrea's hand; after a few seconds, this is captured in a freeze-frame and the end credits begin to run. Stranded between life and death and between the past and the future, the domestic and the public, Andrea's body is emphasised as both a liminal and a transgressive space, where new constructions of female identity are negotiated but ultimately left unresolved. This is arguably why her transitional identity resonates so vividly with the melodramatic mode. Melodramas, after all, present and explore social conflicts without fully resolving them, which is why the ruptures in realistic representation are so significant. As a melodrama, *Gary Cooper* is unable to truly accommodate Andrea's embodied subjectivity, just as democratic Spain, in spite of its constitutional changes, cannot yet accommodate a fully liberated female identity.

Andrea's agency is not only thrown into question through her body, but through her inability to communicate effectively with those closest to her. She is unable to disclose the truth about her illness to either Mario, her boyfriend, or her mother; instead, she verbalises her anxieties obliquely, either through misleading Mario into believing that she is having an abortion, or through cryptically hypothetical questions ('Mamá, ¿qué dirías tú si supieras que te ibas a morir mañana?' ('Mum, what would you say if you knew you were going to die tomorrow?'). In an argument, Mario tells Andrea that he can no longer endure her 'reticencias' (reticence) and that 'hace mucho que el diálogo no nos sirve de absolutamente nada' ('dialogue has been useless for a long time'). The problem of articulation is often a central component of the melodramatic mode. Indeed, the female protagonists of melodramas are frequently unable to fully access language; their trauma or emotional burden far exceeds the capacity of words. Silence, then, is a prevalent feature of melodrama, as it simultaneously conveys and conceals the ineffable 'truth' of the female protagonist. According to Gledhill, the 'central drive of melodrama is to force meaning and identity from the inadequacies of language' (1987: 33). This need to extract meaning from what is left unsaid, or to represent the unrepresentable, bears particular relevance to women during the transition. According to Radcliff, the tensions among women during this period were created by the 'disjuncture between new rights and modes of participation and a *discourse that had trouble assigning meaning to them*' (2002: 502, my italic). In other words, although recog-

nised as 'equal' citizens, women were not socially and culturally recognised as such; Spanish discourse still failed to provide an adequate expression for a new construction of female identity.

Andrea's silent moments are most often accompanied by non-diegetic music. Indeed, one of the most striking elements of *Gary Cooper* is its over-wrought score, composed by Anton Garcia Abril. In its first theme, which opens the film, the melody is led by a plaintive oboe in a minor key; in the second, more dramatic theme, which is first heard moments after Andrea's diagnosis, rhapsodic chords are struck on the piano, accompanied by strings which underpin the harmony and augment the tension. The overall effect is one of melancholy and pathos – an effect so overstated that, at times, it risks slipping into bathos. Nevertheless, the crucial thing to note here is that the affective structure of the music, although on a more thinly textured, pared-down scale, recalls the sweeping, late-Romantic inspired scores of the classical woman's film – scores of epic feeling that were designed to appeal to the emotions and to align the viewers sympathetically with the protagonist. But while in subordinating itself to the demands of image and narrative, the classical score was largely designed to be self-effacing, thereby subordinating itself to the demands of the image and narrative, the music in *Gary Cooper* frequently draws attention to itself, often running ironically counter to the largely unsympathetic portrayal of Andrea's character in the film. Its presence is most conspicuously felt when Andrea is at her most inarticulate, swelling up as a substitute for the words that elude her. If for Andrea, self-expression is as inadequate as it is artificial, music is central to revealing her emotional 'authenticity'. Non-diegetic music, therefore, not only emerges as a surrogate voice, but alerts us to the importance of diegetic silence.

Andrea's favourite composer is Jules Massenet, and she plays two arias from his opera *Werther* the night before the operation. Heather Laing has explored the relationship between music, gender and emotion in both opera and melodrama, and demonstrates the strikingly similar ways in which female subjectivity is constructed in both forms. She shows how in opera, much like in cinematic melodrama, the musical–dramatic narrative is able to 'present "private" moments of female musical–emotional self-expression that would normally be considered inappropriate for public display' (2007: 15). She explains that 'while the musical–emotional voice may be powerful' in both forms, 'it nevertheless exists in a space conventionally marked by a sense of power*less*ness in the "real" terms of the diegetic world' (2007: 20). That the opera was written by Jules Massenet, a famous proponent of late Romanticism, bears particular relevance here. As is well known, Romanticism was most explicitly associated with the exploration of 'authentic' feeling and inner subjectivity, and its anachronistic use in classical Hollywood, according to Caryl Flinn, 'displays an almost obsessive concern with establishing some kind of human agency' (cited in Laing, 2007: 21). As we have seen, it is precisely Andrea's agency – both authorial and bodily – that the melodramatic mode throws in to doubt in the film. The

diegetic music of the arias, the echoes of which reverberate around the hard surfaces of Andrea's spacious apartment, thus provides a critical reflection on the strategic use of the non-diegetic score: both serve to restore fullness where there is absence and to recuperate female agency which is foreclosed elsewhere in both text and body.

Several studies on melodrama have examined the importance of the affective role of melodrama and its relationship with the body. Linda Williams, for instance, has written about how melodrama can be understood primarily as a 'body genre', as it triggers a bodily reaction (i.e. crying) in the audience (2003). While the use of music in *Gary Cooper* not only contributes towards pathos, it also forcefully establishes a correspondence with the body in a more direct and sustained way. The intersection of pathos and pathology finds itself in the body of Andrea, where as we have seen, 'excess' is inextricably linked with disease and pain. The emotion generated in the film, therefore, is quite literally foregrounded as an *embodied* emotion. This is most eloquently expressed in the film's final sequence, where Andrea, lying silently on a trolley, is wheeled through the dimly illuminated hospital corridors to the operating theatre. The two motifs heard previously during the film now weave together into one urgent, final crescendo, while close-up shots of her face alternate with various shots of the ceiling and hospital walls filmed from her point of view. Although the narration has been firmly focalised through Andrea from the outset, the camera shots and editing here establish a particularly explicit 'over-identification' with the protagonist, where we are compelled to experience the emotion and affect that Andrea experiences. In particular, the movement of the camera, which denotes a close spatial attachment to Andrea, vividly brings into play the relationship between vision and the body. The use of music here, therefore, provides a vivid illustration of how emotion can be understood and experienced primarily as an embodied affect.

The film's over-identification with its protagonist is mirrored by Andrea's own relationship with Gary Cooper. After her mother leaves hurriedly to go to a classical concert, Andrea stays behind to find a suitcase of her old belongings from when she was younger. Rummaging through the case, Andrea finds a letter from her childhood sweetheart, Bernardo, as well as a photograph of Gary Cooper, dressed in cowboy garb, still handsome in his distinguished late middle age. The photograph of the actor becomes Andrea's sole comfort in the film: when Andrea finds herself alone and at her lowest ebb, she touches and gazes tenderly at the photograph. Captured through a series of extreme close-ups, Sampietro's facial expressions denote warmth and comfort – emotions that rarely shine through her tough exterior during the film. That Gary Cooper should be a source of identification for Andrea is important on several levels. The discourse of 'authenticity' has long been integral to the star persona of Gary Cooper. Andre de Toth, who directed the Cooper star vehicle *Springfield Rifle* (1952), once recalled that the actor never needed to perform, as 'Coop was as real as his pants

... Whatever he did, Gary Cooper was the truth' (Anon., 2005: 50). This was partly achieved through his trademark minimalist performance style: through his brooding silences and monosyllabic delivery of dialogue, his star persona would appear to resonate with Andrea's own reticent character. If Andrea seeks authenticity in Gary Cooper, this is because her own real-life relationships are shrouded in secrets and artifice. It transpires, for instance, that her current boyfriend Mario (played somewhat incongruously by Jon Finch, a classically trained English actor, who spoke poor Spanish) is having an affair with his colleague María (Alicia Hermida). As Miró was unable to synchronise Finch's dialogue successfully with the Spanish dubbing artist, his voice is very loosely dubbed – a shortcoming of the film which, although unintentional, chimes ironically with his role as an insincere and distant lover.[4] Her mother similarly would appear to hide her feelings from her daughter: while her heavily laden make-up suggests both a veneer of bourgeois composure and vanity, it also serves as a public mask that conceals her private world of emotion. Moreover, as Rikky Morgan has observed, the location of the film within the space of the television studio, where Andrea is directing an adaptation of Jean-Paul Sartre's *Huis clos* (*No Exit*), provides a 'particularly apposite context for [the film's] concern with authenticity, given the essential blurring of the boundaries between reality, representation, and artifice inscribed within these particular forms of cultural production' (1999: 184).

Significantly, Gary Cooper can also be seen as occupying a melodramatic role within the film. Central to both the systems of stardom and melodrama is the importance of the 'person'. Christine Gledhill shows how, in a post-sacred and individualistic world, the remaining source of moral value resides in the human personality itself. Just as melodrama imbues the actions of characters with ethical consequences, so the star system invests its stars with clear moral identities. According to Gledhill, 'melodramatic characterisation is performed through a process of personification whereby actors – and fictional characters conceived as actors in their diegetic world – *embody* ethical forces' (1991: 210). As a personification of the dependable, populist all-American male – a role most famously cemented in *Meet John Doe* (dir. Frank Capra, 1941) and *High Noon* (dir. Fred Zinneman, 1952) – Cooper constitutes the sole positive moral force within Andrea's world. Indeed, as the title of the film would suggest, Andrea elevates the actor to a quasi-religious status. The night before the operation, Andrea utters the words of the paternoster while touching his photograph: 'Gary Cooper, que estás en los cielos, líbrame de todo el mal' (Gary Cooper, who art in heaven, deliver me from evil'). In striking contrast, Miró rejects the more traditional mediation of religious guidance when, just before undergoing surgery, she brusquely sends away the hospital chaplain who has come to pray for her. In the construction of both the genre of melodrama and stars, these ethical forces manifest themselves in 'outwardness'. Just as characters in melodrama articulate emotions primarily through the physical (through

gesture rather than dialogue), stars similarly reach their audiences through their bodies. As a result, writes Gledhill, 'photography, and especially the close-up, offers audiences a gaze at the bodies of stars closer and more sustained than the majority of real-life encounters' (1991: 210). In the three scenes in which this occurs, the shots of Andrea's face and the photograph are alternated in a shot–reverse-shot sequence, the central building block of the classical Hollywood style of continuity editing. The editing serves to highlight her closeness and attachment to the star – a closeness which, as we have seen, she lacks in her real life. Part mythical and part real, the figure of Gary Cooper is therefore a structuring absence in the film. As a moral and ethical force of authenticity, his fantastical presence throws into Manichean relief the artifice of the 'real' relationships that surround her in the film.

Miró's engagement with pathos, therefore, does not so much detract from the authenticity of Andrea's emotional and social world as expose it. Melodrama, as we have seen, explores what is hidden or 'beneath'. Through its play between surface and depth, the represented and unrepresentable, and the spoken and the unspoken, it seeks to reveal the limitations of conventional representation. And these limitations, as we have seen, point to the wider cultural and political limitations that are at play within society. The melodramatic use of pathos in *Gary Cooper, que estás en los cielos* contributes towards our understanding of the process of female identity formation during the transition – an identity which, as I have shown, is as fraught and contradictory as the generic legacy of melodrama itself.

Notes

1 There have been recent attempts to redefine the perimeters of melodrama. Linda Williams (1998), for instance, argues that melodrama should be seen as a mode rather than a genre. This is because she considers it to be *the* foundation of the classical Hollywood filmmaking, and can therefore be found across a whole number of different genres.
2 According to Kinder, Spanish melodrama differed from that of its Hollywood counterpart. Whereas Hollywood suppresses the political by focusing exclusively on the domestic, 'fascist melodrama politicises and acknowledges the connection between domestic and public spheres' (1993: 72).
3 Abortion was not made constitutionally legal until 1985.
4 Miró also dubbed the voice of the actor José Manuel Cervino, who plays Bernardo (Pérez Millán, 2007: 138).

References

Anon. 'Me crezco con las dificultades', *El País*, 19 October 1980, p. 5.
Anon. 'Gary Cooper', *Premiere*, 18(7), (April 2005) p. 50.

Besas, P. 'Gary Cooper, que estás en los cielos', Variety, 4 February 1981, p. 20.

Bosch, A. and M. Fernanda del Rincón 'Franco and Hollywood, 1939–56', New Left Review, 232 (Nov.–Dec. 1998).

de Beauvoir, S. The Second Sex (New York: Alfred A Knopf, 1957).

Doane, M. A. 'Pathos and pathology: the cinema of Todd Haynes, Camera Obscura, 57, 19(3) (2004), 1–21.

Foucault, M. Discipline and Punish (New York: Vintage Books, 1995).

Gledhill, C. 'The melodramatic field: an investigation', in C. Gledhill (ed.), Home Is Where the Heart Is (London: BFI Publishing, 1987), pp. 5–42.

——'Signs of melodrama', in C. Gledhill (ed.), Stardom: An Industry of Desire (London: Routledge, 1991), pp. 207–32.

Huyssen, A. 'Mass culture as woman: modernism's Other', in T. Modleski (ed.), Studies in Entertainment: Critical Approaches to Mass Culture (Bloomington: Indiana Press, 1987).

Kinder, M. Blood Cinema: The Reconstruction of National Identity in Spain (Berkeley and Los Angeles: University of California Press, 1993).

Labanyi, J. 'Feminizing the nation: women, subordination and subversion in post-Civil-War Spanish cinema', in U. Sieglohr (ed.), Heroines without Heroes: Reconstructing Female and National Identities in European Cinema 1945–1951 (London: Continuum, 2000).

Laing, H. The Gendered Score: Music in 1940s Melodrama and the Woman's Film (Aldershot: Ashgate, 2007).

Marinero, F. 'Gary Cooper, que estás en los cielos', Diario, 16, 26 November 1980, n.p.

Martin-Márquez, S. Feminist Discourse and Spanish Cinema: Sight Unseen (Oxford and New York: Oxford University Press, 1999).

Morgan, R. 'Female subjectivity in Gary Cooper que estás en los cielos' in P. Evans (ed.), Spanish Cinema: the Auteurist Tradition (Oxford and New York: Oxford University Press, 1999).

Nowell-Smith, G. (1987), 'Minnelli and melodrama', in Gledhill, Home Is Where the Heart Is, pp. 70–2.

Pérez Millán, J. A. Pilar Miró: directora de cine (Madrid: Calamar Ediciones, 2007).

Radcliff, P. B. 'Imagining female citizenship in the "New Spain": gendering the democratic transition, 1975–1978', Gender and History, 13(3) (2002), 498–523.

Vernon, K. M. 'Screening room: Spanish women filmmakers view the transition', in O. Ferran and K. M. Glenn (eds), Women's Narrative and Film in Twentieth-Century Spain: A World of Difference(s) (New York: Routledge, 2002), pp. 95–113.

Vidal Estevez, M. 'Gary Cooper, que estás en los cielos', Contracampo, 3(19) (1980) pp. 56–7.

Williams, L. 'Melodrama revisited', in N. Browne (ed.), Refiguring American Film Genres: History and Theory (Berkeley and Los Angeles: University of California Press, 1998).

——'Film bodies: gender, genre and excess', in B. K. Grant (ed.), The Film Genre Reader (Austin, TX: University of Texas Press, 2003).

Icíar Bollaín's 'Cartes de Tendre': mapping female subjectivity for the turn of the millennium*

Jo Evans

Since the turn of the millennium, studies of European film have paid increasing attention to interdisciplinary theories of space and mobility (Konstantarakos, 2000; Everett and Goodbody, 2005; Mazierska and Rascaroli, 2006; Fish, 2007). The sense that 'places are no longer the clear supports of our identity' (Morley and Robins, 1995: 87) has influenced this attention to the ideological mapping of moving bodies, and it is an attention that has, in turn, been influenced by the way that the moving image came to dominate the twentieth century. Film is a particularly attractive case study, both for the mobile and mobilising effects of *mise-en-scène* and for the fact that it shares with maps the power to fix 'in place conflicting ideas about the constitution of social space' (Konstantarakos, 2000: 1). Bruno's (2002) contribution to theories of subjectivity, space and mobility gives precedence to gender. In it, she uses a fictional map from the seventeenth-century novel, *Clélie*, as a metonym to illustrate the reciprocal link that exists between visual representation, social space and affect. Her discussion and the reproduction of this map in her account draw attention to the fact that subjectivity is a dynamic product of the relationship between the individual and the environment: the 'Carte du Pays de Tendre', which might be translated loosely as a 'map of the lands of affections or love' is a haptic map on which the landmarks are named after human emotions. Its aim is to provide an intimate, microcosmic guide to the novel's wider emotional and diegetic trajectory (Bruno, 2002: 2–3). For Bruno, the *Carte de Tendre*, takes on the role of a metonymical guide to her own macroscopic tour de force of creative and critical 'site-seeing'. And its function for the twenty-first century is to remind us that visual culture does not simply provide new 'sights', but new 'sites' for subjectivity: new spaces for emotional, bodily and intellectual engagement (2002: 15–16).

Icíar Bollaín belongs to a generation of Spanish filmmakers who released their first films in the 1990s. Influenced by increased familiarity with the moving image, they were 'más viajada' (better travelled); less influenced by literature; more familiar with English, and more likely to be influenced by

*I am grateful to the British Academy for funding research towards this chapter.

what they had seen than what they had read (Bollaín, in Heredero, 1997: 222). Their films respond to turn-of-the-millennium changes that date back to the oil crisis in the early 1970s and the death of Franco in 1975. These were decades of radical change: formerly a dictatorship of 'emigrants', Spain became a democracy of 'return' and, from the 1980s, a country of 'migrants'.[1] Bollaín brings to this historical context the desire to produce 'recognisable' female protagonists, an admiration for the cult director, Luis Berlanga, and the experience of working with Ken Loach.[2] She has also worked with well-known Spanish directors including Víctor Erice, Gutiérrez Aragón, Luis Borau and Felipe Vega, although her self-confessed ambition to make films like Berlanga and Fernán-Gómez highlights her attraction to humorous, poignant, socially committed comedies that are, as she describes it, 'más realista o más en contacto con lo que pasa en esta sociedad' (Heredero, 1997: 221–2)[3] ('more realistic, more in touch with what is really going on in society').

This chapter takes Bruno's theoretical metonym as a starting point from which to examine Bollaín's deceptively transparent film narratives. Like de Scudéry's (Bruno, 2002: 217–19), her work is highly collaborative.[4] And like de Scudéry's map, early and enthusiastic responses to Bollaín's first two films make repeated reference to their diegetic 'transparency', to their documentary quality, and to their 'desnudez estética, su deliberada sencillez formal' (Heredero, 1999: 76, 78, 84) ('stripped aesthetic and deliberate formal simplicity'). Like the fictional 'Carte du Pays de Tendre', Bollaín's *mises-en-scène* map her characters' movement through contemporary Spain with narratives that give precedence to geographical and emotional journeys: *Hola ¿estás sola?* (*Hi, Do You Come Here Often?*, 1995) follows two young women's attempt to find work on the south coast and in Madrid; *Flores de otro mundo* (*Flowers from Another World*, 1999) explores female migration; *Te doy mis ojos* (*Take My Eyes*, 2003), domestic abuse, and *Mataharis* (2007), three private investigators working in Madrid. The titles of these films play an integral part in this 'mapping', or rather, this remapping of women: each of them is associated with a gendered cliché that is subverted by Bollaín's co-scripted, open-ended narratives: the cheesy chat-up line in *Hola*; the exotic female other in *Flores*; the eyes as the window to the soul in *Te doy*, and the female spy in *Mataharis*.[5]

Bollaín's treatment of the title of the first of these films, *Hola ¿estás sola?*, is indicative of her approach to the subversion of gendered clichés. As a chat-up line, the closest English equivalent would be 'Do you come here often?', but the Spanish translates more literally as 'Hi, are you alone?'. Niña uses the line about half-way through the film on the short, balding, older man she finds sitting in a Madrid bar, and his disarmingly literal response, 'un poquito' (a little) highlights the irony of their encounter.[6] It is ironic, not only because a younger woman is using the line on an older man, rather than vice versa, but because Niña is sizing him up as a potential partner, not for herself, but for her attractive, 20-year-old friend, Trini.[7] Trini has sent

her out to find a man because they want to throw a party, but they know only two other people in Madrid: Niña's mother and the Russian labourer Trini has nicknamed 'Olaf'. Until recently, the two friends were sharing Olaf, but he and Niña have fallen in love, leaving Trini with no partner. The purpose of the party is to cement their friendship after a monumental row: a row that was not provoked by this unconventional joint sexual liaison with Olaf, but by Trini's decision to move in with Niña's mother. The comical incongruity of their situation, two friends fighting over the mother rather than the man, and the re-contextualisation of the traditionally male chat-up line is typical of Bollaín's approach to remapping gender and to representing the complexities of contemporary relationships.[8]

In addition to the ironic approach to gendered clichés that she adopts in her screenplays, Bollaín has published two intelligent, witty essays on the 'ghettoisation' of women directors as producers of 'women's films' (1998, 2001). In one, she notes that despite the critical success of *Hola*, the fact that her reference point was *The Snapper* (dir. Frears, 1993), the homages made in it to Berlanga and Loach, and that she collaborated with Julio Medem on the script, her female protagonists meant that the film was labelled 'cine de mujer', and that she was, therefore, a 'directora' rather than a 'cineasta' (1998: 80, 84). In general, however, Bollaín says she reserves her version of feminist engagement to the effect produced on her audience by the interaction of her characters on-screen (Camí-Vela, 2005: 62). Her taste in directors is wide-ranging and anti-Godardian (Heredero, 1997: 219). She is interested in directors 'que van a dejar historia con el cine' (Camí-Vela, 2005: 53–4) ('who use film to record history'). Her own films are aimed at a non-art house audience and her strength lies in her experience as a success-ful actress, writer, script-writer, assistant director, director and producer.[9] This extensive experience on both sides of the camera has left her finely attuned to the affective spaces of the apparatus, to the gap on both sides of the camera, and to the gap between viewer and screen. If the 'haptic' is not just about touch, but 'the ability to come into contact with' (Bruno, 2002: 6), then this is an ability that marks Bollaín's work profoundly. Camí-Vela has described her cinematography as a form of 'negotiated gaze' (2000); Santaolalla notes the blurring of the subjective and the objective (2005: 199), and Martin-Márquez highlights the representation of contemporary global concerns with 'home ... displacement and ... cultural difference' (2002: 257). Bollaín's interest in a rounded point of view and the repre-sentation of global issues has produced films that are socially committed, but that are also intended to entertain and move. She credits directors such as Almodóvar, Saura and Camus with producing historical documents of Spanish society, and her own approach to filmmaking is based on the under-standing that 'el cine tiene un fin social, aunque no es el único. También tiene una función de entretener y ... de emocionar' (Camí-Vela, 2005: 53–4) ('Film has a social role, but that's not its only function. It also has the capac-ity to entertain and move us'). And it is this gift for social documentation,

entertainment, collaborative transparency and the engaging of affect that suggests de Scudéry's haptic map as a metonym for the way that Bollaín's first three films 're-map' turn-of-the-millennium female subjectivity.

Hola, ¿estás sola? (1995)

The fortune-seeking protagonists of this film are influenced by the social effects of unemployment and the post-nuclear family. The film opens with a rapidly edited four-minute, pre-credit sequence cross-cutting between the bedroom and kitchen of an unidentified flat. A father walks in on his daughter and her boyfriend in bed. The daughter hurries the boyfriend out of the flat then rows with her father in the kitchen. She asks him for money and swears at him. In retaliation, he slaps her, so she packs her bag and leaves. The camera follows the daughter outside, but the *mise-en-scène* gives equal weight to both sides of the row. The young woman's father is frustrated because he wants her to get a job like 'normal' people. She is frustrated because she does not want to work in his shop and has not yet found an alternative.

The credit sequence begins as she leaves. Rapidly edited static shots track her progress in and out of frame as if to suggest that it is difficult to keep up with her. This is Niña. In Spanish, her name also means 'female child', which is appropriate for this engaging, but sometimes truculent, child-woman, who is old enough to want her independence but young enough to have hoped her father would fund it. One particularly comical shot of her progress in this sequence is dominated by an elderly man in the foreground of a square populated by pensioners sitting on a line of benches in a diagonal row from bottom right to top left. The focus is held just long enough for us to wonder where Niña is when she appears, momentarily, entering and exiting diagonally bottom right, the contrast between the two diagonals emphasising her pace and the stasis of the inhabitants of this conventional town square in Valladolid. There is something of Berlanga's *Bienvenido Mr Marshall* (1953) in the 'now-you-see-her-now-you-don't' editing, and there is also a kind of comic self-reflexivity in the credit for the cinematographer, Teo Delgado, that appears in the gap that she leaves behind her.[10] The final directorial and title credits appear over her diminishing back view as she walks away down a nondescript, scruffy, urban street.

This opening establishes the mood of youthful mobility that Bollaín wanted to convey: 'esa sensación de improvisar sobre la marcha a los veinte años' (Heredero, 1999: 78) ('that feeling you have in your early twenties that you can improvise as you go along'). And yet, despite the illusion of improvisation (the gritty realism of the argument, the handheld camera, and the grainy 16 mm film stock) this is a tightly constructed, tightly edited film about two 'normal' friends in search of life beyond Valladolid. 'Light-touch' self-referential devices also are used: comical verbal bridges; rhythmically stylised *mise-en-scène*; temporal ellipses, and some disconcerting

blurring of the boundary between non-diegetic and diegetic music. Even the initial row between Niña and her father is co-opted as a comic (and uncanny) device for narrative development. Each stage of the friends' journey (to the south coast, to Madrid, to the south, and then back to Madrid) is preceded by a quarrel that is in some way linked to Niña's mother, Mariló. Niña resents Mariló because she left the family home years earlier and failed to stay in touch, but the mother is something of a MacGuffin; she precipitates the action, but the action is about the way the friends negotiate their frustrated desires, rather than the unattainable objects of those desires, who are personified, for Trini by Mariló, and for Niña by the Russian they call Olaf.[11]

These intensely personal, microcosmic rows are symptomatic of macroscopic changes to the constitution of contemporary Spain: Mariló is a symptom of wide-reaching social changes that had made it, at this point in Spanish history (just about) feasible for a not very wealthy mother to have a career, a husband and a child, and Olaf is symptomatic of Spain's new status as a country of migrants. Although Niña's father's exhorts her to behave like 'normal' people, she and Trini *are* the new 'norm': neither comes from a traditional nuclear family and neither is grounded geographically. They do not 'own' the spaces they occupy and their appreciation of their own environment is comically partial and provincial (Trini has heard that there are palm trees in the south. Niña has heard that it is cold in the north, she also jokes to Trini that her father calls Madrid 'ese pueblo manchego' ('that town in La Mancha').

The *mise-en-scène* emphasises their partial perspectives. Ironically, it is the non-Spanish-speaking incomer, Olaf, who has the most comprehensive views of Madrid from the aerial perspective of the rooftops he works on. The views of rooftops from the flat that the friends share, on the other hand, are always truncated by the window frame. Bollaín credits Julio Medem with placing Olaf on the roof, and anyone who has seen Medem's film *Tierra* (also released in 1995), will appreciate the irony of her comment that this gave her a pretext to lift the 'gaze', preventing the representation of the relationship between the two friends becoming 'demasiado psicológico' ('too psychological'). Bollaín concurs that the Russian is an enigma, a form of 'ángel', whose origin is never explained, but she qualifies this by saying that 'la idea más metafórica o metafísica de la historia, y esa dimensión proviene de Julio, sin duda. Yo soy más de la tierra' (Heredero, 1997: 232) ('the more metaphorical or metaphysical aspects of the story come from Julio, no doubt. I'm more down to earth') Bollaín grounds her characters. She allows their rows and youthful optimism to produce narrative momentum, then leaves them at a suitably mobile point of temporary resolution. The final long shot is of the Madrid train moving upwards and off-screen right: Niña has decided to resume her search for Olaf and Trini and, having concluded that Mariló is a very poor mother substitute, has decided to become a mother herself.[12]

Flores de otro mundo (1999)

In *Hola*, the protagonists' relationship with Olaf functions as a foil to their central friendship. Niña may be passionately attached to him, but they do not share a language, his Russian dialogue is not translated, we never discover his real name, and at a certain point in the narrative he disappears and does not return. If this abrupt departure gestures towards the vagaries of the Spanish *Ley de Extranjería* (Immigration Law), the film does not articulate this openly, whereas in Bollaín's next film, immigration, the *Ley de Extranjería*, and intercultural relationships take centre stage.

Flores is based on an event that took place in Spain in the 1980s. After watching the film *Westward the Women* (dir. Wellman, 1951), the inhabitants of a rural village issued an open party invitation to the women of Spain, hoping that some would stay and produce families (Santaolalla, 2005: 192). Bollaín's fictional account of this event focuses on three women: Patricia is from the Dominican Republic and she has come in search of work and a stable home for her two children; Marirrosi is a Basque single parent who is looking for a new relationship now that her son is nearly an adult. The youngest, Milady, is from Cuba. She arrives separately. Her trip to the village is paid for by the misogynist builder, Carmelo, and there is an allusion to sex tourism in the fact that he shuns the 'fiesta de mujeres' because he has already found himself this attractive, younger Cuban partner. Language is not a problem in this post-colonial rural landscape, because all the characters speak Spanish, but conflict does arise from their divergent views on the role of women and the need for compromise.[13] The title is linked to the affable gardener, Alonso. He shows Marirrosi the exotic plants he is growing under glass and tells her that, with enough care, non-native plants will thrive anywhere. However, as Martin-Márquez points out (2002: 267), the plant metaphor is clearly inappropriate for the living, breathing 'flores de otro mundo' who arrive in the village, and Alonso will manifestly fail to 'transplant' Marirrosi from Bilbao, despite the relatively narrow geographical divide that separates them.

The role of the environment is fundamental to this representation of women on the move. The narrative is punctuated by aerial bridging shots of village rooftops and barren landscapes that provide a spatial context for the evolving relationships. For Bollaín, the landscape functions almost as another character in the film (cited in Santaolalla, 2005: 203), and with the arrival of the bus and the villagers' reception of the women, the opening *mise-en-scène* establishes that this is a film about 'negotiating location' and about 'looking' (Santaolalla, 2005: 192). Meaning was constructed between rows and journeys in *Hola*, but here it is constructed between long shots of the landscape and shot–reverse–shot sequences that give equal weight to 'native' and 'incoming' points of view. Point of view is central to the *mise-en-scène*, as the cinematography reflects Bollaín's conviction that racism is reproduced by fear of the unknown and an unwillingness to look more closely (Camí-Vela, 2005: 63).

Patricia and Damián are the only couple who marry, and Damián is furious when he finds out that Patricia is still legally attached to the father of her children. His anger is a response to the realisation that his marriage to her is invalid, both legally and according to the Catholic Church, but Patricia is equally infuriated by his docile obedience to the kind of paperwork that traps women like herself, whose only motivation is to provide a secure life for their children. For Bollaín, this sequence is the crux of the film (Camí-Vela, 2005: 64). Their row is punctuated by long shots: of Patricia looking up at the tractor in the distance as she prepares to make her confession; and of her daughter, frightened, running away across the open fields. Here, the wider landscape functions not so much as a spatial punctuation point as an integral part of the *mise-en-scène* of intimacy. By emphasising the relationship between subjectivity and social space, it reminds us that migration involves a reciprocal and ongoing engagement with environment and point of view.

Like *Hola*, *Flores* presents an optimistic, often humorous picture of conflict between individuals and, at the same time, it engages seriously with wider social issues. Patricia and Damián retrieve their relationship, and the light-hearted ending and upbeat tone serve to bring the issue of migration to a mainstream Spanish-speaking audience, illustrating the effects of the commodification of what Braidotti calls our 'organic capital' (2006: 3) and contributing to a growing need to look at the role of women as a 'a key dimension in our understanding of contemporary migration' (Kofman *et al.*, 2000: 194).

Te doy mis ojos (2003)

Bollaín's next project would focus on something 'más concentrada, menos coral, y quizá por ello más descarnada e intensa' (Bollaín and Luna, 2002: 7) ('more concentrated, less choral and perhaps, as a result, more stark and intense'). She had directed a short, pseudo-documentary on domestic abuse, starring Luis Tosar, and her research with Alicia Luna for a feature-length film on the same issue led them to the uncomfortable conclusion that if they were going to represent an abusive relationship 'teníamos que aceptar que estábamos contando una historia de amor' (Bollaín and Luna, 2002: 7, 15) ('we had to accept that we were telling a love story').

Te doy is Bollaín's most sober haptic mapping to date of the reciprocal relationship between environment, subjectivity and 'point of view', as it represents the point of view of the abusive husband as well as that of the abused wife.[14] Metaphors of sight recur in the introduction to the published script. Luna refers to the character of the son in the film as 'el niño que asume y calla como esos niños de familias maltratadas que evitan mirarte a los ojos' (2002: 11) ('the child who takes everything on board silently, like children in abused families who try to avoid looking you in the eye'). Bollaín describes the women she met in refuges as 'mujeres al borde, mujeres

que han pensado que estaban locas hasta que se han visto en el espejo de las demás' (2002: 15) ('women on the edge, women who thought they were mad until they saw their own reflection in others'). Bollaín explains that she also wanted to convey a confused, self-doubting, abusive husband, who was afraid to 'verse a sí mismo y cambiar' (2002: 7) ('look at himself and change'). The importance given to 'looking' in the successful negotiation of the relationship between subjectivity and environment is accentuated in this film by the metaphorical weight given to the role of painting in Pilar's journey and by the film's location in Spain's patriarchal, cultural 'heartland', Toledo (2002: 16).

The film begins with a sinister reworking of the flight from home that opened *Hola*. This time, the rapidly edited shots show a woman packing her bags and rushing out of her flat with her young son. She only notices once she is on a bus that she is still wearing her slippers. This image of an abused woman in slippers provides the first metaphorical link between the cultural history of Toledo and Pilar's escape. Later, in an irreverent reaction to a painting of *La dolorosa* that makes Pilar smile, her sister will joke that *La dolorosa* is obviously another 'slipper' (i.e. abused) woman. This joke produces an effect that Lacan might describe as anamorphic: it tilts Pilar's perspective on the kind of cultural iconography that has encouraged her to identify with the self-sacrificial female. Taking on a job as a guide, Pilar will begin to find a new space between herself and the paintings in the museum that helps her to begin the process of her own reconstruction. Studying painting allows her to describe and to articulate for herself a range of different forms of cultural iconography, from Klee's abstract expressionism to the Renaissance nymphs and goddesses of classical myth (Bollaín and Luna, 2002: 17). These paintings, and Pilar's response to them, provide an accessible, condensed metaphor for the relationship between subjectivity, gender and environment. They highlight the fact that Pilar's survival depends upon her ability to 'see' herself and to articulate her own position in relation to a patriarchal cultural history that has conditioned her submission, a form of submission conveyed, metonymically, in the painting of *La dolorosa* that her sister had gently mocked.

The space between the paintings, Pilar and her new-found audience of museum-goers mimics the relationship between the spectator and the film screen that Metz (1982) links to the mirror stage. It offers an alternative space in which Pilar can begin to re-envisage her own reflection. And our own engagement with her, via the *mise-en-scène*, allows us to begin to appreciate the complexity of the relationship she has with her equally vulnerable, but violent partner. Two sequences are particularly important to the representation of this central relationship and the social order that frames it (an order that is tacitly approved of by Pilar's mother and overtly rejected by her sister). The first occurs when the couple reunites. This sequence clarifies that the film title refers to Pilar's habit of listing the parts of her body that she offers to Antonio as an act of love. Pilar appears in what is, for

Bollaín, an extremely rare shot of a naked woman. She is lying on the bed in the traditional position of the art historical nude, but this framing is not about scopic desire; it is, rather, about the dangerous position that Pilar has placed herself in. The knowledge that we have of the damage Antonio has inflicted subverts this offering up of her body and the romantic cliché of the eye as the window to the soul of the beloved, expanding the connotations of this 'love' scene to include the physical abuse that accompanies the physical attraction Pilar feels for a man she still loves.

This framing of their reunion is directly contrasted with the attack on her that will bring the film to its conclusion. Pilar and her son have returned to the flat that they share with Antonio, but Antonio finds Pilar's growing confidence (the result of her new interest in art history) threatening. In this attack, the only physical attack shown on-screen, Antonio strips off Pilar's clothes in a direct and violent response to the reproductions of classical nudes in the book she has just been discussing with her son. He then pushes her out onto the balcony of their flat. This vicious 'offering up' of a woman's cowering, naked body to the public gaze is an appropriate catalyst for the dénouement and an effective metonym for the patriarchal cultural tradition that Pilar is learning to renegotiate. Shortly afterwards, she will leave the flat, supported by her work colleagues. They intend to set up a new life together as museum guides in Madrid, but the connotations of Pilar's journey are far wider than this. Her departure signals an escape from the metaphorical association of Toledo with a claustrophobic cultural history that has produced:

> una madre que consiente, una hermana que no entiende, un hijo que mira y calla, unas amigas, una sociedad y una ciudad como Toledo que añade con esplendor artístico y su peso histórico y religioso una dimensión más a esta historia de amor, de miedo, de control y de poder. (Bollaín, in Bollaín and Luna, 2002: 7) [a mother who colludes, a sister who cannot understand, a son who watches silently, friends, a society and a town like Toledo that adds artistic splendour and historical and religious weight to this story of love, fear, power and control].

Conclusion: 'Por tu propio bien' ('For your own good')

Bollaín's work frames women in the context of the 'real social and economic issues' Mazierska and Rascaroli tend to associate more with Eastern, rather than with Western European women filmmakers (2006: 199). However, this is not unusual for a woman director working in Spain. The importance of *cine social* in Spain from the 1990s onwards is demonstrated by the fact that *Te doy* won seven major awards at the Spanish Goyas in 2004,[15] and by the release, the same year, of the collaborative film, *Hay motivo*, which was intended to galvanise voters in the run-up to the general election that would be overshadowed by the Atocha bombings.[16]

Hay motivo includes thirty-two shorts addressing social issues ranging

from the provision of water and education to racism, domestic abuse and war. Bollaín's was the ironically entitled, *Por tu propio bien*. In it the actor Luis Tosar, who also stars in *Flores* and *Te doy* plays a woman giving birth in hospital who is strapped up, prodded, patronised by medical staff and exposed to the casual gaze of passers-by. Like the other films examined here, like Madeleine de Scudéry's map, this short film raises interesting questions about the reciprocal link that exists between visual representation, social space and affect. It takes a well-rehearsed gendered cliché and diegetically 'remaps' it in a way that is straightforward, funny, engaging and, at the same time, profoundly serious. In this case, the cliché is that women should let others take control over childbirth for 'their own good', and the diegetic 're-mapping' is provided by the simple substitution of a male for a female body. This short film could stand as a metonym for the three full-length features discussed here: it provides a fine example of the deceptive transparency of Bollaín's work and of the ease with which she engages us in re-mapping the complex affective relationship that exists between the gendered body and the environment in which it moves.

Notes

1 See Kofman *et al.* (2000: 5–6); and Sassen (2006: 639).
2 For Bollaín's opinion of on-screen female characterisation, see her interview in Anon. (2001: 201). Elsewhere, she singles out Estrella, the character she played in Erice's *El sur* (1973) as one of the most developed and realistic of the roles she has acted and as an influence on her own desire to produce more 'recognisable' young women protagonists Bollaín (2001: 83–4).
3 This interview provides extensive detail on Bollaín's background, her views on the Spanish film industry and her experience working with various Spanish directors and with Loach.
4 With regard to the three films examined here, Julio Medem was recommended by Spanish producers, Sogetel, to work on the screenplay for the first; the second was co-scripted with Julio Llamazares, and with contributions from a group of Dominican women living in Madrid, and Alicia Luna was closely involved in researching and writing the script for the third.
5 There is space here to focus only on the first three of these films, but *Mataharis* could equally well be examined for its gentle subversion of the *femme fatale*/spy cliché.
6 Bollaín plays down Camí-Vela's suggestion that we might read a wider existential query about 'aloneness' into this title, saying that, for her, it is just a cheesy chat-up line. However, the literal response that Niña receives 'Un poquito', makes the existential implications comically and immediately clear (Camí-Vela, 2005: 56).
7 It reappears once more towards the end of the film when a young male tourist with heavily accented Spanish uses it to try to chat up Niña.
8 The reaction of the actor playing Olaf demonstrates the ramifications of Bollaín's approach to gender reversal. Dismayed by the idea that his character would be cynical enough to sleep with one then with the other of the friends,

Bollaín had to encourage him to see that it was not a case of a Russian 'tirándose a dos chicas' but rather the reverse (Heredero, 1997: 237).

9 For more detail, see Heredero (1997) and the website of the production company Bollaín co-founded in 1992, at www.la-iguana.com/principal.htm

10 The comical effect of the opening sequence of *Bienvenido* is enhanced by the use of narrative voice-over, a technique Bollaín experimented with and then rejected for this film (Heredero, 1997: 237). See Martín-Márquez (2002: 258) and Santaolalla (2005: 195), for other references to Berlanga in Bollaín's work.

11 Martin-Márquez expands on the role of the mother (2002: 258–9), and for Bollaín's comments on the representation of the family in this and other films of the period, see Heredero (1997: 227).

12 For Bollaín's comments on her indecision over this ending, which was completed two weeks after the film arrived for screening at the Valladolid festival, see Heredero (1997: 239).

13 For detailed analysis of *Flores*, see Donapetry, (2001); Martin-Márquez (2002); Nair (2002); Santaolalla (2005) Ballesteros (2005).

14 Since writing, Bollaín has released *También la lluvia*, which is a similarly sober reflection on the hardship caused (here by the need for water) by different points of engagement with landscape. For more detailed analysis of *Te doy mis ojos*, see Cruz (2005) and González del Pozo([n.d.]).

15 Best Film, Best Director, Best Actress, Best Actor, Best Supporting Actress, Best Original Screenplay and Best Sound.

16 The ratio of male to female contributors (seven to twenty-five) also demonstrates the small but significant rise in the number of women directors working in Spain at the turn of the millennium: these were Gracia Querejeta, Icíar Bollaín, Chus Gutiérrez, Isabel Coixet, Yolanda García Serrano, Ana Díez (with Bernardo Belzunegui) and Mireia Lluch.

References

Anon. Interview with Bollaín, *Arizona Journal of Cultural Studies*, 5 (2001), 195–202.

Ballesteros, I. 'Embracing the other: the feminization of Spanish "immigration cinema"', *Studies in Hispanic Cinema*, 2(1) (2005), 3–14.

Bollaín, I. 'Cine con tetas', in C. F. Heredero (ed.), *La mitad del cielo. Directoras españolas de los años 90*, Málaga: Ministerio de Educación y Ciencia (1998), pp. 51–3. Repr. in *DUODA Revista d'Estudis Feministas*, 24 (2003), 89–93, www.raco.cat/index.php/DUODA/article/viewFile/62926/91111. Accessed 7 January 2010.

——'El cine no es inocente', *II encuentro de nuevos autores 2000* (Valladolid: Semana Internacional de Cine de Valladolid, Sociedad General de Autores y Editores, Fundación Autor, 2001), pp.13–19. Repr. in *DUODA Revista d'Estudis Feministas*, 24 (2003), pp. 83–8, www.raco.cat/index.php/DUODA/article/view-File/62924/91110. Accessed 7 January 2010.

Bollaín, I. and J. Llamazares. *Cine y literatura: Reflexiones a partir de 'Flores de otro mundo'* (Madrid: Páginas de espuma, 2000).

Bollaín, I. and A. Luna *Te doy mis ojos: Guión cinematográfico* (Madrid: Ocho y medio, 2002).

Braidotti, R. *Transpositions: On Nomadic Ethics* (Cambridge: Polity, 2006).

Bruno, G. *Atlas of Emotion: Journeys in Art, Architecture and Film* (London: Verso, 2002).

Camí-Vela, M. '*Flores de otro mundo*: una mirada negociadora', in, G. Cabello-Castellet *et al.* (eds), Cine-Lit 2000 (Corvallis, OR: Cine-Lit Publications, Oregon State University, 2000).

——*Mujeres detrás de la cámara: Entrevistas con cineastas españolas 1990–2004* (Madrid, Ocho y Medio, 2005).

Cruz, J. 'Amores que matan: Dulce Chacón, Icíar Bollaín y la violencia de género', *Letras Hispanas*, 2(1) (2005), spring 67–81, http://letrashispanas.unlv.edu/Vol2/JacquelineCruz.pdf, accessed 6 January 2009.

Donapetry Camacho, M. *Toda ojos* (Oviedo: Universidad de Oviedo, 2001).

Everett, Wendy and Axel Goodbody (eds). *Revisiting Space: Space and Place in European Cinema* (Oxford: Lang, 2005).

Fish, R. *Cinematic Countrysides* (Manchester: Manchester University Press, 2007).

González del Pozo, J. 'La liberación a través del arte en *Te doy mis ojos* de Icíar Bollaín' [n.d.], www.lehman.edu/faculty/guinazu/ciberletras/v19/gonzalezdelpozonuevo.html, accessed 7 January 2010.

Heredero, C. F. *Espejo de miradas. Entrevistas con nuevos directores del cine español de los años noventa* (Alcalá de Henares: Edición del Festival de Cine de Alcalá, 1997).

——*20 nuevos directores del cine español* (Madrid: Alianza, 1999).

Kofman, E., A. Phizacklea, P. Raghuram, R. Sales. *Gender and International Migration in Europe: Employment, Welfare and Politics* (London and New York: Routledge, 2000).

Konstantarakos, M. *Spaces in European Cinema* (Exeter and Portland, OR: Intellect, 2000).

Martín-Márquez, S. 'A World of difference in home-making: the films of Icíar Bollaín', in O. Ferrán and K. M. Glenn (eds), *Women's Narrative and Film in Twentieth-Century Spain: A World of Difference* (New York and London: Routledge, 2002), pp. 256–72.

Mazierska, E. and L. Rascaroli *Crossing New Europe: Postmodern Travel and the European Road Movie* (London and New York: Wallflower, 2006).

Metz, C. *Psychoanalysis and Cinema: The Imaginary Signifier* (London: Macmillan, 1982).

Morley, D. and K. Robins *Spaces of Identity: Global Media, Electronic Landscapes and Cultural Boundaries* (London and New York: Routledge, 1995).

Nair, P. 'In modernity's wake: transculturality, deterritorialization and the question of community in Icíar Bollaín's *Flores de otro mundo*', *Postscript*, 21(2) (2002), 38–49.

Santaolalla, I. *Los 'Otros': Etnicidad y 'raza' en el cine español contemporáneo* (Zaragoza: Prensas Universitarias de Zaragoza, Madrid: Ocho y medio, Libros de Cine, 2005).

Sassen, S. 'Europe's migrations: the numbers and the passions are not new', *Third Text*, 20(6) (London: Routledge, 2006), 635–45.

Murmuring another('s) story: histories under the sign of the feminine, pre- and post- the Portuguese revolution of 1974

Rui Gonçalves Miranda

Portugal is a full name,
a male name, if you wish
The other kingdoms, women

Gonçalo Anes Bandarra

It is from the margins of historical masculine recollection and assertion that this chapter will depart. It is therefore not devoted to memory, to history or to women as concepts, but to an analysis of how gender, memory and history overlap and interact in the revisioning (see Rosenstone, 1995a) enacted by the films (*Costa dos murmúrios*, *The Murmuring Coast*, Margarida Cardoso, 2004) and by (*Capitães de Abril*, *April Captains*, Maria de Medeiros, 2000).

Aiming to prioritise the histories constructed by these women directors over *a* history of any kind (of nation, of war, of revolution or of women), one is far from following an anti-historical or a-historical trail, but, on the contrary, one is set on teasing out the historicity, that is, the conditions of possibility underlying any historical constructs. The significance of both these films, among many others directed by Portuguese women, is that both revisit and review the discourse scaffolding the main pillars of modern Portuguese national identity: the revolution of 1974 and the end of the colonial wars in Angola, Mozambique, Cape Verde and Guinea-Bissau (1961–74). Eduardo Lourenço points out how, in a compensatory manner, the wars have been read as the founding act of a modern Portugal which was reinvented as a politically progressive state under the new-found myth of an exemplary revolution (Madureira, 2006a: 151).This is achieved by re-engendering (see Ferreira, 1997) the histories of conflict surrounding the individuals as well as the national community with a double refocusing[1] through the directors Cardoso and Medeiros and through the characters Evita and Antónia and her daughter Amélia. The analysis of these films will be framed by Jacques Derrida's discussion of the 'feminine', namely in his interview with Christie McDonald (Derrida and McDonald, 1991).

The historical period under focus and being 'seen' (Rosenstone, 2006:

11–31) is particularly relevant in terms of the struggle for gender equality, as women's liberation is intrinsically linked to the democratic revolution of April 1974. Indeed, an often overlooked fact is that in Portuguese historical and artistic cultural memory and production the 'advent of Portuguese women' is one of the most immediate changes brought about by the Carnation Revolution (Ferreira, 1997: 222), which ended the forty-eight-year rule of the *Estado Novo* (New State) regime. Margarida Calafate Ribeiro offers an incisive account of its main tenets:

> Nationalist politics drew on tradition, history, empire, catholic moral values, order and national unity, and it opposed internationalism … The corner stone of a national resurrection was a return to the original values of the Portuguese imperial adventure. (2002: 158)

To all of this, one must add the construct of femininity imposed on women, as the pillars of the Portuguese family. Homebound, deprived of any effective political or social power (Ferreira, 1996: 137), women were excluded from 'legal citizenship' under the terms of the 1933 Constitution, 'on account of their "natural" sexual difference and for the good of the family' (Owen, 2000: 4). As a social group, women were endowed only with a simulacrum of importance as the regime 'called upon them as a last resort of national salvation' (Ferreira, 2001: 139) and indoctrinated them to fulfil their role in the family and in the home, fighting wars in the private arena as men did in the public sphere (Pimentel, 2002: 125). The New State, as Irene Pimentel demonstrates, was highly committed to creating a 'future woman' ('Catholic and Portuguese, an educator and a social worker, a prolific mother and obedient wife') who could fulfil her role within the imperial nation, giving rise to a number of women's organisations to that effect (124). At least since 1972, with the publication of the groundbreaking *Novas Cartas Portuguesas* (*The Three Marias: New Portuguese Letters*) by Maria Isabel Barreno, Maria Teresa Horta and Maria Velho da Costa, the 'notion of women as the last colony' has been put forward (Nunes, 1987: 19).

The imperialistic ideology which ultimately sustained the regime, however, was in an ever more fragile state with the outbreak of the colonial wars (1961). Women, alongside left-wing political groups or democrats, were repressed within a constructed national discourse which aimed to veil the historical frailty of the nation state (Lourenço, 2000: 86; Ribeiro, 2002: 147) by projecting an imaginary national body supplementing itself, in the Derridean sense, with the colonial territories in Africa. These phantom limbs of a veiled, mangled national body were inclusively renamed as 'overseas provinces' in response to the international uproar regarding the Portuguese state's colonial stance after the Second World War. The ideological refashioning that took place in 1951 with the Constitution that led to the revoking of the Colonial Act was supported by Gilberto Freyre's luso-tropicalist thesis, departing from Freye's 1933 book *Casa-grande e senzala* (*The Masters and the Slaves*).[2] Gilberto Freyre studied the Brazilian racial

heritage to conclude that the Portuguese were somewhat more adjusted to living in the tropics and that rather than establishing their colonies on racial separation, miscegenation was a key component in their territories. Thus, it could be concluded, by projecting the Brazilian experience onto the whole of Portuguese colonial possessions, as Freyre did in 1940 with *O mundo que o Português criou* (*The World Created by the Portuguese*), 'that Portuguese colonialism was "unique" and "distinct" (read "better") in relationship to other colonialisms', which had strong 'geopolitical consequences' (Arenas, 2003: 7). Although this masking was, in social and political terms, nothing more than an 'endearing fiction' (Madureira, 2006a: 141), it can be said to have had lasting effects regarding the way in which the national community perceives its colonial past, and it also established a libidinal economy in the imaginary of Portuguese colonialism. The narrative of decline that had dominated Portuguese intellectual writings prior to the *Estudo Novo* (Arenas, 2003: 7–8) was counterbalanced by a simplistic and romanticised account of Portuguese colonialism (Madureira, 2006a: 141) which was seen as the best strategy to justify it particularly from 1951 onwards (139, 42).However, even this ideological facelift was ultimately inefficient in masking the evidence that the imperially transposed '*casa-grande e senzala*' (which literally means 'the house of the master and the house of the slave') was unsustainable as the supplement of the '*casa portuguesa*' ('Portuguese house'), itself empty and wholly artificially constructed:

> The empire had been definitively shaken, both as a reality and as an image. The whole structure of the 'casa portuguesa', established during the Salazar era – from nation to family, from school to church, and even the Portuguese language itself – was in tatters. The movement for change was signalled by the poets of *Poesia 61*. In Fiama Hasse Pais Brandão, Luiza Neto Jorge and Maria Teresa Horta's poetry and in works such as *Casas Pardas*, by Maria Velho da Costa and *Novas Cartas Portuguesas*, by Maria Velho da Costa, Maria Isabel Barreno and Maria Teresa Horta, this movement acquired a female face that reclaimed women as agents of history. Change, on this side of the ocean, included the feminine (Ribeiro, 2002: 171).

In analysing Maria de Medeiros's *Capitães de Abril* (*April Captains*) and Margarida Cardoso's (*The Murmuring Coast*, 2008), we will address not the opposition to the masculine, but the disruption of a *locus* assigned to the feminine.[3] We will do so by supplementing the 'female face' with a feminine gaze, going beyond the conceptualisation of a Mulveyan gaze which, even when feminine, partakes of the objectification and domination of the masculine gaze, following the insight of Paulo de Medeiros (2008) regarding *A costa dos murmúrios*. The gaze is not only an inevitable metaphor when addressing the refocusing and the revisioning of history by women, but it is also, as this chapter will make clear, an operative term for an analysis that seeks to tease out the differences, disruptions and discontinuities which a teleological historical discourse necessarily veils and excludes. Rather than denying the masculine construct of history (of nation, of revolution, of war

or of women) and instituting an alternative path as both replica and reply, it is the feminine as part of change which is at work in both films, as they put forward their performance of a historical past. This performance is conscious not only of historical constructs, but is also aware of the structurality articulating any construct, path or locus.

History's masculine predominance, univocality and claim to authority, its phallogocentrism in Derridean terms, is undermined by being supplemented with the gaze from the margins. Not only that of the narrators and the central characters of both films (Evita, Antónia and Amélia), but also of, and doubled by, those of Margarida Cardoso and Maria de Medeiros.

> The past is never dead. It's not even past.
>
> William Faulkner

The renegotiation of paradigms of femininities will take place under the sign of the feminine, as enacted by Antónia (the unsuspecting wife of a revolutionary, Manuel) and her young daughter, on the day of the Revolution of the Carnations in 1974, and by Evita in Mozambique, the wife of a soldier in a long colonial war, a last gasp of a crumbling Portuguese imperialist ethos. The subjective, individual stories of Evita and Antónia and Amélia are enacted against the official history (always) already in construction. If *A costa dos murmúrios* is an exercise of remembrance from Eva (Eve) looking back upon her younger self, Evita (little Eve), as a reply to an objective and masculine narration, 'where both gaze and voice belongs to a woman' (Ribeiro, 2002: 207), the ending of *Capitães de Abril* will feature the voice-off of Antónia and Manuel's daughter, Amélia, narrating their lives up until the present of the diegesis.

In the same way, both films are structured, to a large extent, around the personal memories of the filmmakers, regarding colonial Portuguese Africa in Cardoso's case and, in Medeiro's case, of the day of the revolution. This does not necessarily mean that personal memory is opposed to an historical account, but rather that the films enact a performance of history[4] which incorporates, rather than excludes, the subjective and personal memories and accounts.

As such, the historicity of the points of view put forward by the characters is in close dialogue with the represented historical events. These are textually addressed from the margins of history by establishing an intertextual dialogue with the images of war atrocities during the colonial wars. In different ways and in different moments, images of atrocities make a significant appearance in both films. One could read the opening shots of atrocities which introduce *Capitães de Abril* and the digitally altered authentic photos of war atrocities which Helena shows to Evita in the *A costa dos murmúrios* as the intertextual instance which paves the way for a conjoint analysis of both works, focusing on the constructed identification of violence (namely through war) with masculinity. These are, in fact, the mangled bodies of the imperial mission which is ideologically shielded and justified by a lusotropicalist ethos which animates the ailing regime.

It is through women's gazes that one is alerted to the atrocities: Evita, when Helena opens her husband's, vault; Antónia, who reads Manuel's diary behind his back. These brutal acts of violence, openly exposed via the footage and the photographs, serve to underline the 'systemic violence'[5] which permeates both stories.

If, in *Capitães de Abril*, the footage of atrocities serves as a powerful visual epigraph, in Cardoso's film, on the other hand, the photographs which Evita is shown dismantle the idyllic nostalgic Super 8 footage which can take in a less attentive viewer. By integrating into the diegesis a well-known photograph of a Portuguese soldier holding the head of an enemy combatant, digitally altered so that it is the character Luís who appears, the 'discomfort and guilt' (in Cardoso's own words) which arise become 'more acute when one focuses on the image's original context of combatants' grisly wartime memento-making' (Sabine, 2010: 268).

The images of violence act in both films as a 'return of history (Žižek, 2009: 159), the marks upsetting the teleological march of colonial society and imperial society masquerading as multiracial and pluri-continental, in which the empire functioned as the imagination of the centre (Ribeiro, 2002: 136). These spectres, resisting incorporation into the ideological narrative supporting the status quo in both films, haunt the supposed substance of both the narrative of a colour-blind and non-violent 'Portuguese integration' and that of a Portuguese 'centrality' whose periphery was dissimulated via the supplements of the 'overseas provinces'.

The feminine gaze ultimately undermines not only the ideological and violent constructs, identified with the masculine, but also the existence of the pre-formatted concepts of history and revolution, which it both exposes and confronts. Thus, the interest of both films lies in the political and historical revisioning which is offered, unveiling the historical masculine gaze, in an enterprise which is interested not so much in putting forward a history of woman as it is in revisiting history as a masculine concept. History is addressed only through the storying of Evita and Antónia, who start as wives of soldiers but end the diegesis as more than that, separated and independent, as *others*, another which now is a self. Evita symbolically becomes Eva the narrator of events, and Antónia becomes a politician after the day of the revolution. Both nations and women become different, and that they are able to change, and to continue to promote and allow for change from constructed and assigned paths and loci, seems to be what distinguishes the feminine from the masculine.

Neither film attempts to replace the masculine march of history with a feminist[6] or feminine version so much as to resist such teleology, to step back from it, to undermine it from the margins. One is reminded of Christie McDonald's example of Emma Goldman, who 'once said of the feminist movement: "If I can't dance I don't want to be part of your revolution"' (Derrida and McDonald, 1991: 441). The teleological lines of historical process are only too eager to harmonize differences or, concomi-

tantly, to locate and neutralise them, to find a place both for revolution and woman:

> Perhaps woman does not have a history, not so much because of the notion of the 'Eternal Feminine' but because all alone she can resist and step back from a certain history (precisely in order to dance) in which revolution, or at least the 'concept' of revolution, is generally inscribed. That history is one of continuous progress, despite the revolutionary break – oriented in the case of the women's movement towards the reappropriation of woman's own essence, her own specific difference, oriented in short towards a notion of woman's 'truth'. Your 'maverick feminist' showed herself ready to break with the most authorized, the most dogmatic form of consensus, one that claims (and this is the most serious aspect of it) to peak out in the name of revolution and history (442).

So, what is the place of women pre- and post- revolution?[7] The question already betrays the presupposition that there is such a thing as a place for women. Both films seem to deny not only a locus for women, but the positive existence of such a locus, which would both mirror and reaffirm the presence, even in attempted subversions, of the masculine locus. What both films do is signal the valuable contribution of women to maintaining a society from becoming fixed, participating in the 'dance' of the feminine. It is by highlighting its supplementary positioning (rather than a secondary or complementary one) that the feminine undermines the masculine and phallogocentric conception of society. The masculine wars in the public arena fought by men are found to be ultimately dependent on the 'secondary' wars fought by women in the private sphere (Ferreira, 1996: 134), in the same way as Freyre's notion of a racially or ethnically 'democratic' colonialism appropriated by the *Estado Novo* could be seen to rest entirely on the 'sexual availability' of the native women (Madureira, 2006a: 142). Women's refusal to participate, as both films demonstrate, involves and is part of a change of regime.

Antónia and Evita, exposed to the official historical narratives which are presented about the state and colonialism through the voices of the several masculine characters, have both, by resisting and stepping back from the social, cultural and historical structures, past and present, found themselves in a position similar to that of Walter Benjamin's historian in relation to the past: their own time is 'more distinctively present' to their 'visionary gaze than it is to the contemporaries who "keep in step with it"' (2003: 405). More than merely turning their backs on their own time, they, like Emma Goldman, like Maria de Medeiros and Margarida Cardoso, do not abdicate the right to dance.

This is evident in the first public events in which both Antónia and Evita are (re)presented: the party to which Antónia goes after discussing with her husband his role as a soldier in the service of Portugal's imperialism and Evita's wedding. Antónia's presence in the reception is signalled as being out of place not only by the contrast between her active presence and the

dormant figures surrounding her, but also, most significantly, by the refusal of her photographer friend (later a photographer of the revolution), who, working at the party at the service of the regime, refuses to take Antónia's photograph in that midst. As Antónia storms out of the reception, refusing to turn a blind eye on the inequalities and of the injustices of the regime, her movement and her red dress establish a semiotic contrast with the pale colours surrounding her.

Evita's dance with an officer during the celebration of her marriage to Luís is perhaps the first sign that Evita is out of step with and will inevitably step out of the society around her. The official's description of Africa as being yellow 'like whisky' fits with Margarida Cardoso's memories of Africa as a place of 'pale colours, typical colours of suffering' (Soares, 2004), with Evita's presence contrasting with her pale surroundings at the beginning of the film, in the hotel and in the streets. This dance, led by the officer, also emphasises the existence of a social environment in which women cannot dance, in more than one sense: a shot features a string of women who, in the absence of their husbands, are leaning against the wall while the dance takes place.

> The most serious part of the difficulty is the necessity to bring the dance and its tempo in tune with the "revolution." The lack of place for [*l'atopie*] or the madness of the dance.
>
> Jacques Derrida

Capitães de Abril and *A costa dos murmúrios* thus confront in different ways the constructs of femininity promoted by the right-wing, conservative dictatorship of the *Estado Novo*, revisioning, at the distance of decades of democracy, the memories and histories of the women characters whose visions, different and expressed differently in each film, shape a revised understanding of the historicity of women's (non-)place. These films can be read as being politically committed, offering a historical revisioning rather than revisionism via a feminine gaze which addresses the *pas* (step(s)/not(s)) (see Blanchot, 1992), each and every one of them, singular and plural, of women attempting to escape the patriarchal and the masculine conceptions of society and even of revolution. Both films ultimately reject the assignment of women's place in war, in revolution, and in history, necessarily out of step with the prescribed evolution and revolutions of the times.

In this historical revisioning one could suggest that Evita, Antónia and Amélia act as the Benjaminian angels of history (Žižek, 2009: 151) both within and outside the surrounding historical and ideological constructs, addressing with their gaze the grand narratives of a national (imperial, colonial) imaginary.

The empirical images of violence presented in the films are a reminder of the imperative which pushes these women into becoming female agents of history rather than observers. Unlike Benjamin's angel, they can act as

their gaze exposes that lusotropicalism and other *Estado Novo* narratives are but ideological vehicles masking historical violence and the violence of history. Under the guise of appealing to the other, lusotropicalism obscured the colonised others, within and outside the nation, to be negated in the sublimation of the Portuguese empire.

Evita's ever wandering gaze sees the lack of human dignity with which the natives are treated, as their corpses are being transported in dumpers that the other guests in the hotel cannot see even through binoculars. Contrary to the other guests, what Evita sees is not the clear and distinct violence of war, but the ever present underlying systemic violence that the others cannot see (if they ever could).

Antónia and Amélia also represent a different focus on the historical event of the revolution. Theirs is a gaze that travels through the margins of the day of the revolution, always transgressing, in the sense that it goes beyond what is seen by others, or what should be seen, as in the instance where Amélia's point of view is directed at the members of the political police who were stripped in public or when, in the car, she looks out into a crowd attacking her father and Salgueiro Maia as they significantly confuse them with members of the state police.

Nevertheless, what is most striking is Maria de Medeiros's presentation of the revolution as being 'feminine' (2000a), despite the fact that it appears masculine, thus opposing it to a masculine violence that seems to be embodied by the members of the regime. *Capitaes de Abril*'s representation of the event of the 25 April 1974 can certainly be accused of putting forward a romanticised view of the revolution by being centred around the actions of the young group of soldiers (most notably around the figure of Maia).[8] However, factual inaccuracy or historical revisionism are not the main points of contention. Indeed, the criticism directed at the film relates to the audience's expectations regarding the representation of the pivotal historical event of democratic Portugal not being met, as one can argue, alongside Madureira's reading of António Lobo Antunes's *Fado Alexandrino*, that the revolution became 'the most recent wish-fantasy to replace fascism's imperial sublime' (2006b: 165). Several criticisms are focused on the lack of a solemn tone to the film, as Maria de Medeiros reports (2000a). The dispute relates not to content but to form, thus revealing that the film simultaneously appears to fulfil its expected mimetic role regarding the historical event (the facts) while disrupting the historical discourse. What seems to elude critics is that the film (as is also case regarding *A costa dos murmúrios*) does not represent the past, but performs it, electing to bypass the solemn and celebratory tone of the revolution by highlighting the improvisation that accompanied the event and even allowing a certain degree of humour (provided by Captain's Salgueiro Maia's description of the events (2000b)).

The absence of a 'solemn' or 'historical' tone exemplifies resistance to a truth, to a history which is itself already constructed, although presented

as natural. Against the march of ordered concepts and preconceptions of what revolution was and should be historically, the film moves in a certain *pas* (a certain step; a certain not) (Derrida, 1993: 6) which, rather than openly challenging the constructs of masculinity and femininity tradition-ally espoused in the representation of the revolutionary moment, obliquely challenges the masculine traditional historical representation of the day of the revolution.[9] In a sense, Medeiros is re-engendering history by going behind both history and the historical, cutting through the historical mas-culine façade of revolution to the particularities of the atypical revolution of 1974. Comments by Maria de Medeiros, such as those stating that this was 'an atypical revolution, in which the military preferred to use dialogue rather than weapons', which she claims to be an 'essentially feminine trait' (2000a)[10] can indeed be questioned, but this declaration of intent is certainly useful when addressing the fabric of the film. It nevertheless proves that the conception of the feminine explored by Maria de Medeiros can be seen to go beyond the 'feminine' as a substance to the 'feminine' as a mode. History is re-engendered through the 'poetic licence' of insert-ing demonstrations by women for sexual freedom with slogans such as 'Men to the kitchen now', paying homage to the reigning spirit and the factual debt that the revolution owed to women, even if events such as these did not actually take place on that day. This poetic licence is justi-fied by the fact that the 'revolutionary spirit is quintessentially libertarian and transformative' (2000b). The 'revolutionary spirit' – if there is such a thing – cannot, by definition, be conservative. Nor can the feminine. As a Derridean supplement, it always exceeds the signification of the mas-culine narrative to which it should conform, be it that of the revolution (with Amélia, in the end, providing its eulogy) or that of colonial war and conflict, which Eva, as above mentioned, supplements with her dissensual point of view.

> The intention of my film is to make people question themselves. Above all, one essential thing must be kept: dualism.
>
> Margarida Cardoso

As Margarida Calafate Ribeiro addresses the changes brought about by 25 April, she highlights that there is now a certainty that after the revolution of 1974 'identity will have to be lived, built and transformed by the two sub-jects of history, men and women'. Ribeiro additionally notes how women, with their writings and sculptures inspired by war, have demonstrated that 'gender plays a determining role in nationalisms, in wars, in history, in struggles' (2009: 160).

Artistic responses by women continue to erupt in 2000 and 2004. Women are indeed no longer homebound, nor are they bound to any other locus. The feminine is not a locus, but a *movement* which must never be refused; a dance, with an always singular *pas* (step/not). The 're-engendering of history', if it is to resist appropriation by phallogocentrism, implies not

only a different role for the feminine, but that the feminine remains other, respects difference. Ribeiro is right in pluralising nations, nationalisms, wars, struggles and (I would necessarily pluralise) histories. It is the feminine which allows for this turn away from the univocal, allowing for the murmuring from the margins. If the path of history is masculine, the steps and the negations of histories/storying are consequently, and in a strategy of subversion and reversion, feminine. The feminine is a marginal operation, a gaze, a mode rather than a substance.

Supplementing a 'female face', the 'feminine' would thus be a gaze, not partaking of a historical, solemn, epic view of the past, but nonetheless politically committed to the enactment of different and differing histories. These 'feminine' histories, avoiding objectification and domination, provide an alternative revisioning of the past and, consequently, of nationness. The 'doubly peripheral condition of the Portuguese: Portugal on the periphery of Europe and its own empire', which from 1961 onwards men and women started to address (Ribeiro 2002: 168), challenges the traditional construction of Portuguese identity and politics as the imagining of a centre (132–9), albeit one haunted by the periphery (139). This does not happen, as in the *Estado Novo* regime, via the recuperation or the invention of a new mythography, but by inscribing a supplementary channel of communication (in all senses of the word) in the construction of a historical discourse on the nation: different, differing and deferred.

It is then with a feminine gaze, understanding the feminine as 'that which will not be taken in (by) truth [truth?]' (Derrida and McDonald, 1991: 442), and the feminine gaze as not partaking in the assured certainty of phallogocentrism, not partaking in masculine domination (as Paulo de Medeiros would put it (2008)), that the historical and mnemonic reconstitutions of the past are addressed, refigured and reconfigured. It is through the gaze of Antónia and her daughter and through Evita, that the stories of the end of colonial wars, the revolution and the post-revolution are retold, refocused and reconstructed. It is through them that, while avoiding the epic narrative, one is shown how heroes were soon abandoned and forgotten, as Antónia's daughter will testify for the future, and that there were no heroes in war, as Evita will remember.

The feminine gaze does not disrupt a historical line, although it certainly denies both the nostalgic conception of the future originating in the past and the modernist binary counterpart of a future without a past. History is not interrupted; it is already interruption under the guise of continuity, and the gaze merely undresses the guise, the metaphysical nudity of a historical line. If the march of history can be plainly conceived as a phallogocentric structure and institution, these films revisit the feminine (*her*) stories in *history*, the oblique rewriting from the margins, supplementing an 'objective' history with its purposefully marginal gazes and murmurs.

Notes

1 I am using the term refocusing, following the lead of Levitin *et al.* (2003).
2 Cláudia Castelo (1998) offers an extensive treatment of the reforms of the 1951 Colonial Act and how they were justified by the subtext of Gilberto Freyre's lusotropicalism. Ribeiro demonstrates that this legitimisation of a colonialist position by using lusotropicalism was all the more effective given that Freyre's thesis resonated strongly with the tradition of Portuguese imperial ideology and its cultural imaginary, by allowing for 'an identity under construction' (2002: 166).
3 One must stress how the 'feminine' cannot be mistaken for '"woman's femininity, for female sexuality, or for any other of those essentialising fetishes"', as Derrida stresses in *Spurs: Nietzsche's Styles/Eperons: Les Styles de Nietzsche* (1979) (Derrida and McDonald, 1991: 442).
4 The fact that films construct history rather than mimetically representing it has been strongly backed by academic research (Rosenstone, 1995b, 2006; Sobchack, 1996). Films have always been performances and, as Daniel Frampton puts it, cinema 'has never been, and is definitely becoming less and less, a simple and direct reproduction of reality' (2006: 1).
5 I am using the term 'systemic violence' to refer to the structural conditions which generate cases of subjective and objective violence. For a discussion of these terms, please see Slavoj Žižek (2009: 8–33).
6 It would be equally simplistic to reduce the feminine gaze to a feminist concept when it is precisely the '-ism' which is under scrutiny. I would follow Isabel Allegro de Magalhães when, noting the lack of feminist writing in Portugal, she prefers to search for 'predominantly feminine' characteristics in writings by women (1997: 202–3). Re-engendering history does not equate to gender history.
7 Ana Paula Ferreira demonstrates in her reading of contemporary Portuguese women's writing how 'women and revolution are not a smoothly matched pair' (see Ferreira, 1997).
8 The Portuguese viewer can appreciate how the revolution is revisioned historically when *Capitães de Abril* frames in a photograph Captain Salgueiro Maia as the soldier making the victory sign immediately after the confrontation with Brigadier Pais. A well-known photograph immediately after the confrontation in the *Rua do Arsenal* in Lisbon depicts Maia as one of the soldiers around the central figure of a man making the victory sign. It is the footage of war atrocities at the beginning of the film which reminds the viewer that the '25 April was not the uniquely peaceful liberation that everyone, under the spell of a new democracy, wanted it to be. From its first movement, from the imperial periphery to the centre, the Revolution was stained by blood, shed far away in Africa' (Ribeiro, 2002: 186).
9 Maria Teresa Horta was a pioneer in confronting the male rhetoricians of the revolution, with her writing that 'defies the temptation to recount a story of historical progress under the patriarchal sign of the carnation: "Flor sublinhada, macha, única flor de serrilha e hirsuta"' (Ferreira, 1997: 225) ('Underlined, male flower, the only serrated and hairy flower').
10 Translations from original Portuguese are author's own.

References

Arenas, F. *Utopias of Otherness: Nationhood and Subjectivity in Portugal and Brazil* (Minneapolis, MN: University of Minnesota Press, 2003).

Benjamin, W. 'Paralipomena to "On the concept of history"', in H. Eiland and M. W. Jennings (eds), *Selected Writings: 1938–1940*, vol. 4 (Cambridge, MA and London: Belknap Press of Harvard University Press, 2003).

Blanchot, M. *The Step Not Beyond*, trans. L. Nelson (Albany: State University of New York Press, 1992).

Castelo, C. *'O modo português de estar no mundo': o luso-tropicalismo e a ideologia colonial portuguesa (1933–1961)* (Porto: Afrontamento, 1998).

Derrida, J. *Aporias*, trans. T. Dutoit (Stanford: Stanford University Press, 1993).

Derrida, J. and C. McDonald. 'Choreographies', in P. Kamuf (ed.), *A Derrida Reader: Between the Blinds* (New York: Columbia University Press, 1991), pp. 441–56.

Ferreira, A. P. 'Homebound: the construct of femininity in the *Estado Novo*', *Portuguese Studies*, 12 (1996), 133–44.

—— 'Reengendering history: women's fictions of the Portuguese revolution', in H. Kaufman and A. Klobucka (eds), *After the Revolution: Twenty Years of Portuguese Literature 1974–1994* (London: Associated University Presses, 1997), pp. 219–42.

—— 'Tell me the mother you had…: Anti-feminist discourses and the making of *The Portuguese Home*', in *Global Impact of the Portuguese Language* (New Brunswick and London: Transaction, 2001), pp. 127–43.

Frampton, D. *Filmosophy* (London: Wallflower, 2006).

Freyre, G. *Cash–grande & senzala: Formação da família brasileira sob o regime de economia patriarcal* (Rio de Janeiro: Maia & Schmidt, 1933).

——*O mundo que o português criou. Aspectos das relações sociaes e de cultura do Brasil com Portugal e as colónias portuguesas* (Q10 de Janeiro: Jose Olympio, 1940).

Levitin, J., J. Plessis and V. Raoul (eds). *Women Filmmakers: Refocusing* (New York and London: Routledge, 2003).

Lourenço, E. 'Da literatura como interpretação de Portugal (De Garrett a Fernando Pessoa)', in *O Labirinto da Saudade: Psicanálise Mítica do Destino Português* (Lisboa: Gradiva, 2000), pp. 80–115.

Madureira, L. 'The empire's "death drive" and the wars of national liberation', in *Imaginary Geographies in Portuguese and Lusophone-Africa: Narratives of Discovery and Empire* (Lewiston, Queenston and Lampeter: Edwin Mellen Press, 2006a), pp. 135–61.

—— 'The April revolution, or, the desire for the absent of history', in *Imaginary Geographies in Portuguese and Lusophone-Africa: Narratives of Discovery and Empire* (Lewiston, Queenston and Lampeter: Edwin Mellen Press, 2006b), pp. 163–74.

Magalhães, I. A. de. 'Women's writing in contemporary Portugal', in H. Kaufman and A. Klobucka (eds), *After the Revolution: Twenty Years of Portuguese Literature 1974–1994* (London: Associated University Presses, 1997), pp. 201–18.

Medeiros, M. de. 'Maria de Medeiros fala sobre o tema de seu filme, "Capitães de

Abril"' (2000a), *Jornal da Tarde*, online text: www.terra.com.br/cinema/noti-cias/2000/11/01/001.htm, accessed 30 May 2010.

—— 'Maria Medeiros fala de seu filme' (2000b) *Estadão*, online text: www.estadao.com.br/arquivo/arteelazer/2000/not20000801p1279.htm, accessed 30 May 2010.

Medeiros, P. de 'Double takes: violence, representation, and the border gaze', paper given as guest lecturer at the University of Leeds Centre for World Cinema's New Approaches to Film Studies series, Leeds, 23 April 2008.

Nunes, M. L. *Becoming True to Ourselves: Cultural Decolonization and National Identity in the Literature of the Portuguese-speaking World* (New York: Greenwood, 1987).

Owen, H. *Portuguese Women's Writing, 1972 to 1986: Reincarnations of a Revolution* (Lewiston, NY and Lampeter: Edwin Mellen Press, 2000).

Pimentel, I. 'Women's organizations and imperial ideology under the *Estado Novo*', *Portuguese Studies*, 18 (2002), 121–31.

Ribeiro, M. C. 'Empire, colonial wars and post-colonialism in the Portuguese con-temporary imagination', *Portuguese Studies*, 18 (2002), 132–214.

—— 'Uma outra história de regressos: Eduardo Lourenço e a cultura portuguesa', *Colóquio/Letras*, (171) (2009), 151–63.

Rosenstone, R. A. 'Introduction', in R. A. Rosenstone (ed.), *Revisioning History: Film and the Construction of a New Past* (Princeton, NJ: Princeton University Press, 1995a), pp. 3–13.

—— *Visions of the Past: The Challenge of Film to Our Idea of History* (Cambridge, MA and London: Harvard University Press, 1995b).

—— *History on Film/Film on History* (Harlow: Pearson Longman, 2006).

Sabine, M. 'Killing (and) nostalgia: testimony and the image of empire in Margarida Cardoso's *A Costa dos Murmúrios*', in C. Demaria and M. Daily (eds), *The Genres of Post-conflict Testimonies* (Nottingham: Critical, Cultural and Communications Press, 2010), pp. 249–76.

Soares, A. 'Margarida Cardoso, da ficção ao documentário' (2004), *Festival do Rio* online website, accessed 12 January 2010.

Sobchack, V. (ed.). *The Persistence of History: Cinema, Television, and the Modern Event* (New York: Routledge, 1996).

Žižek, S. *Violence* (London: Profile, 2009).

Index